ICON

MOSHE BARASCH

I C O N

Studies in the
History of an Idea

NEW YORK UNIVERSITY PRESS
NEW YORK AND LONDON

NEW YORK UNIVERSITY PRESS
New York and London

Library of Congress Cataloging-in-Publication Data
Barasch, Moshe.
Icon : studies in the history of an idea / Moshe Barasch.
p. cm.
Includes bibliographical references and index.
ISBN 0-8147-1172-3 (cloth : acid-free paper)
ISBN 0-8147-1214-2 (paper: acid-free paper)
1. Icons—Cult—History of doctrines—Early church, ca. 30-600.
2. Image (Theology)—History of doctrines—Early church, ca.
30-600. 3. Iconoclasm. 4. Icons—Cult—History of doctrines—
Middle Ages, 600–1500. 5. Image (Theology)—History of doctrines—
Middle Ages, 600–1500. I. Title.
BR238.B36 1992
246'.53'090015—dc20 91-45350
 CIP

New York University Press books are printed on acid-free paper,
and their binding materials are chosen for strength and durability.

Manufactured in the United States of America

10 9 8 7 6 5 4 3 2

Contents

ICON

Introduction

The student of religious images will always wonder about the strange ambivalence, or even conflicts, in attitudes to the artistic depictions of the divine. On the one hand, we know that often in history such images have not been accepted as a matter of course. In many generations we find philosophers, priests, or political leaders who doubted or even attacked the validity and "truth" of holy icons, sometimes going so far as to describe them as "lies," as "dead matter," or even as outright representatives of the devil, or what in different societies passed as the equivalent of the devil. These thinkers found communities who followed them, and great movements were sometimes initiated. We know, of course, that there were always large groups and organizations, ecclesiastical and political, that defended these very same images, and invested great effort in demonstrating their value and usefulness. These defenders of sacred images, however, never managed to restore a naive belief in the image, a trust untouched by doubt. Even the most enthusiastic

champion of pictures acknowledges, by the very fact that he or she has to defend the image's validity, that the object of his or her veneration is problematic. On the other hand, the student also knows that the philosophers, religious or political leaders, or simply fanatical believers who rejected sacred images as lies, as appearances lacking in substance, rarely merely neglected or ignored them, as one would perhaps expect if something is believed to be devoid of truth and vigor. On the contrary, they seemed to have sensed a strange and uncanny danger in these images. Precisely because they felt the power of images, they were driven to destroy them physically, smashing the statues and burning the paintings. Perhaps no more eloquent tributes have been paid to the force inherent in images than the outbursts of violent hatred directed against these supposedly "dumb objects" and the sometimes uncontrollable urge to smash them to pieces.

This conflict of attitudes is perhaps latent in our viewing of pictures in general, but it becomes particularly striking when we consider how people have approached the images of God or of sacred figures. We need not attempt here to explain why the image of the god or the saint stirs emotions more profoundly than does the image of a simple mortal. It is sufficient to note that before a god's image—in whatever culture, and whatever the look of that image—it seems to be particularly difficult to maintain a neutral beholder's detached attitude. It was therefore mainly in discussing divine images that feelings ran high, both in rejection and in defense. In trying to understand some basic attitudes to artistic images, the student will have to concentrate on the portrayal of the gods.

Thoughts about the nature and status of the image have stood, as is well known, at the center of great historical movements; they dominated processes and events that shook societies, upset old institutions, and determined the course of events for centuries. What are euphemistically called Iconoclastic Debates in the Byzantine Empire, and in Western Europe in the wake of the Reformation, as well as other movements with a similar ideology,[1] were in fact great social, political, and religious movements accompanied by a great deal of violence. At least part of this violence was directed towards images. Many of the statues with chopped-off noses, obliterated faces, and broken limbs that populate our museums bear eloquent witness to the amount of force that was directed against them.

Carefully following the deeds of the iconoclasts in different ages and

attentively studying their slogans, one necessarily observes the emergence of a characteristic and articulate attitude towards the image. To be sure, the specific reasons for smashing images differ from one country to the other and from one age to the other. But when we disregard for a moment the specific conditions and formulations, it is not difficult to see some common elements in the attitudes of the various individual movements. If "attitude" is too narrow or concrete a term, we could perhaps say that the iconoclastic movements and trends of thought have a common horizon. This attitude, or horizon, is perhaps best grasped when we compare it with the approach to artistic images with which we ourselves are most familiar, what we are used to calling "the aesthetic experience." Let us therefore briefly turn to the aesthetic attitude.

I shall not attempt here an analysis of the aesthetic experience, a subject that has not suffered from neglect in modern thought. I shall only remark that in surveying the various theories put forward to explain this kind of experience one notes that, however different the particular point of departure may have been, all students agree that some specific elements or qualities determine the overall character of the experience. Thus, the aesthetic experience, all thinkers accept, involves a certain detachment of the spectator, a certain psychological distance from what is depicted in the image he or she is looking at. If by looking at the image the spectator is carried away and moved to new action or new behavior—all theories agree—his or her experience may be valuable for educational, political, religious, or other purposes, but it stops being a specifically aesthetic experience. Aesthetic experience, it has been said many times, is pure contemplation, a contemplation that does not lead anywhere beyond itself. Even when the spectator only asks what an image purports, or signifies, or symbolizes, he or she is already overstepping the limits of the aesthetic domain.[2]

Closely related is another feature that must also be briefly touched on. In an aesthetic approach it is essential that the work of art be considered in isolation from anything else, completely resting on itself. What has been called the "autonomy of the work of art" or the "isle-like character of the work of art" are other expressions for the total separation of the work of art from any reality outside of itself. For our purpose it must be stressed that to ask what essential features the work of art has in common with what is outside it is to undermine its autonomy.

Now, it is important to remember in our context that in the various great debates concerning the icon's status, the aesthetic attitude never even came up for discussion. For both the breakers of images and their defenders, the iconoclasts and the iconodules from late Antiquity to the Reformation, an aesthetic attitude was utterly beyond consideration. However dramatically opposed their views of icons may have been, they held the common conviction that the image does not exist for itself, that it is not autonomous, and that it should bring the spectator beyond mere contemplation. In fact, a study of these debates can show us how recent the aesthetic attitude is, and how slight its hold in past ages.

The great Iconoclastic Debates in European history were not waged for the sake of aesthetic experience, or even for the ultimate clarification of theological concepts. One need not be an ancient or medieval historian to know what was at stake in these debates, and that battles for the domination of empires were waged in the turmoil brought about by the iconoclastic movements. Behind seemingly theoretical questions the struggle went on for the establishing of new political and social orders or for the preventing of change, for or against new classes attempting to gain control over society and the institutions of power. To use a parlance common in our days: the different attitudes to sacred images were a kind of signboard of the radical and conservative camps in the respective periods.

Modern research on iconoclastic movements and conflicts in western history is indeed oriented mainly towards the "underlying" causes, the motives "behind" the slogans and doctrines that were explicitly proclaimed in the course of the debates. Many scholars see the great iconoclastic crises in European history essentially as power struggles, and therefore they look for the "true" causes or reasons, to use some of the terms frequently employed. We need not go into methodological discussions (that is surely not our aim) in order to see the danger of approaching ideological attitudes—that is, what was explicitly said about icons —as if they were mere pretexts. That historical situations are a great deal more complex than would seem to follow from a simpleminded division between "true" reason, on the one hand, and "pretext" on the other, has of course not escaped scholarly attention. Some of the historians who are inclined to look for social causes behind ideological stances are well aware of the complexity prevailing in the turbulent processes and movements associated with the question of images.[3] But having said

all this, it remains obvious that for the general historian the explicit contents of iconoclastic debates are not the primary subject of attention. It is natural, therefore, that the historian should approach the dispute about the nature of the image, and whether or not it is true and valid, as a kind of document, asking what we can learn from it about the society and the culture in general.

Now, no modern student will deny that the historians' use of the literary records of the various Iconoclastic Debates primarily as "documents" is justified. He or she will agree that the texts that form these records, and that so often strike us as remote or even abstruse, are more valuable for what they indirectly suggest, disclose, or betray than for what they openly proclaim. In studying the past, it is well known, we cannot do without that indirect testimony that often forms the major part of what we call "sources" in the study of history. I do not intend, therefore, to question in any way the legitimacy and usefulness of the historians' approach. However, in reading the conceptual statements and the records of the debate, as they were written down in the course of struggles over the use of sacred pictures, one cannot help observing that they also contain a doctrine of the image in general, and the image of the divine in particular. Its formation, and perhaps even its character, may have been determined by the conflict over social, political, and religious issues, but the doctrine itself is a significant contribution to human thought about the image. It is a doctrine, I think, from which we can still learn, although the conditions of our reflection on images have so dramatically changed. In the following chapters, then, I shall concentrate on the doctrine itself, on the arguments employed in attacking images of God and in defending them. I shall focus on these arguments in the early Christian world, from what we call late Antiquity to the great, and classic, defense of images by St. John of Damascus and Theodore of Studion.

Speaking of a "doctrine of images" in this broad context is, of course, apt to make one apprehensive. Even in the period to which we shall limit ourselves, we encounter such a bewildering variety of contexts, of religious beliefs and ritual customs, that one can never hope to make them fit the framework of one, even if comprehensive, "doctrine." In speaking about a theory that emerged in a process lasting for many centuries one cannot think of doctrinal positions in a precise sense of that word, or of definite reasons given for a specific position. What lends a certain unity

to the various statements, made over many centuries and in different political, cultural, and religious contexts, is that several definable themes kept recurring, and attracted the main attention of the parties in the historical dispute. The unity, then, consists in *what* was being discussed rather than in the specific attitudes assumed towards these themes. Comparing these themes to those that formed the focus of art theories in other periods, and even comparing them to present-day reflections on images, makes it possible, I believe, to draw an outline of that "doctrine," at least as it appears from a bird's-eye perspective.

Perhaps the most striking feature in that bird's-eye map is that in iconoclastic literature—whether composed in attack or in defense—the major theme is the image itself, totally disregarding what preceded it, its own history, as it were. Were we to describe this feature in terms customary in the workshop, we would have to say that it was only the *completed* picture, the *finished* work of art that was considered in the Iconoclastic Debates. This feature stands out with particular clarity when we compare iconoclastic literature with the more or less practical art theory of the same period and culture. For the painter in the workshop, and the critic who wishes to influence the outcome of his efforts, the stage preceding the finished work, that is, the process of shaping the icon, is of course of central significance. No wonder that, in one form or another, questions pertaining to that stage emerge in regular art literature. But in the literature originating in the Iconoclastic Debates, references to that stage are virtually absent. We hear close to nothing about the artist, nor is there any consideration of how the icon (that very icon that is so violently attacked or so enthusiastically defended) comes into being. All that is sometimes said is that the icon is "made by hands," or, rather rarely, that it has descended miraculously from heaven. So far removed is that literature from the real artist that the authors do not even make demands on his behavior.

This finished, completed icon was approached—and this is another crucial feature of the doctrine that resulted from the Iconoclastic Debates —mainly with one particular question in mind: How does the image relate to what may be described as its model? How truthful or "valid" an image of the god is it? In all the deliberations about the sacred icon that were presented, by one party or the other, in the course of the iconoclastic upheavals, no other question seems to have been considered with comparable attention. Such modern considerations as, for instance,

whether the icon is beautiful or artfully executed, do not arise at all. What is asked is only, is the image "true"?

To the student of reflections on images this formulation may sound familiar, but the familiarity may well be misleading. The question of whether a picture is "true" has been raised in history, primarily in the Renaissance. But Renaissance culture provided a conceptual framework within which an answer could be found. An independent branch of knowledge, usually called "science," served as a criterion for determining whether an image is, or is not, truthful. Thus, geometrical calculation made it possible to tell whether a perspective representation was in fact valid. Anatomy, the accumulated knowledge of the body's structure, was called upon when one had to decide whether a painter's depiction of a human figure was "true." In the Iconoclastic Debates, on the other hand —regardless of whether they were conducted in a pagan or a Christian context—the problem was altogether differently posed. There were no independent criteria to fall back on when you had to decide about the truthfulness of an image. The god who was portrayed in the icon had no known form, and you did not know its external appearance from your own personal experience. In these conditions, what sense does it make to ask whether an image is true or false?

Sometimes the problem was raised to its highest levels, or pushed to its ultimate limits. Can God be depicted at all? It was mainly the iconoclasts who posed such all-inclusive problems and used such extreme rhetoric. Pressed to the utmost, the question naturally seems to lead to querying the very basis of all religious imagery. And indeed, whenever in history we are faced with such an extreme posing of the dilemma, a total rejection of images is suggested.

In the history that will be told in the following chapters we shall sometimes find that an image's "validity" was seen as resulting from the kind of relationship that was believed to prevail between the image and its sacred model. If the icon "partakes" of, or "participates" in, the figure it portrays, it can claim validity—this is what was widely believed. Now, discussing an image's partaking in the "original," the figure or even the idea was not, of course, anything radically new. Such a notion always loomed on the horizon of any reflection on artistic imitation, especially in the period of Plato and in late Antiquity. For Plato, "partaking" or "participation" *(methexis)* is the term used to describe the relationship between *eide* and sensible particulars *(Phaedo* 100d; and

see also *Parmenides* 130c–131a). Aristotle clearly saw how wide was the scope of Plato's concept. There is nothing, he said (*Metaphysics* 987b), but a verbal difference between *methexis* and another Platonic term, *mimesis* (imitation). At the very last stage of Antiquity, in the fifth century A.D., Proclus, who will play an important part in our story, frequently used, particularly in *The Elements of Theology*, the *methexis* metaphor in the traditional Platonic sense.

When the iconoclasts raised the problem of the icon's *methexis* in the original Christ, they were, then, in a sense continuing a venerable tradition. But the intellectual and emotional urgency with which they endowed the concept, and the discussions in which it was employed, were new, and constitute a significant departure from the tone of traditional explorations. It was, it seems, the intrinsic leanings of this concept that became inseparably linked to an attitude of total rejection of images. "Participation," it should be kept in mind, was in iconoclastic thought considered outside any frame of sensual experience, of a beholder's psychological impressions. It is not a spectator's reaction to what he or she sees that makes him or her believe that the icon is "similar" to the original. Similarity, resemblance, or "participation"—however you like to call it—is considered as a purely metaphysical problem, beyond any basis in sensual experience.

The metaphysical resemblance of the icon to the true Christ, then, is the second great theme of the iconoclastic debate. A third theme is altogether different; it is not what a sacred image *is*, but rather what it *does*. As we shall see, the belief in the icon's effect on the beholder was very broadly held. It is known from both pagan and Christian traditions, in various versions—from the simple, crude belief in the miracles of healing worked by the images of, say, Asclepius or the Holy Virgin, to the highly sophisticated analyses of the spectator's inner experience, his or her being carried away by the glimmering gold of the icon, or his or her mind being lifted up by looking at the scenes depicted. Stories and ideas about the holy image's effect on believers and beholders are, therefore, found in the whole hierarchic scale of literary genres in late Antiquity and the Middle Ages: from the simple legend about the miraculous intervention of the Madonna to the highly intellectual scholastic treatise.

Whenever such workings of the holy image on believers and spectators are adduced, particularly when the defense of icons is based on

them, this is as a rule an indication that the position of the icon's actual "participation" in the divine figure is being given up (though this may not be openly stated). It was particularly the learned and critical thinkers, those who made the assumed resemblance of the icon to God a metaphor rather than a statement of fact, who used the icon's effects on beholders, effects they subtly observed and analyzed, as their central argument in defending the use of images in the church.

This is not the place to analyze in detail how observations of the holy image's psychological and aesthetic effects go together with a renunciation of the bold metaphysical position, namely, the claim that the icon really partakes in what it portrays. In the following chapters we shall come back several times to this nexus. Here it will be sufficient to say that, whatever the profound and partly hidden implications, the attention given to the icon's effect on the spectator forms an important part of the doctrine of images that slowly emerged from the great Iconoclastic Debates.

NOTES

1. I am not aware of any systematic investigation of iconoclasm as a social and cultural phenomenon found in different religions and political systems. Some idea of the universality of iconoclastic movements, at least in the European context, is given by Martin Warnke, ed., *Bildersturm: Die Zerstörung des Kunstwerks* (Munich, 1973).

2. Since these views are so common, and occur, in one version or another, in almost every systematic presentation of aesthetic doctrine, it does not seem necessary to mention any particular sources.

3. As a single example I shall mention the stimulating survey of recent scholarly literature on Byzantine iconoclasm by Hans Georg Thummel. See his "Der byzantinische Bilderstreit: Stand und Perspektiven der Forschung," in Johannes Irmscher, ed., *Der byzantinische Bilderstreit: Sozialökonomische Voraussetzungen, ideologische Grundlagen, geschichtliche Wirkungen* (Leipzig, 1980), pp. 9–40.

Reflections in
Classical Antiquity

ONE

The Biblical Prohibition of Images

The student attempting to outline the intellectual background and sources of iconoclastic traditions in the West has a clearly defined starting point: it is the biblical prohibition of images. In the Middle Ages or during the Reformation, in the period between, say, Tertullian and Luther or Ignatius of Loyola, whoever dealt with images had to come to terms with the Second Commandment, to interpret it, and to assess its place in a comprehensive system of beliefs. Modern scholars are of course aware of the sources from which the biblical prohibition of images derived; they know that this prohibition had forerunners in prebiblical cultures.[1] But when we look at our problem from the point of view of a late antique or early medieval believer, whether highly educated or illiterate, these prebiblical sources and early cultures vanish into nothingness, disappear altogether. To the periods between early Christianity and High Baroque the biblical prohibition of images was an absolute beginning, the unprecedented formation of a persisting attitude. Had an iso-

lated fragment of an early aniconic culture ever been noted by a medieval or humanistic scholar (as in some isolated cases may actually have happened), the scholar would have had to make it dependent in some way on what the Bible says. For fifteen centuries it was an established truth that the ban on depicting God began with the Bible.

The biblical text itself is beyond the domain in which an historian of aesthetic ideas usually feels at home. It is only in order to outline some of the sources of late antique and medieval thought on the status of sacred images that I shall make some comments on the biblical prohibition of images.

I wish I could enter the mind of a careful and pious student living in one of the centuries with which this study deals. Disturbed by ever-renewed and violent conflicts over the status of sacred images, he may have turned naively—so we imagine—to the Bible for help and instruction. What could he have found there? We know, of course, that such direct questioning of the Bible was rare in the periods we shall discuss in the following chapters. But regardless of how it was approached, the Bible was, as everybody knows, the ultimate authority. Even though as a rule the text was known only through a thick filter of interpretations, biblical attitudes determined the direction of thought. Our first task is, therefore, to understand what our student may have found, or believed to be said, in the Scriptures.

What the Old Testament says about images is not free of a certain ambiguity.[2] A modern student, trying to bring the concise biblical statements into a system, cannot escape the feeling that he or she is faced with contradicting attitudes. The simple question of what precisely the Scripture says about images is not easily answered. In the Middle Ages, every educated person, one assumes, must have been aware that rejection, or at least suspicion, of images was an attitude characteristic of the Old Testament. Nevertheless, there must have been additional questions. What precisely does Scripture prohibit? Could I indeed enter the pious student's mind, I would probably realize how much he hesitated in proposing an answer, and how many of his doubts remained unresolved. Eventually he must have found—as have students in the course of many centuries—that the Bible suggests more than one answer, articulating, in quintessential form, two different attitudes. In some respects these attitudes may be felt as contradictory, but they cannot be divorced from each other.

One attitude, and also one answer to our initial question, may conveniently be termed "comprehensive." It is the attitude that rejects every mimetic image, whatever the figure or object it represents. The classic formulation of this attitude is the Second Commandment: "Thou shalt not make unto thee any graven image or any likeness of any thing that is in heaven above, or that is on the earth beneath, or that is in the water under the earth" (Exodus 20:4). The same prohibition is repeated, almost verbatim, in Deuteronomy 5:8. Another passage (Deuteronomy 4:9–20) is so detailed that it has recently been called a "theological exposé."[3] "Only take heed to thyself, and keep thyself diligently," so the text reads, "lest you corrupt yourselves, and make you a graven image, the similitude of any figure, the likeness of male and female." One should not make the image that is "the likeness of any beast that is on the earth, the likeness of any winged fowl that is in the air, the likeness of anything that creeps on the ground, the likeness of any fish that is in the waters beneath the earth."

What these famous statements amount to is a total negation of the image depicting something. The "graven image" and the "likeness" are forbidden, no matter what they depict. It is clear, then, that here the text is not concerned with the image of God, and does not specifically prohibit this specific icon. One notices that in this specific context the danger of idolatry—that is, of worshipping the image of God as if it were the god itself—is not mentioned at all. What is prohibited is the pictorial representation as such, "mimesis," as a humanistic scholar might have translated it into his or her conceptual vocabulary.

The educated person whom we earlier imagined would of course have known that even in biblical times such a sweeping prohibition of images was not observed. Scripture itself provides ample evidence of frequent violations of this prohibition, many of the violations being sanctioned by the sacred text itself. It will be sufficient to recall the images that dominated the Salomonic Temple, and the shapes of various ritual implements located and employed in the Sanctuary. In reading the biblical description of these implements we encounter a rich natural imagery. The candlestick, for instance, should be patterned like a shaft and branches, each branch with "bowls made like unto almonds, with a knop and a flower" (Exodus 25:31 ff.). In shaping the candlestick the artisan should follow a model: "And look that thou make them after their pattern, which was showed thee in the mount" (Exodus 25:40). Elsewhere in the

Bible, a long chapter is devoted to describing the actual temple building, and this description abounds in mimetic imagery. The figures of the cherubim are carved in olive tree wood (1 Kings 6:23). "And he carved all the walls of the house round about with carved figures of cherubims and palm trees and open flowers, within and without" (1 Kings 6:29). The "molten sea" in the temple "stood upon twelve oxen," and the borders of the bases "were lions, oxen, and cherubim" (1 Kings 7:25 ff.).[4] The educated medieval person must have noticed that all these mimetic renderings, recorded in great detail, are not rejected and are not critically regarded.

The Bible yields records of artistic representations of various creatures, plants, etc., that suggest a keen observation of nature as well as of the artifact. So far as we can judge, most of these renderings did not serve as ritual implements. Some of them, particularly the images of the fantastic beasts, may have been inherited from rituals performed in the region in prebiblical times, and others probably emerged later, at the time of the Bible itself.[5]

While these detailed records of carved images show that in biblical times the comprehensive prohibition of sacred icons was not (or not fully) observed, the attitude expressed in most of the records indicates that the condemnation survived. Thus Ezekiel copiously describes (8:5– 12) the pictorial reliefs at the northern city gate of Jerusalem, but he does so with eloquent disapproval. Representations of beasts and hybrid creatures are found both in the palace area and in private homes, but these violations of the Second Commandment are a grave sin. The reliefs are "the image of jealousy in the entry" (8:5), they are "great abominations," as "every form of creeping things, and abominable beasts, and all the idols of the house of Israel [are] portrayed upon the wall round about" (8:10). By rejecting the representation of natural creatures Ezekiel shows, even if only implicitly, that he accepts the comprehensive interpretation of the prohibition of images. Once again we have to say, no matter what images represent, they violate the Second Commandment.[6]

To our question—what precisely does the biblical prohibition of images prohibit?—the "comprehensive" attitude provides a sweeping answer: any mimetic image, whatever its subject, is banned. But this is not the only answer that biblical texts and traditions yield to the question we have asked. The other answer is more restricted in scope: it does

not reject mimetic representation as such; rather, it prohibits the depiction of only one subject—the representation of God. This attitude we may conveniently call the "restrictive" one. The historical impact of this attitude was broader and more decisive than that of the former one, and therefore it will also play a more central role in the chapters of this book.

The limits of the "restrictive" attitude are not clearly laid out in the Old Testament. It is implied suggestions rather than explicit statements that point to the image of God as the principal, or only, subject of the prohibition. Thus we read in Deuteronomy 27:15, "Cursed be the man that maketh any graven or molten image, an abomination unto the Lord, the work of the hands of the craftsman, and putteth it in a select place; and all the people shall answer and say, Amen." Here, it seems, the "graven or molten image" is rejected not because it is a mimetic representation of something in nature, but because it is an idol, an object considered to be an image of God. The passionate tone of this statement (and perhaps similar ones) may also be linked with the view that specifically the image of God is here in question. It is the tone that recurs in all later debates about the image of God.

We know today, and it cannot have been lost on the medieval reader, that even the prohibition on portraits of God was not strictly implemented in biblical times. Even if one disregards the classic story of the golden calf (Exodus 22), evidence still remains that certain images were considered divine, and were worshipped accordingly. Ancient Israel was familiar with cult images, and even the virulent condemnation of them attests to an intimate knowledge of how they were produced (Judges 17:3–5; Jeremiah 10:3–9; Isaiah 44:9–20).[7] We know also what in biblical times were considered the essential parts of an idol. To be complete, an idol seems to have consisted of four parts: (1) *pessel* was probably the wooden kernel of the whole image; (2) *masseha* was probably a chased and adorned covering, perhaps often of precious materials (Isaiah 30:22, 40:19; Jeremiah 10:9); (3) *ephod* was probably an armor-like cloak; and finally there was (4) *teraphim,* a cultic mask.[8] All this seems to have been well known in biblical times, and it shows a familiarity with the idol "made by hands."

As we have said, Christianity was concerned with the "restrictive" attitude; it only marginally touched on the question of whether images as such, regardless of what they represent, are justified, but it devoted a

great deal of intellectual and emotional energy to discussing the justification or rejection of the image of God. The student educated in the medieval exegetical tradition may well have noted that the Bible never explicitly says why precisely it is forbidden to represent God, or that no specific reason is given for the Second Commandment. A modern scholar may explain certain confusions, or even contradictions, in biblical language as the result of history. For the medieval student, it goes without saying, such an explanation was altogether excluded. For him, the sacred biblical text emerged from divine revelation, and, as one knows, no historical approach could be applied to the word of God.

Only rarely does the Bible intimate a reason for the prohibition of images of the divine, and even when it does, the wording remains obscure. In the fourth chapter of Deuteronomy, a text we have already mentioned, Israel is admonished: "Ye shall not add unto the word which I command you, neither shall ye diminish ought from it, that ye may keep the commandments of the Lord your God which I command you" (4:2). Now, why should precisely the image of God be an addition? The text refers to the mythical event of Mount Sinai. A few verses later we read, "And ye came near and stood under the mountain; and the mountain burned with fire unto the midst of heaven, with darkness, clouds, and thick darkness. And the Lord spake unto you out of the midst of the fire: ye heard the voice of the words, but saw no similitude; only ye heard a voice" (4:11–12). And after a few sentences, as if to draw a conclusion from what has just been said, the text again addresses the reader, or listener, directly: "Take ye therefore good heed unto yourselves; for ye saw no manner of similitude on the day that the Lord spake unto you in Horeb out of the midst of fire" (4:15).

These sentences are now considered a "scriptural proof" for the prohibition of images, to quote the felicitous phrase of a modern scholar.[9] But they also suggest a kind of rational reasoning. In its basic features, this reasoning seems to be rather clear. Nothing should be added to what was revealed by the divine, and what the children of Israel experienced in the original revelation, that formative event at the foot of Mount Sinai, did not include any visual manifestation. The medium of the revelation was the voice only, characteristically described as a "voice of words." (The Vulgate correctly translates *vocem verborum*.)

The concentration on the word (and specifically on the spoken word) easily lends itself to a spiritualizing interpretation, and may perhaps also

yield some indications concerning the ritual of ancient Israel. A modern biblical scholar, von Rad, claims that "here the antithesis is worked out with full clarity." With particular reference to ritual he sees here the predominance of the spiritual. "In its relationship to God Israel, unlike other peoples, is not dependent on ritual image, only on God's words."[10] But does this mean that the sacred image is rejected because the supposedly "spiritual" character of the word is a more appropriate medium for the revelation of God than the material nature of the image? Such a reading proved tempting to some exegetes, and commentators, especially in more modern times, have tended to accept it. But the Bible itself does not say precisely this, and some scholars would now even maintain that such spiritualizing thought is altogether alien to the spirit pervading the biblical text. The juxtaposition of word and image, in other words, provides no explicit reason for the rejection of sacred icons.

In those parts of the Bible that are now considered as belonging to the latest stages in the composition of the text we find another attempt at rationalizing the rejection of icons. While it has little to do with the juxtaposition of word and idol, this rationalization shows an affinity with the thought of ancient enlightenment. Two features make the idol an object of suspicion: one is that it is the work of man, the other that it is made of materials that in themselves are profane, and could be transformed into other objects. Isaiah 44:9–11 anticipates some of the literary motifs that were to become famous in the thought of Hellenistic rationalism.[11] The prophet begins his invective against idolatry by describing the makers of images: "They that make a graven image are all of them vanity; and their delectable things shall not profit; and they are their own witnesses; they see not, nor know; that they may be ashamed. Who hath formed a god, or molten a graven image that is profitable for nothing? Behold, all his fellows shall be ashamed; and the workmen, they are all of men: let them all be gathered together, let them stand up; yet they shall fear, and they shall be ashamed together." In Hellenism, the fact that the idol originates in the work of mortals became a major topos in rejecting and ridiculing the worship of idols; in the words of the Hebrew prophet, this motif is not as prominent, but it is not difficult to see that it is meant to show that the idol is a false image.

The other feature employed in ridiculing the idol is stated in greater detail: it is the idea that the material of which the idol is made is, in itself, devoid of any divine presence. The piece of wood or stone of

which the idol is made could also serve other, altogether prosaic, purposes. The craftsman, to quote Isaiah once again, "heweth him down cedars, and taketh the cypress and the oak, which he strengtheneth for himself among the trees of the forest; he planteth an ash, and the rain doth nourish it. Then shall it be for a man to burn; for he will take thereof, and warm himself; yea, he kindleth it, and baketh bread: yea, he maketh a god and worshippeth it; he maketh it a graven image, then falleth down thereto. He burneth part thereof in the fire; with part thereof he eateth flesh; he roasteth roast, and is satisfied: yea, he warmeth himself, and saith: Aha, I am warm, I have seen the fire: and the residue thereof he maketh a god, even his graven image: he falleth down unto it, and worshippeth it, and prayeth unto it, and saith, Deliver me; for thou art my god."

The poet of the Psalms links the character of the dead, inert material (even if it be precious) of which idols are made with the false assumptions an image arouses if the depiction is taken for what it depicts. The inert, opaque material exposes the figures' lack of life. A famous passage of the Psalms (115:4–8) reads,

Their idols are silver and gold,
The work of men's hands.
They have mouths, but they speak not:
eyes have they, but they see not:
They have ears, but they hear not:
noses have they, but they smell not:
They have hands, but they handle not:
feet have they, but they walk not:
neither speak they through their throat:
They that make them are like unto them:
so is every one that trusteth in them.

This awareness of how unfit the icon's material nature is for a proper image of God, together with the fact that it is produced by men, reaches most explicit expression in satire. Satire is not a frequent genre in the Bible, but it is employed with particular vigor in ridiculing idols, and in manifesting their frailties. Thus, Isaiah, in the midst of proclaiming God's assurance to Israel, refers in passing to the production of idols (41:6–7). Describing the cooperation of different craftsmen in the production of idols, he says, "So the carpenter encouraged the goldsmith, and he that smootheth with the hammer him that smote the anvil,

saying, It is ready for the soldering: and he fastened it [the idol] with nails, that it should not be moved." [12]

A falling, tottering, nailed-down idol—a motif of iconoclastic satire that even the Enlightenment did not surpass.

At the end of these brief remarks let us return to the medieval reader or exegete we have tried to imagine. The strongly negative tone of all biblical statements on images of the divine cannot have been lost on him. But could he have formed an opinion as to why images of God are denied and even prohibited? None of the many biblical passages in which images of God are rejected indicates a reason for this negative attitude. Only the claim that on Mount Horeb the figure of God was not seen may perhaps suggest such a reason. But, then, why was God's figure not seen, while his voice was heard? The question remains open. It became the focus of an important contribution to the theology of images, and of the violent debate that raged around this theology.

NOTES

1. See Othmar Keel, *Jahwe-Visionen und Siegelkunst: Eine neue Deutung der Majestätsschilderungen in Jes 6, Ez 1 und 10 und Sach 4* (Stuttgarter Bibelstudien 84/85; Stuttgart, 1977), especially pp. 37 ff.
2. Of the literature dealing with the prohibition of images in the Old Testament, see mainly K. H. Bernhardt, *Gott und Bibel: Ein Beitrag zur Begründung und Bedeutung des Bilderverbots im Alten Testament* (Berlin, 1956). Bernhardt's article "Das 'Bilderverbot' im Alten Testament und im antiken Judentum," in J. Irmscher, ed., *Der byzantinische Bilderstreit: Sozialoekonomische Voraussetzungen, ideologische Grundlagen, geschichtliche Wirkungen* (Leipzig, 1980), pp. 73–82, is a concise statement of his position. G. von Rad, *Theologie des Alten Testaments*, I (Munich, 1966), pp. 225–32, makes an important contribution. (There is also an English translation of this work.) W. Zimmerli, "Das Bilderverbot in der Geschichte des alten Israel: Goldenes Kalb, eherne Schlange, Mazzeben und Lade," in the author's *Studien zur alttestamentlichen Theologie und Prophetie*, II (Munich, 1974), pp. 247–60, is particularly instructive in showing the complexity of trends prevailing in biblical times. How much of this complexity survived in the mind of a medieval reader is a different story. One would probably not go wrong in assuming that in late Antiquity and in the Middle Ages biblical attitudes were seen as more consistent than they appear to us now.
3. See G. von Rad, *Theologie des Alten Testaments* I, p. 228.
4. For a detailed discussion of the texts with regard to the visual imagery, see Keel, *Jahwe-Visionen*, pp. 37 ff.

5. Zimmerli, in his study of the "Bilderverbot" (see above, note 2), offers a suggestive discussion of images inherited from Near Eastern rituals. I do not feel competent to express an opinion of my own on this problem. It should be stressed that for the student of medieval readings of the Bible, the investigation of possible precedents of biblical images is of marginal interest.

6. For the interpretation of the "great abominations" Ezekiel saw (8:6), see the old, but still valuable, work by Wilhelm Neuss, *Das Buch Ezechiel in Theologie und Kunst* (Münster, 1912), pp. 41 ff.

7. In addition to von Rad, see also Tryggve Mettinger, "The Veto on Images and the Aniconic God in Ancient Israel," in H. Bazais, ed., *Religious Symbols and Their Functions* (Stockholm, 1979), pp. 15–29.

8. Von Rad, *Theologie des Alten Testaments* I, p. 229, note 60; Mettinger, "The Veto," p. 16.

9. Keel, *Jahwe-Visionen*, p. 39.

10. Von Rad, *Theologie des Alten Testaments* I, pp. 231 ff. Bernhardt, "Das 'Bilderverbot,'" p. 73, also sees in this passage a "bibelkundlicher Beleg" employed by the author of Deuteronomy who, writing at a late stage of the biblical period, draws on the authority of earlier traditions.

11. See below, chapter 3.

12. Modern biblical scholarship considers this passage as belonging to a late layer of the text, possibly of the period of the Babylonic Exile. This would make it roughly contemporary to the earliest Greek expressions of the rejection of sacred images (see below, chapter 3). For a medieval reader, to say it once again, these chronological layers, and the possible relationship with developments in Greek culture, would of course be altogether without significance.

Antiquity I:
The Animated Image

1. An Introductory Observation

No student of the ancient world, or of any field of inquiry that has some bearing on ancient culture, is in danger of forgetting the part that the images of the gods played in Greco-Roman Antiquity. There are too many texts that evoke one aspect or another of these images, and demand an explanation of their meaning and role. Whether we turn to fantastic stories of miraculous healings or to dreary documents attesting to the struggle over political symbols, whether we study mystery religions or the patterns and techniques of administrating distant provinces, whether we concentrate on art or on literature, we are sure to come across some facet of what a god's image may have meant to the ancient world. It is not surprising, therefore, that it is so difficult to offer a clear answer to a seemingly simple question, namely, how did the Greek and Roman world approach sacred images, and how did it account for its

own attitude towards them? However we may try to narrow down our question, and thus to make it more manageable, the difficulties of providing an answer remain. It may be useful to outline, even if only in a few words, some of these difficulties.

To begin with, there is the well-known, yet astonishing, variety of religious beliefs in the Greco-Roman world, particularly in its later stages, which are also the more important ones for our story. "To move about in the Roman Empire at all," Ramsay MacMullen wrote, "or to make the hastiest survey of its religious variety, brings home the pullulation of beliefs."[1] Such a burgeoning and bewildering variety of religious beliefs, easily understandable in a world lasting for a thousand years and extending from Spain and Ireland to Persia and India, could not have failed to affect attitudes to the images of gods.

The social and cultural stratification of the ancient world poses another problem, perhaps more directly bearing on what we shall have to discuss in the present chapter. It is precisely with regard to the attitude towards sacred images that some concepts now fashionable, such as that of popular versus elitist culture, impose themselves on the student. Did people living in rural conditions in, say, the third century b.c. relate to the statues of the gods in a way similar to that of the educated inhabitants of the wealthy quarters of, say, second-century A.D. Alexandria or Rome? It is enough to formulate such a question to see immediately the significance and implications of the problems that arise. But these are problems difficult to solve. There are, of course, well-known studies of popular religion and popular piety in Antiquity[2] that have deepened our understanding especially of the world of late Antiquity. But our specific problem—the attitude to divine images—does not seem to have occupied the minds of modern scholars. How far do labels such as "popular" or "elitist" apply to the attitude to divine images? Do the naive stories about miracles worked by holy statues reflect a "popular" approach, and does the sophisticated irony voiced in making fun of these same statues express an attitude typical of a social elite? The assumption is seductive, yet one hesitates to reach conclusions.

Another difficulty, directly bearing on the subject of the present study, should also be mentioned. To speak of an articulate attitude to the icon, images of the gods must be perceived as a specific group, set apart from images of other figures that do not participate in the divine nature. But

did the ancient world conceive of the images of the gods as a distinct group? Greek and Roman writings yield, of course, a great many references to cult statues and to the images of the gods in contexts other than ritual. From these scattered, and mostly indirect, utterances one may perhaps be able to reconstruct underlying attitudes. It remains, however, true that there is little in classical literature to support an explicit separation of divine images from the images of other beings or objects, and thus to make them into a class of their own. For Plato, one suspects, the image of a god would be doubtful, or downright false, for the same reason that the image of an ordinary object, a bed or a table, is insufficient or false. Modern scholars, one is not surprised to find, have also treated the divine images mainly as works of art, and have thus paid relatively little attention to the problems specific to this particular type of images.

In these conditions it may seem audacious to suggest a concrete typology of the gods' images in the ancient world. Yet if one wants to understand how ancient cultures approached the representations of their divine beings, and to know where the main problems are in fact located, one must attempt to group the chaotic mass of materials—stories, statements, deliberations—into some kind of pattern. I shall therefore suggest that in Antiquity we find two basic attitudes to the statue of the god. One tends to identify the image with the god, and the other denies any kind of relation between the two. These attitudes, I should stress, are not meant as a portrayal of actual patterns of belief and behavior. They are only meant as indications of some underlying trends, and as pictures of what these trends might have led to could they have actually crystallized in reality. The two polar attitudes are, then, *Idealtypen.* "An ideal type," Max Weber said, "is achieved by the one-sided *accentuation* of one or more points of view and by the synthesis of many diffuse, discrete, more or less present and occasionally absent *individual* phenomena, which are arranged according to those one-sidedly emphasized viewpoints into a unified mental construct."[3] I should particularly emphasize that the juxtaposition of these two contrasting attitudes is meant as a heuristic device rather than as the depiction of mental or social reality. In real life, and in most literary documents reflecting contemporary conditions, the two attitudes are not neatly separated from each other, and thus in individual, concrete situations and texts it is often

very difficult to draw a clear line of demarcation between the two mental tendencies. Many of the texts I shall refer to in order to support my suggestion are, in fact, ambiguous, and contain elements of both attitudes.

2. Eidolon

Before we can start to chart a map, even if only in bare outline, of attitudes to the image, especially the image of the god, we should remember that Greek culture was from its early beginnings familiar with the concept of "image" in a specific sense. This image was believed to have an existence of its own, at least at certain stages of human life, and to hold a unique, and crucial, position in the world as seen in Antiquity. In modern times, this concept of the "image" *(eidolon)* has been carefully explored by students of Greek religion, and at least since Erwin Rohde's pioneering work[4] the subject has not disappeared from classical studies. These studies are too well known for me to repeat their findings. From the many sources that have been quoted to illuminate this concept I shall select a few that will help to stress the points that may be of importance for the understanding of the god's image, as here discussed.

I shall begin with the simple observation, stressed in many studies of Greek religion, that in certain contexts *eidolon* is a synonym of *psyche.*[5] *Eidolon,* however, is not an overall synonym for *psyche;* the human soul can be called so only after it has left the body, and has thus become a being in its own right. It is not for me here to attempt an analysis of the different aspects of "image" in Greek religion; I shall only briefly discuss what pertains to our subject. Seen in the context of the present study, it is two characteristics of the concept that are crucial. First, the *eidolon* lacks any material substance. It can be seen, but it cannot be touched. Secondly, the *eidolon,* though devoid of tangible matter, is fully articulate in form, and is clearly outlined. As far as its visible shape is concerned, the "image" is a precise replica of the person whose image it is.

Already in Homer these two characteristic features are fully developed. Patroclus's *eidolon* appears to Achilles, and they talk to each other. At the end of the dialogue "Achilles held out his arms to clasp the spirit, but in vain. It vanished like a wisp of smoke and went gibbering underground." Achilles, the poet tells us, "leapt up in amazement. He

beat his hands together and in his desolation cried: 'Ah then, it is true that something of us does survive even in the Halls of Hades.' "[6] In the *Odyssey* we read of how Odysseus speaks to the "image" of his mother. "As my mother spoke, there came to me out of the confusion in my heart the one desire, to embrace her spirit, dead though she was. Thrice, in my eagerness to clasp her to me, I started forward with my hands outstretched. Thrice, like a shadow or a dream, she slipped through my arms and left me harrowed by an even sharper pain."[7]

On the other hand, it is clear that the *eidolon* fully resembles the real person. Odysseus has no difficulty recognizing the images of his mother, of Elpenor who had died recently, and of his companions in the Trojan war. He is aware that the *eidola* are not the real persons themselves:

After him I noticed Heracles in all his strength—
A mere image, for himself [was] with the immortal gods.[8]

This concept of the "image" did not remain within the limits of religion and beliefs. Greek philosophical schools, in a long and venerable sequence, perpetuated the idea of the *eidolon,* transferring it from Hades to the world surrounding us. The atomists' theory of visual perception assumed that *eidola* of the same shape as the body are given off and enter the pores of the viewer.[9] The Epicurean school taught that these images enter the senses of people also during sleep, and that people consider them as of divine origin.[10]

Plato also employs the concept of "image." In the *Sophist* he even speaks of *eidolon* in connection with the work of the artist who produces images (236a–c). A discussion of Plato's views of images would, of course, go far beyond the scope of the present brief observations. What we should like to stress here is only that, whatever his views on the origin and nature of *eidola,* he enhanced the concept and broadened the range of phenomena referred to by subsuming under this term images seen in the mirror and reflections in water (239c–240a). All these phenomena have the characteristics of Homer's *eidolon*—they are clearly visible, they precisely show the original figure, but they lack a material substance of their own. In the *Timaeus* (52c) Plato formulates the principle of the image: it is like the real thing, but its existence is derived: "For an image, since the reality, after which it is modelled, does not

belong to it, and it exists ever as the fleeting shadow of some other, must be inferred to be in another."[11]

In the centuries of late Antiquity the metaphor of the image becomes common in descriptions of how the universe is structured. Plotinus, to mention the dominant figure of late antique thought, frequently speaks of *eidola*. He also perceives the chain of being, or the chain of emanations, as a chain of images. It is precisely this extensive use of the term that makes it less precise. Thus the image of the Soul is Matter *(hyle)*,[12] and the image of Intelligible Matter is Sensible Matter.[13] Yet although in the Plotinian system the notion of "image" has more facets, and many more applications, than in earlier doctrines and beliefs, the essential characteristics of the concept survive. In Neoplatonism, as in earlier stages of Greek thought, the *eidolon* both resembles, and is different from, what it reflects.

The concept of *eidolon,* as outlined in the above sketchy remarks, is not necessarily linked to the artist's craft and work, but it must have made Greek culture susceptible to the carved and painted image of the god. We now turn to those images, and to how they were understood.

3. The God and His Image

(i) *The Desire to Be Close to God* Throughout Antiquity, the historian knows, people felt an intense desire to be close to God, to attain his proximity. This wish may have been more powerful at some stages or in some groups than in others, but never and nowhere did it completely disappear. In these brief comments we shall concentrate on those periods and areas of ancient culture in which this emotional drive seems to have been more topical than in others. The later centuries of Antiquity, as is well known, are considered as such a stage, and it is therefore natural that most of our material will pertain to this period. What precisely a desire for proximity may have meant is not always obvious. The modern student is well aware of the vagueness and ambiguities that prevailed in so much of ancient religion. He cannot doubt, however, that one of the ways—and probably not the least of them—of gratifying this craving was to put up, and adore, and be close to, an image of the god. Ancient literature abounds with stories and statements of all kinds that provide impressive testimony both to the emotional need for nearness to the god,

and to the practice of erecting statues. In the present short section I can give only a few examples from the great store of these statements.

Let me start with a well-known text. Taking Seneca as his authority, Augustine vividly describes in *The City of God* how the pagans of his age satisfied their craving to be phsyically near to the god:

Go into the Capitol. One is suggesting divine commands to a god; another is telling the hours to Jupiter; one is a lictor; another is an anointer, who with the mere movements of his arms imitates anointment. . . . A learned and distinguished comedian, now old and decrepit, was daily playing the mimic in the Capitol, as though the gods would gladly be spectators of that which men had ceased to care about. . . . There sit certain women in the Capitol who think they are beloved by Jupiter. . . .[14]

Augustine here sums up a long history. Praying before a statue of the god is, of course, an old custom, and it is frequently mentioned in Greek literature. Take, for instance, Herodotus's story of a mother standing in front of a statue of Hera and praying for her sons,[15] or the story of the nurse who took an ugly child to the shrine of Helen, "set the child close to Helen's image and pray[ed to] the goddess to deliver her from her ugliness."[16] Or see what Euripides tells the reader. In the *Andromache* he makes the Messenger relate how the hero is attacked in the temple:

So my master faced the god and began to implore him
When they, armed to the teeth, steel sharpened specially,
Lunged at him from behind.[17]

But it was mainly in the later centuries that praying before, or close to, the images of the gods becomes a popular theme. Sometimes the authors become keen and empathic observers of the moods permeating the person praying, and the movements that person performs. To give but one example I shall mention how Heliodor, a Greek novelist of the third century A.D., describes the dramatic prostration of a hero in front of an image of Isis.[18]

Access to the god's image, normally placed in a grotto or in a temple, is not always easy; the efforts invested in overcoming the difficulties and dangers of the approach indicate the importance accorded to the task. Again one or two examples will suffice. Access could be difficult and dangerous because of the natural site where the image is located. An extremely ancient statue of Apollo that "gives you physical powers of any kind," as Pausanias tells his readers, is located in an almost inacces-

sible grotto. "Men consecrated to this statue leap from precipitous cliffs and high rocks, they pull up giant trees by the roots, and travel with loads on the narrowest footpaths."[19] But access to the images of gods could also be the result of policy and administrative rule. Philostratus the Elder gives a vivid account of how difficult it was to get at the gods' images in the temples of Rome. Telesinus, an influential consul, offers Apollonius of Tyana, by whom he is deeply impressed, a remarkable favor: "You shall have access to all the temples in Rome, and I will give you written instructions."[20] Apollonius protests that he prefers open temples, where the gods "let [him] share their roof," but he is told that the barbarians are in advance of the Romans in deserving such praise.

These texts, easily chosen from the many stories and descriptions that could have been adduced, show how pervasive and deeply felt was the desire to be near the god's image. A comprehensive expression of this feeling is the atmosphere surrounding the cult image in the temple. Beginning from archaic times, the temple's primary function is to be the dwelling house of the god, that is, of its image.[21] But when the image is placed inside a natural grotto, the emotional climate is the same. Ovid imagines the cave of the Mother-Goddess as filled with the cult images of gods, and people, even if sinners, are attracted to them.[22]

What all these stories tell us may now be rather trite. It is that in Greco-Roman Antiquity the tendency to fuse the god and its image into one directly perceptible figure was widespread and was known in many forms. To feel close to the god when you are near to its image brings home, however vaguely and dimly, the perception that in some way they are one. This perception may not have reached an explicit and systematic formulation. Antiquity did not have an articulate, "rational" theology of the holy image. But such beliefs, the tradition of practically equating the god and its image, formed an important underpinning of later attempts to deal with this problem. Together with other factors they not only shaped the direction of ecclesiastical art and actual religious beliefs of later periods; they also determined some of the theoretical reflections and theological doctrines that are the subject matter of the present study. It is, therefore, worth our while to try to extricate, as far as possible, the semitheoretical assumptions implied in the ancient beliefs.

I am not attempting, of course, any contribution to the study of the religions of Antiquity. Modern scholarship has dealt with this field extensively, and even a brief survey of the recent literature on the subject

would go far beyond the scope of the present study. I shall only select a few examples of how the trend of merging the god and its image was expressed in Antiquity, and how the hidden assumptions were perhaps manifesting themselves. It goes without saying that even within these restricted limits, my sampling does not aspire to give a balanced picture of classical opinions and beliefs; it is meant to underscore such aspects as may shed light on the particular questions with which we are here concerned.

(ii) *Dream Literature* One field from which I shall choose my examples is that of ancient beliefs in the significance and meaning of dreams, and the literature concerned with recording and interpreting them. In Antiquity, as is well known, dreams constituted a large subject of study. For centuries, learned men devoted great intellectual efforts to decoding their meaning. The literature devoted to dreams was apparently very large (only a small part of it has reached us), it had scholarly traditions of its own, and in modern times it has been intensively studied from different points of view. For our purpose we should stress, as Ramsay MacMullen has recently done, that apart from images it was largely dreaming that was considered to make possible a direct contact with the gods.[23] Dreams were considered as the meeting point of people with the gods; in dreams pagans of all classes kept company with the gods.[24] It was believed that dreams are sent by the gods, and one could seek them for different reasons: to get advice, to see the future, or to be healed. Whatever the purpose, it is to meet the gods that dreaming is encouraged. Sorcerers offered spells for conjuring up dreams of all sorts, mainly prophetic ones; they considered "dream-seeking" and "dream-sending" an essential part of their craft.[25] The best-known technique for provoking a god-sent dream was "incubation": the dream seeker will sleep in the temple, possibly near the statue of the god, to make the god send a dream with the desired message or cure.[26] As one went to the temple to offer prayers directly to the god (who was standing there in the shape of a statue), so one went to sleep in the temple expecting the god's direct appearance and intervention.

For the purpose of our discussion the crucial feature is that as a rule the gods, directly appearing in the "divine" dream, seem to have had an articulate shape. Directness of experience seems to have been linked with full articulation of what is perceived. The god may appear to the dreamer

in its own, authentic shape, or may disguise itself in the form of other beings, or transform its figure in the course of the dream. However, its shape is always distinct, and even in being transformed it does not lose its distinctness. No wonder, then, that the dream figure could have been understood also as an *eidolon,* an "image" created for the occasion. That *eidolon* may lack the material substance of the true figure, but it is fully identical with it in shape and appearance.[27]

Looking at the ancient literature on dreams, we are not concerned with what is recorded about the appearance of the gods as such. The gods appear so often in the dreams they send that a study of their manifestations would almost be tantamount to a study of this whole literary genre. Here we are concerned only with what is said, or implied, about the images of the gods, and what we can learn from this literature about how ancient culture conceived of divine portraits. The stories concerning the images of gods appearing in dreams, said Weinreich, a scholar who made a significant contribution to the study of our subject, were too common to be disregarded by the professional dream interpreter.[28]

A major and well-known source of what we know about ancient interpretations of dreams is the *Oneirocriticon* by Artemidorus of Daldis, a manual of dream interpretation composed by Artemidorus in the late second century a.d. in Alexandria. Artemidorus himself tells us how diversified his sources were; he studied the professional literature, and he spent many years in the company of the soothsayers who could be heard in the open markets, and learned from the "cities and festivities of the Greeks."[29] He can thus be said to reflect both the scholarly tradition and the opinions and beliefs common in all strata of society.

It is a matter of course that Artemidorus often speaks of the gods appearing in dreams; for us it is of particular interest that he also records our dreaming of the images—mainly statues—of the gods. These two, the gods and their images, he treats interchangeably, as if they were identical. If you dream that the gods leave your house or that the images of the gods in your house are shattered, it means the death of the dreamer or of one of his or her relatives.[30] It brings luck, he says, to see in one's dream either Zeus himself or his statue.[31] As if his intention were not sufficiently clear, he adds in the same chapter, speaking of Artemis, that "it makes no difference whether one sees the goddess herself, as she lives in our imagination, or her statue." In a more general

formulation he later claims that "the gods and their images possess a common relationship."[32] Though Artemidorus does not say what precisely he means by "relationship," we shall probably not go wrong in assuming that he has the formal composition in mind, what we are used to calling "artistic form." The "common relationship," that somewhat obscure identity of the god and its image, becomes manifest in what they both "mean" as indications of the future. "Those divinities who in themselves as in their images signify happiness, it is not good to see either smashed or shattered," we read in the same chapter. On the other hand, it is beneficial when either the gods of evil foreboding or their statues are seen disappearing. At least in their "function," there is, then, no difference between the god and its statue or icon.

Even where the—admittedly partial—identity of the god and its image is not explicit, it continues to play a crucial role. How does the dreamer know which god he or she is seeing? One of the indications the appearing god gave, and the dream interpreter had to understand, was that the gods are described in the shapes sanctioned by the statues.[33] (For iconographers, one should add, Artemidorus is a source that has not yet been fully used.) Another implicit indication of the identity link between the gods and their images is Artemidorus's occasional concern with the facial expression of the statues. If the statue of a god, made of durable material, smiles at the dreamer, something good will happen to the dreamer.[34]

(iii) *Rituals* So much for dreaming the gods. If the reading of dreams indicates beliefs that are widely held in the dreamer's world, we would have to conclude that the society reflected in the *Oneirocriticon* saw a close connection between the god and its carved image. In some cases, as we have noted, the image is even substituted for the god itself. But was such a link feasible only in the domain of irrational dream? One cannot help asking how the actual statues of the gods were approached in real life. Statues of gods, we know, were erected in temples and public squares, they were seen, worshipped, or rejected by innumerable crowds of people, and obviously it is difficult for us to grasp clearly how they were perceived. In one domain, however, the meeting with, and treatment of, divine images became institutionalized. I mean, of course, ritual. In recent years we have become increasingly aware of what may be termed "the cognitive value of ritual."[35] In rituals a view of the world

is encoded, as it were. A careful analysis of rituals can therefore reveal a whole system of attitudes, and even of conceptual approaches. It is, then, to the ritual treatment of divine images that we now turn. Again we shall briefly look at only two examples, rituals that seem to have been well known in the ancient world.

In Antiquity the appareling of the god's image is among the best-known ritual acts pertaining to our subject. One of the oldest passages in Greek literature in which a statue is mentioned may serve as a good example. Hector's mother chooses an embroidered robe ("shipped across the sea from Sidon"), and, accompanied by several older ladies, sets out for the temple.

When they reached the temple of Athene in the Acropolis, the doors were opened for them by Theano of the lovely cheeks, daughter of Cisseus and wife of Antenor the charioteer, who had been made priestess of Athene by the Trojans. With a loud cry, in which all joined, the women lifted their hands to Athene, while Theano of the lovely cheeks took the robe, laid it on the knees of the Lady goddess, and prayed to the daughter of Almighty Zeus.[36]

The dressing of the goddess (or the goddess's image), as here de-scribed in vivid and evocative detail, clearly suggests a behavior that follows an established ritual—the opening of the doors by the priestess, the lifting of the hands, the cries of joy. Most important in our context is that in the crucial lines the reader is left in doubt, at least according to the formulation, as to who precisely is being dressed with the robe. Is it the real goddess or is it her carved image?[37] The rationalistic approaches of later periods suggested that from the beginning the Homeric formula-tion clearly referred to a statue,[38] but in the light of modern scholarship one cannot be so sure that this was indeed the original intention.[39] Ambiguity, it need hardly be stressed, plays a part in both literature[40] and religion. It has been pointed out that Vergil's ambiguous wording in telling this story is particularly characteristic.[41] So well-known and wide-spread was the ritual of clothing the statue of the god that it gave rise to an important topos in satirical literature, making fun of the superstitious worshipping of sacred statues. Polemical literature abounds in stories about people removing the golden mantle of the goddess, placing around her shoulders a woolen one instead; the woolen cloak, the thief says, will keep the goddess warmer than the golden one.[42] In Greek art, as in Greek religion, the clothing of a god's statue plays a memorable part, giving rise to the most famous works. The great Panathenaeic procession

that is represented in the Parthenon frieze could have taken place only with the ritual purpose of bringing a mantle to the statue of a goddess, the statue that eventually was set up in the Erechteion.[43]

The draping of a divine statue, of course, is only one way of ritual "caring" for the god or for its sacred image. The formal bathing of a god's statue is another ritual, one that seems to have been common in the ancient world. Studies of primitive societies, or cultures of a distant past, have made us familiar with acts of formal washing, bathing, or immersion, of a god's image or of a miraculous stone believed to be inhabited by a god. These rituals have been explained as derived from ceremonies for the magic rain making,[44] or as part of purification ceremonies.[45] In Greek religion and Roman religions, the bathing of the god's statue seems to have been a well-established ritual. How firmly crystallized this ritual was in public awareness of the custom and in social patterns one can infer from the fact that the statues of the different gods were bathed on specific days, and that this function was performed by specifically authorized people. Thus in Athens, the statue of Athene, so we learn from Plutarch, was bathed on special days, the days of the Plynteria, the Athenian festival in honor of the goddess of the city, and the ritual was performed by a group of the Praxi, especially designated for this task.[46] We also know of Athene's statue being ritually bathed in other places.[47] Aphrodite's image was bathed in Sykion, as Pausanias tells us,[48] and in Rome, as we know from a vivid and detailed description by Ovid:

Take off the golden necklaces from the marble neck of the goddess; take off her gauds; the goddess must be washed from top to toe. Then dry her neck and restore to it her golden necklaces; now give her other flowers, now give her the fresh-blown rose.[49]

The mother of the gods was also bathed. Once again Ovid not only testifies to the washing, but also gives an evocative description of the ceremony:

There is a place where the smooth Almo flows into the Tiber, and the lesser river loses its name in the great one. There a hoary-headed priest in purple robe washed the Mistress and her holy things in the waters of Almo. The attendants howled, the mad flute blew, and hands unmanly beat the leathern drums.[50]

The meaning of the ceremony of bathing the god's statue, the aim that was hoped to be achieved by washing it, may have changed in the

course of time.[51] What remained unchanged, however, was the treatment of the image as if it were a living being, the attribution of some kind of life to it.

4. The Animated Image

There is only one step from draping and bathing a god's image to explicitly believing that it is indeed filled with life, that the statue is animated. Animation, it was generally accepted in Antiquity, means that the god himself is dwelling in its image, and that therefore the image possesses powers that would not normally be ascribed to a statue. The belief in the animated statue of the god is an attitude; it is expressed in stories of miracles and healings, in prayers and rituals, in behavior towards the material images, and in various other ways. I shall only briefly point out those aspects that are signficant for our present subject.

Since stories about miracles worked by the statues of gods and heroes are so well known, it will suffice here to select only a few typical examples from the abundance that comes to mind. Thus, to employ Pausanias's matter-of-fact style of recording, "the statue of Artemis which was bronze with weapons of bronze, dropped its shield" when destiny decided on the fall of the city (Messenia).[52] The lance in the hand of another god's statue trembled when Timoleon was about to overcome the Carthaginians.[53]

The ability of a god's statue to move by its own powers is a striking manifestation of its supernatural animation. The movements thus performed by animated images are of great variety. One could begin a list of such acts with changes in facial expression, smiling[54] or looking sad, raising the eyes or casting them down.[55] More extensive movements are, of course, also recorded. In a famous story, frequently quoted, Lucian tells of the bronze statue of a hero, Pelichus, that moves freely according to its own intentions. "Perhaps," says one of the interlocutors in the story, "it is not Pelichus at all, but Talos the Cretan, the son of Minos? He was of bronze, and used to walk all around the island."[56] Some statues of gods or heroes leave the spot on which they are erected to take a bath. Pelichus's statue does so, as Lucian the satirist puts it, because "he is fond of taking a bath." Another statue, such as the image of the hero Eunostos, to give just one more example, goes on its own to take a bath because a woman has entered its sanctuary.[57]

Nothing vindicates the miraculous animation of the statue more clearly than the healing power it possesses. The stories about divine statues performing miraculous cures belong to the repertory of all religions. They also abound in Greek literature in Antiquity. These stories, however, are too well known to be retold here.

While healing statues are common to many religions, the oracles pronounced by the images of the gods seem to be a feature characteristic of Greco-Roman Antiquity. In the stories telling of the oracles pronounced by, or in connection with, statues of gods, other elements of institutionalized religion, such as prayer and particularly priests and magi, play a prominent part. Tacitus tells of the appeal to the magi who are "in the shadow of Apollo."[58] Pausanias stresses other features of ritual. A stone statue of Hermes, placed in the central square of the city of Pharai, pronounces oracles:

They call it the Market Hermes and it has a traditional oracle. In front of the statue is a stone hearthstone, with bronze lamps stuck onto it with lead. You come in the evening to consult the god, burn incense on the hearthstone, and fill up the lamps with oil; then you light them all and put a local coin . . . on the altar to the right of the god; and then you whisper in the god's ear whatever your question is . . . and whatever phrase you hear next is the oracle.[59]

Let me conclude with an example from the last stage of pagan Antiquity. At the very beginning of the fifth century of our era, Macrobius in his *Saturnalia*, that treasurehouse of knowledge for later generations, tells of the gods, their statues, and the oracles they give, and also of the rituals performed by the people. The statue of the god of Heliopolis, he tells us,

is borne in a litter, as the images of the gods are carried in the procession at the Circensian Games, and the bearers are generally the leading men of the province. These men, with their heads shaved, and purified by a long period of abstinence, go as the spirit of the god moves them and carry the statue not of their own will but whithersoever the god directs them, just as at Antium we see the images of the two goddesses of Fortune move forward to give their oracles.[60]

The god of Heliopolis is even consulted from a distance, Pausanias tells us, and he provides precise information as to how this is accomplished.

Belief in the animation of the divine images not only shaped the ritual approach to them, but also how they were treated (or are related to have

been treated) beyond ritual, in everyday life, as it were. An interesting insight is afforded by the stories of how the images of the gods were chained in order to prevent them from escaping.[61] Pausanias, recounting customs in different—often rural and distant—parts of Greece, is a real mine. From his book on Arcadia we learn of an "antique statue of Enyalios in chains." Why was Enyalios, another name for Ares, the Greek god of war, chained? Pausanias tells us what people believed. "The Lakonians," he says, "have the same idea about this statue as the Athenians have about Wingless Victory: in Lakonia they think the god of war will never desert them if they keep him in chains; in Athens they believe Victory will stay with them for ever because she has no wings."[62] In the same chapter Pausanias tells of another chained statue, this time of Aphrodite. "The Beautiful goddess is a title of Aphrodite; she is enthroned and veiled, with fetters on her feet."[63] In another place in Arcadia there is a statue of Eurynome, the mother of the Graces. She is "a wooden idol tied up with gold chains."[64] Another version of the same topos appears in the book on Boiotia: "An apparition with rocks in hand was devastating the countryside." To check the destruction the oracle ordered the citizens, in addition to other actions, to "make a bronze image of the ghost and rivet it with iron to the rock."[65] Plutarch mentions a particularly Roman version of our theme, applying legal concepts to the belief in the animation of statues. Some Roman historians report, says Plutarch, that there are certain exorcisms by means of which the gods can be summoned out of a city; the Romans have already done this with the gods of hostile cities. To prevent this happening, the people of Tyre fastened the statues of their gods with chains. In other places they followed a different pattern: when the statues of the gods had to be carried in festive procession to be bathed, they asked for securities.[66]

The treatment of the statues of the gods, at least as it is reported in many extant ancient texts, can be explained only by the widespread belief in an identity of sorts of the god and its material image. Motivated by approaching danger or enticed by magic spells, the gods could retreat from their temples, or even leave the city. That the gods leave their abodes was understood as leaving their temples and statues. In *Seven against Thebes* Aeschylus makes the ruler of Thebes say,

> The Gods, they say,
> of a captured town desert her (218–219)

and it is for this reason that the maidens, terrified by the idea that the protecting gods will foresake the city attacked by enemies, cling to the feet of the ancient idols; by holding the feet of the idols, they believe they are preventing the gods from leaving the city.[67] The same motif we find in the work of Euripides. In *The Trojan Women* he records Poseidon's words:

> So I must leave my altars and great Ilium,
> since once a city sinks into sad desolation
> the gods' state sickens also. (25–27)[68]

Sophocles related that shortly before the fall of Troy the gods left the city, carrying their statues on their shoulders.[69] To prevent the gods from leaving, people used to chain their statues. Pausanias tells of a "wooden idol tied up with golden chains."[70]

Another striking example of how the belief in some identity between the god and its image influenced the treatment of statues is the punishing of the idol. When Pan does not provide sufficient prosperity for the flocks, and as a result there is a lack of meat, the Arcadian shepherds scourge his statue with onions.[71] The statue of a hero, a distinguished Greek runner, was flogged by "somebody who hated him in his lifetime," until it eventually fell on the attacker and killed him.[72] There is no need to tell additional stories; many scholarly investigations discuss Greek and Latin texts attesting to this custom.

The anthropologist may wonder whether all these stories faithfully record actual customs; for our purpose it is not crucial whether statues of gods were actually chained, or whether real securities were asked when they had to be taken out from their temples and carried in public procession. What we ask is, what is the system of beliefs that motivated the stories and made them intelligible, indeed acceptable, to the readers in late Antiquity? What is the attitude to the god's image that lies behind all these testimonies?

5. Conclusions

The beliefs and stories of which I have briefly touched on a selection are, of course, well known to the student of the classical world. The documents where the pertaining opinions and events are recorded have been frequently explored by modern scholars. They have been approached

from different points of view and with different questions in mind; they have been made to answer questions on religion and social life, on the patterns of political symbolism, and on plain prejudice. So far as I know, however, the question of what these testimonies may yield for the understanding of images as such, qua images, has not received the full attention it deserves. I cannot attempt to carry out this task, but I wish to conclude the foregoing comments on the animated image by a brief discussion of some specific points pertaining to this question.

I begin with the broadest problem that here imposes itself to us. To use the title of a recent study of ancient religion, we could ask, "Did the Greeks believe in their myths?"[73] To put it a little more modestly, we could ask, what did the animation of the god's image actually mean to people in Antiquity? No doubt, in the course of the centuries between, say, Homer and Macrobius, many people literally and naively believed that the very image they were worshipping, the idol carved in wood or stone, was indeed the god itself. Such a literal approach, though certainly quite common, was not the main factor in shaping the mind of Greco-Roman culture. Among the educated elite, many altogether rejected the belief in an identity, whatever its nature and extent, between the god and its image as sheer prejudice, and ridiculed the simpleminded folk who believed in it. To the polemical attitude of the educated we shall turn in the next section. Here we may only say that the dominant quality in the ancient attitude to images of the gods was a certain ambiguity. This ambiguity contains some of the problems that are of crucial significance for our theme, and suggests how the god's image was understood in the centuries to come.

The central question that here arises is, how does animation come about, and what actually makes it happen? The answer to this question may seem obvious, but in fact it isn't. In Greco-Roman Antiquity the question was not put in a direct and explicit way, but clearly it occupied people's minds. That some of the images, carved in wood or stone, to which supernatural powers were ascribed, were said to have fallen from heaven indicates the concern with the origin of their animation. The mysterious origin of the image also suggests the origin of the animation. But some images of gods believed to be permeated with mysterious life, and thus performing miracles, were known to be the work of famous artists. A statue could be seen as a testimony to the greatness of the

individual artist who shaped it, and at the same time be regarded as performing miracles.[74]

Walter Burkert has called attention to the significant fact that in ancient Greece there were no magical rites to give life to the cult image.[75] To be sure, there was a certain tendency to look for, and indeed find, a ritual of animation.[76] But the sources that have been mentioned to support the assumption that the "pagans" did have an animation ritual are not only vague; they are also late, and all of them are by Christian authors.[77] One feels safe in concluding that in Greek lore there was indeed no specific act that, at a specific moment, transformed the statue from an inanimate object made by man into a living god. That such a ritual was not known, or at least was insignificant, in Greco-Roman culture is remarkable since it did exist in the ancient Near East.[78]

If the priests did not animate the god's image, who did? Philosophical and religious reflections in Antiquity, particularly in the late stages of that period, suggest that the god inhabits its cult image because in some way the image resembles it, or that, at least, an affinity prevails between them. We are not here asking what such an affinity may mean in a general sense; in the present context we are concerned only with whether it was assumed that this affinity also had an optical aspect, as it were—that is, whether we can speak of a visually perceptible resemblance.[79] It is enough to put the question in this blunt formulation to see how difficult it would be to apply a literal reading of the affinity supposed to exist between the god and its image. Even for a devout late antique spectator, properly worshipping the cult statue, it would be difficult to maintain that the facial features and bodily characteristics of the image faithfully reproduce those of the god itself. As a rule, the antique, especially late antique, believer was well aware that one did not know the god apart from the carved images one saw in the temple, or else-where. Dion Chrysostomus, in the Twelfth (Olympic) Oration, takes it as a matter of course that we imagine the gods in the shape of the cult images we see around us. The artist's responsibility is so great, Dion Chrysostomus stresses, because the artist determines how we will imagine the gods in our minds.[80] The idea of the affinity between god and image, then, remains a feeling, an emotional disposition or attitude, rather than an explicitly stated doctrine.

In the expressions of feelings and beliefs concerning the affinity be-

tween the god and its image that we have from late Antiquity we encounter, for the first time in the history of our subject, that particular ambiguity, the conceptual obscurity, that was to remain the character-istic feature of the intellectual atmosphere in which the problem of God's image was to be treated for centuries. A statement by Plotinus is in many respects typical. A brief analysis of this statement will illustrate, I hope, both the many-sidedness of the theme and the nature of the discus-sion.

In a treatise on "Problems of the Soul," Plotinus conjures up the structure of his whole system, and introduces some of his central meta-phors. He stresses the idea of affinity: "whatsoever touches soul is molded to the nature of soul's Real-Being."[81] Affinity, being a general principle, is also used to explain why shrines and cult images are estab-lished:

I think, therefore, that those ancient sages, who sought to secure the presence of the divine beings by the erection of shrines and statues, showed insight into the nature of the All; they perceived that, though this Soul is everywhere tractable, its presence will be secured all the more readily when an appropriate receptacle is elaborated, a place especially capable of receiving some portion or phase of it, something reproducing it, or representing it and serving like a mirror to catching an image of it.[82]

Plotinus goes on to say that "every particular entity is linked to that Divine Being in whose likeness it is made." Can we here assume resem-blance in the simple, straightforward sense we have in mind when we speak of recognizing a family likeness? It is difficult to give a simple, unambiguous answer. Yet the metaphors, and the suggestive tone, make it likely that the assumption of a visual similarity was not far even from the minds of the followers of Plotinus. Many must have believed that it is the statue's similarity to the god that makes the god inhabit it, and that ultimately accounts, however vaguely, for its animation. To the common believer it must have seemed obvious that it is the god itself who animates its image. That common believer would have found it unthinkable that the images of Aphrodite or Jupiter could be animated by anyone but Aphrodite and Jupiter themselves. Now, if we follow this trend of thought, however carefully we may qualify our assertions, we shall necessarily arrive at the conclusion that there is some kind of identity—affinity, if you wish—between what was called the prototype and the likeness, that is, between the real god and its artistic image. In a

later chapter I shall attempt an analysis of the theoretical foundations of this affinity, as they were laid down in the late centuries of Antiquity.

Every student of Greek and Roman religion knows that many more legends could be related, and that they would enrich the picture of ancient beliefs in the animated image of the god. My aim is not to provide such a picture. The few examples I have quoted are only meant to illustrate a continuous trend of religious beliefs, quite common in many parts of the ancient world throughout its history. These beliefs formed a significant component in the approach to the gods' images, as, I hope, the examples cited show. The theoretical assumptions underlying these various miracle stories may be vague, confused, or plainly contradictory. They nevertheless constituted a conceptual pattern that, despite all its faults in logic, was of long-lasting historical significance.

Historians cannot help being curious about how far the belief in animated images of the gods bears some social imprint: Was it common in certain parts of society and rare in others? It is tempting to assume that among lower-class, less educated groups the belief had a stronger hold than among more highly educated ones. So far as I am aware, the question has not been broached systematically. But whatever the answer may be when it is eventually investigated, the historical power of this belief, its role in shaping European attitudes to divine images, and to art in general, will not be placed in doubt.

The student of aesthetic ideas, concerned with the status of the work of art and with what makes it efficacious, will not overlook yet another aspect of the beliefs and attitudes we have briefly outlined. It is an aspect that is not historical, in the sense that it is not related, or restricted, to a specific period or style; it is, rather, an innate dimension, as it were, of artistic rendering as such. The belief in the animated image gives urgency —to be sure, in a crude, coarse way—to the complex, perhaps insoluble, problem of a certain unity between the representation and what is represented. In that sense, the belief in icons, as well as the criticism of this belief (to which we shall now turn), reveal a basic problem of art.

NOTES

1. Ramsay MacMullen, *Paganism in the Roman Empire* (New Haven and London, 1982), p. 1. The literature on ancient religions, I need hardly say,

seems to be inexhaustible, far beyond the grasp of a single person, even one who devotes all his or her energies to this subject.

2. I shall mention only Martin Nilsson, *Greek Folk Religion* (New York, 1940; several reprints), and idem, *Greek Piety* (New York, 1969). Many of Peter Brown's studies relate to our present subject, but see especially his article "Town, Village, and Holy Man," reprinted in Peter Brown, *Society and the Holy in Late Antiquity* (London, 1982), pp. 153–65.

3. See Max Weber, *Gesammelte Aufsätze zur Wissenschaftslehre* (5th ed., Tubingen, 1982), p. 191. An English translation by E. A. Shils and H. A. Finch was published as *The Methodology of the Social Sciences* (Glencoe, Ill., 1949); the sentence quoted may be found on p. 90.

4. Erwin Rohde, *Psyche: Seelencult und Unsterblichkeitsglaube der Griechen* (Tubingen, 1893).

5. Rohde, *Psyche*, pp. 2–8. (I am using the seventh and eighth editions [Tubingen, 1921], in which the pagination of the first edition is given in the margins). Among recent studies I shall mention only Walter Burkert, *Greek Religion* (Cambridge, Mass., 1985 [original German edition, *Griechische Religion der archaischen und klassischen Zeit*, Stuttgart, 1977]), pp. 195 ff. See also Martin P. Nilsson, *Geschichte der griechischen Religion*, I (3rd ed., Munich, 1976), pp. 195 ff.; and Jan Bremmer, *The Early Greek Concept of the Soul* (Princeton, 1987), pp. 78 ff.

6. *The Iliad* XXIII, 72 ff. I use the translation by E. V. Rieu (Harmondsworth, 1950), p. 414.

7. *The Odyssey* XI, 204–8. I use the translation by E. V. Rieu (Harmondsworth, 1946), p. 176.

8. *The Odyssey* XI, 601–2.

9. Democritus is even said to have written a treatise (now lost) *On Eidola*, which, in all likelihood, contained a theory of sensual perception. For the sources, see Kathleen Freeman, *Ancilla to The Pre-Socratic Philosophers* (Cambridge, Mass., 1970), p. 93 (# 10a). See also Alexander of Aphrodisias, *De sensu*, 56, 12.

10. Sextus Empiricus, *Adversus Mathematicos* IX, 19; and see also Cicero's *De natura deorum* I, 19, 49.

11. For Plato's dialogues I have used Benjamin Jowett's English translations.

12. See Plotinus's *Enneads* V, 2, 1; see also III, 9, 3. A passage of the latter is worth quoting in our context: ". . . for by willing towards itself it [the partial Soul] produces its lower, an image of itself—a non-Being—and so is wandering, as it were, into the void, stripping itself of its own determined form. And this image, this undetermined thing, is blank darkness, for it is utterly without reason, untouched by the Intellectual-Principle, far removed from Authentic Being." I use Plotinus, *The Enneads*, translated by Stephen MacKenna (London, n.d.). The passage quoted is on pp. 252 ff.

13. *The Enneads* II, 4, 5; pp. 107 ff. of the translation quoted.

14. Augustine, *The City of God* VI, 10. I use the translation by Marcus Dods,

in the Modern Library edition (New York, 1950). From the vast literature I shall mention only H. S. Versnel, "Religious Mentality in Ancient Prayer," in Versnel, ed., *Faith, Hope, and Worship: Aspects of Religious Mentality in the Ancient World* (Leiden, 1981), pp. 1–64, esp. pp. 30 ff.

15. I, 31.
16. VI, 61. See p. 432 in the recent English translation by David Grene (Herodotus, *The History* [Chicago, 1987]).
17. *Andromache*, 1117 ff. (translation John F. Nims).
18. See Heliodor, *Aethiopica* VII, 8, 7.
19. X, 32, 4. See Pausanias, *Guide to Greece* I, translated by Peter Levy, S. J. (Harmondsworth, 1971), p. 490.
20. Philostratus the Elder, *Life and Times of Apollonius of Tyana* IV, translated by Charles P. Bells (Stanford, Calif., 1923), 40.
21. Rather than many bibliographical references I shall mention the concise summary by Walter Burkert, *Greek Religion,* translated by John Raffan (Cambridge, Mass., 1985), pp. 88 ff. Burkert's attention, of course, is focused on the earlier periods of Greek culture.
22. Ovid, *Metamorphoses* X, 695 ff.
23. See Ramsay MacMullen, *Paganism in the Roman Empire* (New Haven and London, 1981), pp. 60 ff.; and the literature listed in note 45.
24. The classic account, at least in our generation, is E. R. Dodds, *The Greeks and the Irrational* (Berkeley, Los Angeles, London, 1971), chapter 4. From recent literature I should also mention Robin Lane Fox, *Pagans and Christians* (New York, 1987), pp. 108 ff.
25. Fox, *Pagans and Christians*, p. 151.
26. See Dodds, *The Greeks and the Irrational*, pp. 110–16. Very valuable is E. J. and L. Edelstein, *Asclepius: A Collection and Interpretation of the Testimonies*, 2 vols. (Baltimore, 1945). For a general, very readable account, see Mary Hamilton, *Incubation* (London, 1906).
27. See *Odyssey* IV, 795 ff. Joachim Hundt, *Der Traumglaube bei Homer* (Greifswald, 1935), speaks of a "Bildseele." For a criticism of Hundt's thesis, cf. Boehme in *Gnomon* XI (1935).
28. See Otto Weinreich, *Antike Heilungswunder: Untersuchungen zum Wunderglauben der Griechen (Religionsgeschichtliche Versuche und Vorarbeiten)*, VIII (Giessen, 1909), pp. 157 ff. And see also MacMullen, *Paganism in the Roman Empire*, pp. 60 ff.
29. See the introduction to the *Oneirocriticon*. Particularly informative is the introduction to part 4 of the book. Of modern studies, see Claes Blum, *Studies in the Dream-Book of Artemidorus* (Uppsala, 1936). R. L. Fox, *Pagans and Christians*, pp. 155 ff., stresses the "tireless empirical research" carried out by Artemidorus.
30. *Oneirocriticon* II, 33.
31. *Oneirocriticon* II, 35. If you see the god itself, Artemidorus here adds, it is better to see it motionless, standing or sitting on its throne, than moving

around. One cannot help feeling that the motionless manifestation of the god makes it more statuelike than if it were moving. See the careful annotation of the French translation (Artemidore, *Le clef des songes*, traduction par A. J. Festugière [Paris, 1975], esp. pp. 144 ff.).

32. *Oneirocriticon* II, 39.

33. Fox, *Pagans and Christians*, p. 158. There were, of course, also other conventions that could not be fully realized in statues. One of them are the colors of the figures, their draperies, etc.

34. *Oneirocriticon* I, 5.

35. See Clifford Geertz, "Religion as a Cultural System," reprinted in the author's *The Interpretation of Cultures* (New York, 1973), pp. 87–125, esp. pp. 112 ff.; and S. R. F. Price, *Rituals and Power: The Roman Imperial Cult in Asia Minor* (Cambridge, 1984).

36. *The Iliad* VI, 311 ff.

37. A little earlier (VI, 270) great Hector had said: "Take a robe, the loveliest and biggest you can find in the house and the one you value most yourself, and lay it on the Lady Athene's knees."

38. For an early, though only brief, reference, see J. Geffcken, "Der Bilderstreit im heidnischen Altertum," *Archiv für Religionsgeschichte*, XIX (1916–1919), pp. 286–315, esp. p. 286, note 3, and p. 291. Robert Lamberton, *Homer the Theologian: Neoplatonist Allegorical Reading and the Growth of the Epic Tradition* (Berkeley, Los Angeles, London, 1986), concentrates, as the title says, on a different tradition of interpretation, but is useful also for understanding the rationalistic approaches.

39. Walter Burkert, *Greek Religion*, pp. 88–92.

40. William Bedell Stanford, *Ambiguity in Greek Literature: Studies in Theory and Practice* (Oxford, 1939; reprint New York and London, 1972).

41. See Geffcken's study, p. 286. And cf. *The Aeneid of Virgil*, I, translated by C. Day Lewis (Oxford, 1952), 480–85. As the goddess's ritual robe is brought in procession to the statue (?), "the goddess keeps her eyes on the ground and regards them not." Here the reader cannot help feeling that ambiguity as to whether it was a statue or a living goddess who did not look at the women was intentional, an artistic device.

42. For some examples, see below, chapter 3.

43. See C. J. Herrington, *Athena Parthenos and Athena Polias* (1955).

44. J. G. Frazer, *The Golden Bough*, I (London, 1911), pp. 299 ff. And see also O. Gruppe, *Griechische Mythologie und Religionsgeschichte* (Munich, 1906), p. 821, note 1.

45. Mircea Eliade, *Patterns in Comparative Religion* (New York, 1963), pp. 194 ff. For classical Antiquity, see Burkert, *Greek Religion*, pp. 75 ff.

46. See Plutarch, *Alkibiades*, 34; Pollux, *Onomasticon* VIII, 141.

47. In Argos, as we learn from Callimachus's tale of Teiresias. Cf. Ulrich von Wilamowitz-Moellendorf, *Hellenistische Dichtung in der Zeit des Kallimachos*, II (Berlin, 1924), pp. 14–24, a section called "Das Bad der Pallas."

48. See Pausanias, *Guide to Greece* II, 10, 4.
49. *Fasti* IV, 135 ff. See *Ovid's Fasti* with an English translation by Sir J. G. Frazer (Loeb Classical Library; Cambridge, 1967). The lines quoted are found on p. 199.
50. Ovid, *Fasti* IV, 337 ff. See p. 213 of the English translation.
51. Gruppe, *Mythologie*, p. 821, note 2, lists a wealth of material, suggesting that the ceremony may originally have been a charm for rainmaking, and eventually became an act of ritual purification. It is beyond the scope of the present study to attempt an investigation of the process.
52. Pausanias, *Guide to Greece* IV, 13, 1.
53. Plutarch, *Timoleon*, 12 ff.
54. See Suetonius, *Caligula*, 57. The soldiers, shivering with fear, well illustrate the effect such miracle has on people.
55. Strabo, *The Geography*, VI, translated by H. L. Jones (London, 1949–69), p. 264 (statue closes the eye in order not to see a crime committed); Lucian, *De dea Syria*, 32 (statue follows with its gaze the movements of the specta-tor); Cassius Dio, *Roman History*, LIV, translated by E. Cary (London, 1914–63), 7; XLVI, 33; XXXIX, 20 (statues turning away); similar *Athen-aeus the Deipnosophist*, XII, translated by C. Gulick (Cambridge, Mass., 1951), p. 521.
56. Lucian, *The Liar*, translated by H. W. Fowler, 19.
57. Plutarch, *The Greek Customs*, 40. See *Plutarch's Moralia*, IV, translated by Frank O. Babbitt (Loeb Classical Library; Cambridge, Mass., and London, 1972), pp. 177 ff. For the passage referred to, see pp. 227 f.
58. Tacitus, *Annales* XII, 22.
59. Pausanias, *Guide to Greece* VII, 22. English translation I, p. 285.
60. *Saturnalia* I, 23, 13. For the English wording see Macrobius, *The Saturnalia*, translated by Percival Vaughan Davies (New York, 1969), p. 151.
61. The chaining of a god's image is not limited to ancient Greece. See W. Crooke, "The Binding of a God: A Study in the Basis of Idolatry," *Folklore* VIII (1897), pp. 325–55. And see also R. Merkelbach, "Gefesselte Götter," *Antaios* XII (1970/71), pp. 549–65. And cf. Edwyn Bevan, *Holy Images* (London, 1940), pp. 28 ff.
62. Pausanias, *Guide to Greece* III, 15, 9. J. G. Frazer, in his commentary to Pausanias (*Pausanias' Description of Greece*, edited and translated by J. G. Frazer [London, 1898–1913]), collects a great deal of material, both Greek and comparative, important for the study of chained images. Cf. his com-mentary to the passages in Pausanias mentioned in the present paragraph.
63. Pausanias III, 15, 11. Martin Nilsson suggests (*Geschichte der griechischen Religion*, I [3rd ed., Munich, 1976], pp. 82 f.) that the chains could also have served as decoration. Yet he does not doubt the chaining of divine statues in order to prevent their departure.
64. Pausanias VIII, 41, 6.
65. Pausanias IX, 38, 4.

66. Plutarch, *Roman questions*, 58.

67. Bevan, *Holy Images*, p. 28, believes that the maidens are aware that the idols are not identical with the gods, yet nevertheless they feel that by holding the images they keep the gods in the city.

68. Cf. Gruppe, *Mythologie*, pp. 981 ff.

69. In a scholion, fr. 414. I am quoting after Gruppe, *Mythologie*, p. 981, note 6.

70. Pausanias, *Guide to Greece* VIII, 41, 6. He has not seen it himself, he conscientiously notes, since he "did not manage to be there at the moment of the festival." For additional texts telling of chained statues of gods, see Gruppe, *Mythologie*, p. 982, note 2.

71. Theocritus VII, *Idylls*, 106. The story is also told by Pausanias. Modern scholarship, particularly in anthropology, has emphasized that similar behavior can be observed in recent times, even in Europe. For additional material see Frazer, *The Golden Bough* I, pp. 296 ff., and Versnel, "The Religious Mentality in Ancient Prayer," pp. 38 ff.

72. Pausanias, *Guide to Greece* VI, 11, 6.

73. See Paul Veyne, *Did the Greeks Believe in Their Myths? An Essay on the Constitutive Imagination* (Chicago and London, 1988). The original French edition, *Les Grecs ont-ils cru a leurs mythes?* was published in Paris, 1983.

74. The examples are well known. It is sufficient to recall those mentioned by Burkert.

75. *Greek Religion*, p. 91. Given the broad scope of his work, Burkert unfortunately cannot go into a discussion of the meanings and implications of his observation.

76. See, for instance, O. Gruppe, *Griechische Mythologie und Religionsgeschichte* (Handbuch der klassischen Altertumswissenschaft, 5. Band, 2. Abt.; Munich, 1906), p. 982.

77. Minucius Felix, *Octavius* 23, 13; Tertullian, *Apologeticus*, 12; *De Idololatria*, 15; *De spectaculis*, 13.

78. See A. L. Oppenheim, *Ancient Mesopotamia* (Chicago, 1964), p. 186. Burkert himself refers to this source.

79. I shall come back later to the problem of resemblance in general (see below, chapter 4). Here I touch on it only in the context of the animation of the god's image.

80. See Dion Chrysostomus, *Discourses*, esp. XIIth discourse. And cf. my *Theories of Art from Plato to Winckelmann* (New York, 1985), pp. 25 ff.

81. *Enneads* IV, 3, 10. I use the translation by Stephen MacKenna (Plotinus, *The Enneads* [London, n. d.]). There are two essays on Problems of the Soul, *Enneads* IV, 3 and 4. For the passages here discussed, see pp. 269 ff. of the translation.

82. *Enneads* IV, 3, 11; p. 270 of the English translation.

Antiquity II:
Against the Images of Gods

In a schematic map of the typical attitudes to the images of the gods in the Greek and Roman world the belief in the animated statue marks one end of the scale. It embodies the tendency to reduce the distance between the god and its portrait until it is made to dwell in the statue and to animate it. We are here close to identifying the image with the god itself. At the other end of the scale we commonly place the rationalistic, skeptical approach, an attitude that has much in common with the Enlightenment outlook and anticipates many modern formulations.[1] The critical tradition stressed the gap between the god and its image. We are here close to the denial of any possibility of making an appropriate image of the god.

Critical thought has a long history, and this is true also concerning reflections on the images of the gods. It goes without saying, but has perhaps not been sufficiently emphasized in modern studies, that even in

this relatively minor subject—the images of the gods—a critical attitude should not be taken as a unified stance, or as an amorphous world view, devoid of internal distinctions. Antiquity has not transmitted an analysis of the types of rejection of the images of gods, but it might be helpful for our purpose to propose such a typology. The types here suggested, it need hardly be said, are not to be understood as fully distinct from each other; further, in the many rejections that have been transmitted, different motives prevail.

In a systematic scheme one should begin with the rejection of the gods' images because the very existence of the gods is denied. In modern scholarship it seems to be generally accepted that outright atheism was rather rare in Greek and Roman thought, and especially that it played no significant role in classical culture.[2] Ancient literature does not seem to have preserved any explicit atheistic reasons for the rejection of images of the gods.

Another reason for rejecting the statues and pictures of the gods is the belief that God is imageless. This is, of course, a central theme of the present study, and in the course of the current section we shall have to deal with the major expressions of this view. Already here, however, I should emphasize that the attribute of "imageless" is not unambiguous in Greek and Roman discourse. It may mean that God cannot be seen at all, somewhat similar to the biblical assumption; but it may also mean that God has no human form. As a rule, form means human form, but there are also other versions. We find a good example of this particular ambiguity already at an early stage of ancient culture: Herodotus tells of the customs in Persia, of which, as he points out, he has personal knowledge: "They [the Persians] are not wont to establish images or temples or altars at all; indeed they regard all who do so as fools, and this, in my opinion, is because they do not believe in gods of human form, as the Greeks do."[3]

The gods' images are, finally, rejected because idol worship is criticized. Ridiculing the worshipper of a statue is a common topos in ancient literature, one that occurs in most phases of Antiquity. We shall therefore have to refer to this argument frequently, but it should be said at the beginning that a criticism of idol worshipping is not directly concerned with the image, but with the worshipper's behavior. By implication, however, it also contains a view of what is the nature of the

image. It is this implied view, often coming close to a clear statement, that concerns us here.

From our point of view, of course, the arguments pertaining to the second type, that is, those concerned with the shape of the gods, are the most interesting ones. As long as the Greeks reflected on matters divine, the question of what the god's shape *(morphe)* is did not disappear. It was none other than Cicero who showed that this question remained an essential part of investigating the "nature of the gods."[4] He begins the second part of *De natura deorum* by dividing the inquiry into several themes; the second theme, the kinds of gods, also includes the question of their shapes.[5]

At the beginning of this history, at least in Greek culture, we find the great Ionian poet-philosopher of the end of the Archaic Age, Xenophanes. Xenophanes' criticism of the concepts we form of the gods is well known; it has often been said that he was an "intellectual revolutionary," and that it was this criticism that opened up a philosophical dimension in the consideration of the divine. This does not mean that he was an atheist. "It is proper for men who are enjoying themselves first of all to praise God," he says in the "Elegy" on the opening of a symposium. This should be done, however, "with decent stories and pure words."[6] What he means by this becomes clear in the following sentences, where he turns against treating on such an occasion the Homeric and Hesiodic myths "of the battles of the Titans or of the Giants, figments of our predecessors." The ancient poets pictured the gods in human form and attributed to them human frailties and fate. "Both Homer and Hesiod have attributed to the gods all things that are shameful and a reproach among mankind: theft, adultery, and mutual deception."[7] Parallel to seeing the gods acting like humans is the view that they actually look like humans. Following the ancient poets we believe that the gods are begotten, and that they have our "raiment, voice and body."

We reach here the question of where this anthropomorphism originates. Xenophanes' thesis is clear: humanity projects its own image onto the gods. To invert the biblical phrase we could say that human beings shape god in their own image. No wonder, then, that the gods show features characteristic of the human frame. Thus racial differences are mirrored in the gods. "Aethiopians have gods with snub noses and black

hair, Thracians have gods with grey eyes and red hair."[8] He carries the idea that the image of the god always reflects its "creator" on earth to the ultimate conclusion that beasts, were they able to create images, would create theriomorph icons of the gods:

But if oxen [and horses] and lions had hands or could draw with hands and create works of art like those made by men, horses would draw pictures of gods like horses, and oxen of gods like oxen, and they would make the bodies [of their gods] in accordance with the form that each species itself possesses.[9]

Xenophanes does not seem to have known that in Egypt there were in fact images of gods cast in the shapes of beasts. Whether or not this fact would have disturbed his thought[10] is not for us to say.

Now, does this mean that Xenophanes' god is altogether invisible, or has no traceable shape, and that therefore it cannot be represented? Not necessarily, some scholars would say.[11] From a Hellenistic source, the authenticity of which has been questioned, we learn that, according to Xenophanes' teachings, God has the shape of a sphere.[12] Whether or not this is a reliable source, the idea that God looks like an abstract geometrical body, a sphere, had little impact on the conception of the god's image in Greek culture. Denying the god *human* form was, for large parts of Greek culture, tantamount to denying it any form at all.

Xenophanes' observations of how the images of the gods are made to bear the racial characteristics of their human producers, it has been suggested,[13] attests to his wide travels; it also shows that he was a careful observer of shapes and colors. What is no less important is that, being aware of popular beliefs,[14] he breaks away from them, and thus declares humanity's nature as a god-creating agent. In so doing, he announced a motif in the intellectual rejection of the gods' images that was to have an important afterlife, and to become prominent in modern times.[15] In Antiquity, however, this motif was overshadowed by another theme.

The philosopher Heraclitus, Xenophanes' younger contemporary, was also concerned with divine images. In negating the images of the gods he emphasized that other theme, and formulated a motif that was to become a central subject in the rationalistic critique of beliefs in the animated image, and in holy images in general. This theme is simple: it emphasizes the well-known fact that the material of which the gods' images are made is plain matter, regular wood or stone or metal, totally inanimate and utterly incapable of any perception, or understanding.

Heraclitus exposes the flagrant contrast between people's belief in the image, and their behavior resulting from this belief, and the real nature of the idol they pray to and address in different ways. Believers, he said, "pray to statues of the gods, that do not hear them, as if they heard, and do not give, just as they cannot ask."[16] It is correct to say that Heraclitus is not opposed to praying as such for, "his complaint is aimed at the obtuse idea that the images are gods."[17] "Moreover," so another fragment reads, "they [the believers] talk to these statues [of the gods] as if one were to hold conversation with houses, in his ignorance of the nature of both gods and heroes."[18] Heraclitus's satirical tone in the rejection of divine images, it has been said,[19] anticipates that of the Christian polemicists.

I do not intend to trace here the history of the critical attitude to sacred images in Antiquity, but I should note that the dependence of the god's forms on those of the people who make its images, and the utter lifelessness of the matter of which the images are made—that is, the arguments of Xenophanes and Heraclitus—in fact became the central topoi of the skeptical, critical tradition. As I have said, it was mainly the latter theme on which later critics focused.

Contacts, reliable or fantastic, with foreign cultures and religions in distant lands brought home the acquaintance with aniconic cults. Of the Scythians Herodotus tells us that "images, altars, and shrines they do not make customarily, except to Ares."[20] But what was the image on the altar to that one god? It was not a statue in human shape. A large amount of wood is piled up, Herodotus relates, and "on this pile is set an ancient iron sword" that serves as the cult image.[21] But stories of foreign countries are also made to support the traditional themes of the critical tradition, especially the stress on the material of which a god's image is made. The Egyptian king Amasis, we learn, "had many treasures, and among them a golden footbath, in which Amasis himself and his fellow guests washed their feet on occasion of need. Amasis cut this up and made out of it an image of a god and set it up at the most suitable part of the city."[22] The Egyptians, Herodotus continues, showed great reverence to the statue.

Rejecting the god's image because it is a mere material object is a central argument in the satirical literature, especially in Hellenistic and Roman times. Ridicule and satire played a major part in combating popular beliefs in sacred and animated images. Making fun of the gods'

statues lasted throughout Antiquity, and in the course of the centuries it assumed many forms. An important theme is the striking contrast between a god's omnipotence, and other qualities deemed to be characteristic of a divine being, and the utter helplessness of the image representing the god. This particular contrast, taken up time and again, was elaborated in concrete detail and taken to grotesque, laughter-evoking dimensions. I shall mention only a few examples.

Heraclitus already strikes a satirical tone in dealing with adoring sacred images; as we have just seen, he compares the believers who talk to the statues of gods to people who are conversing with walls. But here the specific motif is that of the statue's inanimate nature, a subject to which we shall shortly return. Explicit satire of the god's image based on the helplessness of matter seems to have emerged only in Hellenism. The *Battle of the Frogs and the Mice* (known as the *Batrachomyomachia*) is an ancient parody of the *Iliad*. Although actually composed only in the third century b.c. (possibly even later), in late Antiquity it enjoyed the prestige of a text of legendary age. Athene (or rather Minerva), we learn from the parody, complains to Saturn that mice have nibbled away her mantle, and she cannot afford to pay the tailor for a new one.

O father, never will I come as an assistant to the mice in trouble, since they have done me many ills, having befouled my garlands, and lamps, for the sake of the oil. But this thing, such as they have done, has particularly eaten into my soul, they have nibbled away a garment, which I had worked with my own toil, and they have made holes in it. But the weaver presses me, and demands usury of me, [and] on this account I am worn out. For having borrowed, I worked it, and have not the wherewithal to pay back.[23]

Mice inside the statue of a god, nibbling away at its very substance—that was an image that captivated the satirical imagination of Greek rationalists. One could hardly think of a more striking example of the contradiction between a god and its material image. We keep hearing of mice eroding a holy image from within. A satirist such as Lucian would certainly not miss the point. In the "Zeus Tragoedus" he tells the story, combining it with an interesting observation on the materials artists in different countries prefer for their work. He juxtaposes the techniques of Greek and Egyptian sculptors: the Greeks make marvelous statues of gold and ivory (a good description of the *xoana*, the typical cult statues). These statues, Lucian says, "have grace, beauty, and artistic workmanship," but they are "wood inside, [and thus] harboring whole colonies

of mice." The Egyptian statues, on the other hand, are "dog-faced," but they are made of solid stone, and they thus escape the danger, and the humiliation, of being destroyed by mice. No wonder, then, that, to use Lucian's words, in the assembly summoned by Zeus, "the front row will be exclusively barbarian."[24]

Lucian comes back to this image of inner corruption, so totally belying the pose of dignity and elevation. The works of the famous sculptors, pieces of sculpture that became legends in ancient culture, are not exempted. In another story Lucian makes the cock relating his dream say,

I was like those colossal statues, the work of Phidias, Myron or Praxiteles: they too look extremely well from the outside; 'tis Poseidon with his trident, Zeus with his thunderbolt, all ivory and gold: but take a peep inside, and what have we? One tangle of bars, bolts, nails, planks, wedges, with pitch and mortar and everything that is unsightly; not to mention a possible colony of rats or mice. There you have royalty.[25]

The mental picture of mice eroding the statue of a god from within found its way also into the Christian literature of late Antiquity. In the early third century a.d. Arnobius, in his *Seven Books against the Heathen,* gives a Christian version. The Sixth Book deals with pagan temples, idols, and rituals (mainly sacrifices). The heathen forget that their idols are made of clay, wood, metal sheets, or "from the tooth of the Indian beast" (ivory).[26] Arnobius gives some information that is of great interest to the art historian, especially concerning the way the statues are composed of independent parts. What he emphasizes, however, is that all the materials of which idols are made are subject to the laws that govern the material world in general; they decay and disintegrate. In his picturesque language he describes how the statues of the gods "crumble away under dripping of rain; . . . disintegrate through decay and rot; . . . vapors and smoke begrime and discolor them . . . neglect over a long period causes them to lose their appearance because of weathering and they are eaten away by rust." All this, needless to say, is in striking contrast to the supposed power and dignity of the divine. Addressing the heathen, Arnobius exclaims,

I say, do you not see that newts, shrews, mice, and cockroaches, which shun the light, build their nests and live under the hollow parts of these statues? that they gather carefully into these all kinds of filth, and other things suited to their wants, hard and half-gnawed bread, bones dragged [thither] in view of [proba-

ble] scarcity, rags, down, [and] pieces of paper to make their nests soft, and keep their young warm?[27]

When he wrote his work, Arnobius was of course already a Christian, but he was raised and educated as a pagan, and his work reflects the tradition of the educated trend in Greek culture of the time. His attack on the idols shows, in style and imagery, how good a pupil he was of the Greek Enlightenment.

A cluster of related motifs, perhaps less biting in tone but also satirical in intention, developed in Hellenistic and early Christian literature. It will suffice to mention one of them, which early Christian authors found particularly appealing. It is the god's statue's inability to fend off the birds, and other creatures, that defile it from the outside. Clement of Alexandria mentions swallows and other birds as unconcernedly defiling the statues. He gives famous examples: the Olympian Zeus, the Epidaurian Asclepius, the Athena Polias, and the Egyptian Sarapis.[28] Arnobius tries to give a didactic turn to the motif:

Do you not see, finally, swallows full of filth flying around within the very domes of the temples, tossing themselves about and bedaubing now the very faces, now the mouths of the divinities, the beard, eyes, noses, all the other parts on which the outpouring of their emptied fundament falls?

Blush, then, however late, and take your lesson and norms from the dumb animals and let them teach you that there is nothing divine in images, on which they do not fear or scruple to cast filth, following as they do, their own laws and impelled by their unerring natural instinct.[29]

Another theme belonging to the subjects traditionally brought up in arguments against divine images relates to the material origin of the god's statue. Time and again we hear that from the very same piece of material the artisan can fashion either the figure of a god or some everyday, regular object, usually one lacking significance or dignity, and sometimes even serving base needs. As we have seen, this theme, clearly bearing a satirical character, already appears in the Bible (Isaiah 44).[30] In Greek and Roman literature it is well known. Earlier in this section we have seen that Herodotus, who praises the Persians because they do not imagine their gods in human shape, tells of a golden footbath being melted down to become the image of a god.[31] I shall not here set out to trace the history of this motif in Greco-Roman intellectual life. Perhaps its continuity may be suggested by a text composed many centuries after

Herodotus. Horace begins one of his satires by making a god's image tell the story of how it came into being: "Once I was a fig-wood stem, a worthless log, when the carpenter, doubtful whether to make a stool or a Priapus, chose that I be a god. A god, then, I became."[32]

The mental picture of an artisan contemplating a piece of wood or stone, wondering whether to make of it some ordinary object or the image of a god, bears testimony to two important points. It shows, first, that there is nothing divine or supernatural in the stuff of which the god's statue is made. In its material substance, at least, the god's statue is not different from any other material object, and this total indifference of the matter to the shape of the god, into which it is cast, cannot but affect the god's image itself. Secondly, that mental image forcefully shows that the very existence of the god's statue is a matter of chance, or a human's arbitrary decision. There is no compelling inner necessity of the statue's coming into being.

In Jewish-Hellenistic literature, well known for its influence on the intellectual world of emerging Christianity, the motifs here discussed found forceful expression. I shall limit myself to one quotation from the *Wisdom of Salomon,* an influential work of biblical apocrypha composed in the first century b.c. This passage from the *Wisdom of Salomon* (13:10–19) shows how several of the themes repeatedly adduced in rejecting divine images have grown together:

> But if some carpenter saws down a tree he can handle,
> And skillfully strips off all its bark.
> And shaping it nicely
> Makes a dish suited for the uses of life,
> And burns the chips of his work
> To prepare his food, and eats his fill;
> But the worst of them, which is good for nothing,
> A crooked piece, full of knots
> He takes and carves to occupy the spare time,
> And shapes it with understanding skill,
> He makes it a copy of a human form,
> Or makes it some common animal,
> Smearing it with vermillion, and painting its surface red,
> And coating every blemish in it;
> And making an abode for it worthy of it,
> He fixes it on the wall, and fastens it with iron,
> So he plans for it, so that it will not fall down,
> For he knows that it cannot help itself;

For it is only an image and needs help.
But he prays to it about his property and his marriage and his children,
And is not ashamed to speak to a lifeless thing.
And appeals to something that is weak, for health,
And asks something that is dead, for life,
And supplicates what is utterly inexperienced, for aid,
And something that cannot even take a step, about a journey,
And he asks strength for gain and business and success in what he undertakes
From something whose hands are most feeble.

Considering the god's statue as a mere material object leads to still another literary version: the statue, even after it had been honored for years as the image of a powerful and adored figure, can still become "raw material," as it were, and be turned into an ordinary object. In ancient literature this particular version is found mainly when the images of heroes or political leaders are discussed, but they are not in principle different from the images of the gods. The process of melting large-scale bronze statues (the typical form of reducing images to raw material) reminds one of iconoclasm. Now, the destruction of venerated images did not play a major part in the life of the ancient world; nothing comparable to the iconoclastic breaking of images was known in classical Antiquity.[33] Still, we do find in ancient literature occasional references to the breaking of statues, or to melting them down and making "useful" objects of them. A lively, suggestive description of destroying the statue of a powerful and venerated figure is found in Juvenal's *Satires*. The text is so rich in allusions that a large part of it must be quoted.

Down come their statues, obedient to the rope; the axe hews in pieces their chariot wheels and the legs of the unoffending nags. And now the flames are hissing, and amid the roar of furnace and of bellows the head of the mighty Sejanus, the darling of the mob, is burning and crackling, and from that face, which was but lately second in the entire world, are being fashioned pipkins, basins, frying pans and slop-pails. Up with the laurel-wreaths over your doors! Lead forth a grand chalked bull to the Capitol! Sejanus is being dragged along by a hook, as a show and joy to all.[34]

The student of ancient literature and religion knows that many more quotations could be quoted to support what we have been trying to suggest. I hope, however, that even those chosen will suffice to show that the representatives of the critical tradition considered the images of the gods primarily in their material nature, as physical objects. Before

we try to draw some conclusions from this approach we cannot help asking, did the ancient authors know that this was in fact their attitude? Were they aware of the principles directing their thought? In some cases at least it is obvious that they were fully conscious of the principles underlying their criticism of popular beliefs. A single quotation may testify to this. My witness is Athenagoras of Athens, one of the earliest Christian authors who, describing himself as a "Christian philosopher," composed in Alexandria, between a.d. 177 and 180, his *Appeal on Behalf of the Christians,* better known as the *Apology.* The adoration of the statues of the gods, so common in his world, was a subject he could not avoid discussing. Naming the gods and heroes worshipped, he asks, "Is it Neryllinos, Proteus, Alexander who brought this [the miracles] about in the images? Or is it the material composition of the images themselves? But the material [of which the images are made] is bronze. What can bronze by itself bring about? One can still cast it into another shape; so, according to a story told by Herodotus, Amasis has cast an idol out of a foot-basin."[35] The idea that it could be the form into which the bronze is cast that performs the miracle has obviously not crossed Athenagoras's mind.

Seeing the image of the god primarily as a material object is not self-evident; it calls for an explanation. The concern with the material nature of the idol is particularly striking since most of the authors I have quoted in the present section were philosophers and theologians. They were far removed from the popular beliefs that tended to fuse the god and its image, and they had no links with, and very little interest in, the work of the creative artists who actually handled the materials. Why then, one cannot help wondering, did they consider the gods' images only as material objects?

I shall not attempt a discussion of the fascination with materials (such an investigation would go far beyond the scope of the present study) but would like to mention briefly two points. The first may be called a didactic intention. Nowhere could the total incongruity between the god and its artistic image be made as manifest as when one considered the image as a material object. It is not surprising, then, that all the arguments against the belief in images—from Heraclitus to Arnobius—focus on the idol's material. Wherever the "vanity" of the gods' images had to be shown, the corruptible nature of the materials of which the idols are made is vividly presented. The failure of the image to reveal the god

becomes almost tangible when we consider the material aspect of the idol.

My second point is more problematic; what I am going to say is admittedly hypothetical. In identifying the god's image with the piece of material in which it is carved, the authors betray, or suggest, a certain social awareness. In Greek and Roman culture, one may suggest, the attitude hostile to divine images seems to have been characteristic of a thin layer of intellectuals. We have no explicit sources to this effect, but such a conclusion seems to follow from many indirect statements. The aniconic religions of the East, mainly of the Persians, were known in Greece, but their influence remained limited to small groups of intellectuals.[36] Of Socrates it was said that, in spite of his wisdom, he was not impious as are those "madmen . . . [who] pay no respect to temple, or altar, or anything dedicated to the gods."[37] But it is mainly Clement of Alexandria who has preserved for us the spirit of the educated Greeks looking down at the people worshipping images. In the fifth book of *The Miscellanies*, a wonderful testimony to the survival of classical culture in early Christian thought, he quotes, and elaborates on, Xenophanes' and Heraclitus's statements, and speaks about "the idolatry of the multitude."[38] It is clearly an intellectual aristocrat who is here speaking, and he sums up a venerable tradition. By the late third century a.d. the pagan author Porphyry, trying to defend the cult of images, is still saying (in his early work *About Images*, preserved only in fragments) that it is only the uneducated who identify the gods with the images.[39] For these intellectuals, one feels tempted to say, the coarse identification of the god with a piece of material is a further expression of their setting themselves off from "the multitude."

NOTES

1. For a concise survey of these movements, and an interesting typology, see Dieter Metzler, "Bilderstürme und Bilderfeindlichkeit in der Antike," in M. Warnke, ed., *Bilderstürme* (Munich, 1973), pp. 14–29. I should like to refer to an old study that is still remarkably useful, valuable both in the abundance of materials it collects and in some penetrating analyses. I mean Johannes Geffcken, "Der Bilderstreit des heidnischen Altertums," *Archiv für Religionswissenschaft*, XIX (1916–1919), pp. 286–315.

2. I am not aware of any recent treatment of atheism as a whole in Greek and

Roman culture and social life. Hermann Ley, *Geschichte der Aufklärung und des Atheismus*, I (Berlin, 1966), is written from a rather limited point of view, but brings much information. From the older literature, see A. B. Drachmann, *Atheism in Pagan Antiquity* (London, 1922), especially the introduction. Another rather old work is Paul Decharme, *La Critique des traditions réligieuses chez les Grecs* (Paris, 1904; reprint Brussels, 1966). Decharme does not pay much attention to outright atheism, but see pp. 120 ff. Cf. Walter Burkert, *Greek Religion* (Cambridge, Mass., 1985), pp. 311 ff., for a particularly important stage in the development of ancient doubts in religious truths. Much can be learned from P. A. Meijer, "Philosophers, Intellectuals, and Religion in Hellas," in H. S. Versnel, ed., *Faith, Hope, and Worship: Aspects of Religious Mentality in the Ancient World* (Leiden, 1981), pp. 216–63.

3. I, 131. See *The History: Herodotus*, translated by David Grene (Chicago and London, 1987), p. 95. But see I, 60 (p. 59), a striking illustration of the personification of a goddess.

4. See Cicero, *De natura deorum* II, 1 and 17. I am here following Werner Jaeger, *Die Theologie der frühen griechischen Denker* (Zurich, 1953), p. 56.

5. The subjects are (1) *esse deos*, (2) *quales sint*, (3) *mundus ab his administrari*, (4) *consulere eos rebus humanis*. The question of *quales sint* includes reference to the shape of the gods.

6. I use Kathleen Freeman's English translation. See *Ancilla to the Pre-Socratic Philosophers* (Cambridge, Mass., 1970). For the sentence quoted, see p. 20. On Xenophanes' views of God, see now, in addition to Jaeger's chapter (see note 4), Burkert, *Greek Religion*, pp. 308 ff.

7. Xenophanes of Colophon, ## 11, 12, 14. See *Ancilla*, p. 22. And see Herodotus II, 53, who claims that Homer and Hesiod "created for the Greeks their theogony; it is they who gave to the gods the special names for their descent from their ancestors and divided among them their honors, their arts, and their shapes."

8. Xenophanes, # 16.

9. Xenophanes, # 15.

10. See Werner Jaeger, *Die Theologie*, pp. 60 ff.

11. That god is altogether devoid of shape, Jaeger, *Theologie*, p. 56, says, "would not even cross his mind."

12. The pseudo-Aristotelian *De Xenophane*, 977, b1 (see Jaeger, *Theologie*, p. 247, note 23) makes this claim. It has been suggested that this reflects the influence of Parmenides, who attributes to Being the characteristics of "a well-rounded sphere." I do not feel competent to follow up the philological discussion.

13. See E. R. Dodds, *The Ancient Concept of Progress and Other Essays on Greek Literature and Belief* (Oxford, 1973), pp. 4 ff.

14. Drachmann, *Atheism*, p. 19, stresses that Xenophanes "everywhere starts from the definitions of the gods as given by popular religion."

15. I think particularly of the interpretation of Ludwig Feuerbach.
16. Heracleitus of Ephesus, # 128 (*Ancilla to The Pre-Socratic Philosophers*, p. 33). The reading of this passage is not altogether certain, but for our purpose the variations are not significant.
17. See Meijer (see above, note 2), p. 223.
18. Heracleitus, # 5.
19. See Burkert, *Greek Religion*, p. 309.
20. Herodotus IV, 59; p. 302 of the English translation.
21. Herodotus IV, 62; p. 303.
22. Herodotus II, 172; p. 206.
23. Lines 178–87. I use the English version in *The Odyssey of Homer, with the Hymns, Epigrams, and Battle of the Frogs and Mice*, literally translated by Theodore Alois Buckley (London, 1906), p. 344. Cf. Geffcken, "Der Bilderstreit des heidnischen Altertums," pp. 290 ff.
24. "Zeus Tragoedus," 7, 8. See *The Works of Lucian of Samosata*, III, translated by H. W. Fowler and F. G. Fowler (Oxford, 1905), p. 84.
25. The Cock (*Somnium: Gallus*), 24. See *The Works* III, p. 121.
26. See *Arnobius Adversus Gentes* VI, 14. In English *The Seven Books of Arnobius Adversus Gentes*, XIX, translated by H. Bryce and H. Campbell (Ante-Nicene Christian Library; Edinburgh, 1871), p. 288.
27. *Arnobius Adversus Gentes* VI, 16; II, p. 469 of the English translation.
28. *Protrepticus* IV, 52.4.
29. *Adversus Gentes* VI, 16; II, p. 469.
30. See above, chapter 1.
31. Herodotus II, 172. See above in the introduction to chapter 3.
32. It is the piece known as *olim truncus eram*. See *Satires* I, 8, 1–3. See Horace, *Satires, Epistles, and Ars Poetica*, translated by H. Rushton Fairclough (Loeb Classical Library; Cambridge, Mass., and London, 1948), p. 97.
33. See Metzler, "Bilderstürme und Bilderfeindlichkeit in der Antike," p. 23.
34. *Satires* X, 56 ff. See *Juvenal and Persius*, with an English translation by G. G. Ramsay (Loeb Classical Library; London and Cambridge, Mass., 1957), p. 197.
35. *Appeal on Behalf of the Christians*, translated by M. Dods, chapter 26. For the study of Athenagoras, and our problem in general, the old work by J. Geffcken, *Zwei griechische Apologeten* (Leipzig and Berlin, 1907), is still important.
36. See W. Nestle, *Vom Mythos zum Logos* (Stuttgart, 1942), pp. 99, 141.
37. See Xenophon's *Memorabilia of Socrates*, I, translated by A. D. Lindsay, 1, 14.
38. I use the translation by William Wilson. See *The Writings of Clement of Alexandria*, II (Edinburgh, 1869), pp. 285 ff.
39. The surviving fragments of this work may be found collected in J. Bidez, *Vie de Porphyre* (Gand and Leipzig, 1913). For Porphyry, see below, chapter 4, the section discussing Porphyry.

Resemblance: The Internal Development of the Concept

In the preceding chapters I have tried to outline two extreme types of reading the image of God. To put it crudely, one of them conceived of the image as of the god itself, and the other saw the image as totally inadequate and alien to the god. I selected some salient texts and stories from ancient literature to illustrate these extreme approaches. Yet notwithstanding these literary examples, these types, as here outlined, in a sense remain constructions. The notion of the animated image, on the one hand, and the concept of the image as a lifeless, merely material object, on the other, represent extreme positions; they are the ends of a scale constituted by the various attempts to come to terms with the icon of the god, and to place it properly in an overall view of the world. In reality, such extremes are rarely, if ever, reached. To be sure, in both cases, the approach is consistent in itself, clear, and easy to grasp. But in such uncompromising formulations they remain abstract types, and do not capture and reveal the intricacy of the problems posed by the very

existence of divine images. To understand what the image of the god may really have meant, and what were the sources of its power, a power that often strikes us as mysterious, one must enter the domain of evocative suggestions, of beliefs that are not fully thought through, of ambiguities. The story we are about to study in the following chapters in effect unfolded in the shadow of ambiguities.

This state of affairs raises difficulties that are well known to historians and to students of fantasy, of religion, and of art. Workers in these fields are well aware of the power with which ambiguities are sometimes endowed. To study a psychological and religious reality one needs categories capable of being applied to the domain of the ambiguous. Can such categories be discovered? With regard to the specific subject of the present study, the image of God, I should like to suggest such a category, resemblance. I shall try to show that in Antiquity the concept of resemblance was actually employed in discussions of divine images. But resemblance was far from being a clear-cut concept. Moreover, in the course of the centuries it underwent some remarkable transformations. In the present chapter I shall attempt to trace the internal development of the concept. In speaking of "internal development" I do not propose that the idea of resemblance, quite particularly the resemblance of the god's image to the god itself, was isolated from other concepts, or from the religious, cultural, and social life of the world in which it evolved. Yet the challenges and pressures of the external world brought out the potentialities and limitations of the concept itself. It is these that the present chapter will attempt to investigate.

1. Allegory

To understand how the concept of resemblance was applied to the images of the gods, especially in the centuries of late Antiquity, we have to begin with a category that was often applied in this period to such images, namely allegory. The category of allegory was developed for, and applied to, written texts. What do we refer to when we speak of allegory in the context of material images of the gods, carved statues or painted icons? As is well known, many efforts have been made to define allegory, and to set it off from other types of symbolic expression. In the modern world it was particularly German Romanticism that tried to

establish such a distinction between symbol and allegory. I shall not attempt any additional definitions, and shall only recall some essential features. As we know, allegory literally means "saying something else." As a rule, we were taught, allegory is a narrative in which the agents and the actions, and possibly also the settings, are contrived to make sense in themselves; at the same time, however, they also signify a second, correlated order of things, events, or meanings. It is the understanding of this correlation, a correlation of different realities, that the concept of allegory represents in our context. Whenever we attempt to understand an allegorical image of God, we shall have to ask in what this correlation consists, and how it is experienced.

In Antiquity, so far as we know, the concept of allegory was employed only in the interpretation of literature. Like metaphor, allegory was considered a category of verbal expression. A continuous series of metaphors, said Quintilian, the great teacher of rhetoric and style, "runs into allegory and enigma."[1] Cicero, after declaring that no words add more brilliance to style than do metaphors, says that "from this class of expression comes a development not consisting in the metaphorical use of a single word but in a chain of words linked together, so that something other than what is said has to be understood."[2] "Something other than what is said," we should recall, is a literal translation of the Greek term *allegoria*.

Philo of Alexandria, as one knows, was one of the most explicit representatives of the allegorical method in Antiquity. He had little to say about sacred images, either carved or painted, and what he said is not new. He repeated what was accepted wisdom among educated and enlightened critics in his world. He rejected material images of the gods, and in so doing he not only showed that he was adhering to the Judaic tradition, to the Law of his fathers, but also that he belonged to the upper class of highly educated Hellenists. "Again, what shall we say of those who worship carved works and images?" he rhetorically exclaims in his essay *On the Contemplative Life*.[3] The images worshipped are made of stone and wood, and these materials "were only a little while before [the craftsman carved them] perfectly destitute of shape." Nor does Philo forget the other motif so common in the enlightened rejection of divine images: what remained of the materials of which the gods' images were made, "their near relation and brother, as it were," is

turned into ewers and foot-pans, "and other common and dishonored vessels, which are employed rather for the uses of darkness, than for such as will bear the light."

The student of images may be particularly interested in Philo's acquaintance with Egyptian sacred images and their theriomorph features. The Egyptians, we learn, "have introduced irrational beasts, and those not merely such as are domestic and tame, but even the most ferocious and wild beasts to share the honors of the gods."[4]

Sceptics and philosophers of the critical tradition, who so violently denounce idolatry and even the production of idols, seem hardly to have asked in detail why these images are made, and what it is that moves people to making and worshipping them. Philo seems occasionally to have departed from this inherited limitation; he did wonder, at least from time to time, what might be the reason for such production. In one of his most interesting essays, *On Drunkenness*, we read,

Man, who is devoid of any consideration, who is blinded as to his mind, by which alone the living God is comprehensible, does, by means of that mind, never see anything anywhere, but sees all the bodies that are in the outward world by his own outward senses, which he looks upon as the causes of all things which exist.

On which account, beginning to make gods for himself, he has filled the world with images and statues, and innumerable other representations, made out of all kinds of materials, fashioned by painters and statuaries, whom the lawgiver banished to a distance from his state.[5]

Philo uses passionate language to describe humanity's desire to see God. Of Moses he says that he "so insatiably desires to behold" God that "he will never cease from urging his desire," and though he "is aware that he desires a matter which is difficult of attainment, or rather which is wholly unattainable, he still strives on."[6] But people who do not have the spiritual powers of Moses, we understand, attempt to substitute images of their own making for the true God they cannot attain. People, then, make idols not simply out of stupidity, but because of profound desire that will forever remain unfulfilled. In modern parlance one could say that images are the product of humanity's tragic limitation.

Philo is aware of how powerful images may be.[7] He uses strong expressions to describe the spell the image may cast upon the spectator.

The arts of statuary and painting, he says, win over the spectator "by well fabricated appearances of colors and forms"; they "may ravish the unstable soul" by the "exquisite beauty of lifeless forms."[8] But all this does not make images any more reliable. He denies the images of the gods any real existence. Idols resemble "shadows and phantoms"; they "have about them nothing strong, or trustworthy, or lasting." Images "appear as in a mirror, deceiving the outward senses and imposing upon them with traps."[9]

But does this mean that images do not reveal anything beyond themselves? With all his vehement rejection of images, Philo does not detach them entirely from other things. Thus images bear testimony to their source and origin. In an attempt to deal with the question of what the essence of God (whom we cannot know directly) may be, he says,

> It has invariably happened that the works which they have made have been, in some degree, the proofs of the character of the workmen; for who is there who, when he looks upon statues and pictures, does not at once form an idea of the statuary or painter himself? And who, when he beholds a garment, or a ship, or a house, does not in a moment conceive a notion of the weaver, or shipbuilder, or architect, who has made them?[10]

What becomes manifest in the image, according to what we have just heard, is something of the maker's nature, rather than of the figure represented.

There is still another dimension to Philo's concept of icon; it fulfils a significant function in his theory of allegory. He thinks of the image (this term taken in a broad sense) as of an important, perhaps a crucial, means of reaching universal abstraction. The image is something that leads the mind from a specific, individual object to a general, "spiritual" meaning.

The inherent significance of the icon is made possible by the elevated position of sight. Philo continues, and is emphasizing, an old belief by claiming that sight is the best of all senses, and the eye is the finest of all organs. The position of the eye in the body is analogous to the position of the mind in the soul.[11] The dignity of sight naturally makes what sight perceives, that is, the image, a means of understanding, or at least of coming close to, the mysteries of the divine. The god has created the universe as a kind of allegorical icon of itself. Philo explains the process of God's creation of the world by looking at the architect building a city. (That he is here following Platonic thought, mainly the *Timaeus,* is

obvious.) We are not concerned here with the creative process and shall therefore not analyze his views of it. However, what he says about the process allows us to draw some conclusions as to the nature of the world created, and the general meaning of the image. The architect who is about to build a city, Philo says, forms an image of that city in his mind, and only afterwards proceeds to turn it into a material reality. Both the architect outlining the plan of the city and the builder erecting the individual building do so by looking at the image in their mind. The worker who is building the house, Philo says in the same passage, is "making the corporeal substances to resemble each of the incorporeal ideas." It is worth our while to repeat the obvious: the actual building is a kind of image—one could say, an icon—of the idea in the mind; what keeps the idea and the actual building together is the resemblance between them.

The icons Philo is speaking about are dematerialized, and the resemblance he refers to is metaphorical. Thus he conceives of the stars in the firmament as images of God. Yet even in metaphorical speech he evokes the memory of the real image. Taking into account that everybody knew of the gods' images in the temples, he thus defines the stars:

But the Creator having a regard to that idea of light perceptible only by the intellect, which has been spoken of in the mention made of the incorporeal world, created those stars which are perceptible by the external senses, those divine and superlatively beautiful images, which on many accounts he placed in the purest temple of corporeal substance, namely in heaven.[12]

To understand Philo's use, even if it is only metaphorical, of what he calls God's image, we must turn to another concept, of what is befitting to God.

The general concept of the "suitable, befitting" emerged, as one knows, in the analysis of linguistic and artistic expression. First it emerged in rhetoric, later it was extended to other fields of art, and finally it was applied, though in a vague sense, to human behavior in general. Originally, then, the doctrine of the suitable was what in modern parlance would be called a theory of style. Its central assumption, underlying all the variations of the doctrine, was that there exists, and should be made manifest, a relationship of congruence between the character of the subject or figure described and represented, and the means employed in describing and expressing the subject or figure.[13] To be sure, ancient authors did not consider that relationship to be one of physiognomic

resemblance, of a similarity that can be perceived by the naked eye. But this doctrine, we should remember, was the broad context in which reflections of a physiognomic similarity between a god's image and the god itself could emerge and be articulated.

The special idea of the "God-befitting," for which in Antiquity a particular term, *theoprepes,* was coined, is of course a further extension of the general notion of the suitable. It played an interesting part in Greek thought about the gods, and is thus of immediate bearing on our subject.[14]

The concept of the God-befitting, as it emerged in Greek thought and letters, is primarily applied to behavior, both that of people toward the gods, and that of the gods among themselves and to people. Yet visual experiences are not altogether excluded, and sometimes the concept—as a rule implicitly, but occasionally also openly—is referred to shapes produced by artists and perceived by the eye. It has been noted that the verb from which the term for "suitable, befitting" is derived actually means "to be clearly seen or heard, to be conspicuous," or "to be distinguished in."[15] It is, then, not surprising that it could also be applied to works of art.

The "God-befitting," it goes without saying, is not a concept in the theory of art, or in art criticism; the term was not coined for the analysis of works of art. Thus when Philo mentions the God-befitting he turns mainly against attributing human passions and human emotions to God.[16] Occasionally he may think that anthropomorphic speech about God may serve as a means of instruction or explanation.[17] But even here he is thinking only of texts; artistic images are altogether beyond his horizon.

Yet even though the concept of the God-befitting was not designed for the treatment of art, the notion of what befits a god is found in ancient descriptions of statues representing gods. If one considers the many cult statues that populated the ancient world it is natural that the notion of the God-befitting should also have been applied to the carved image. It is mainly the expressive qualities of the carved or painted figure (more rarely, of a work of art in general) that in Antiquity were sometimes interpreted in terms of the God-befitting. Polycleitus, we read in a well-known passage in Quintilian's work on rhetoric, failed to properly express the *auctoritas* of the gods, "for though he gave supernatural grace to the human form, he is said not to have adequately expressed the

majesty of the gods. . . . But what was wanting in Polycleitus is said to have been fully exhibited in Phidias and Alcamenes. Phidias, however, is thought to have been a better sculptor of god than of men." The majesty of his statue of Jupiter at Elis "is thought to have added something to the impressiveness of received religion; so exactly did the nobleness of that work represent the god."[18] This is one example where the visual qualities inherent in the concept of the God-befitting become manifest, and where the notion, originally one of pagan theology, is applied to real works of art. That this was not mere standard praise, but that Quintilian meant what he said, that a quality of the god is revealed in the statue, one can perhaps learn by comparing him to his near contemporary, Lucian, who stressed in the same statue the "overall beauty" of the famous image.[19]

Expressive qualities, as everybody knows, are vague, and it is difficult to define them clearly. Powerful as they can be, they often remain elusive, and lack clear distinctions. It was therefore unavoidable that people asked whether the carved and painted image could not in a more specific sense be made suitable to the god it portrayed. It is in this conceptual context that the problem of similarity arose.

2. Resemblance

Thoughts about the God-befitting perhaps become more specific in another concept, that of resemblance. Philosophers and psychologists of our time have taken much interest in resemblance, and have discovered and discussed various facets of it.[20] It is not for us to take up this subject, and all I should like to do is to dwell on a few points of importance for the late antique and early medieval discussion of icons.

The first point is the simple statement that in religious consciousness and theological reflection of the early centuries of our era, whether Christian or pagan, the matter of the god's image resembling the god itself emerged in various contexts. Such similarity thus became a theme of theoretical consideration in both theological thinking and in what we would today call aesthetics.

My second point concerns the extension, as it were, of ancient discussions of such similarity, and the factors that have to be taken into account when you study resemblance. Here the distance between the modern attitude and that prevailing in late Antiquity and in the Middle

Ages becomes strikingly manifest. To modern thinkers it is a matter of course that the criterion of deciding on resemblance, especially of an artifact to what it portrays, is the viewer's perception. In Antiquity it is not so much that the viewer's part is rejected; it is not considered at all, especially where one spoke of the cult image resembling the god itself.

This leads us naturally to our third point. Similarity was taken as the manifestation of an inherent objective link between beings or objects resembling each other. The son resembles his father—to quote the best-known formulation—because there is an intrinsic link between them, a real, objective interrelation of their very natures. That resemblance could be produced by chance, that there might be a similarity in appearance without a community of natures—such an idea simply does not seem to have arisen at all.

My final point is the most elusive one, and it seemingly contradicts another observation I have already made. It is important to state it, however, because it concerns a matter most directly pertinent to the subject of the present essay. In Antiquity it was felt that resemblance is particularly apt to reveal itself in visual experience; similarity is best perceived by the eye. Ancient authors do not seem to have reflected on why this is the case, nor on how one can practically ignore the viewer's judgment when claiming that the cult image resembles the god and yet believe that it is primarily the eye that grasps similarity. I am not aware of a single classical text that attempts to explain this problem, or even merely state it. Yet Greek and Roman literature provides the student with so many descriptions of visually perceived resemblance that the reader tends to accept this connection as a matter of fact.

The discussion of similarity was carried on, though intermittently, throughout Antiquity. But it was mainly in the last phase of the period that the discussion of whether or not the divine image resembles the god itself became more intensive. The question arose, and was argued about, in different cultural and religious traditions, and one is therefore not surprised to find in the literary works that reflect these the marks of different schools of thought. It is not for me to describe the intricate fabric of late antique thinking; I shall only briefly note the interweaving of two threads that help to outline the problem of resemblance in the god's image. These are the attempts to explain the riddle of language, and to come to terms with the problem of intuitive cognition.

(i) *Plato's* Cratylus Ancient reflection on language—and, by implication, on any form of articulate communication—started with Plato's *Cratylus,* and later often took the form of commentaries to this text. (The term "commentary," of course, need not be taken literally. What ancient commentators aimed at was not always to bring to light Plato's intention, obscured by difficult formulations; rather, they often used Plato's text as a starting point for stating their own views.)

The *Cratylus,* it is well known, poses the question crucial not only to the philosophy of language, but also to a great deal of the reflection on images. It is the question of whether words describe the things "by nature" or "by convention." This implies, though it does not always explicitly articulate, the other question: whether the description by words, be they "by nature" or "by convention," is a correct and valid one, and whether there is a difference of validity between the two types. The problem is clearly stated right at the beginning of the dialogue, and one sees that the two themes, the origin of words "by nature" or "by convention" and the question whether the linguistic rendering is correct, are fully intertwined. Cratylus claims that "names are natural and not conventional," and in the same breath, as it were, he also claims that there is "truth and correctness" in them. The truth of the names is warranted by their being rooted in nature. This can best be seen when you cross the border between different languages. The truth of the names "is the same by nature for all, both Hellenes and barbarians" (383a).[21] Cratylus's opponent, Hermogenes, not surprisingly holds the opposite view. Believing that words are based "on convention and agreement," he cannot accept the very existence of a principle of truth in names. Hermogenes is unable, he says, to "convince myself that there is any principle of correctness in names other than convention and agreement; any name which you give, in my opinion, is the right one."

Plato's juxtaposition of the two attitudes to language had a rich afterlife. I cannot go into the many problems raised by the *Cratylus* and its commentators throughout the ages. I should only like to comment briefly on two issues. One is that generations of students and commentators learned from Plato's *Cratylus* that a "name," given to whatever it may be that it designates, is altogether detached from the speaker's, or listener's, individual nature or memories. These personal experiences in no way determine what a name means. What we nowadays call the speaker's "personal contexts," his "psychological" makeup, etc., is sim-

ply not considered. What a word, or a "name," means is determined only by the relationship between the "name" and the thing it describes. A considerable part of the *Cratylus* is made up of etymologies. Most of these are downright mistaken, or outright fantastic,[22] but they teach us an important lesson because they indicate the direction of Plato's thought: the structure of the word reflects the structure and nature of the thing it names. So crucial is this idea that, as has been said,[23] the proper understanding of the *Cratylus,* and of Greek linguistics in general, hinges on properly grasping and appreciating this particular point. For centuries, and even millenia, it was therefore believed that etymology can serve as a category of objective cognition.[24]

The theme of the *Cratylus* is, of course, language, and what the participants in the dialogue talk about are words. But Plato cannot avoid bringing in the problem of images. "And you would further acknowledge that the name is an imitation of the thing?" asks Socrates. "Certainly," echoes Cratylus. Moreover, "primitive nouns may be compared to pictures," Socrates specifically stresses. There can, of course, be good and bad pictures; if you render too many colors and figures, or if you depict too few of them, the picture will be deficient. But "he who renders all gives a perfect picture and image" (431c–d).

Such a good—or, as Socrates puts it, "perfect"—picture will also produce full communication. The spectator will recognize what is depicted, and this is so because, in some way, the picture is "like" the thing it portrays. Socrates does not forget that even in the most perfect likeness there remains a crucial difference between original and icon,[25] but he still believes that the image does show something of what it represents. This is made possible by the resemblance between them. With regard to materials this is obvious. "How could any one ever compose a picture which would be like anything at all," Socrates asks, "if there were not pigments in nature which resembled the things imitated in portraiture, and out of which the picture is composed?" (434a–b). But what is true of materials is also true of shapes and colors. There is an affinity between the picture and the object it represents, even if that affinity is confined to only one aspect of the object, such as shape. Even if the picture does not capture the full amplitude of reality, it produces a real likeness.

Here we cannot undertake a discussion of what these sentences say about Plato's views of images, and how they relate to his theory of art. What is obvious is that the statements he makes about language are, at

least to some degree, applicable to images. Thinkers of later ages, approaching Plato's texts and ideas with great veneration, could not fail to draw conclusions from these statements for their investigations of holy images.

(ii) *Plotinus on Intuitive Knowledge and Resemblance* An important stage in the unfolding of our problem is reached with Neoplatonism. In contemplation, as Plato understood it,[26] a certain affinity to visual experience was always present. But it was mainly in the Neoplatonic tradition that the elements of visual experience came to be considered in a new light, and images were seen as one of the main roads to cognition. Plotinus's work abounds in metaphors of looking and contemplation; he also frequently employs the noun "image." He not only speaks of image in general terms, but also often uses words that designate a work of art, a carved or painted image.

In the treatise on Intelligible Beauty, Plotinus says that

one must not then suppose that the gods or the "exceedingly blessed spectators" in the higher world contemplate propositions *(legoumenon)*, but all the Forms we speak about are beautiful images *(agalmata)* in that world, of the kind someone imagined to exist in the soul of the wise man, images not painted but real. This is the way the ancients said ideas were realities and substances.

Here, then, we have a clear distinction between "mental images," that is, the images dwelling in the soul, and works of art, executed by the worker in tangible materials. (It is interesting to note that it is the mental images, those that are "not painted," that are considered "real.") Plotinus moves easily from one type of image to the other. The profound difference in the mode of existence—an image in the mind and a material object—is of no great significance in this respect. He can shift from one kind to the other because both, the mental and the material, have some common characteristics. They show, or represent, ideas in a particular way.

The wise men of Egypt, I think, also understood this, either by scientific knowledge or innate knowledge, and when they wished to signify something wisely, did not use the form of letters which follow the order of words and propositions and imitate sounds and the enunciations of philosophical statements, but by drawing images [*agalmata*] and inscribing them in their temples, one beautiful image for each particular thing, they manifested the non-discursiveness of the intelligible world.

The Egyptian sages, then, thought in images. Plotinus suggests that thinking in images is the original form of human thinking. Only after humanity thought in images, after we got to know the world by intuition, did we develop discursive thinking and speech. Continuing the passage just quoted, Plotinus says,

Every image is a kind of knowledge and wisdom and is a subject of statements, all together in one, and not discourse and deliberation. But [only] afterwards [others] discovered, starting from it in its concentrated unity, a representation in something else, already unfolded and speaking it discursively and giving the reasons why things are like this.[27]

This passage did not go unnoticed in later ages. Especially in the Renaissance it proved a major source of inspiration.[28] That it should have had such a rich afterlife is not surprising, for here Plotinus addresses a cluster of problems that many generations felt to be mysterious and alluring. Without attempting an interpretation of the Plotinian text, I should like to enumerate, as it were, some of the issues raised in it that are of significance for understanding the problem of divine images. First, Plotinus tells us what intuition is as a form of knowledge. It is knowledge "all together in one." What is to be known, the object of knowledge, is grasped in its totality; and we get to know it directly, without having to rely on another, an intermediary, process. Secondly, he indicates the difference between discursive and intuitive thought. Sequence or simultaneity are the criterion of distinction. Discursive thought brings the parts of an idea consecutively, one after the other, before our mind. Intuitive thought, on the other hand, comprehends its object at once, as we grasp a picture in a single instant.

To properly appreciate Plotinus's attitude to intuition as a form of integrating knowledge we should also keep in mind how easily he shifts from the process of intuition to the image seen by the mind's eye. The dividing line between the act of intuiting and the image intuited is fluid. But even more important in our context is the ease with which he moves from mental images, perceived only in introspection, to images carved and painted in real, tangible materials. This is not to suggest that in other contexts Plotinus would not distinguish between intuition and the image perceived in one's soul, or between the mental image and the icon produced by the artist. I should only like to stress that, in the context pertinent to our question, Plotinus's tendency to fuse the different com-

ponents (the act of intuition, the mental image, and the material icon) is prevalent, and tinges his views on the subject as a whole.

So far we have referred to Plotinus's views on the image in general, but we have not touched the specific question of the images of the gods. Divine images, in fact, did not attract much of his attention, perhaps because the images of the gods were not conceived as a definite, well-defined category. However, he occasionally mentions them, and his comment, brief as it is, provides an important clue to what he thought of our problem. In a short section of the first essay on the Problems of the Soul he puts forward, concisely formulated, his views on divine images. He begins by answering a question that, as we know,[29] had hardly been asked; it is the question, why do people at all make and erect images of the gods? The reason is human nature: humanity feels a need, a craving, to be close to the god. The divine image is a means to achieving this end; it makes it possible for us, or so we believe, to secure the presence of the gods in our own world. The ancients well understood the force of this desire. "And I think," says Plotinus, "that the wise men of old . . . made temples and statues in the wish that the gods should be present to them."[30] He here continues a thought that we have already encountered in Philo.

How can one make sure that the god will indeed be present in the image? What can we do to make the god inhabit the statue we have made for it? Nobody erecting a divine image can escape this question. Plotinus's answer is, one has to shape an object "sympathetic" to the gods. Let us first listen to his own formulation. The sages of old who erected the statues of the gods, he says, continuing the sentence just quoted, were "looking to the nature of the All, [and they] had in mind that the nature of the soul is everywhere easy to attract, but that if someone were to construct something sympathetic to it and able to receive part of it, it would of all things receive soul most easily."

"Sympathy" was a well-known concept in the ancient world, and it was applied in many fields of investigation.[31] It was particularly the Stoics, conceiving the cosmos as an organism whose parts have a community of experience (*sympatheia*), who were prone to adopt this concept. At the very last fringe of Antiquity, in the first half of the sixth century a.d., Philoponus compared the cosmic force of "sympathy" to the forces that keep a rope together by the intertwining of the threads of which it consists.[32] Now, ancient, especially Stoic, cosmology should, of

course, not be confounded with certain esoteric, occult doctrines of more or less magic sympathies, but the notion that "sympathy" binds the world together made it easier for many educated readers and writers to accept the beliefs of occult groups as well. The maker of a divine image faces the particular question that Plotinus attempts to answer in the section here discussed. It is, how do we make the god choose a specific object, his statue that we have prepared?

Plotinus's solution, at least in its broad outlines, follows from the doctrine of sympathy. The cosmos is one "sympathetic total," as he says.[33] Within that totality, the theory of sympathy assumes that like attracts like. A full identity of one being with another is unattainable, and thus similarity becomes the foundation of attraction. Everything is interrelated, but influence can also be detrimental; one thing can hurt, and even destroy, the other. Individual beings interact not (only) by reason of their being in contact, but because of their similarity (*homoiotes*). "Where there is similarity between a thing affected and the thing affecting it, the affection is not alien."[34]

This general truth also holds true for the image:

That which is sympathetic to it [the World Soul] is what imitates it in some way, like a mirror able to catch [the reflection of] a form. Yes, the nature of the All, too, made all things skilfully in imitation of the [intelligible] realities of which it had the rational principle, and when each thing in this way had become a rational principle in matter, shaped according to this which is before matter, it linked it with that god in conformity with whom it came into being and to whom the soul looked and whom it had in its making.[35]

The view suggested by Plotinus can be put in simple words: the statue of the god is suited to attract, and make the god dwell in it, because it resembles the god.

Plotinus's suggestion that the god's image resembles the god itself marked the limit of what the ambiguity of religious thought could sustain. Further than that a reflective theory could not go; any additional step in the same direction would bring us to a coarse belief in the statue being actually animated. The period after Plotinus saw not only the spread of his general ideas; what his text adumbrates concerning the relationship of the god's image to the god itself was taken up by philosophers, writers, and scientists. Several texts, composed between the third and the fifth centuries a.d., testify both to the diffusion of beliefs in the resemblance of the god's image and the god, and to the variations of

which these ideas were capable. Both the diffusion of the beliefs and their variations shaped the intellectual background of the great debates concerning the sacred image that took place in the Christian world.

(iii) *Porphyry* Plotinus, we have just seen, did not concentrate on man-made images of the gods. Porphyry, his disciple and biographer, did. No scholar has ever claimed that what Porphyry has to say about divine images constitutes a novel departure in philosophical thought, but few will deny that his comments are a significant document of an intellectual development, and bear ample testimony to beliefs that were widely current. Though he is best known for his preaching of Neoplatonic doctrine, it should be noted that, in his wide erudition, he was familiar with the different schools of thought of his time. Of contemporary religious practices he had personal knowledge,[36] and he approached them in a spirit somewhat similar to that of a modern scholar: he edited the texts of Oracular utterances, and stressed that he did not interfere with the traditional versions.[37] In his youth, before he came into the orbit of Plotinus, Porphyry composed a treatise *On Images*. This juvenile work was lost, but a new version has been reconstructed by J. Bidez from lengthy quotations, incorporated in Eusebius's *Preparatio Evangelica*.[38]

Under the influence of Plotinian teaching, as modern scholars seem to agree, Porphyry's views concerning the gods became more spiritual than they had originally been. But the ambiguity as to whether we can see the gods—and, by implication, represent them truthfully—did not altogether dissolve even in his mature thought. None other than Augustine, who devoted several chapters to Porphyry in his great work *The City of God*, clearly saw his ambiguous position.[39] The older Porphyry preached an introverted, spiritual piety, and this led him to reject, or at least doubt the "truth" of, divine statues. The way to God, he says in the *Letter to Marcella*, written in his old age, leads inwards into man's soul; the cult of statues, he here specifically remarks, is devoid of religious significance.[40] In another of his late compositions, the *Letter to the Egyptian Priest Anebo*, he argues against popular beliefs, and against the crude and superstitious practices current among the people around him; the true concept of God is the one that dwells within the human soul.[41] Yet even the old Porphyry did not conceive of the gods as totally beyond reach, as altogether transcendent, invisible beings. He combines the view

of the universe as a hierarchic ladder, a view common in his world, with the specific aspect of visibility, and can thus ask which of the gods are visible and which remain invisible, and what the two groups may have in common.

On Images conveys something of the atmosphere of the intense strife going on among the great religious movements of that world. The modern student of what remains of Porphyry's juvenile work feels that the problem of sacred images was then a topical issue. The treatise has been described as an apology of polytheism.[42] Porphyry accepts, as a matter of course, the belief that the gods may appear to our eyes, and he naturally concludes that therefore they can also be represented in images.[43] What he means by "image," it is true, is rather broad, and thus necessarily lacks precision. But he also raises some specific points. It is of particular interest that, in defending the rituals performed in front of divine images, he mentions representations of sacred beasts used as images of the divine.[44]

As a rule, however, Porphyry's text illustrates rather the general ambiguity of the beliefs in divine images than their specific forms. As I have just noted, his treatise echoes some of the well-known debates on religious matters that fascinated the intellectual world at the end of the third century. A central issue in these debates was the confrontation of polytheism with the other great religions. In other words, Porphyry also had to argue with the beliefs in an invisible god. (Porphyry's symbolic interpretation of visible nature as a revelation of the gods also indicates, I believe, his attitude to another great subject of the time, the problem of whether God or the gods are altogether beyond our perception, and therefore also invisible. If visible nature is a revelation of the god, then the god itself is not altogether transcendent.)

The other controversy that cast its shadow over Porphyry's time and is, I think, reflected in his treatise *On Images* as well as in his other writings, is not the struggle between the great religions, but the debate with the atheistic skeptics. A central argument of the rationalists and skeptics, as we remember,[45] was to point out the striking dissonance between the idol as a material object, and the god who is a spiritual being, or idea. Only fools, the skeptics kept saying, can confound the two, or can perceive the material object as the image of a spiritual idea. In their foolishness, or "ignorance" as it was frequently put, they attribute the nature of a nonmaterial being to a mere piece of matter.

Porphyry reverses the argument, and what he says is of interest to students of art in all ages. It is the learned and enlightened skeptics, he says, who are in fact totally ignorant. Their ignorance consists precisely in the conviction that the statue, the carved or painted image, is nothing but a piece of matter. In the same vein, Porphyry continues, people who are not able read might claim that a written text, a letter or a book, is nothing but a network of woven threads of papyrus. Were we to put Porphyry's thought in modern words we would have to say that the skeptics disregard the spiritual dimension of the image, and in so doing they ignore one of its essential aspects.

Porphyry, one should note, is perhaps the first thinker who thus explicitly acknowledged a spiritual dimension of the material work of art. In that dimension he saw an essential part of the image as such.

In his famous work *Against the Christians* Porphyry formulates his views concerning the ambivalent nature of the image, of its being at home in two worlds. He is trying to defend the icon against two opposite claims.

Those rendering proper worship to the gods do not believe the god to be in the wood or stone or bronze from which the image is built . . . ; for the statues and the temples were built by the ancients as reminders so that those who went there might be at leisure and be purer hereafter and might come to think of the god; or that they might approach it and offer prayers and supplications each asking for him what he needs. For even if someone makes a portrait of a friend, he does not believe the friend himself to be in it nor that the limbs of his body are confined within the parts of the painting, but that the respect for the friend is shown through the portrait.[46]

Two ideas are here indicated, one of them manifest, the other more implied. First, it is obvious that the image of the god is not to be taken as an embodiment of the god. There is a symbolic dimension to the image, however one may choose to define these terms. The other idea, implied rather than explicit, is that a certain similarity exists between the image and the figure it depicts. To be sure, the limbs of the friend's body are not confined in the parts of the painting portraying the friend, but one cannot escape the conclusion that the painting, in some way, repeats the shapes of those limbs. To put it in simple words, the painting resembles the real friend. In referring from the example, the friend's portrait, to the god's icon, one cannot help saying that the god's image

resembles the god. Resemblance is brought in by the back door, as it were.

Resemblance is perhaps indicated, though not clearly articulated, in still another way. As we have just seen, Porphyry compares a statue, or a painting, with a written text;[47] both are material objects, but both have a "meaning." It is implied that images, like written texts, must be interpreted, or "read," as we say. But should they be read in the same way? Letters, in proper combination, convey a meaning, but they do not *resemble* the meaning they convey. The references to the icons portraying the gods, however vague and ill defined these concepts are, suggest that the approach to them must, in some way, be different. To use modern terms, letters are signs, but they are not icons, of ideas.

Neither in *On Images*, at least in what has come down to us from this work, nor in his later writings does Porphyry take up this problem. There is only one additional clue that might suggest—however vaguely —his concern with an iconic quality of the images of the gods. In *On Images* he also deals with the names of the gods. It is in keeping with the tacit assumption of a resemblance of the religious icon to the god that he believes the etymology of the names might disclose the mysteries of the gods' nature. Etymology, as we remember,[48] was believed to show that names have an affinity of nature to what they denote because they are images of what they mean. To use the modern term just mentioned, names have a certain "iconic" quality. It is characteristic that when Porphyry, later in life, turned to a spiritual conception of God, he also explicitly rejected any "link of sympathy" between the god and its name. Calling an individual god by a specific name, he says in the *Letter to Anebo*, is merely a matter of convention.[49] But when he wrote *On Images* he still believed in the ability of the etymological exegesis of a name to reveal the essence of what it names. Etymology can reveal the nature of things named because the name is "an image" of that thing. The attitude to language, seeing the word as emerging "by nature" or established "by convention," is thus, though indirectly and vaguely, an indication of whether or not you accept the possibility of the god's man-made image resembling the god itself.

The vagueness and ambiguity that are so characteristic of Porphyry's views on our subject are only partly explained by the fragmentary state in which most of his writings have reached us. The student of history

cannot help concluding that it was precisely such ambiguity, an attitude that left crucial issues unexplicated, that best suited the conceptual needs prevailing in that late stage of antique culture. The Neoplatonic tradition, more than any other school, continued the reflection on sacred images, and did so in the spirit of ambiguity. It was precisely this tradition that laid the foundations of later notions of similarity, including some that are still alive in our world.

(iv) *Iamblichus* The tradition of reflections on, and half-mystical concern with, the names and images of the gods was continued by Iamblichus, Porphyry's pupil, who was prominent in pagan thought of the early fourth century. In his time, and for generations to come, he was admired as a sage, a philosopher (equal to Aristotle and Plato, if we are to trust Julian the Apostate),[50] and a teacher. Some even saw him as a saint, and believed that he performed miracles.[51] Modern scholarship has sometimes used harsh words in judging Iamblichus's thought,[52] but all students agree that his erudition was wide, and that he was thoroughly acquainted with the religious beliefs and practices of his age. His works, whatever we may think of their philosophical or scientific merits, are thus an important source for our studies of late pagan views of the gods and their images. Most of his writings are lost, among them also a treatise on images. Only fragments of a refutation of what was said in this lost work by Iamblichus have been preserved in a later encyclopedic work.[53] But even in the few texts that have survived, such as the *Life of Pythagoras* and *Mysteries of Egypt*, we can see how much he was concerned with the names and images of the gods.

Two issues in Iamblichus's texts are of significance for our problem. First is his attitude to the argument, so often discussed, that the images of the gods are material objects. Now, in the early fourth century a.d., especially in Iamblichus's world, the attitude to matter was different from what it had been among the educated sceptics of earlier centuries. Far from seeing matter as the embodiment of evil, Iamblichus conceived of it as a creation of the great god.[54] In enthusiastic phrases he therefore praised the use of different materials in building temples and in shaping the images of the gods.[55] That the images of the gods are material objects does, then, not detract from their validity and power. Images of the gods carved by ordinary mortal workers in regular materials, he believes, can be filled with divine power, and perform miracles. Moreover, matter is

not alien to the gods themselves. In some of the gods themselves he discovers a material nature. Iamblichus's complex system of gods (which is not free from internal contradictions) essentially consists of immaterial and of material gods.[56] Carving their images in materials, therefore, does not contradict their character.

The other aspect of his thought that is pertinent to our purpose is what he says about the well-known topic of the names and images of the gods, and how they relate to each other. In *Mysteries of Egypt* the reader learns that what the images and names of the gods have in common is their "symbolic resemblance" to the gods themselves.[57] One may, of course, wonder what precisely "symbolic resemblance" means here. Iamblichus himself, it seems, was not certain. He did not claim to have any direct knowledge of it; we have to "presuppose" it, he says. He did not define resemblance, yet it is likely that what he understood by resemblance had some affinity to what can be experienced visually. With the help of divine names we can perceive in our souls the comprehensive mystical and secret image of the gods.[58]

Statements such as this show how deeply ambiguity had permeated Iamblichus's thought. Yet his ambiguities should not be understood as literary metaphors only; within his ambiguous thinking there always remains the belief in a real link between the image and the god. When Porphyry, Iamblichus's teacher, turned late in life to a spiritual view of God, and considered the link between the god and its image as established "by convention" only, his pupil did not follow him. Opposing his teacher's views, Iamblichus proposed a doctrine of the icon as a "likeness" or a "reflection" of the god. The name of the god is its icon, he says. This statement, if not understood as a mere metaphor, may sound odd, but at least the general direction of Iamblichus's thought becomes more intelligible when he suggests that the name does not merely refer to the god from the outside, as it were; the god is not totally beyond its name. On the contrary, both the name and the icon of the god are united —in an "ineffable way," as Iamblichus says—with the god itself. The god's image, as Iamblichus puts it, is full of divine participation. It is this participation that endows the image with almost the same power as has the god itself.[59] This does not depend on some supernatural origin of the statue. The images of the gods have such miraculous power, he expressly states, whether they are descended from heaven (something he did not doubt) or "made by hands."

(v) *Proclus* Antique reflections on similarity reached a climax, and in a certain sense also came to an end, in the work of Proclus, the last great representative of pagan Neoplatonism. Proclus preserved, and tried to cast into a unified system, the stored wisdom of the ancient world,[60] and here we should also look for the main reason for his influence on later periods. His thought represents, as E. R. Dodds put it, "the result of a speculative movement extending over some five centuries."[61]

Proclus's work was of truly encyclopedic nature and dimensions. But he tried to illuminate the great variety of topics by one central idea. So far as we know, he did not compose a special treatise on sacred images, but the subject was not far from his mind, and he held articulate views on it. The major sources from which we can learn his opinions are his commentaries to Plato's *Cratylus*[62] and *Parmenides*[63] and his systematic treatise, *The Elements of Theology*.[64]

Similarity, in a broad and general sense, plays a significant part in his thought. He saw the world as an all-embracing, unified system in which everything is interrelated, and no single thing can be isolated. If something were not related to something else, it would exist all by itself, without influencing and being influenced; such a thing could not be known. Thus, Proclus says, the gods of Epicurus existed all for themselves, and therefore they were not known at all.[65] To be known presupposes a relation to the knower. It is relationships that hold the world together, and make it *one* world.

Proclus is not content with the abstract notion of relationship. Looking for a law that governs the whole of his universe, he finds it in the cycle of procession and reversion. Similarity, likeness (or unlikeness), is the force that moves the process of existence. In his language,

For if the producing cause brings into existence like things before unlike, it is likeness *(homoyotes)* which generates the product out of the producer: for like things are made like by likeness, and not by unlikeness. The procession accordingly, since in declension it preserves an identity betwixt engenderer and engendered, and manifests by derivation in the consequent that character which the other has primitively, owes to likeness its substantive existence.[66]

The chain of beings is also a chain of similarities. Since Proclus takes continuity in the divine procession as a matter of course, he also takes it for granted that the secondary rank is closely related to the source. What

relates them is likeness: "Now conjunction is effected through likeness. Therefore there will be likeness between the initial principles of the lower order and the last members of the higher." [67]

As creation follows similarity, so does "reversion," the returning of every single creature and object to its source, or the desire of returning.

For that which reverts endeavors to be conjoined in every part with every part of its cause, and desires to have communion in it and to be bound to it. But all things are bound together by likeness, as by unlikeness they are distinguished and severed. If, then, reversion is a communion and conjunction, and all communion and conjunction is through likeness, it follows that all reversion must be accomplished through likeness. [68]

In sum, then, as everything is related to its source by means of the resemblance, so reversion is the process of regaining the resemblance that has been diminished, or partly lost. Resemblance remains the universal principle.

Given this world view, it is not surprising that Proclus is so much concerned with similarity. But it is precisely because similarity is applied to everything that it is less clearly defined than one might think at a first glance. Proclus attempts to outline what similarity actually is, and what are its major variations. He discerns several types of similarity, and he also tries, though to a lesser degree, to say what resemblance in general is. The two main types of resemblance that he distinguishes are, on the one hand, the similarity between the superior and the inferior, and, on the other, the similarity between two equals. The first type, [69] clearly showing the impact of the hierarchic world view, is the model of causal relationships, that is of the process in which everything is created; the second type is the model for nonhierarchic affinities.

These types, however, do not say what similarity actually is. In the *Commentary to Parmenides* Proclus attempts to explain similarity by discerning three distinct aspects of it: he calls them "union," "identity," and "similarity" proper. [70] This distinction of types shows that he considered similarity in the general context of identity and otherness. Similarity is partial identity, as it is partial otherness. A full analysis of similarity in general, as Proclus saw it, would go beyond the scope of the present study. I shall only make a brief comment on one aspect.

How is it possible for the cause, Proclus asks, to bring forth the effect, that is, to create something new that, though different from its origin, is nevertheless intimately linked with it? His answer is—through similar-

ity. "All procession," we read in *Elements of Theology*, "is accomplished through a likeness of the secondary to the primary."[71] It is likeness, he goes on to explain, that generates the product out of the producer. A modern student of Proclus, Beierwaltes, correctly stressed that here similarity acquires a kind of existence of its own; it is not only *in* the cause and in the effect; it also exists *between* them.[72]

The exalted position of similarity, making it a governing principle of the universal procession, in a sense also limits its usefulness for our particular subject. Proclus's doctrines concerning likeness, applied as they are to the whole universe, seem far removed from our specific topos, the divine image "made by hands." To be sure, one cannot doubt that his ideas were a major factor in shaping the cultural orientation in which, two centuries later, the validity, or the "truth" of the icon, to use a term that was so important in the Iconoclastic Debate, became a topical issue. His emphasis on the continuity that holds the world together also suggested a continuity that bridges the gap between ideas and matter. Spiritual "models," it followed from his teaching, can be reflected in the "copies" made in visible and tangible materials. He was himself concerned with this limited question, and he used traditional analogies to explain how ideas can act upon matter.[73] He thus spoke of ideas impressing themselves upon matter like seals on wax, and of matter behaving like a mirror reflecting ideas.

In spite of these analogies, however, similarity, as Proclus understood it, lost its immediate applicability to the product of the artist's labor. The philosophical difficulties here involved need not concern us. What is crucial in our context is that the outlines of what is meant by likeness begin to fade. Could an eighth-century Christian teacher, educated in Hellenistic traditions and familiar with Proclus's thought, employ this notion of "likeness" in order to defend the image of Christ painted on a piece of board and exhibited in the church? One doubts it. In a sense the internal development of the concept of resemblance came to an end with Proclus. There is no denying that the Iconoclastic Debate, especially the arguments put forward by the defenders of icons, would be unthinkable without Proclus's heritage, and what he represents. On the other hand, however, it is equally clear that in some specific sense, the Christian apologist of the sacred image had to begin anew.

NOTES

1. *Institutio oratorica* VIII, 6, 14–15.
2. Cicero, *De oratore* III, 41, 166. I use the English translation in the Loeb Classical Library. See Cicero, *De oratore*, II (London and Cambridge, Mass., 1948), p. 131.
3. See *The Works of Philo Judaeus*, IV, translated by C. D. Yonge (London, 1855), pp. 1 ff. The sentence quoted may be found on p. 2. See also Harry Wolfson, *Philo: Foundations of Philosophy in Judaism, Christianity, and Islam*, I (Cambridge, Mass., 1947), pp. 300 ff., on Philo's views of animal worship in Egyptian religion. The literature on allegory in general is, of course, so vast and complex that a survey would require a separate volume. Of particular value for our purpose is Jean Pepin, *Mythe et allégorie: Les origines Grecques et les contestations Judéo-Chretiennes* (Paris, 1958). Indications of attitudes to Philonic concepts in modern literary theory may be found in Joel Fineman, "The Structure of Allegorical Desire," in Stephen Greenblatt, ed., *Allegory and Representation* (Baltimore and London, 1981), pp. 26–60.
4. In the same essay on the *Contemplative Life*. See *The Works* IV, p. 3. See also the essay *On the Posterity of Cain* (*Works* I, p. 287) about "the godlessness of the Egyptians" in this context.
5. See *The Works* I, p. 475.
6. *On the Posterity of Cain* (*Works* I, p. 289). Among the essential qualities that make Moses the unique figure he is is the intensity of his desire to see God. In Philo's work on Moses one finds many expressions of this view. God also gives to Moses "visible signs." See, e.g., *Moses* I, 14; I, 29; *Works* III, pp. 17 ff., 51 ff. It is also worth mentioning that, in his view, "the therapeutic sect of mankind . . . may well aim at obtaining a sight of the living God, and may pass by the sun." See *Contemplative Life*, 2; *Works* IV, pp. 3 ff.
7. Here one should perhaps also mention the significance Philo grants to sight in general. See, for instance, what he says about the power of the sense of sight in his *On Abraham*, 31; *Works* II, pp. 80 ff. In a single moment the eye reaches "from earth to heaven."
8. *On Monarchy* I. See *Works* III, p. 181.
9. *On Monarchy* I. See *Works* III, p. 180.
10. *On Monarchy* I. See *Works* III, p. 182.
11. See Philo's *On the Creation of the World* XVII, and the English version in *Works* I, p. 14.
12. *On the Creation of the World* XVIII; *Works* I, p. 15.
13. See M. Pohlenz, "*To prepon*: Ein Beitrag zur Geschichte des griechischen Geistes," now reprinted in M. Pohlenz, *Kleine Schriften*, I (Hildesheim, 1965), pp. 100–39.

14. See Werner Jaeger's work, *Die Theologie der frühen griechischen Denker*, frequently mentioned in notes above. Another work by Werner Jaeger, *Early Christianity and Greek Paideia* (Cambridge, Mass., 1961), investigates another aspect of this problem. See also Karl Deichgräber, *Der listensinnende Gott: Vier Themen des griechischen Denkens* (Göttingen, 1952). A survey of this subject in Greek thought, with particular emphasis on Plutarch and Philo, is given by Oskar Dreyer, *Untersuchungen zum Begriff des Gottgeziemenden in der Antike*, XXIV (Spudasmata; Hildesheim and New York, 1970).

15. See the sources analyzed by Pohlenz in the article referred to in note 13.

16. See the materials collected by Dreyer, *Begriff des Gottgeziemenden*, pp. 124 ff.

17. Dreyer, pp. 133 f.

18. Quintilian, *Institutio oratorica* XII, translated by J. Watson, 10, 7–9.

19. *De Historia conscribenda*, 27; and see J. J. Pollitt, *The Ancient Views of Greek Art: Criticism, History, and Terminology* (New Haven and London, 1974), pp. 172 f.

20. Nelson Goodman's discussions of similarity are among the recent investigations of this subject that have a more or less direct bearing upon our specific theme. See especially his *Languages of Art: An Approach to a Theory of Symbols* (Indianapolis and Cambridge, 1976).

21. I use the English translation by Benjamin Jowett, edited by R. M. Hare and D. A. Russell.

22. For a brief but useful survey of Plato's fantastic etymologies, see Alvar Ellegard's entry, "Study of Language," in P. Wiener, ed., *Dictionary of the History of Ideas: Studies of Selected Pivotal Ideas*, II (New York, 1973), pp. 659–73, esp. p. 662.

23. See the still important work by H. Steinthal, *Geschichte der Sprachwissenschaft bei den Griechen und Römern mit besonderer Rücksicht auf die Logik* (Berlin, 1863), p. 86.

24. See the interesting excursus, "Etymology as a Category of Thought," in Ernst Robert Curtius, *European Literature and the Latin Middle Ages*, translated by W. Trask (New York and Evanston, Ill., 1953), pp. 495–500.

25. In fact, Plato stresses the gap that will always remain. If a god were to depict Cratylus's "color and form, as painters do," but also flexibility and warmth, motion, life, and intellect, "would there be in such an event Cratylus and an image of Cratylus, or two Cratyluses?" (432b–c). See Goran Sörbom, *Mimesis and Art: Studies in the Origin and Early Development of an Aesthetic Vocabulary* (Bonniers, Sweden, 1966), pp. 109 ff.

26. I am aware of the philosophical discussions of these subjects in Plato's thought, but I cannot take up the matter here. An interesting, though perhaps one-sided, presentation of Plato's thought on the subject may be found in A. J. Festugière, *Contemplation et vie contemplative selon Platon* (2nd ed., Paris, 1950).

27. See Plotinus, *The Enneads* V, 8, 5, 19; V, 8, 6, 11. Here I have used the translation in the Loeb Classical Library. See Plotinus, V, with an English translation by A. H. Armstrong (Cambridge, Mass., and London, 1984), pp. 255–57.

28. Best known is Ficino's rendering. See Ficino, *In Plotinum* V, viii (see *Opera*, II [Basel, 1561], p. 1768). See also André Chastel, *Marsile Ficin et l'art* (Geneve-Lille, 1954), pp. 72, 77. And see also Edgar Wind, *Pagan Mysteries in the Renaissance* (New Haven, Conn., 1958), pp. 169 ff.

29. See above, the introduction to the book.

30. *Enneads* IV, 3, 11, 1–14; see Plotinus IV, p. 71.

31. From the modern scholarly literature I shall only mention Karl Reinhardt, *Kosmos und Sympathie: Neue Untersuchungen über Poseidonius* (Munich, 1926), passim, esp. pp. 111 ff.

32. See S. Sambursky, *Das physikalische Weltbild der Antike* (Zurich and Stuttgart, 1965), p. 502.

33. *Enneads* IV, 4, 32. "This One-All, therefore, is a sympathetic total and stands as one living being."

34. Ibid.

35. Ibid. See also *Enneads* IV, 3, 3; and IV, 3, 10, 11, 18.

36. For Porphyry's experience with oracles, see Hans Lewy, *Chaldean Oracles and Theurgy: Mysticism, Magic, and Platonism in the Later Roman Empire* (Cairo, 1956), pp. 7 ff.

37. A good survey of this aspect of Porphyry's work and character may be found in the still valuable work by Johannes Geffcken, *Der Ausgang des Griechisch-Römischen Heidentums* (Heidelberg, 1920), pp. 56–77.

38. See J. Bidez, *Vie de Porphyre* (Gand and Leipzig, 1913); the reconstructed text is printed in the appendix. For this early treatise, see Fr. Bortzler, *Porphyrius' Schrift von den Götterbildern* (Erlangen, 1903). And see also Vittorio Fazzo, *La giustificazione delle imagini religiose della tarda Antichità al Cristianesimo, I, La Tarda Antichità* (Naples, 1977), pp. 181 ff. For Porphyry's philosophy in general Eduard Zeller, *Die Philosophie der Griechen in ihrer geschichtlichen Entwicklung*, 3. Teil, 2. Abteilung, 2. Hälfte (2nd ed., Leipzig, 1868), pp. 568–611, is still essential.

39. Actually the whole of Book Ten of the *City of God* is devoted to a discussion of Porphyry's teaching. For our purpose chapters 9 and 11 of this book are of particular importance.

40. *Letter to Marcella*, chapter 17.

41. See esp. Zeller, *Philosophie der Griechen*, 3. Teil, 2. Abteilung, 2. Halfte, pp. 600 ff.

42. See Bidez, *Vie de Porphyre*, 21 ff.

43. It should be noted that, so far as we can judge on the basis of the fragments preserved, Porphyry did not make the question of whether or not the gods can be represented—the subject of a systematic investigation. The fragments are not sufficient to let us form a detailed opinion of the treatise's original

form, but we can say that our question—can the gods be represented?—was not at the center of his speculations.

44. See Bidez, pp. 1 ff. of the appendix, with Porphyry's text.

45. See above, chapter 3.

46. I follow the translation by Paul J. Alexander, *The Patriarch Nicephorus of Constantinople: Ecclesiastical Policy and Image Worship in the Byzantine Empire* (Oxford, 1958), p. 27. The classic discussion is A. von Harnack, *Porphyrius: Gegen die Christen* (Abhandlungen der Kgl. Preussischen Akademie der Wissenschaften, Phil.-hist. Klasse; Berlin, 1916).

47. See above, the section discussing Porphry.

48. See above, the section on Plato's *Cratylus* in the present chapter.

49. *Letter to Anebo* 1, 20. See *Lettera ad Anebo,* a cura di Giuseppe Faggin (Florence, 1954), pp. 4, 12 ff.

50. See Julian's Seventh Oration, "To the Cynic Heracleitos," 217 B, C. And see *The Works of the Emperor Julian*, II, with an English translation by W. C. Wright (Loeb Classical Library; London and Cambridge, Mass., 1949), p. 105.

51. See Eunapius, *Lives of the Philosophers and Sophists*, 458 ff. I use *Philostratus and Eunapius: The Lives of the Sophists*, with an English translation by W. C. Wright (Loeb Classical Library; London and Cambridge, Mass., 1968), esp. pp. 363 ff., 369 ff.

52. See mainly Johannes Geffcken, *Der Ausgang des griechisch-römischen Heidentums* (Heidelberg, 1920), pp. 103 ff. See also Zeller, *Philosophie der Griechen*, pp. 611–46.

53. See Fazzo, *La giustificazione*, p. 237.

54. Iamblichus, attracted to neo-Pythagorean traditions, not only was concerned with the symbolism of geometrical forms, but also wrote a treatise on chemistry.

55. *De mysteriis Aegyptiorum* V, 23.

56. *De mysteriis Aegyptiorum* V, 14.

57. *De mysteriis Aegyptiorum* VII, 4. I am using the French edition, *Jamblique: Les Mystères d'Egypte* (Collection Guillaume Bude; Paris, 1966), see esp. pp. 191–92.

58. *De mysteriis Aegyptiorum* VII, 4; p. 255 of the French edition.

59. *De mysteriis Aegyptiorum,* p. 258 f. The historian may find it interesting that this statement is made in a discussion of the practices of the Egyptian priests.

60. On Proclus, see mainly L. J. Rosan, *The Philosophy of Proclus: The Final Phase of Ancient Thought* (New York, 1949); and W. Beierwaltes, *Proklos: Grundzüge seiner Metaphysik* (Frankfort, 1965).

61. See E. R. Dodds's introduction to *Proclus: The Elements of Theology,* translated by Dodds (2nd ed., Oxford, 1963), p. xviii.

62. *Proclis diadochi in Platonis Cratylum commentaria,* ed. G. Pasquali (Leipzig, 1908).

63. *Procli Diadochi Commentarium in Platonis Parmenidem.* The original edition was translated into French by A. Ed. Chaignet and published in three volumes; see *Proclus le philosoph: Commentaire sur le Parmenide* (Paris, 1900–1903; reprinted Frankfurt am Main, 1962).

64. See note 60.

65. See Rosan, *Proclus*, pp. 68 ff. for an interesting discussion of this example.

66. *Elements of Theology*, prop. 29. I use Dodds's translation. See p. 35 of his edition.

67. *Elements of Theology*, prop. 147; pp. 129 ff. of Dodds's translation.

68. *Elements of Theology*, prop. 32; p. 37.

69. For the main discussion in Proclus's commentary to Plato's *Parmenides*, see col. 911. See also Beierwaltes, *Proklos*, pp. 132 ff.

70. See the *Commentary to Parmenides*, cols. 744–45.

71. *Elements of Theology*, prop. 29; p. 35 of Dodds's edition.

72. Beierwaltes, *Proklos*, pp. 155 ff.

73. See his *Commentary to Parmenides*, cols. 839 ff. And see Rosan, *Proclus*, pp. 161 ff.; and Beierwaltes, *Proklos*, pp. 299 f.

The Icon in
Early Christian Thought

Early Christian Apologists

Anyone at all curious about how believers in an invisible god react to the visible images of gods when they are confronted with them will be fascinated by the first attempts of Christianity to come to terms, within a conceptual framework, with the surrounding culture. If considered as mere theory, the literary records of these attempts—normally undertaken to defend the new religion in specific historical conditions—will not be counted among the most important of the documents discussed in this book. The reasoning is not always as strict as a critical reader might wish it to be, and the practical needs and historical constraints are often intractable, forcing the writers to adopt compromises that, when measured by intellectual yardsticks only, may not be satisfactory. But these early attempts have the rare merit of letting us witness directly, as it were, how the great question of the god's image was broached. History itself compelled them to face the problem. Here they were, rejecting the material images of a god they believed to be invisible, and surrounded

by the many images of different gods. Our concern, as I have already said, is less with how in practice they reacted to these images. Modern scholarly literature has dealt extensively with similar questions, and I have no new contribution to offer. What I should like to ask is, what were the reasons that the early Christians gave for the theoretical positions they adopted?

The historian need not be told that ancient Christianity in countless ways absorbed the culture, the taste, and the thought of its time. The new religion continued, sometimes only thinly veiled, the great pagan cultures it inherited. Modern scholarship has taught us, with great intensity and much success, to see this continuity, and thereby has much enriched our view and understanding of the time. Over and above the study of continuities, however, we should not forget the reality and significance of change. At the risk of stating the obvious, I think we should be aware of, and accord proper proportions to, the new ideas, and the ensuing conflicts. These conflicts—one sometimes feels the need to remind onself of this simple fact—were real struggles, in intellectual respects as well as in many others. Everybody knows that this struggle can be observed in innumerable facets; one of them is the attitude to the images of God. In the following pages I intend to outline the first encounter between Christian thinkers, who rejected images of God, with the abundance of such images and the ideologies defending them.

The period between roughly a.d. 140 and 180 saw the composition of the treatises recording the earliest Christian attempts to come to terms with the cultures surrounding the new religion. These are the writings of the so-called early Greek apologists.[1] Reading these early statements, one cannot help noting, sometimes with surprise, how great a significance is granted to the problem of images. Images, the modern student may feel, could not have been an issue of such vital importance in the first centuries of a new religion. And yet they must have been a very disturbing factor indeed to preoccupy people's attention to such a degree. To be sure, the tone and intensity of the discussion varies from one author to the other, and from one occasion to the other, but one can rarely find a theoretical statement of the new religion in those decades that does not include some discussion of "idols."

Aristeidis of Athens, the first Christian apologist whose work has come down to us, wrote around a.d. 140.[2] The transmission of his text to posterity is in itself an extraordinary episode in the history of western

culture; without even touching on this subject, I should only like to remark that most of it was incorporated in *Barlaam and Josaphat,* an eighth-century novel to which we shall return in a later chapter.[3]

Aristeidis raises the problem of idols and idol worship shortly after the opening paragraphs of his *Apology.* Worshipping images is a central criterion for distinguishing between pagans and Christians, as the offering of sacrifices helps to immediately distinguish Jews from Christians. The distinction between Christians and pagans was obviously an important issue in Aristeides' generation, and one is therefore not surprised that he pays careful attention not only to the worshipping of idols, but also to the images of the gods themselves. He distinguishes between the "barbarians'" visualization and represention of their gods, and the Greeks'. Although the gods of both barbarians and Greeks are "false gods," Aristeidis considers their images worthy of minute observation.

Justin Martyr wrote his two *Apologies* about a decade or so after Aristeidis. Justin came from Samaria in Palestine, both a more eastern and a more provincial region than Athens, the home of Aristeides. In these eastern provinces the images of the gods may have been less obtrusive and posed a less pressing difficulty. But Justin was concerned with ritual,[4] and in this context he must have encountered the "question" of images.[5] Justin addressed his *Apologies* to a gentile audience, familiar with pagan idols, and he therefore feels the need to discuss images.[6] The other systematic treatise by Justin Martyr that has come down to us, *The Dialogue with Trypho,*[7] is a debate with a representative of Judaism. In Judaism the image of God plays no part, and here Justin Martyr does not bring up the question of the divine image. The obvious conclusion from all this is that the problem of the gods' images does not follow from Justin's theology; it is forced upon him by the culture surrounding him.

Some two decades later, Justin's disciple Tatian, a Syrian who was formerly a student of rhetorics, addressed himself to the heathen in defense of the Christian religion. Idols are not one of his major themes, but the few observations he makes on the subject are of interest for the historian of culture. His rejection of any allegorical explanation of the gods[8] may suggest that his audience, at least in part, consisted of the educated, who did not take the stories of the gods in a literal sense. This may also be supported by his statement that the erecting of statues to the gods is even more stupid than "the multitude of philosophical sys-

tems."[9] His invective against theater masks is of particular interest to the historian of images.[10]

At about the same time (according to some scholars shortly after a.d. 176), a Christian writer who remains anonymous addressed an epistle to a certain Diognetus, possibly one of the emperor Marcus Aurelius's tutors.[11] The *Epistle to Diognetus* begins with a list of apologetic subjects, among them the "folly of idolatry" as well as the "superstition of the Jews."[12] It is obvious that the anonymous author considers the attitude to divine images as a question of great significance to Christians.

At the same time, around a.d. 180, the last document to be considered here was composed. Athenagoras of Athens wrote, perhaps at Alexandria, the *Appeal on Behalf of the Christians*.[13] Once again we see how the attitude towards the images of the gods becomes the criterion for distinguishing between pagans and Christians. But Athenagoras, being an "Athenian Christian philosopher,"[14] suggests in his extensive discussion of idols some of the metaphysical perspectives of the god's image. He introduces topics of speculation that were destined to become leading themes in medieval and Renaissance thought.

The documents selected here form the core of the literature we are used to calling "early Christian apologies." As we have seen, they were written by authors of different backgrounds, and were addressed, at least in part, to audiences of diverse character. It is remarkable that, in spite of the varying conditions, what these early Christian apologists have to say about the images of the gods is so similar, actually unified.

After this brief presentation of the sources from which we shall try to draw, we shall now turn back to the proper theme of this essay. The student of certain aspects of the Iconoclastic Debates approaches these texts with two questions in mind. The first is, of course, simply, what was the early Christians' attitude to sacred images? More important for the precise subject of the present study is the second question: What were the theoretical reasons that the early apologists gave to explain and support their attitudes? What kind of general doctrine concerning the image of God underlies the varying reasons they propose? Though we are concerned mainly with the second question, we shall also have to make some comments regarding the first one.

The first question is easily answered. All apologetic documents attesting to that first encounter of the Christians with the pagan culture surround-

ing them clearly express a negative attitude to the images of the gods. Though careful reading may reveal some differences of nuance, these are differences in the style of presentation rather than in substance. Not a single one of these Christian documents composed between a.d. 140 and 180 suggests a deviance from the basic attitude of rejection. Whatever may have been the motives and reasons for this uniform rejection, as expressed by the apologists, the attitude is common to all authors, and it cannot be doubted.

The answer is so clear-cut that it would not seem necessary to consider it further, were it not for two phenomena linked with it that make such a unanimous rejection more problematic than would appear at a first glance. The first thing that makes us wonder is provided by history: about two generations after these early apologists, that is, roughly in the middle of the third century, Christian art began to flourish. It was, as one knows, an art that took over forms and symbols from the surrounding pagan art, yet it also shaped new motifs and expressed new, specifically Christian, ideas. Now, how can we understand the growth of such a rich and specific art in view of the total rejection by the theoreticians immediately preceding it?[15] It is, of course, true that early Christian art did not indulge in portraying God, but no student of it need be told that it was religious in character.[16] Now, could such an art have grown, could the imagination that produced it have developed in a religion and culture that uniformly rejected the image of God, and implicitly religious art in general? One cannot help wondering whether the rejection of icons in early Christianity was indeed as general and consistent as the apologists declare. Whatever the answer (and it is not for us in the present context to analyze this seeming contradiction), we can be certain that in the *theoretical* attitude, as articulated in the writings of the early apologists, the rejection of divine images is complete.

Another reason for a certain perplexity is of a different nature; it is perhaps tenuous, but it should be considered, as it may help us define more precisely the original Christian approach to divine images. As a rule, apologists, as Robert Grant rightly notes, are not advocates of confrontation or revolution.[17] They will tend to interpret their own message in terms of a general consensus, and naturally they will confront that consensus only in matters that appear to them essential. Seen in this light, their concentration on the images of the gods shows that they considered this question as one of crucial significance.

The emergence of Christian art as well as the desire, however uneasy, to remain within a general consensus may cast some doubts on the rejection of images on the part of Christian communities in the late second century. One asks whether the rejection of images of the gods was really so complete and consistent as it appears today. Yet in reading the texts of the apologists we do not find a single statement that, however interpreted, would oblige us to qualify the conclusion that the Christians of the time rejected sacred images. At least on the level of ideology, to use a modern term, that is, of an attitude taken in full awareness, the Christian apologists altogether condemned such images.

As I have already indicated, our main concern in this section is not so much with the very rejection of divine images—as a historical fact, this rejection is well known—than with the more or less conscious motives given for it in the second century. What are, in fact, the Christian apologists' reasons for rejecting these images? Though they did not present their motives in systematic fashion, it is not difficult to make them out.

The first and most obvious reason for rejecting the images is that the gods they portray, or refer to, are false gods. That the pagan gods are false gods is, of course, one of the dominant themes in the Christian debate with pagan religions. It is stated, in one form or another, on almost every page of the apologists' writings. Christian apologetic literature, in fact, starts with a rather detailed presentation of the pagan gods—this is the major content of Aristeides' *Apology*. As a purely theological theme this is not a subject for the present essay. We are concerned with the assertion that pagan gods are false gods only when this claim in some way involves their images.

The principal form this claim takes is the assertion that both the statues and the gods they portray are demons. This is a common theme in Christian apologetic literature of the second and third centuries. Justin Martyr devotes an important chapter to it. We do not offer sacrifices to the images erected in temples, he says, because we know that these images are "dead, and without souls." What are they, then? The images "bear the names and shapes of those evil demons that appeared to our sight."[18] These views were formulated most succinctly by a Latin author who wrote in the late second or early third century, Minucius Felix:

Now these unclean spirits, the demons, as the magi and philosophers have shown, conceal themselves in statues and consecrated images, and by their spiritual influence acquire the authority of a present divinity.[19]

In the second century the concept of demons was a truism. Virtually everyone believed in the existence of these beings and their function as mediators, whether, as E. R. Dodds put it, "he called them demons or angels or aions or simply 'spirits.' "[20] In the Christian context, the term "demon" assumed a pejorative meaning, bringing it close to "devil." It may be true that speaking of demons is actually a kind of implicit acknowledgment of polytheism;[21] however this may be, demons populate early Christian imagination and doctrine. The statues of pagan gods are either their embodiment or the place they prefer to inhabit.

The link between statues and demons is made possible by the nature of the latter. This follows from the views the authors of the apologies express concerning the demons' nature or essence. Tatian's text is particularly important for this question. Like human beings, so he believes, demons have received a material constitution and a material spirit.[22] In early Christian thought, "matter" or "material" has a pejorative ring; it is equivalent to "darkness." This character of matter is found in demons. Indeed, demons cannot repent; "they are merely mirror images of matter and evil."[23] But their material nature also makes them visible, and therefore capable of being depicted in the visual arts.[24] To be sure, matter can also be thinner, as it were more spiritual. Tatian agrees that demons may have a more spiritual organism; sometimes they are as if made "of smoke and mist." In this form most people will not be able to see them, but to those who are protected by God, demons remain visible even when made of smoke and mist.[25] Even in this more spiritual form, the demons remain in principle capable of being represented.

Athenagoras suggests a different reason why the demons are attracted to the statues of the gods. In front of these statues sacrifices are offered, and the demons who delight in the blood of sacrifices lap it up. One understands, then, why they lure believers to these statues, and make them offer their sacrifices there.[26]

We need not consider here in detail the apologists' descriptions of the images of the pagan gods. What is important in our context is that they reject these images because they depict false gods, or demons, and that the link between the demons and the images is well established. But is

this the only reason for rejecting images of the gods? And is the rejection limited only to the gods of the pagans?

In the writings of the early Christian apologists yet another reason is suggested for rejecting the images of the gods. Though that second reason cannot be completely separated from the one just described, that is, from the claim that the images of the pagan gods are to be rejected because the gods they portray are false gods, it needs separate discussion. The second argument is not concerned with the specific images of pagan gods; rather, it poses the problem of the icon of God in general. Any image of God is false, so the idea of this second reason runs like this: because the god itself is invisible, since the god cannot be seen, any rendering of it in visible form is bound not to be true, and thus to deceive the spectator. Here a theme is announced that was to become crucial in the criticism of images as it emerged in the course of the iconoclastic debate.

The desire for a personal encounter with God, the craving for a direct meeting with the divine, was not unknown in the religious tension that was prevalent in the second century; it was not very far from the minds of the Christian apologists. There is interesting testimony in another composition by Justin Martyr, the *Dialogue with Trypho*. Here the author describes how he sought in vain to learn about God from a Stoic, an Aristotelian, and a Pythagorean, until he finally attended the lecture of a Platonist; the latter gave him the hope of seeing God face to face, "for this," he continues, "is the aim of the philosophy of Plato."[27]

The apologists were also aware of the role the image of the god may play in seeking to attain that desired meeting with God. An anonymous opponent to monotheistic lore, quoted by Athenagoras, declares that there is no other way to get close to the gods, and he quotes a Homeric verse to support his claim.[28]

It is the tragic fate of man, however, that this intense desire to see God face to face remains unfulfilled. Among men, said the anonymous author of the *Letter to Diognetus*, nobody has seen God. There are indeed some few to whom the god has chosen to reveal itself; however, adds the author, to them it revealed itself through faith.[29] In other words, the author turns the directness of visual experience into a mere metaphor. Nobody has ever seen what God looks like, Aristeides says, following some New Testament verses, and nobody is able to see God.[30] The idea of God's being invisible, as well as the thought that the god

selects those to whom it reveals itself, remained topical in Christian thought. Let me here only add one brief quotation from Origen. Human nature, the Church Father says, "is not sufficient in any way to seek God and to find Him in His pure nature, unless it is helped by the God who is object of the search. And He is found by those who, after doing what they can, admit that they need Him, and shows Himself to those to whom He judges it right to appear, so far as it is possible for God to be known to man and for the human soul which is still in the body to know God."[31] That God is invisible, then, remains the underlying idea.

Here one may perhaps add an observation based on speculation rather than on the direct explication of the texts. By making a proper and correct image of the true god, were we able to produce one, and by exhibiting it publicly, we would act against the will of God. As we remember, the god reveals itself to a chosen few, if at all, yet an openly displayed image would make its appearance available to everybody, and would thus act against its will. To be sure, this idea is not explicitly set forth in the writings of the apologists, but it seems to follow from their way of thought.

From what has been said one could perhaps infer that the god remains invisible because of its arbitrary decision. Already in the early stage of the second-century apologists another reason was suggested for rejecting the images of the divine. If we say that human beings are not able to see God, we only outline the limits of our own experience, and say what we can, or cannot, perceive. Is the god's invisibility only a matter of our being unable to perceive it? The apologists seem to have felt the need to derive the rejection of divine images from a more primeval source, and they therefore made a specific statement about God's very nature.

In the nature of the true god itself—this is the gist of their reasoning —there is something that makes it impossible for it to be seen and portrayed. God is without shape. We know, says Justin, that the images shown do not have God's shape.[32] Aristeides puts it most clearly. God has no name and no shape;[33] both name and shape belong to what has been created, not to the creator. Aristeides is still more specific. That God has no shape means to him that God has no "composition of organs" and that God lacks the specificity that goes with shape: the god, he says, is neither male nor female, and nothing can encompass it.[34]

Without offering an explicit definition of form, the apologists enu-merate the elements of shape; in addition to being visible, shape is

something finite, it has a beginning and an end, and it is composed of parts. Implicitly they accept the classical concept of form as a system composed of finite, measurable parts. Whether such a system is given an organic form, the parts being organs, or whether it remains more abstract, it is the internal relationships—the proportions of classical thought—that determine the character of the whole. Yet such a system cannot describe the essence of the divine. Only the passing, the transient, and the created is structured of parts. The divine is beyond structure precisely because it is beyond measurable relations within itself.

Whatever the explanation, the apologists do not follow it up. All these themes appear in their writings as vague suggestions only. What is crucial, and what was transmitted to later generations, was the attempt to derive the rejection of sacred images not only from the portrayed gods being alien, false gods, but also from the unbridgeable gap between God's nature and the character of the image. Most of the essential themes of the critical Christian attitude to the holy image are already found in these early writings.

NOTES

1. See now Robert M. Grant, *Greek Apologists of the Second Century* (Philadelphia, 1988). An old study remains of central importance. See Johannes Geffcken, *Zwei griechische Apologeten* (Leipzig and Berlin, 1907).
2. See Grant, *Greek Apologists*, pp. 36–39. For the time of composition, see Geffcken, *Zwei griechische Apologeten*, pp. 28 ff. A well-balanced and detailed survey is found in Otto Bardenhewer, *Geschichte der altchristlichen Literatur*, I (Freiburg, 1913), pp. 187–202. And see also Edgar Goodspeed, *A History of Early Christian Literature*, revised and enlarged by Robert Grant (Chicago, 1966 [originally 1942]), pp. 97–99. Some students date Aristeides' composition slightly earlier; if it has been presented to the emperor Hadrian, it must have been composed before a.d. 136.
3. See below, chapter 10, the second section.
4. For a general assessment of Justin, see Grant, *Greek Apologists*, pp. 50–73; Geffcken, *Zwei griechische Apologeten*, pp. 97–104; and mainly Otto Bardenhewer, *Geschichte der altchristlichen Literatur*, I (Freiburg, 1913), pp. 206–62. Justin Martyr did, in fact, play an important part in the crystallization of Christian liturgy, as has often been pointed out. See especially his *First Apology*, 61–67. For an assessment, see, e.g., Hans Lietzmann, *Geschichte der alten Kirche*, II (Berlin and Leipzig, 1936), pp. 121 ff., 126 ff.

5. See, e.g., *First Apology,* 9; *Second Apology,* 12; and Bardenhewer, *Geschichte* I, pp. 157 ff.
6. For interesting observations on the possible impact of the pagan audience on the ideas and forms of Christian apologists, see Adolf von Harnack, *Lehrbuch der Dogmengeschichte* (5th ed., Tubingen, 1931).
7. *Justin Martyr: The Dialogue with Trypho,* translated by A. Williams (London, 1930).
8. For Tatian, see Grant, *Greek Apologists,* pp. 112 ff., 124–32; Bardenhewer I, pp. 262–84. For Tatian's rejection of allegorical explanation, see his *Address to the Heathen* XXI, 6.
9. *Address to the Heathen* XXIII, 3–4.
10. *Address to the Heathen* XXII, 1.
11. For the *Epistle to Diognetus,* its writer and addressee, see Grant, *Greek Apologists,* pp. 178–79; Bardenhewer, *Geschichte* I, pp. 316–25; and Goodspeed, *A History of Early Christian Literature,* pp. 105–6.
12. *Epistle to Diognetus,* chapters 2 (against idolatry) and 3 (against the Jews). On the *Epistle* and its author, see, in addition to the authors mentioned, Geffcken, *Zwei griechische Apologeten,* pp. 41 ff., 273 ff.
13. For Athenagoras, see Grant, *Greek Apologists,* pp. 100–11; Bardenhewer, *Geschichte* I, pp. 189–302; and particularly Geffcken's commentary to Athenagoras's text in his *Zwei griechische Apologeten,* pp. 155 ff.
14. This is how he was called in an old manuscript. See Grant, *Greek Apologists,* p. 100. Geffcken, *Geschichte,* pp. 273 ff., stresses Athenagoras's atticism, and adduces many examples of style and metaphor.
15. This question is briefly touched on by Hugo Koch, *Die altchristliche Bilderfrage nach den literarischen Quellen* (Göttingen, 1917), pp. 81 ff. And see also, in general, W. Elliger, *Die Stellung der alten Christen zu den Bildern in den ersten vier Jahrhunderten* (Leipzig, 1930).
16. The question of whether the early Christians approved of a "profane" art, a question occasionally referred to in nineteenth-century literature, need not detain us here. Interesting, as a document of nineteenth-century thought, are the observations by J. C. W. Augusti, *Beiträge zur altchristlichen Kunstgeschichte und Liturgik,* I (Leipzig, 1841), pp. 103 ff.; II (Leipzig, 1846), pp. 81 ff.
17. Grant, *Greek Apologists,* p. 9.
18. Justin Martyr, *Apologies* I, chapter 9. See *The Writings of Justin Martyr and Athenagoras,* translated by M. Dods, G. Reith, and B. P. Pratten (Edinburgh, 1867).
19. *Octavius* XXVII, 1. See *The Octavius of Minucius Felix,* translated by J. H. Freese (London and New York, n. d.), p. 77. The precise date of Minucius Felix, and of the composition of *Octavius,* have not been established, although a great deal of research has been devoted to the subject. See Bardenhewer, *Geschichte* I, pp. 323–49; and Goodspeed, *A History of Early Christian Literature,* pp. 166 ff.

20. E. R. Dodds, *Pagan and Christian in an Age of Anxiety: Some Aspects of Religious Experience from Marcus Aurelius to Constantine* (New York, 1970 [original publication Cambridge, 1965]), p. 38.

21. See Dodds, *Pagan and Christian*, p. 117.

22. Tatian XII, 7.

23. Tatian XV, 10. See *The Writings of Tatian and Theophilus*, translated by B. P. Pratten, M. Dods, and T. Smith (Edinburgh, 1867).

24. In chapters 33–35 of his Oration, Tatian derides Greek sculpture, particularly the representations of the gods. In so doing, he however provides an interesting list of common ritual images. The list has attracted the attention of students of ancient art, and several instructive studies have been devoted to it. See, e.g., Puech, *Recherches sur le Discours aux Grecs de Tatien* (Paris, 1903), pp. 47 ff.

25. Tatian XV, 8. They remain visible because they never strip themselves of a residue of material nature. That demons, particularly bad ones, always remain material beings was commonly believed in late Antiquity. Jamblich claims that "matter" (*hyle*) and "darkness" (also conceived as material in nature) are the elements of bad demons. See Friedrich Cremer, *Die Chaldaischen Orakel und Jamblich De Mysteriis* (Meisenheim am Glan, 1969), pp. 78 ff.

26. Athenagoras, chapter 26. These demons are mythical beings of venerable ancestry: they are the souls of the biblical giants, the sons of the fallen angels and the daughters of man (Genesis 6:2 ff.).

27. Justin, *Dialogue with Trypho*, 2.3–6. See *The Writings of Justin Martyr and Athenagoras*, translated by M. Dods, G. Reith, and B. P. Pratten (Edinburgh, 1867). The Platonic "conception of incorporeals," he here says, "quite overpowered me, and the contemplation of ideas furnished my mind with wings." For some observations on the philosophical implications of Justin's Platonism, cf. Harry A. Wolfson, *The Philosophy of the Church Fathers: Faith, Trinity, Incarnation* (Cambridge, Mass., 1956), pp. 258 ff.

28. Athenagoras, 18. The verse quoted is from *Iliad* XX, 131. And cf. in general J. Geffcken, *Zwei griechische Apologeten*, pp. 196 ff. For an earlier formulation of the idea that the statue is a means of approaching God, see above, the first section of chapter 2.

29. *Letter to Diognetus*, chapter 8.

30. Aristeides XIII, 3. And see John 1:18: "No man hath seen God at any time"; 1 John 4:12, with the same wording; and 1 Timothy 6:16.

31. *Contra Celsum* VII, 42. I use the English translation by Henry Chadwick. See Origen, *Contra Celsum* (Cambridge, 1980 [original edition 1953]), pp. 430 f. Cf. the interesting observations by R. P. Festugière, *La Révélation d'Hermes Trismegiste*, IV, *Le Dieu Inconnu et la Gnose* (Paris, 1954), pp. 119–23. For Origen in our context, see below, chapter 7.

32. Justin, *First Apology*, chapter 9.

33. It is worth noting that here name and shape, or image, are equivalent. See also Justin, *Second Apology*, chapter 6, 3. As we have seen (chapter 4, the section on Plato's *Cratylus*), this idea had an important history in ancient Greek thought.
34. Aristeides 1, 5.

Tertullian

In the spiritual world of early Christianity two approaches emerged, even if only vaguely, to support the rejection of images. One of them can be studied in the writings of Tertullian, the North African Church Father of the early third century. Tertullian, as is generally acknowledged, was the first great author to present the essentials of Christian theology in the Latin tongue. Perhaps more than any other author, he shaped the Latin ecclesiastical language.[1] Some of the basic doctrines of the Church, such as hereditary sinfulness, can be traced to his thought, and the impact it had on the theological speculation of later ages.[2] He was broadly educated in the culture of his time, familiar with Ciceronian texts and Stoic doctrines. No less a witness than Eusebius testifies that Tertullian was "an expert in Roman law and famous on other grounds."[3] He was familiar with many and different institutions of the Roman world.[4] Yet in spite of all the urbanity and sophistication, Tertullian was not a philosophically self-critical, reflective thinker. He did not ask what

might be the shades of a certain term, or how far his partisanship might be coloring his judgment. Tertullian, the church historian Karl Holl suggests, was neither what we would call a "scholar," nor an "itinerant sage."[5] Concreteness is the most distinct quality of his thought and style, and it dominates his whole literary production. He always writes prompted by a specific condition, and he aims to provide an answer to some specific and pressing question. This attitude, pervading all his writings, is also manifest in what he has to say about the arts.

Scholars have attempted to reconstruct Tertullian's intellectual and religious development, and thus also establish the precise dates of his various treatises. As could have been expected, opinions diverge, sometimes on rather crucial questions. It is not for us here to go into these problems. Most students, however, seem to agree that most of the treatises that more or less directly bear on the arts were composed within a comparatively brief period; they all belong to one decade.[6]

That Tertullian wrote these treatises in short succession is not really an indication that at this stage of his career he was concerned with problems of aesthetics; it rather shows that at the time the artistic monuments were a challenge of practical urgency to the Christian community, and our author felt he had to address it. These pertinent treatises are relatively short, and for good reasons they are grouped among what is called Tertullian's "practical" writings. Our author clearly does not aim at clarifying concepts for clarity's sake; he wants to formulate an attitude that will serve as a guideline to believers. It is the practical problems posed by the arts that he has in mind.

It seems to be generally agreed among students of Tertullian that he opened the series of treatises dealing with the arts with his violent invective against the theater, *On Spectacles (De spectaculis)*.[7] Belonging to the cultural elite of Carthage, "the second capital of the Empire," he was familiar with the institution of the theater, and was well aware of the social and psychological impact of the performance on stage or in the circus. Even at this early period, opposition to the theater was not a new subject in Christian literature. One generation before Tertullian composed his treatises the Christian apologist Tatian had attacked the theater.[8] What Tatian attacks is the essential of art, the illusion it creates. Tatian's attacks however are only part, even a minor part, of what he has to say. It was Tertullian who took up the stage performance as a subject in its own right, or as a challenge that had to be met. What he

says about the stage, the *pompa diaboli,* was followed by Christian teachers of many centuries.

At about the same time (the precise sequence is disputed) our author wrote one of his treatises against a heretic. What is important in the present context is that Hermogenes, the heretic attacked, was a painter. *Against Hermogenes (Adversus Hermogenem)*[9] therefore also contains some remarks on the arts. Tertullian draws a portrait of the heretic, and the fact that he is a painter plays a significant part in his heretic physiognomy.

The next pertinent treatise was, in all likelihood, *On the Apparel of Women (De cultu feminarum),*[10] probably based on a sermon preached in two successive parts. It is a sermon against cosmetics, and deals with women's behavior. In fact, however, it is directed against the moral and theological implications of destroying, or transfiguring, God's image, the human being. In Roman poetry, satirical and otherwise, cosmetics was often taken up in its relationship to painting; both create an illusion that, even if convincing, is bound to leave one dissatisfied. But by investing this somewhat light subject with the religious fervor of an enthusiastic preacher, Tertullian not only changed its character; he also made cosmetics into an important testimony of the arts of illusion.

Finally Tertullian composed *On Idolatry (De idololatria).*[11] For our subject this is the central text, and we shall analyze it in greater detail. Here I should only like to stress that *On Idolatry* is obviously not an isolated treatise; rather, it constitutes a climax in a process that lasted for almost a decade. Here different threads of thought, expressed in the writings mentioned, come together. Though, again, the treatise is written on a specific occasion, trying to answer specific questions, it is the best formulation of Tertullian's attitude to the arts in general.

The primary aim of the present study, as I have already said, is to analyze the *reasons* the different Christian authors give for their attitudes to images. Yet the attitudes themselves, though they have some essential elements in common, often differ considerably from each other. Even an individual author's attitudes are often not sufficiently clear. Frequently they require elucidation. This is also true for Tertullian. Before we attempt an analysis of his motivations, it will therefore be necessary to describe his opinions of the arts.

To a naive reader, undisturbed by complex methodologies, Tertulli-

an's attitude to the visual and performing arts seems obvious: it is one of utter and total rejection. Not for nothing has he been denominated— with or without reservation—a "Kunstfeind," an enemy of the arts.[12] His negative view of the arts is best seen in the fact that he treats them under the general heading of "idolatry." Indeed, his treatise *De idolola- tria* contains the fullest presentation of his views of the visual arts. The argument of this treatise, it has been claimed, has not been studied with sufficient care.[13] Though this may indeed be the case, the central ideas expounded there are clear. The opening sentences present a forced exten- sion of the concept of idolatry. Idolatry, we read at the very beginning, is "the principal crime of the human race, the highest guilt charged upon the world." Tertullian then goes on to enumerate the major crimes that by necessity follow from—or, as he says, are included in—idolatry: they are murder, adultery, fornication, fraud, and a host of minor vices. The literary form of such a presentation was not new. In Hellenistic philosophical literature it was accepted practice to describe the corrup- tion of society by enumerating its flourishing vices. But Tertullian could also have derived the device of such listings of sins and vices from no less a source than the New Testament itself: "For the time past of our life may suffice us to have wrought the will of the Gentiles, when we walked in lasciviousness, lusts, excess of wine, revelings, banquetings, and abominable idolatries"—to give but one example (1 Peter 4:3).[14]

Some modern students have proposed a distinction between Tertulli- an's rejection of idols (which is total and unconditional) and his attitude to any other images the artist may make.[15] To my mind, this distinction is hard to maintain. While it is true that Tertullian expressly condemns only idols, he never mentions any other classes of images. That images other than idols are not explicitly condemned should probably not be understood as a tacit acknowledgment of their legitimacy. But there are also more outspoken indications of Tertullian's total rejection of all the arts. When he says that the devil has invented the artists, he is rather clearly defining his overall attitude. Idolatry, he believes, can also exist without idols, and in fact existed before idols were manufactured. "But when the devil introduced into the world artificers of statues and images, and of every kind of likenesses," the worship of the false gods and of demons became instantly fixated on them.[16] And as if to make it clear that he is not opposed to a specific art or to an individual medium, but rather to the man-made image as such, he continues, "Thenceforward

[after the devil's invention of the arts] every art which in any way produces an idol instantly became a fount of idolatry. For it makes no difference whether a moulder cast, or a carver grave, or an embroiderer weave the idol; because neither is it a question of material, whether an idol be formed of gypsum, or of colors, or of stone, or of bronze, or of silver, or of thread." Moreover, it is not even essential that the idol be cast in human shape. Continuing the sentence just quoted, Tertullian says, "For since even without an idol idolatry is committed, when the idol is there it makes no difference of what kind it be, of what material, or of what shape; lest any should think *that* only to be held an idol which is consecrated in human shape."

In the Christian world of the third century, that is, shortly after Tertullian's time, suspicion and disdain of the artist were common. "No oblations may be received from those who paint with colors, from those who make idols or workers in gold, silver and bronze," says a third-century Syriac Didascalia.[17] And in a pseudo-Clementine Church order, a painter is put in the same list with a harlot, a brothel keeper, a drunkard, an actor, and an athlete.[18] The attitude expressed in such orders must have been widespread; they hardly derive from Tertullian. But it was he who gave to the common beliefs and opinions a theoretical formulation and foundation.

The same attitude to art and artists prevails in Tertullian's other writings. Hermogenes, we know, was a heretic. In addition to holding and propagating false views, "he exercises the art of painting, a thing forbidden."[19] Tertullian paints the portrait of a heretic, a portrait in which caricatural features are obvious.[20] Hermogenes, Tertullian says in the first chapter of the polemical treatise, justifies his lusts by the biblical command of fertility, but when it comes to his art he despises the biblical command. He cheats both with the pen and with the brush. Cheating by the pen, we are led to believe from the text, follows from stating, and propagating, false beliefs; cheating with the brush results from the very painting of images. Though Tertullian does not explicitly say so, it clearly follows from his text that he condemns artistic rendering as such, the very conjuring up of convincing illusions, and does so without relating it to the production of actual idols.

What is perhaps not explicitly said in the polemical treatise *Against Hermogenes* is fully stated in *De spectaculis*. Here Tertullian clearly condemns all make believe. "And in regard to the wearing of masks, I

ask," so he rhetorically exclaims, "is that according to the mind of God, who forbids the making of every likeness, and especially then the likeness of man who is His own image? The Author of truth hates all the false; He regards as adultery all that is unreal."[21] All painting, we cannot help concluding, is false illusions, and all image making is condemned.

Let us now turn to our proper subject and ask, what are the *reasons* for Tertullian's passionate condemnation of artistic images and stage performances? A careful reader will not fail to notice that more than one motive lies behind his negative attitude to the work of art. These motives cannot always be neatly distinguished from each other, but for the sake of clarity I shall present them separately.

1. *Art as a social danger.* Tertullian's primary reason for rejecting art, the motive he most frequently mentions, is the dangerous and sinful impact the work of art has on the individual spectator or on society at large. The main feature in Tertullian's approach to the work of art is awareness of the spectator's reaction to it. What matters to our author when considering the statue, the painting, or the performance is the impact on the audience. He conceives of the work of art almost exclusively in terms of its social consequence. Hardly ever does he consider it as detached from the social context, as an object embodying unique and autonomous values that are not reducible to anything else; he treats works in the different arts only in terms of what they mean for, and in, society. Here, it should be emphasized, Tertullian differs from the mainstream of ancient aesthetics. Greek and Roman reflection on the arts, it need hardly be said, was aware of the ability of the work of art to arouse the spectator. But this was only one of the different properties characteristic of the work of art. Ancient thought developed other concepts and categories to deal with the specific, unique character of art. Concepts such as "the imitation of nature," the creation of a convincing illusion, the manifestation of beauty, or the expression of the passions are too well known for us to present them here again. Every educated person in the second and third centuries A.D., one should assume, was familiar with these concepts. But Tertullian never even alludes to them. Nowhere does he mention a figure's verisimilitude, the convincing illusion achieved

by a painting, or the beauty of a statue. What he does consider, time and again, is what the statue, the painting, and the performance *do* to people. In modern parlance we could say that for him the existence of a work of art consists in its effect on the audience. The "being" of a work of art is its social impact.

That Tertullian considers the art object as the totality of its social consequences is best seen in *On Idolatry*. This pamphlet, as one knows, is a violent denunciation of statues. But what specifically is wrong with the statue? Why actually is the carved or cast image so totally damnable? To Tertullian the answer seems obvious: the statue should be condemned because it is a sinful object, and it is a sinful object because people worship it. What a statue may be in itself, beyond its meaning to the audience, does not matter at all. Nowhere do we have a hint that our author even considered such a problem. The question simply did not appear on his horizon. Yet the ability to affect the spectator, Tertullian seems to believe, is an essential characteristic of the statue, and of every work of art, as such. Therefore he not only condemns statues that have actually been employed in idolatrous rituals, but rejects every statue, even those that have not yet been produced. The reason is that the statue's impact on society is bound to be fatal. By its very nature it is capable of being used in idolatrous worship, and, given the fallacies of human nature, it will eventually promote actual idolatry. In a somewhat dubious use of etymology he explains, "*Eidos*, in Greek, signifies *form; eidolon*, derived diminutively from that, by an equivalent process in our language, makes *formling*. Every *form* and *formling*, therefore, claims to be called an *idol*. Hence *idolatry* is 'all attendance and service about every idol.' "[22] Tertullian outlines the course of world history: as a trait of human nature, as an inborn inclination to sin, our author would agree, idolatry goes back to the dawn of time; it was practiced even before people learned to produce idols. But once the image, the artistic representation of nature, as we would say, came into being, it instantly came to serve humanity's idolatrous drive: "Every art that in any way produces an idol instantly became a fount of idolatry."[23] Our desire to worship idols is not brought about by the artist's work; it is part of human nature. But artistic activity evokes and furthers it. The artist cannot prevent the work he or she produces from becoming—almost unavoidably—the object of adoration. It is therefore

the *production* of statues—actual or potential idols—that is prohibited. Turning to the artists Tertullian says, "You who *make* [images], that they may be able to be worshipped, *do* worship."[24] For this reason, he thinks, the biblical prohibition of images is formulated as a prohibition to *make* images.[25]

No wonder, then, that Tertullian devotes a considerable part of *On Idolatry* to the makers of images. That he so attentively deals with certain professions, among them the carvers of statues, clearly indicates that they played a significant part in the social reality of the African church of his day. It also shows, however, that the work of art itself, the representation of reality as such, appears to him endowed with the potential to make people sin. The devil invented the artist, the maker of images, because the devil foresaw the impact the artist's work would have on society.

Tertullian does not present systematically—which does not surprise us—the channels by which the work of art reaches and affects the audience, and thus attains its own social existence. Here, as in other respects, we must extract from his texts the concepts and categories he must have employed in his thought, even though he did not state them *expressis verbis*.

Tertullian seems to assume two main channels through which the work of art can make its impact on the individual spectator or the community as a whole. One is the well-known idea of the spectator's emotional response to what he or she sees, the work's ability to arouse his or her passions. Tertullian's awareness of such an emotional impact is best seen in his treatise on the theater. The Christian is not permitted to visit the theater because this institution is so closely related to certain passions: "Since, then, all passionate excitement is forbidden to us, we are debarred from every kind of spectacle, and especially from the circus, where such excitement presides as in its proper element."[26]

The emotional impact, however, is only one part of the social existence of a work of art. When we carefully consider the hierarchy of values in Tertullian's mind we see that to him emotion is not the principal aspect in the social meaning of a work of art. Most of his attention is focused on the uses not in any way related to the passions that are made of a work of art. In modern times the emotional impact of a painting, a statue, or a play became a central part of its role in

society. In the early Christian era this was altogether different. The uses that Tertullian actually envisages may be described as institutional or ritual. The best example is of course the use made of a statue as an idol. Nowhere, it should be stressed, does Tertullian even vaguely suggest that idolatry has any emotional character. The social character of the work of art may include its emotional impact, but is never limited to it.

2. *Images—an index of paganism.* Closely related to the reason for rejecting images I have just outlined—seeing the work of art as a danger to society—is another one that also plays a significant part in Tertullian's thought. Though he never defined it, the idea permeates his writings. The image, the statue and the painting, any object pertaining to the visual arts (be it only an artistically shaped military symbol)—this is the essence of that second reason—all these are indications and embodiments of paganism. Wherever there are images, there are pagan beliefs, pagan ways of living, and pagan culture in general.[27] Images are a hallmark of paganism; nothing is more characteristic of pagan culture than the use of, and the attachment to, visual images. This description is not sufficient, however. Were we to accept it we would have to assume that, in Tertullian's view, paganism is altogether outside the images. Yet he thinks that images are not merely symptoms or illustrations of pagan beliefs, of pagan culture and religion, but that they partly constitute them. This being the case, the Christian's condemnation is, in fact, prescribed. Since Christians are called upon to stay aloof from the pagan world surrounding them, they must necessarily cut themselves off from any contact with images.

To understand Tertullian's views of images as an index of paganism, we must recall the well-known role of images in the official rituals of his time. It is best to turn to what he says about "the devil's pomp." In both *On Idolatry* and *On Shows* he discusses the Christian's repudiation of *pompa diaboli* when undergoing the ritual of baptism: "When entering the water, we make profession of the Christian faith in the words of the rule; we bear public testimony that we have renounced the devil, his pomp, and his angels."[28] In *On Idolatry* he speaks of the Christian cutting himself or herself off from "the nations" in matters of external appearance.[29] The "devil's pomp" is

part of the complex web of idolatry. "Therefore what He was unwilling to accept, He has rejected; what He rejected, He has condemned; what He condemned, He has counted as part of the devil's pomp. . . . If you have forsworn 'the devil's pomp,' know that whatever there you touch is idolatry."[30]

We shall not discuss here what *pompa* in general meant in the Roman world, nor what Christians called *pompa diaboli.* Modern scholarship has significantly deepened our understanding of these processions.[31] I should only like to note that the study of the different *pompae* of the Roman world leads us back to the subject of holy images. These were carried in many processions. How far the Greek *pompa* originally included the carrying of images[32] is a matter for historians to decide. In Rome, however, the carrying of divine images seems to have been accepted practice. The *pompa circensis,* a common type of religious procession,[33] was as a rule concluded by the bearers of the images of the gods, the climax of the whole procession. The statues of the gods were borne by the leading men of the province, who were carefully prepared for this task. Carrying the god's image was not only an honor; it was considered a matter of divine inspiration.[34] Whatever the details in each specific case, the images of the pagan gods were indeed intimately related to the concept of the *pompa.* That this most pagan of rituals appeared to Christians as "devilish," as "the devil's pomp," needs no further explanation.

Another context in which the close connection between the statue and pagan religion (and a particular type of pagan procession) is displayed are the cults performed in association with the imperial image. In these political cults the image and the ritual were linked in many ways, in the process influencing the views held of both.[35] Imperial images were also specifically carried in processions. The meticulous regulations for participation in the processions are important expressions of civic ideology, and, at the same time, documents of a religious attitude. For the carrying of the emperors' images special officials were sometimes appointed. "Imperial bearers" were chosen among the youths of some eastern cities of the Empire.[36] For believers in a still imageless religion, such processions came very close to a *pompa diaboli.* Tertullian often evokes the specifically pagan connotations of the imagery used in the imperial service. How can a Christian be a soldier, he asks, when surrounded by visual symbols

of a distinctly pagan-religious character? His important treatise on the soldier's wreath[37] indicates what he thought of official images, even if for obvious reasons he did not explicitly mention them.

The close link between the statue and the pagan god—so close, indeed, that the former could almost become a synonym of the latter —may also explain another belief that Tertullian suggests, namely, that statues are the abode of demons. Speaking of the visual representations of the dead (an obvious reference to the *pompa funebris*) Tertullian protests, "We know that the names of the dead are nothing, as are their images; but we know well enough, too, who, when images are set up, under these names carry on their wicked work, and exult in the homage rendered to them, and pretend to be divine —none other than the spirits accursed, than devils."[38]

The idea that demons dwell in, or are attracted by, pagan statues, particularly statues of the pagan gods, was very much in the air at the time. Already Celsus, to mention only one of Tertullian's contemporaries, found it necessary to debate the Christian belief that the idols to whom offerings were made were actually demons. Origen, in his basic work *Contra Celsum*, states that "the worship of the supposed gods is also a worship of demons. For all the gods of the heathen are demons."[39]

3. *The artist—a rebel against God.* Still another reason for condemning the work of art is that it originates in, and testifies to, the act of rebelling against God. Nowhere in Tertullian's writings is this idea fully and systematically stated, but it is suggested often enough to make it possible for us to follow the argument. The shaping of a person, so that argument runs, is a function that rightfully belongs to God alone. The artist, by forming a human image in stone or paint, or by impersonating a human being on the stage, is competing with God, is attempting to usurp God's function. By so doing the artist becomes—in a literal sense—God's adversary. This Promethean interpretation of the artist's act[40] brings the artist into close proximity with the devil, God's principal antagonist.

We should keep in mind that Tertullian sees the world as a stage where God, "the Author of nature," constantly clashes with the devil, "the corrupter of nature." In the treatises we have mentioned the unmitigated contrast between the Author and the corrupter is stressed. What is "not God's must necessarily be His rival's," Tertullian says.[41]

The duplications of nature as seen in the artist's work do not originate in God; they are, therefore, necessarily the devil's.

In Tertullian's thought, the juxtaposition of God and devil in human history becomes to a certain extent a juxtaposition between humanity's original state and its condition with the advent of culture. Tertullian's attitude to the idea of primitivism is rather complex, and it is not for us here to take up this subject.[42] We should note, however, that he considers the first state as willed by God, the latter as the result of corrupting God's work: "There is a vast difference between the corrupted state and that of primal purity, just because there is a vast difference between the Creator and the corrupter."[43] Now, art is part of culture. The "corruption" it brings about is clearly seen in wilfully changing nature as God originally shaped it. Every make-belief is corruption. Take the example of the actor. By performing on stage the actor tries to appear as somebody other than he or she really is, and is thus rebelling against God.

4. *Rejecting catharsis.* We should finally like to mention yet another motive for rejecting the arts, though in many respects it is more problematic than the reasons we have discussed so far. Following Georg Lukacs, the Marxist critic of modern literature and philosophy, we can call this motive of Tertullian his "opposition to catharsis."[44] This concept is less explicitly stated than others, and Tertullian himself may have been less aware of it. Nevertheless, it is an important component of his attitude to the arts.

Tertullian denies what we would call the independent realm of art, the mode of existence unique to the work of art. He is of course fully aware of the powerful emotional effect the work of art has on its beholder. The expressive character of the work of art, its magic power to stir and evoke emotions, is most explicitly discussed in his treatise on the theater, but it also occupied his mind when he was writing his other treatises on the arts. The performance on stage is far from being conceived as a mere "play," a performance lacking full reality. On the contrary: vividly and with a sense of great urgency Tertullian describes the disturbing emotional effect of the stage performance on the audience: "For the show always leads to spiritual agitation, since where there is pleasure, there is keenness of feeling giving pleasure its zest; and where there is keenness of feeling, there is rivalry giving in turn its zest to that."[45] The emotions the spectator

experiences in the theater are real emotions. Continuing the sentence just quoted, our author says, "Then, too, where you have rivalry, you have rage, bitterness, wrath, and grief, with all the bad things that flow from them." Because these feelings are real ones, people attending the theater—and, by implication, exposing themselves to the impact of any work of art—forgo their power over themselves. Once the play opens, spectators "fly into rages, and passions, and discords."[46] And Tertullian of course remembers: "No one partakes of pleasures such as these without their strong excitements; no one comes under their excitements without their natural lapses. These lapses, again, create passionate desire. If there is no desire, there is no pleasure."[47]

Tertullian here undermines one of the basic assumptions of ancient aesthetics, an idea that actually remained the central thesis in justifications of the arts. Ever since Aristotle's *Poetics* it was generally accepted that the very aim of tragedy—and, by implication, of the arts in general—is the purification of the spectator's emotions. Tragedy, Aristotle says in a famous passage, "through pity and fear effect[s] the proper purgation of these emotions" (1449b). No further words need be wasted to show how crucial the concept of catharsis was to aesthetic reflection in later periods. Now, it is precisely the stipulation that the spectator's emotions are purified that Tertullian altogether denies. The rage and discord the spectator experiences when watching a play are real rage and discord, in no respect differing from the rage and discord aroused by any regular event in ordinary life. As we condemn the passions in real life, we have to condemn the passions aroused by the play.

Moreover, the emotions produced by art, Tertullian believes, are in a sense even more to be condemned than those experienced in everyday life. While they are not distinguishable from each other in their destructive effect, in the violence to which they lead, the passions provoked by the play are less justifiable than those experienced in nature. The spectators of the play "are saddened by another's sorrow, they are gladdened by another's joy. . . . Whatever they desire on the one hand, or detest on the other, is entirely foreign to themselves. So love with them is a useless thing, and hatred is unjust."[48] The actor's moral position is even worse than the spectator's. The latter may be carried away (as we would say today) by what he

or she watches; he or she loses self-control. The actor—this seems obvious to Tertullian—is consciously putting on an appearance. It did not cross our author's mind that the actor may experience some empathy with the hero he is representing on stage; the actor simply "pretends." Referring to the various aspects of what the actor conjures up on stage (both different characters and different emotions), Tertullian says, "The Author of truth hates all the false; He regards as adultery all that is unreal. Condemning, therefore, as He does hypocrisy in every form, He never will approve any putting on of voice, or sex, or age; He never will approve pretended loves, and wraths, and groans, and tears."[49]

We need not go into detail to see the far-reaching consequences of this reasoning. Tertullian's negation of catharsis necessarily leads to querying, and ultimately denying, any particular mode of existence that would be uniquely characteristic of the work of art. If the spectator's emotions cannot be purified, the work of art as such will eventually have to be rejected as a "lie."[50]

How are we to place Tertullian's views on our subject among the doctrines rejecting images that were current in his time? To determine his specific locus we shall have to set off his doctrines against two different, actually contrasting, trends of thought prevailing in late Antiquity: on the one hand, we must distinguish his views from those of the rationalistic critics who held that the belief in images was simply superstition; on the other, we must demarcate his attitude from that of thinkers who despaired of humanity's ability to portray the divine. Our comparisons, it should be admitted at the outset of this concluding reflection, are often tentative and hypothetical. To some extent they are, unfortunately, derived from what Tertullian did *not* say or even consider. An *argumentum e silentio*, it need hardly be said, is of dubious validity, and as a rule one is happy to avoid it. In some conditions, however, it can bring out more clearly the character of a personality or an historical phenomenon.

Ancient rationalistic criticism of the popular belief in images, it will be remembered, presupposed the assumption that the icon itself, the statue or image of the god, is nothing but a piece of dead matter, an inanimate object deliberately cast by a person into a particular shape. To attribute any secret power to such a regular object—so antique

rationalists thought—is sheer superstition. It was the discrepancy between the mere material, on the one hand, and the irrational beliefs in its miraculous power, on the other, that gave rise to the many satirical stories about the god who is an abode for mice, the goddess whose precious robe has been stolen, or replaced by a cheaper one, and a host of jokes in a similar vein.[51]

Now, one can claim that Tertullian agrees with the rationalistic critics in the final conclusion to which their reflections lead—namely, the total rejection of the worshipping of statues. But while he agrees with their conclusion, his reasons are altogether different.

In two major respects, it seems, Tertullian disagrees with the rationalistic critics. First, he disagrees in the view of what an idol's proper mode of existence is. In contrast to the critics of superstition, he never considered the idol under the aspect of its material nature. On the contrary, as we have seen,[52] he insists that the material nature of the idol is totally irrelevant to the function it fulfils in society. What the apostles of enlightened culture considered as mere superstition, Tertullian perceives as the idol's true existence—people's beliefs in what the divine image is and what it can, or cannot, do. This is not a confusion of concepts, a result of taking a metaphor literally. To somebody trained in the law, as was Tertullian, it would be obvious that considering the social mode of an idol's existence is not the same as seeing its material mode of being. The problem is not one of confusion; it is rather a difference of opinion as to what the idol really is. It is here that he radically differs from the rationalistic tradition. The social beliefs in what the idol is are not external to it; they *are* the idol.

From this follows the other point of disagreement with the rationalistic tradition: Tertullian does not belong with those who ridicule the idol's helplessness. Once you conceive of the idol as a social, rather than as a material, object, it ceases to be the innocuous piece of wood or stone that has by chance been shaped into the image of a god. In Tertullian's view the image is not helpless; it is rather the powerful agent of a foreign religion and culture. One is tempted to say that it was Tertullian who took the image seriously.

Trying to distinguish between Tertullian's attitudes and those of—later—thinkers who queried, or outright denied, humanity's ability to see and portray the divine, the student is in a more difficult situation. Tertullian simply did not deal with this particular topic. The question of

what would be the status of the image were it to portray the true, i.e., the Christian, God, simply never arose in Tertullian's thought. For him the image is firmly associated with the foreign god, nor does he seem to doubt that the image is fully valid, at least in all those social respects that actually matter. Tertullian thus does not deal with the principle of God's invisibility, or with humanity's inability to perceive what is beyond the horizon of its sensual experience. It was the contribution of later ages to have placed this specific problem in the center of speculation on the image of the divine.

NOTES

1. A good summary of the rather large and intricate literature is given by Hans Lietzmann, *Geschichte der alten Kirche*, II, *Ecclesia catholica* (Berlin and Leipzig, 1936), pp. 222 ff. Otto Bardenhewer, *Geschichte der altkirchlichen Literatur*, I (Freiburg, 1913), pp. 69 ff., calls him "creator of ecclesiastical language."
2. F. R. Tennant, *The Sources of the Doctrines of the Fall and Original Sin* (Cambridge, 1903), pp. 328 ff. Interesting material as well as penetrating discussions on our subject, and Tertullian's part in impressing it upon later Christian thought and ritual, may now be found in G. M. Lukken, *Original Sin in the Roman Liturgy: Research into the Theology of Original Sin in the Roman Sacramentaria and the Early Baptismal Liturgy* (Leiden, 1973).
3. Eusebius, *The History of the Church from Christ to Constantine* II, 2.5. I use the English translation by G. A. Williamson (Penguin Books, 1986), p. 75. For Tertullian's use of legal language, see A. Beck, *Römisches Recht bei Tertullian und Cyprian* (Schriften der Konigsberger gelehrten Gesellschaft, Geisteswiss. Klasse, 7. Jahr, Heft 2; Halle, 1930).
4. Lorenz Stager, *Das Leben im römischen Afrika im Spiegel der Schriften Tertullians* (Zurich, 1973).
5. "Tertullian als Schriftsteller," best available in Karl Holl, *Gesammelte Aufsätze zur Kirchengeschichte*, III (Tubingen, 1928), pp. 1 ff.
6. The most recent proposal for a chronology and sequence of Tertullian's writings I know is R. Braun, *"Deus Christianorum": Recherches sur le vocabulaire doctrinale de Tertullien* (Paris, 1962), pp. 563–77. This chronology has been accepted by Jean-Claude Fredouille, *Tertullien et la conversion de la culture antique* (Paris, 1972), pp. 587 ff.
7. *The Shows (De spectaculis)*, quoted in the translation by Rev. S. Thelwall, *Ante-Nicene Fathers*, III (Michigan, 1976), pp. 79–91.
8. See Tatian, *Oration*, chapter 22, p. 230. And see above, chapter 5.
9. For an English translation, see *The Treatise against Hermogenes*, translated by J. H. Waszink, in *Ancient Christian Writers*, no. 24 (New York, 1956).

10. Quoted in the translation by Rev. S. Thelwall, *The Ante-Nicene Fathers* IV, pp. 14–25.
11. Quoted in the translation by Rev. S. Thelwall, *The Ante-Nicene Fathers* III, pp. 61–77.
12. See, e.g., Hugo Koch, *Die altchristliche Bilderfrage nach den literarischen Quellen* (Göttingen, 1917), p. 3. Koch speaks of his "supposed" hostility to the arts.
13. See T. D. Barnes, *Tertullian* (Oxford, 1971), p. 99.
14. See also Revelations 22:15.
15. Early German research of the Church's attitude to the visual arts tended to this view. See, e.g., A. Knopfler, "Der angebliche Kunsthass der ersten Christen," *Festschrift Georg von Hertling zum siebzigsten Geburtstag* (Kempten and Munich, 1913), pp. 41–48.
16. *On Idolatry*, chapter 3; p. 62 of the English translation. He comes back to the origins of the arts in *On Shows*, chapter 10, p. 84 of the English translation.
17. See the German translation, by H. Achelis and J. Fleming, in *Texte und Untersuchungen zur Geschichte der altchristlichen Literatur*, Neue Folge, X (Leipzig, 1904), chapter 18. And see also Edwyn Bevan, *Holy Images: An Inquiry into Idolatry and Image-Worship in Ancient Paganism and in Christianity* (London, 1940), p. 86.
18. Quoted after Bevan, *Holy Images*, p. 86.
19. *Against Hermogenes*, chapter 1. English translation, p. 26.
20. For such portraits in Tertullian's writings, and for his origins in the rhetorical tradition of Rome, see Fredouille, *Tertullien et la conversion*, pp. 38 ff.
21. *The Shows*, chapter 23; p. 89 of the English translation.
22. *On Idolatry*, chapter 3; p. 62 of the English translation.
23. *On Idolatry*, chapter 3; p. 62 of the English translation. As we have just seen, "idol" just means any kind of form.
24. *On Idolatry*, chapter 6, p. 64 of the English translation.
25. *On Idolatry*, chapter 4, p. 62 of the English translation. All the biblical formulations do indeed speak of the *making* of images. "Ye shall make you no idols nor graven image" (Leviticus 26:1); "Thou shalt not make unto thee any graven image, or any likeness" (Exodus 20:4); "Thou shalt not make unto thee any graven image, or any likeness" (Deuteronomy 5:8). So far as I know, in former times this formulation has not led commentators to read these sentences as directed particularly against artist any more than against users of such images.
26. *On Shows*, chapter 16; p. 86. A classic early Christian description of an audience carried away by the passion aroused by what it sees in the arena is found in Augustine's *Confessions* (Book Six, chapter 8). Erich Auerbach, *Mimesis: The Representation of Reality in Western Literature* (Garden City, N.Y., 1957), pp. 58–66, has devoted a penetrating analysis to this description.

27. For the general background, cf. Peter Brown, *Society and the Holy in Late Antiquity* (Berkeley, Los Angeles, Oxford, 1982); and Sabine G. Mac-Cormack, *Art and Ceremony in Late Antiquity* (Berkeley, Los Angeles, London, 1981).

28. *On Shows*, chapter 4; p. 81 of the English translation. And cf. also S. R. F. Price, *Rituals and Power: The Roman Imperial Cult in Asia Minor* (Cambridge, 1984).

29. *On Idolatry*, chapter 13; pp. 68 f. of the English translation. "The first point, indeed, on which I shall join issue is this: whether a servant of God ought to share with the very nations themselves in matters of this kind, either in dress, or in food, or in any other kind of their gladness."

30. *On Idolatry*, chapter 18; p. 73 of the English translation.

31. A survey of the different *pompae* is given by F. Bomer in Pauly-Wissowa, *Realenzyklopädie der klassischen Altertümer* XXI, cols. 1878 ff., s. v. pompa. Cf. also *Enciclopedia di arte antica* VI, pp. 307 ff. For the *pompa diaboli,* see the study by J. H. Waszink, *"Pompa diaboli,"* in *Vigiliae Christianae*, I (1947), pp. 13–41. For some broader contexts, see H. S. Versnel, *Triumphus: An Inquiry into the Origin, Development, and Meaning of the Roman Triumph* (Leiden, 1970), pp. 94 ff.

32. See Walter Burkert, *Greek Religion* (Cambridge, Mass., 1985), pp. 99 ff. (The original edition of this work, *Die griechische Religion der archaischen und klassischen Epoche,* appeared in 1977, Stuttgart). That at least some *agalmata* of the gods were carried seems to be generally accepted. Cf. Louis Robert, *Opera Minora Selecta*, II (reprint Amsterdam, 1969), p. 1009.

33. For the *pompa circensis* in Rome, cf. G. Wissowa, *Religion der Römer* (Handbuch der klassischen Altertumswissenschaft 5, 4; Munich, 1912), pp. 127, 452.

34. See the interesting description in Macrobius, *Saturnalia* I, 23, 13 (English translation by P. V. Davies [New York and London, 1969], p. 151): "For the statue of the god of Heliopolis is borne in a litter, as the images of the gods are carried at the procession at the Circensian Games, and the bearers are generally the leading men of the province. These men, with their heads shaved, and purified by a long period of abstinence, go as the spirit of the god moves them and carry the statue not of their own will but whithersoever the god directs them."

35. Cf. Price, *Rituals and Power*, pp. 188 ff.

36. Ibid., p. 189, referring mainly to Robert, *Opera Minora Selecta* II, pp. 1275 ff.

37. *De corona militis*, chapters 17 ff.

38. *On Shows*, chapter 10; p. 84 of the English translation.

39. See Origen, *Contra Celsum*, VII, translated by Henry Chadwick (Cambridge, 1980), 69 (p. 452 of the translation). See also VIII, 24 (pp. 469 ff.).

40. It is perhaps worth noting that Tertullian nowhere seems to mention Prometheus. We can safely assume, however, that he was familiar not only with

the story itself, but also with the specific interpretations that stressed that hero's rebellious character.

41. *On the Apparel of Women,* chapter 8; p. 17 of the English translation.
42. See Arthur Lovejoy, " 'Nature' as a Norm in Tertullian," in the author's *Essays in the History of Ideas* (New York, 1960), pp. 308–38. And see also George Boas, *Essays on Primitivism and Related Ideas in the Middle Ages* (Baltimore, 1948), pp. 17 ff., 88 ff., 123.
43. *On Shows,* chapter 2; p. 80 of English translation.
44. Georg Lukacs, *Die Eigenart des Ästhetischen,* 2. Halbband (Luchterhand, n. d.), pp. 692 ff., 748 f.
45. *On Shows,* chapter 15; p. 86.
46. *On Shows,* chapter 16; p. 86.
47. *On Shows,* chapter 15; p. 86.
48. *On Shows,* chapter 16; p. 86.
49. *On Shows,* chapter 23; p. 89.
50. Lukacs, in the discussion quoted above (see note 44), thinks that Tertullian only occasionally sinks to the low level of considering the arts as a "lie." Implicitly, I believe, this perspective is unavoidable if one denies the particular character of the passions aroused by the work of art.
51. See above, chapter 3.
52. See above, chapter 6.

Origen

An argument, some philosophers say, may sometimes unfold in a historical process. Its contents, its various steps and aspects, are brought to light in stages, and each stage may last a generation or even longer. The evolution of the Christian rejection of images is an instructive example. After Tertullian completed his work, a new stage began, revealing another facet of the great problem that engaged the energy and thought of so many generations. That stage is well represented by Origen. Surviving Tertullian by about thirty years, Origen gave a new turn to the attitude towards images. This is not to suggest a direct succession of thought between the two theologians. There is no need for us to suppose a continuous tradition in order to see that the question itself—the potential of the argument—is carried further by the later thinker.

Both Tertullian and Origen lived in Northern Africa,[1] but they reflect two different cultures. Not only the difference of language, Latin in the West, Greek in the East, separated the western provinces of Tertullian

and the eastern ones of Origen; more important was the marked contrast in intellectual orientation: Roman law and the prevailing social institutions were Tertullian's central source of inspiration; for Origen it was the venerable tradition of Greek literary culture. Eusebius, who recounts the lives of both teachers, praises Tertullian for his expertise in law, and tells us that Origen "devoted himself entirely and with growing enthusiasm to the humanities, so that he acquired considerable ability as a literary man."[2]

When we come to the specific subject of our study—the attitude to images—a significant shift in both the tone and the circumstance of the discussion becomes apparent. Origen, it seems, is less concerned with images than was Tertullian. He speaks of them less frequently, and in all his huge output he did not devote a single treatise to the subject of the arts. Not less important is the fact that, whenever he does speak of images or the arts, his tone betrays little of the passionate involvement that is so typical of Tertullian's writings on these matters. But in addition to the differences in tone and temperament, there are also profound differences in intellectual context. Origen, unlike Tertullian, does not write primarily to solve specific problems directly posed by immediate social reality; his concerns are more comprehensive. There has been an interesting debate as to whether, and in what sense, Origen can be seen as a "systematic" thinker.[3] Whatever the conclusion scholars will reach as to Origen's work in general, there can be little doubt that what he says about images is pronounced in what one might call a "systematic context." His several scattered remarks seem to provide the beginnings of a speculative Christian attitude towards images.

It is not my intention to survey the whole of Origen's writings, even if only to focus in them on the problem of divine images. For the present study it will be sufficient to analyze in some detail a few of the pertinent passages from his great polemical work, *Contra Celsum*,[4] as well as from *De principiis*, which is probably his main contribution to a systematic theology.

A good starting point for our investigation is the religious and political utopia that Origen outlines, projecting onto the biblical past the wish fulfilment of his present needs. The ideal society of the Hebrews, a society in which religious demands have become a political reality, has no room for artists. Among the ancient Hebrews, Origen says, "none was regarded as God other than the supreme God, and none of those

who made images possessed citizenship. There were no painters or image makers in their society."[5]

Reading Origen's description of his utopian society, one cannot help being reminded of the ideal polis that Plato projects onto the future. From the philosopher's imaginary city, as one knows, poets and artists are also excluded. "And now," says Plato after long deliberations,

"we may fairly take him [the poet] and place him by the side of the painter, for he is like him in two ways: first, inasmuch as his creations have an inferior degree of truth—in this way, I say, he is like him; and he is also like him in being the associate of an inferior part of the soul; and this is enough to show that we shall be right in refusing to admit him into a State which is to be well ordered, because he awakens and nourishes this part of the soul, and by strengthening it impairs reason."[6]

Plato tells us precisely why he wished to exclude poets and painters from his ideal polis. Origen is perhaps less explicit, but closer inspection will show that the reasons he adduces for the Hebrews' exclusion of the image makers from their ideal, or holy, society, were in fact not so far removed from Plato's. Both Plato and Origen assume that the artist appeals, or brings the spectator, to what is perceived as "low."[7] But what it is that is so described differs in the philosopher and the Church Father. Plato discloses his conceptual frame of reference. His terms are borrowed from scientific psychology, or from philosophical anthropology. The imitative poet, like the painter who produces illusionistic pictures, "indulges the irrational nature" of humanity. They both appeal to an "inferior part of the soul," instead of trying to "please or affect the rational principle in the soul."[8] No wonder that their works have an "inferior degree of truth," and that they should be excluded from the community. Origen's frame of reference is theological metaphysics rather than psychology. The image makers, we read, are excluded from the biblical polis "in order that there might be no occasion for the making of images which takes hold of unintelligent men and drags the eyes of their soul down from God to earth."[9] Here the "high" and "low" are not layers in the human mind, but rather symbolic strata in a comprehensive conceptual cosmos. The "high" is God, the "low" is earth.

In a discussion of Origen's attitude to the visual arts it may be of particular interest to understand in what precisely the "low" or terrestrial character of a work of art consists. This is not an easy question to answer. All we know from his words is that the work of art "drags" the

spectator's eye downwards, preventing him from contemplating the divine by making his eyes focus on what belongs to the earth. But the author does not tell us how, in what ways and by which means, the work of art contrives to perform this feat, nor what is specifically terrestrial in a painting or a piece of sculpture. The student, keeping some medieval interpretations of art in mind, could perhaps assume that by "terrestrial" Origen here understood the specific material nature of the work of art. However, Origen never refers to the specific materials of which images are made. The failure to mention materials may, at least in some cases, indicate an underlying conception of what actually makes a work of art, in particular that the material nature of the art object is of no consequence for its artistic nature. To be sure, this conception, if indeed it ever existed, remained mute.

Perhaps a somewhat closer look at a detail—a topos in ancient literature—may help to make more clear what the failure to mention materials may mean. Origen, one is not surprised to see, was acquainted with the literary traditions widely current among the educated in Antiquity concerning famous artists and works of art. "Some image-makers," he says, "do their work with wonderful success." Among sculptors he adduces the canonic names of Phidias and Polycleitus, among painters the not less canonic names of Zeuxis and Apelles. He even specifically mentions Phidias's famous statue of Zeus.[10] It goes without saying that he had not seen the famous statue, nor any other work by Phidias or any other of the masters he mentions. Speaking of these statues and pictures is for Origen, as for so many educated gentlemen in Antiquity, part of a literary heritage, a hallmark of adherence to a cultural tradition. But he treats the different components of this tradition selectively. It was part and parcel of the very same tradition to speak of the precious materials employed in Phidias's image of Zeus, and in the work of artists in general. As typical and influential an author as Quintilian describes Phidias, in connection with his statue of Zeus, as particularly excellent in his work in ivory.[11] And yet Origen, while extolling the success and skill of the work, does not mention the materials. It is difficult to accept this omission as simply a matter of negligence or forgetfulness. Should one not rather infer that the material of which a statue, or any other work of art, is made is of limited significance in his thought? This might also mean that materials, even if precious, are not the embodiment of the terrestrial quality of the work of art. Be that as it may, there seems

to be nothing in Origen's texts to support the assumption that by "terrestrial" he had specifically "material" in mind.

What, then, is the low or terrestrial domain that Origen juxtaposes to the divine? I venture the suggestion that what he has in mind is the realm of sensual experience as such. Regardless of whether the image perceived is a tangible material object or a mere apparition devoid of any substance, once it is perceived by the senses it is part of the terrestrial domain. Origen, to be sure, nowhere says as much, but in following his thought one is tempted to reach the conclusion I have just proposed. That he did not consider the material of which images are made—the marble, the bronze, or the paint—as the quality attaching them to the terrestrial may perhaps be understood more clearly from a passage in which he says that "all those who look at the evil productions of painters and sculptors and image-makers sit in darkness and are settled in it, since they do not wish to look up and ascend in their mind from all visible and sensible things to the Creator of all who is Light." [12] The "visible and sensible," then, are lumped together. It is the fact that they are perceived by the senses that is the criterion of the image makers' productions' "terrestriality." The spiritualization of virtues, describing them not only as lacking matter but also as removed from any kind of sensual experience, may be understood as lending additional support to such a reading. "Our altars," says Origen, "are the mind of each righteous man," and the "true and intelligible incense with a sweet savour" is the prayer from a pure conscience. [13]

At this stage the student cannot help asking what actually were Origen's reasons for condemning images. To be sure, when compared with Tertullian's furious attacks on carved or painted figures, Origen's tone strikes the reader as restrained, almost calm. Yet behind that softer manner of expression there is obviously a rejection of the image makers' products not less firm than Tertullian's. Why, then, does Origen cast out images?

Reviewing the few passages quoted so far it would seem that, except for the difference in tone and temperament, there is little new. The argument seems to have remained very much the same as it was a generation or two before Origen. What we have seen of his occasional reflections on images actually revolves around their social role. Dragging down the beholder's mind and attention from the upper to the lower

spheres, from the celestial to the terrestrial—this still clearly belongs to the impact of images on the spectator, on what images do to us. Like Tertullian, he too believes that the statues of pagan gods become the abodes of demons.[14] There is little doubt that the comprehensive tradition that manifested itself in Tertullian's violent writings also forms the broad background of Origen's thought.

That Origen belongs to the same tradition we have already encountered in the thought of his predecessors, that he has essentially the same distrust of images in general, and of images of the divine in particular, should not prevent us from seeing that in the history of our problem he actually represents a new departure. His observations on the icon, few and general as they are, announce a radicalization of the questions that occupied the minds of many theologians, and that perhaps have not lost their urgency to this very day. The pivotal turn that makes Origen a landmark figure in the unfolding of our problem, as in the history of so many aspects of Christian theology, can be understood from several points of view. Tertullian, his forerunners, and most of his contemporaries who indulged in theological reflection almost invariably had the representations of *pagan* gods in mind when they so violently repelled divine images, or "idols." The modern reader of their texts must ask what made them attack the idols so fiercely: Was it because of their claim to be depictions of the divine, or was it rather because they were images of *false* gods? Often even the most careful consideration of early Christian texts does not seem to lead to a clear answer. The concept of the "idol," as it was used in Christian thought of the first centuries, was a blend of visual representation and the false god. The two components of the concepts cannot be separated from each other. Any Christian rejection of idols referred to both of them.

In Origen's doctrine the problem of picturing the divine is not a central theme, but even if it is marginal, he poses the question in a context different from that inherited from former generations. As a result, the problem becomes a new one. In reading Origen's extensive writings one observes how little attention he devotes to idols proper, that is, to the statues or icons of the pagan gods (regardless of whether they are actually worshipped). His theology raises—probably for the first time on a broad scale in the Christian tradition—the problem of the icon as such, detached from any link with the false god. When

discussing images of the divine, Origen as a rule speaks of icons of Christ, that is, of images of the *true* God. Whether these icons actually existed is a matter of speculation, a question for historians to debate. For our purpose, however, it is not crucial whether icons were actually visible as material objects, or whether Origen discussed them because their absence was pointed out by the opponents of Christianity.[15] What is crucial is that the claim that idols portray false gods can no longer be the reason for rejecting the image. Now that Christ was portrayed in the icon, one had to formulate an attitude to the image itself. If I believe in the God represented, do I also accept his image?

When Origen speaks of the "image," it should be kept in mind, he often leaves us in doubt as to what precisely he means: Is he thinking of the material icon produced by a painter or sculptor, or is he rather using the term in a metaphorical sense? In other words, are we moving in the realm of sensual experience, or in that of intellectual suggestion? Origen was well aware of the ambiguity of the term. In an attempt to explain how one should understand the apostle Paul's claim that Christ "is the image of the invisible God" (Col. 1:15) Origen says that he will start with what "according to human custom one is used to call 'images' [*imagines*]." Sometimes, he says, a painted or carved depiction is called image, but sometimes what is generated is called an image of the generator, if the resemblance between the two is so obvious that it cannot be denied.[16]

Whether or not Origen presents a Christian version of Greek philosophy (as some students claim and others deny),[17] all scholars agree that the text and exposition of the Bible stand in the center of his work. His reading of the biblical metaphors in which the invisible god is personified is therefore of obvious significance for our understanding of his attitude to images. Now, it is well known that Origen made use of the concept of the "spiritual meaning" of the sacred text. "The Scriptures," he wrote in the introduction to *De principiis*, "were composed by the Spirit of God and they have not only that meaning which is obvious, but also another which is hidden from the majority of readers. For the contents of Scripture are the outward forms of certain mysteries and the images of divine things."[18]

The principle of a "spiritual meaning" that is different from the literal meaning of the text is obviously applicable to the many biblical descrip-

tions of God that attribute to God human traits. Celsius, Origen says, has not properly grasped the true meaning of the anthropomorphic metaphors in the Bible:

Again, perhaps because Celsius misunderstood the words "For the mouth of the Lord has spoken these things," and perhaps also because some of the uneducated have been hasty in interpreting sayings like this, and because he did not understand with what object the Bible uses the names of physical limbs in reference to the powers of God, he says "He has neither mouth nor voice." [19]

However these and similar passages may be interpreted, what they ultimately say is that there is a hiatus between the bodily metaphor and what that metaphor attempts to describe.

In this context the biblical theme of humanity being created "in the image of God" is inescapable. In what sense is humanity created "in the image of God"? Origen proposes a distinction between "in the image of God" and "His image." Lumping together different parts of Scripture ("in the image of God" is taken from Genesis 1:27, "His image" from the Epistle to the Colossians 1:15) he says,

Then Celsus failed to see the difference between what is "in the image of God" and His image. He did not realize that the image of God is the firstborn of all creation, the very Logos and truth, and, further, the very wisdom Himself, being "the image of his goodness," whereas man was made "in the image of God," and, furthermore, every man of whom Christ is head is God's image and glory. [20]

We cannot here take up the fine points of Origen's exegesis of Scripture. However, as far as our problem is concerned, the basic line of his reasoning is clear. That humanity was created "in the image of God" does not refer to the whole person, body and soul. The metaphor "in the image of God" can be related to a specific aspect of humanity only, and that aspect, it turns out, is not even a component of a person in the regular sense of that word. The body, it goes without saying, is not the part of the person that is specifically "in the image of God," as that would make God a simple bodily creature. But also the whole person, composed as he or she is of body and soul, cannot have been created "in the image of God." Were we to accept the whole person as created "in the image of God," we would have to conceive of God as a composite being. "And none of us says that," Origen declares. The only possibility that remains is that what was created in the image of God and can attain perfection is "the inward man, as we call it." [21]

Whatever the implications, philosophical or otherwise, of the concept of "inward man," it obviously makes the pictorial representation of the divine even more difficult than it already was. No continuity leads from the "inward man" to a painted or carved icon. The "inward man" cannot be seen with bodily eyes, cannot be imitated on a panel. Once we accept the existence of an "inward man," we also accept that there is an unbridgeable hiatus between him and anything that can be represented by painting or sculpture.

Origen was not thinking of the arts when he spoke about the "inward man" and man created "in the image of God." In the course of his debate with Celsius, however, he actually employed examples or descriptive formulae that originally had a special affinity to the arts. "Not one of us," Origen stresses, "says that God participates in shape and color."[22] Here, in fact, Origen was partly following his opponent in the choice of metaphors. It is a venerable motif, going back at least to Plato, that spiritual beings are "colorless and shapeless and intangible."[23] The particular form of expressing spirituality by denying color and shape was taken over by the Christian tradition, and became, as it were, a topos of Christian imagination. Thus Justin Martyr, two generations before Origen, described "the originator of all intellectual things" as "having no color, no shape, no magnitude, or any other attribute that the eye can see."[24]

In looking for the reasons for Origen's rejection of images, we arrive at an answer that in several respects differentiates it from Tertullian's. The image of the divine is to be rejected, it follows from Origen's thought, because it cannot, and never will, be an adequate reflection of the original. This conclusion indicates that the intellectual context of Origen's approach to the image is altogether different from that of Tertullian. It is not the social impact of the sacred image that matters to Origen, though, as we have seen, it did play a certain, rather limited part in his considerations. He does not locate the problem of the sacred image in the field between the icon representing a divine figure and the spectator perceiving it; he rather places it in the relationship between the representation to be seen on the icon and the divine model that this very icon purports to represent. In other words, Origen does not ask, what does the image do to people? He rather asks, how valid, or how "true," a representation of the divine does the icon provide? The very posing of the problem of the image as the juxtaposition of a visible image and an

invisible being determines the answer. When the question of the image's validity is presented in this form, the answer can be only one of total rejection.

Origen, it is well known, had a complex, intricate mind; contradictory trends and concepts could coexist in his intellectual world. The complex nature of his thinking has not only given rise to different scholarly interpretations of his teachings; it was also reflected in history. Students are familiar with the great ideological and historical struggles that, under the heading of "Origenism," for centuries shook the foundations of the Church.[25] This complexity, one is not surprised to find, is also reflected in the fragmentary thoughts and opinions about the image. Though Origen, as we have seen, laid the foundations of what may be called "metaphysical iconoclasm," making a true image of the divine totally impossible, one can also find in his doctrine the rudiments of a different approach to the image. These ideas and formulations pertaining to that other approach, it must be admitted, are general and not sufficiently explicit for a discussion of the painted icon, but they must be considered in our study.

Origen's doctrine of the image presupposes, as we have seen, concepts concerning both the nature of God and the nature of people.[26] These concepts are, indeed, clearly implied in the few remarks he makes about the icon. The problem of the icon arises precisely where theology and anthropology meet, or rather where they part from each other. In other words, the difficulties inherent in the image come to the fore when our awareness of God's bodiless and invisible nature is juxtaposed to our knowledge of people's inability to perceive and experience what is bodiless and invisible. It is this juxtaposition that, to follow modern interpreters, makes Origen's thought one of "the roots of anti-iconic theology."[27] But it is the very same awareness of the abyss between the divine and the human that contains the rudiments of a different approach to the sacred icon, one that endows it with an almost messianic task.

To put it in a grossly oversimplified way: in that other approach the image is assigned the role of a "mediator" between the two worlds, the divine and the human. In the introduction to the first book of *De principiis*, Origen describes, in well-known formulae, the emergence of Christ from God the Father. In the same way as the will proceeds from the mind, "without cutting off part of the mind and without being

separated or severed from it," so the Son proceeded from the Father. He did so as His, the Father's, image.[28] But as the Father is by nature invisible, so is his Son an "invisible image." As there is nothing bodily in the Father, so nothing that could be perceived by the senses can be assumed to be in the Son.

But it lies in the very nature of the image, Origen seems to have felt, that it demands to be seen, that it requires visibility. Taking up the age-old metaphor that God is light, he finds it both supported and further developed in the New Testament. The author of the First Epistle of John (1:5) tells us that "God is light, and in him is no darkness at all." Origen also quotes from the Epistle to the Hebrews (1:3) where Christ is defined as "the brightness [splendor] of his [God's] glory and the express image of his person."[29] We have to understand, he says, "the working of splendor: through splendor we grasp and perceive what light itself is. This splendor presents itself to the frail and weak eyes of the mortals more gently and more mildly [than light itself], and gradually teaches and trains them to withstand the brightness of light."

Origen himself seems to have felt how complex and problematic the example of splendor is. What can be learned from that sentence? he asks. The terms, and particularly that of splendor, are nowhere defined in his writings, but we can understand what he had in mind when he employed this example. While light itself exceeds what people can perceive by their bodily senses, splendor is what we *can* see of light. Splendor, then, is light, luminosity adjusted to the conditions of human vision, adapted to the limitations of our perceptual abilities.

Another quality of splendor, characteristic of the way Origen understands and uses it, is that it proceeds from light without any dramatic break, without a rupture in the continuity of being. The idea of the continual emergence of one quality from another, without implying in any way a rupture in the fabric of being, was common in Origen's time and culture. Thus, about a generation after Origen composed *De principiis*, none other than Plotinus described the emergence of the Nous from the One in precisely the same terms.[30] And a generation before Origen Tertullian described in similar words the emergence of the Son from the Father.[31] What informed all these examples and metaphors is the desire to find a bridge over the abyss dividing the two worlds, the spiritual and the material, the invisible and the visible. The desire to create, or discover, a "mediator" between the two different levels of being was a

powerful motivating force in second-century thought, and plays a significant part in the background of Origen's theology.[32] Origen himself, drawing upon the First Epistle to Timothy (2:5), speaks of the *mediator*. In this case the mediator is splendor, bridging the gap between pure light and people's ability to perceive.[33] The splendor, however, let us remember, is itself an image; it shows us what the nature and function of the image are. The apostle, said Origen, describes Christ not only as the "splendor of his glory," but also as the "express image of his person."[34] Splendor and image are equivalent; the "splendor" shows us what the "image" is meant to do.

NOTES

1. For studies of the religious and intellectual development of Africa in early Christian times, see mainly W. H. C. Frend, *The Donatist Church: A Movement of Protest in Roman North Africa* (Oxford, 1952; reprint 1971), and Peter Brown, *Augustine of Hippo* (Berkeley and Los Angeles, 1967). Both works naturally focus more on the Latin than on the Greek culture of Africa.

2. Eusebius, *The History of the Church from Christ to Constantine* II, 2, 15. See the English translation by G. A. Williamson (Penguin Books, 1965), pp. 241 ff.

3. See H. Crouzel, *Origène et la philosophie* (Paris, 1962), pp. 179–215, who rejects the characterization of Origen as a "systematic" thinker, and J. Danielou, *Origène* (Paris, 1948), pp. 201 ff., who stresses the systematic character of his thought, though he does not use that particular term. As Ch. von Schönborn, *L'Icone du Christ: Fondements théologiques elaborés entre le Ier et le IIe Concile de Nicée (325–787)* (Fribourg, 1976), p. 78, note 2, correctly says, the difference in opinion is probably explicable by the different meaning given to the word "systematic."

4. *Origen: Contra Celsum*, translated by Henry Chadwick (Cambridge, 1980), is the text I shall use in this chapter. I shall refer to the conventional division into books and chapters of Origen's text, and shall add the page number of the translation I quote.

5. *Contra Celsum* II, 31; p. 207.

6. *Republic*, 605a, b. I am using the English translation by Benjamin Jowett.

7. I shall not enter here into an investigation of Origen's Platonism, a subject that has attracted a considerable amount of scholarly attention. I shall only mention the still classic work by Charles Bigg, *The Christian Platonists of Alexandria* (Oxford, 1886). And see also the important discussion in Hal

Koch, *Pronoia und Paideusis: Studien über Origines und sein Verhältnis zum Platonismus* (Berlin and Leipzig, 1932) passim, esp. pp. 180 ff. In Koch's work the concept of the image is hardly mentioned.

8. *Republic*, 605a.

9. *Contra Celsum* IV, 31; p. 207.

10. *Contra Celsum* VIII, 17; p. 464.

11. *Institutio oratoria* XII, 10. 9.

12. *Contra Celsum* VI, 66; p. 381 of the English translation.

13. *Contra Celsum* VIII, 17; p. 464 of the English translation.

14. *Contra Celsum* VII, 69; p. 452. As we have seen, early Christian thinkers kept coming back to this motif; see above, chapter 6.

15. See, for example, Celsus's criticism of the Christians because of their opposition to images. See *Contra Celsum* VII, 62; p. 446.

16. *Origenis De principiis libri IV* I, 2, 6.

17. As an example defending the first position, see Claude Tresmontant, *La Metaphysique du Christianisme et la naissance de la philosophie chrétienne* (Paris, 1961). And see also H. A. Wolfson, *The Philosophy of the Church Fathers* (Cambridge, Mass., 1956). For a position denying Origen a philosophical system, see Emil Brehier, *Historie de la philosophie* (Paris, 1931). For a good brief survey, see John Meyendorff, *Byzantine Theology: Historical trends and Doctrinal Themes* (New York, 1983), pp. 23 ff.

18. *De principiis* I, praefatio, 8. See *Origen on First Principles*, translated by G. W. Butterworth (London, 1936).

19. *Contra Celsum* VI, 62; p. 377. For Origen's views of body and soul, important as a background of our specific problem, see Peter Brown, *The Body and Society: Men, Women, and Sexual Renunciation in Early Christianity* (New York, 1988), pp. 160–77 (chapter 8).

20. *Contra Celsum* VI, 63; p. 378.

21. *Contra Celsum*, loc. cit. Modern studies of Origen's exegesis form a considerable body of literature. A good selective bibliography of these studies may be found in Marguerite Harl, *Origène et la fonction revelatrice du Verbe Incarné* (Paris, 1958), pp. 42–43. H. du Lubac, *Histoire et Esprit: L'Intelligence de l'Ecriture d'apres Origène* (Paris, 1950), is useful also for our purpose, though it does not deal explicitly with painted images.

22. *Contra Celsum* VI, 64; p. 379.

23. *Phaedrus* 247C. My translation.

24. Justin Martyr, *Dialogue with Trypho*, 4. My translation.

25. See the lucid summary in Henry Chadwick, *Early Christian Thought and the Classical Tradition* (Oxford, 1984), pp. 95 ff; and the same author's *The Early Church* (Harmondsworth, 1967), pp. 184 ff. For a reflection of the great debate in the Renaissance, see Edgar Wind, "The Revival of Origen," in D. Miner, ed., *Studies in Art and Literature for Bella da Costa Greene* (Princeton, 1954), pp. 412–24, reprinted, with some additions, in

E. Wind, *The Eloquence of Symbols: Studies in Humanist Art* (Oxford, 1983), pp. 42–55.

26. Interesting discussions of Origen's anthropology may be found in *Arche e Telos: L'antropologia di Origene e di Gregorio di Nissa: Analisi storico-religiosa*, originally a symposium, edited by U. Bianchi and H. Crouzel (Milan, 1981). See especially the contributions by H. Crouzel, pp. 36 ff., and Christopher Stead, pp. 170 ff.

27. Schönborn, *L'Icone du Christ*, pp. 77 ff.

28. *De principiis* I, 2, 6.

29. *De principiis* I, 2, 7.

30. *The Enneads* V, 6, 1. See the English translation by Stephen MacKenna, *Plotinus: The Enneads* (London, 1930), pp. 373 ff.

31. *Apologeticum*, chapter 21. See *The Apology of Tertullian*, translated by W. Reeve (London, 1890). A few sentences bear quotation: "When a ray is projected from the sun it is a portion of the whole sun; but the sun will be in the ray because it is a ray of the sun; the substance of the sun is not separated but extended, as light is kindled from light."

32. See Marguerite Harl, *Origène et la fonction revelatrice du Verbe Incarné*, pp. 93 ff.

33. *De principiis* I, 2, 7.

34. *De principiis* I, 2, 8. Origen refers, of course, to the Epistle to the Hebrews 1:3.

EIGHT

Eusebius

Eusebius, bishop of Cesarea, erudite scholar, and prolific writer, did not have any particular understanding of, nor any specific interest in, the visual arts. In his large literary heritage there are but few passages directly dealing with images, or with the problems they raise: the fragment of a letter, and some occasional observations on monuments he saw in the emperor's domains. Nevertheless we must consider his thought on our subject, limited as it is, as a signpost on the road along which our problem developed.

Eusebius, it is common knowledge, was intimately linked with some of the central historical developments that determined not only the fate of the Christian church, but also that of European culture. He lived through the difficult years of persecution in Palestine, where it was particularly severe, and he was closely connected with the emperor Constantine and the great turn in the status of the Church that is marked

by that emperor's name. These events that shaped his whole world surely also made some impact on his attitude to the holy image.

Perhaps even more important for the subject of our study is another aspect of history that forms the background of Eusebius's thought; I mean the great Arianic Debate that so profoundly impressed itself on the internal development and concepts of the Christian doctrine. In the first half of the fourth century the Arianic Dispute clearly dominated the intellectual world of Christianity. It is not our task to take up the theological issues so ardently debated in the course of that dispute.[1] The painted icon, it need hardly be said, was not one of the central questions agitating the minds of those taking part in the great controversy. But the core issue of the Arianic Dispute must have had a crucial significance for any attempt to lay down philosophical foundations for imagery, especially of the divine. Whatever the specific notions so fiercely debated at the time, whatever the "technical" points of theology that served as a watershed separating the rival camps—behind all of them there loomed the question of whether and how the divine and the human, the super-sensual and the material, are related to each other. One version of those great problems could have been put—with only slight qualifications— as the question of whether and how the invisible can be related to the visible. Whether Christ is eternally coexistent with God the Father or whether he is "created," as the issue most frequently debated in the Arianic Dispute was formulated, may seem rather remote from any consideration of painted icons; in fact, it was quite closely connected with it. If Christ is "created," he *can* be portrayed, as everything else that is created; if he is eternally coexistent with God, however, the unbridgeable gap separating us from the invisible makes any visual rendering of Christ impossible. The early fourth century paid little attention to the painted icon, but by concentrating on the gap between the two worlds it determined any reflection on icons. It is this debate that forms the background of Eusebius's thought on our subject.

In the unfolding of our problem Eusebius marks a new stage, a crucial turn of the development. As we have just noted, he said very little about the icon. From the few observations that he made, however, one can infer both profound historical changes that actually occurred in his time, and the revealing of new dimensions of the problem. These changes are indicated primarily by the fact of his discussion of specific themes new

to reflection on the problem of the sacred image, and by his dealing with them within new frames of reference.

The first thematic change, already adumbrated by Origen, is the disappearance of the pagan idol as a major topic of discussion. The century or so since Tertullian, and perhaps also the difference between the western metropolis Carthage and the more provincial, eastern Cesarea, seem to have deprived the pagan idol of much of its attraction, as well as its hold on the minds of Christian teachers. In Eusebius's literary legacy we hear very little about pagan idols. What he does say about sacred images deals primarily with depictions of Christ. As in Origen, and perhaps to an even greater extent, the problem of the holy icon is not hidden, or deformed, by the fact that it is the image of a "false" god.

Another change is perhaps still more significant for the purpose of the present study. In his theological writings Eusebius, like Origen and so many other thinkers of the early Christian period, employed the terms "image" and "icon" in a broad, metaphorical sense. He describes the Son as the "image of the Father," though that "image" may well remain invisible, and has of course little to do with an artist's product. In addition to this comprehensive and symbolic use of the term, however, Eusebius also speaks of images of Christ in a narrow and specific sense, that is, as painted icons, material pictures actually made by an artist. His texts provide some early—perhaps the very first—mentions of specific artistic motifs that served to depict Christ, such as the Good Shepherd. He also speaks of pictures that, as we shall see shortly, must be understood as "portraits" of Christ, that is, icons in the sense we now attribute to this art form. By attesting to the emergence and crystallization of specific forms, themes, and motifs, Eusebius becomes an important source for the study of Christian art and iconology. Our present attention, however, is not focused on Eusebius as a witness of social reality and artistic creation; what we are here interested in is the new level of theoretical understanding of the icon that is revealed in his doctrine.

The most explicit and direct expression of Eusebius's view on sacred images is to be found in his by now famous letter to Constantia Augusta, a sister of the emperor Constantine. The letter (which cannot be accurately dated) is not preserved in full. What we know of it has reached us from copies done by the iconoclasts of the eighth century, who found in

Eusebius's letter approval of their own views. Some parts of it were quoted and discussed at the famous Council of Nicea, and were quoted again in a polemical treatise by St. Nicephorus, devoted to an "orthodox" refutation of Eusebius's views. In the very early eighteenth century the pieces were made available in print.[2] But although we know the letter only from the fragments that have survived, we are in a position to follow the main lines of the author's thought.

The letter originated in a situation typical of the religious (pagan) and political culture of Antiquity, still largely alive in the early fourth century when it was written. Constantia asked the bishop of Cesarea to send her an image of Christ. The wish to have the image of a god, a hero, or a saint, and possibly worship it, was of course common usage in Antiquity.[3] The bishop, however, bluntly rejected the noble lady's request. His letter, so far as it is preserved, is actually devoted to setting forth the reasons for this refusal. In so doing, Eusebius presents a complete outline of the ideology opposed to sacred images, the principles of a full anti-iconic theology. Let us first read the main parts of the letter, as it has survived.

You also wrote to me concerning some supposed image of Christ, which image you wished me to send you. Now what kind of thing is this that you call the image of Christ? I do not know what impelled you to request that an image of Our Saviour should be delineated. What sort of Christ are you seeking? Is it the true and unalterable one which bears His essential characteristics, or the one which He took up when He assumed the form of a servant? . . . Granted He has two forms, even I do not think that your request has to do with His divine form. . . . Surely then, you are seeking His image as a servant, that of the flesh He put on for our sake. But that, too, we have been taught, was mingled with the glory of His divinity so that the mortal part was swallowed up by Life. Indeed, it is not surprising that after His ascent to heaven He should have appeared as such, when, while He—the God, Logos—was yet living among men, He changed the form of the servant, and indicating in advance to a chosen band of His disciples the aspect of His Kingdom, He showed on the mount that nature which surpasses the human one—when His face shone like the sun and His garments like light. Who, then, would be able to represent by means of dead colors and inanimate delineations [*skiagraphiai*] the glistening, flashing radiance of such dignity and glory, when even His superhuman disciples could not bear to behold Him in this guise and fell on their faces, thus admitting that they could not withstand the sight? If, therefore, His incarnate form possessed such power at the time, altered as it was by the divinity dwelling within Him, what need I say of the time when He put off mortality and washed off corruption, when He changed the form of the servant into the glory of the Lord God . . . ? . . . How

can one paint an image of so wondrous and unattainable a form—unless, like the unbelieving pagans, one is to represent things that bear no possible resemblance to anything . . . ? For they, too, make such idols when they wish to mould the likeness of what they consider to be a god or, as they might say, one of the heroes or anything else of the kind, yet are unable to approach a resemblance, and so delineate and represent some strange human shapes. Surely, even you will agree that such practices are not lawful for us.

But if you mean to ask of me the image, not of His form transformed into that of a God, but that of the mortal flesh before its transformation, can it be that you have forgotten that passage in which God lays down the law that no likeness should be made either of what is in heaven or what is in the earth beneath?[4]

The main point of Eusebius's argument is clear and obvious; it hardly calls for rephrasing or "explanation." I shall, therefore, only indicate a few questions that arise when the document is read in the context of our present investigation.

Any reader keeping in mind the earlier approaches of Christian authors to the problem of the sacred image will note, first of all, that Eusebius is not concerned with rejecting an existing image, its use or misuse; rather, he wants to demonstrate that a true representation of God is altogether impossible. That demonstration is of a purely theoretical, speculative character. Note that the biblical prohibition of images plays only a minor and subordinate part. Had Constantia asked for an image depicting Christ before he was transformed, while he was still a "servant," in other words, for an image that does not attempt to portray his true, unalterable nature as God—had she asked for this, the biblical injunction against the pictorial representation of "what is in the heaven or what is in the earth beneath" would have been applicable. But since she probably wants an image of Christ the God it follows from what Eusebius writes that the biblical prohibition need not even be invoked. (One notes with some surprise that Eusebius does not even quote the beginning of the biblical commandment, where the text alludes to the idol [the "other god"] in the precise sense of the word.[5] So deeply convinced is he of the utter impossibility of portraying the divine that he does not even pause to cite the prohibition against making an image of a god.)

It is further remarkable that Eusebius does not directly refer to idolatrous practices as a reason for rejecting the request for an image of Christ. Characteristically, he once again puts this association in the form of a conditioned, dependent thought. It is only when one wants to

represent something that does not bear any possible resemblance to anything, as the pagans do when they render their idols, that one can venture to represent the divine. Both references to the great themes traditionally invoked by early Christian authors in this context—the biblical prohibition of images, and idolatrous practices—are here marginal. The main thrust of Eusebius's argument is purely speculative.

Eusebius takes the sharp, unmitigated contrast between the nature of the divine, on the one hand, and our limited abilities to represent and to perceive, on the other, one step further. Other authors might have agreed with the mere principle that the divine transcends the limits of what we can perceive by our senses. Eusebius seems to have asked—even though tacitly and perhaps even subconsciously—what transcending the domain of the visible specifically means, particularly for the business of representation. As a "servant" Christ *was* visible, though from his outer appearance you presumably could not have guessed his divine nature. At the Transfiguration, when Christ's divine nature was revealed and his body was "mingled with the glory of His divinity," even "His superhuman disciples could not behold" him. What, then, happened to Christ's regular appearance, to his "human form"? To describe the fate of Christ's "human form" Eusebius borrows a term from St. Paul. In 2 Corinthians 5:4 we read, "For we that are in this tabernacle do groan, being burdened: not for that we would be unclothed, but clothed upon, that mortality might be swallowed up by life." Eusebius employs the metaphor of "swallowing up" in order to describe what happens to Christ's human form. In the Transfiguration, and particularly after the Ascent to Heaven, Christ's physical features have been "swallowed up" by "the glory of His divinity."[6]

It is difficult to say what Eusebius had in mind in thus using the term "swallowing up." What does one see when one experiences a divine revelation, that is, a revelation in which the human form has been "swallowed up"? Such a question, it seems likely, hardly presented itself to him in so sharp an outline as here indicated. But it may have existed somewhere at the back of his mind, and by following up his thought beyond what he himself said one may perhaps detect its traces. "How can one paint an image of so wondrous and unattainable a form—if the term 'form' is at all applicable to the divine and spiritual essence," our author rhetorically asks. On the one hand, then, he makes use of the term "form" *(morphe),* and I cannot help concluding that what we see,

and may presumably wish to represent, is a kind of form; in other words, that the experience of revelation has some kind of concrete visual content. On the other hand, that form is "wondrous and unattainable."[7]

Against the utter and uncompromising rejection of the divine image, as stated in the letter to Constantia, in Eusebius's other writings one occasionally comes across some references to well-known motifs or works of sculpture and painting, and these references seem to imply, even though they do not clearly articulate, a somewhat different attitude to the image in general. Students of the arts of that period are familiar with Eusebius's mention of these motifs. Rarely, however, have they devoted attention to the general attitude that speaks from the passages.

The best-known example is Eusebius's mention of a sculptural monument erected in honor of one of Christ's miracles. The woman with the hemorrhage (Mark 5:25–34) was said to have come from Cesarea. In front of the house at the time traditionally identified as her home there stood a monument commemorating the event. Eusebius describes it in detail:

As I have mentioned this city [Cesarea], I do not think I ought to omit a story that deserves to be remembered by those who will follow us. The woman with a hemorrhage, who as we learn from the holy gospels was cured of her troubles by our Saviour, was stated to have come from here. Her house was pointed out in the city, and a wonderful memorial of the benefit the Saviour conferred upon her was still there. On a tall stone base at the gates of her house stood a bronze statue of a woman, resting on one knee and resembling a suppliant with arms outstretched. Facing this was another of the same material, an upright figure of a man with a double cloak neatly draped over his shoulders and his hand stretched out to the woman. Near his feet on the stone base grew an exotic plant, which climbed up to the hem of the bronze cloak and served as a remedy of illnesses of any kind. This statue, which was said to resemble the features of Jesus, was still there in my own time, so that I saw it with my own eyes when I resided in the city. It is not at all suprising that Gentiles who long ago received such benefits from our Saviour should have expressed their gratitude thus.[8]

Reading this description, we clearly perceive Eusebius the Hellenist, the scholar familiar with different aspects of Greco-Roman culture. He is acquainted with the gentiles' custom of honoring heroes or saints by erecting monuments commemorating their remarkable deeds. He also shows how familiar he is with the visual motifs of that culture: the posture of the woman with the hemorrhage reminds him of the figure of

the suppliant, a figure common in the political imagery of the imperial period.[9] So thoroughly Hellenistic is Eusebius's outlook in this description that he does not even hesitate to relate how the bronze figure of the Savior "was said to resemble the features of Jesus."[10]

Another description of Christian motifs and works of art is found in Eusebius's *Life of Constantine*. Our author extols the emperor's role in eradicating paganism, and making the Christian religion common belief. This undertaking also transforms the external appearance of the cities. Altars of pagan gods are banned, as are the idolatrous practices that go with them. Instead of monuments to pagan idols one now sees Christian images. Our author makes specific mention of a well in the marketplace of Constantinople, adorned by an image of the Good Shepherd. Those familiar with Scripture, Eusebius says, are well acquainted with what the image conveys.[11] There is also a representation of Daniel in the lions' den, the saint goes on to say; cast in bronze, it is covered with radiant, glistening gold plates. In the very same brief chapter (hardly more than a dozen lines) he also tells the reader that the emperor Constantine had a cross, "the sign of the suffering of our Savior," fixed on the ceiling of his palace; it was a precious cross, made of jewels and glowing in different colors.

In describing these motifs and monuments, Eusebius clearly did not intend to make a statement of principles, like that in his letter to the emperor's sister. But though he indeed did not proclaim any of his general ideas while evoking the works of sculpture he saw in Cesarea and Constantinople, a modern student reading his descriptions cannot help detecting in them an underlying attitude to images. And that attitude, it seems, differs from the one he himself preached to Constantia. Let me make a few brief comments on what he says about the public monuments, and on what ensues from that difference between the two attitudes.

My first comment is obvious. In describing the monuments, mainly works of sculpture representing "holy" figures and scenes, Eusebius adopts a tone very different from the stern criticism that is so striking in the letter to the emperor's sister. Instead of scolding the Christian who looks for an image of the Savior, he praises Constantine for impressing a Christian character on a big city by displaying, in prominent places, Christian religious images. These praises are not reserved for the emperor only. Even the gentile citizens of Cesarea who erected the com-

memorative monument in their city were expressing their "gratitude to the Savior." There is no doubt that Eusebius was pleased by what they were doing. He obviously had no qualms about these images.

The second comment necessarily assumes the form of a question. After the tense, almost violent, rejection of sacred images we saw in Eusebius's letter to Constantia, one is surprised at the relaxed, generally appreciative, tone of his descriptions of the Christian monuments. How are we to account for this difference? Does it perhaps follow from the fact that the public monuments represent mortal figures, such as the woman with the hemorrhage, or even a saint, such as Daniel, but not God? Such a consideration is, of course, instantly refuted by the figures representing Christ, either directly (in the healing of the woman) or in a symbolic form (as the Good Shepherd).

The difference in descriptive tone and implied judgment cannot be denied or disregarded. Moreover, in matters as sensitive as the dogmatic problem of images in the early fourth century even a barely perceptible difference in attitude must have been of great consequence. Surely an explanation is called for. To account for the difference let us assume that Eusebius, and his audience, conceived of the icons here mentioned as two distinct types of images. In other words, he believed, we hypothetically suppose, that the pictures or statues he was evoking attempt to represent different aspects of their subject matter (maybe we can say that they represent different "objects"), that they were meant to perform their task in different ways, and that therefore they invite different reactions, or expectations, in the spectators looking at them. The documentary basis for such a claim, it should be admitted at the beginning, is rather slim. We cannot prove that the early Christian period was aware that we have here two distinct types of images, but the contention is one that deserves to be looked at carefully.

A present-day spectator will not find it difficult to see the difference in genre between an "icon" of Christ, a "holy face," and a representation of the Good Shepherd, or of Christ healing the woman with the hemorrhage. These are images that belong to different levels of meaning; they constitute different art forms. The latter group—that is, the works Eusebius described as public monuments—we would easily classify as symbolic or narrative representations. They either tell a story, or they "mean" something, signify a content. That story or content, it goes without saying, is outside the monument itself, either as an event that

happened in the past, or as a timeless meaning not tied to any specific present, or age. Students of modern semiotics might claim that those religious public monuments that Eusebius evoked in his historical writings "refer" to something that, of course, is different from the statues themselves. Such a student might find it consistent that Eusebius mentions, among the "monuments," a cross, "the sign of our Savior's suffering," that the emperor Constantine had laid out in sparkling jewels on the ceiling of his palace.[12] The cross on the ceiling reminded the emperor and his visitors of the true cross, but in its precious materials it surely did not pretend to be that original cross.

The other type of image is the one Eusebius had in mind when he composed his letter to Constantia. This image clearly does not intend to tell a story, nor does it attempt to "signify" something totally outside itself. It obviously claims to show the Lord's true "form," as that form really is, or rather was. Once again using semiotic terminology we could say that Eusebius, to characterize this particular type of Christ image, thought of what in the late nineteenth century Charles Sanders Peirce called "iconic sign" or "iconicity."[13] For a reader used to the finer analytical distinctions of modern semiotic theory, Eusebius's text may seem primitive or even crude, but his basic belief comes clearly to the fore: it is a belief in an identity of sorts between the form of the icon and God's true form. It is precisely the belief in such an identity that makes the painted icon altogether impossible. Since the form of the living God is unattainable, the icon claiming to have that same form cannot be made.

In sum, then, Eusebius presupposes two different types of images. This not to say that a rigid distinction can be maintained between them, nor that a borderline can be followed throughout all the ramifications of the problem. All we wish to say is that the scattered writings of our author lead us to such a conclusion. Were Eusebius and his audience aware of such a split in their concept of the image of God? Did they account to themselves where their thought was taking them, and did they attempt to apply that awareness to their specific concerns with sacred images? As I have just said, the documentary evidence is slight, but some indications of a possible awareness may nevertheless be detected.

The question here posed has received some attention from modern scholars. Johannes Kollwitz, in an interesting discussion, to some extent

dealt with it.[14] Kollwitz mainly refers to a previous study, an article by D. Ainalov, which appeared as early as 1902.[15] Though, in the nature of things, these scholars were not able to reach any firm conclusions, their attempts indicate a direction that might be worth pursuing.

The terms early Christian authors frequently used to describe sacred pictures or statues may offer some interesting clues, although they leave many questions unanswered. A word of warning should be given in advance. In its early stages, Christian theological literature does not excel by a consistent use of terms, and even less so when the subject described is of admittedly minor import. The terms, moreover, taken over mainly from the Greek philosophical tradition, often carry in themselves various shades. In spite of these reservations, however, the use of terms is not a matter lacking in significance. The very fact that different terms were employed for designating the same object indicates that different aspects and functions of the holy image were clearly perceived.

Except for the generic term *eikon*, early Christian thought, and particularly Eusebius, employed mainly two terms (to which a third was later added) to designate holy images. They were *symbolon* (to which *istoria* was added) and *character*. This alternative terminology, and particularly the fact that two or three different words were used to describe what is seemingly the same kind of object, has not passed unnoticed by students of early Christian art and thought.

The category of images that go under the heading of "histories" *(historiae)*, to begin with the latest term, are the least problematic in our context. What Eusebius and his time meant by this term are representations of events, mainly those related in the Old and New Testament. Though the term may have come into use later, the type of narrative picture, or narrative cycle relating a story in images, was part and parcel of the ancient legacy.[16] It goes without saying that for Christians an historical event, particularly of sacred history, is never devoid of meaning; the event, they believed, figuratively or symbolically expressed the eternal realities hidden behind it.[17] No wonder, then, that the line dividing "history" and "symbol" cannot be sharply drawn.

More important for our present study, and current in the period under investigation, is the category of images Eusebius himself called "symbols" *(symbola)*. These were not narrative pictures, but rather emblematic configurations; they are focused on stable, unchanging meanings rather than on transitory events. As we know, Eusebius specif-

ically mentions two such *symbola*—the Good Shepherd, which he knows as a public monument, and Daniel in the lions' den.[18] In fact, both themes originate in stories told in the Bible,[19] that is, actions or events that unfold in time. Eusebius, however, and probably most of his contemporaries, understood the pictures not as telling a story but as evoking a meaning. Even a brief look at the many representations of these particular scenes in early Christian art convinces one that this is precisely how the two biblical subjects were conceived in the Christian culture and thought of the whole period.

When Eusebius spoke of these images as *symbola*—what precisely did he wish to say? We do not have an articulate theory of symbolism, as embraced by Eusebius, that might guide us, nor, as already noted, was his use of terms very consistent. Nevertheless, it may well be worth our while to look at what he intends when he speaks of symbols in other contexts. A symbol, we know, is a sign, that is, something that is not the real thing it denotes. Origen says that whatever happens in an unexpected or strange way in Scripture is "a sign or a symbol" *(semeion kai symbolon)*.[20] Here, then, there is no essential difference between a sign and a symbol. The same may be true of Eusebius, who speaks of "symbol" in a variety of contexts. To give but one example, we celebrate Christ's offering, he says, "by means of symbols of His Body and Blood."[21] A little earlier in the same chapter he speaks of the symbol in a way that even more strongly emphasizes the distance between the original, the archetype, and the symbol that stands for it. The Christian should not fall back on the prophecies that were made to the Jews, the saint warns true believers. These prophecies are only "symbols and likenesses, but do not contain the truth itself." Since the Jews did not yet have the reality of Christ's offering, they "held fast to their symbols."[22] Here, then, "symbol" does not signfy the true offering; the term clearly marks the distance between the prophecies and Christ's true offering.

The other term employed is "character" *(character)*. Ainalov and Kollwitz have convincingly shown, I believe, that "character" was employed to designate a special group of images, and as such it was almost a technical term. The images so termed were portraitlike faces of Christ, and perhaps also of saints. In other words, here the sacred image is not an emblematic configuration; it is not determined by an action or event, or by a different combination of features that requires that the spectator properly "read" or interpret what he or she perceives. In the image

called "character" it is the face itself that speaks, and it does so directly and immediately. Eusebius himself, in the letter to Constantia, uses the term "character" to designate the face of Christ, and the translators of the letter into Latin did indeed put the Latin *vultus* for the Greek *prosopon*.[23] If we follow this terminology we will have to say that in looking at a *symbolon* we are faced with a transformation of the content, a translation of the original revelation into another medium. This transformation mediates between the invisible God and the limits of our abilities to perceive. Whatever this transformation may consist of, it spares the mortal spectator the direct encounter with the divine appearance, an encounter the spectator cannot bear, or, in some traditions, cannot survive. The portrait of Christ provides precisely this encounter.

The term "character" in itself is indicative of, and supports, this reading. "Character," as one knows, was a technical term, and its origins may well be sought in some workshops. Originally the term designated a seal, and later the meaning was extended to include the impression made by the seal. As the dictionary has it, "Character: that which is 'cut in' or 'marked,' the 'impress or stamp on coins, seals, etc.' " In a figurative sense "character" means the mark or token impressed on a person or thing. Johannes Kollwitz correctly stresses that the notion of "character," in its original meaning, forms the very basis of assuming a similarity between the icon and the divine figure it represents.[24] While this interpretation is true, it does not seem to sufficiently define the specific nature of the term. Similarity, as we shall have occasion to see, can have various shades of meaning. What is suggested by the term "character" as a designation of a type of picture is that the icon flows directly from the original model. In this sense it has an affinity to what Neoplatonic thinkers meant by "emanation."

The significance of the terminological development traced in the preceding pages calls for assessment, at least in a few brief observations.

One should not entertain too high hopes, it is worth reminding ourselves, of the light that the articulation and application of terms may throw on intellectual developments. The dates at which our terms began to appear in a more or less precise sense for the designation of pictures are not clearly established. In most texts, moreover, it is doubtful whether the terms *historia*, *symbolon*, and *character* are consistently used to describe types of sacred pictures. There is no way, then, to make terminology "prove" the precise stages of the development of a doctrine. On

the other hand, however, it would obviously be wrong to look at the processes in which terms are fashioned as arbitrary and random events. The articulation and wide employment of terms, even if not fully consistent, indicate that a problem is taking shape in public awareness, that a need is being felt to distinguish between different components, layers, or aspects of a subject that at an earlier stage were not clearly separated from each other. Eusebius's terms show that such a need was felt with regard to images of Christ.

With all our hesitations, the splitting of the notion "icon" into different types requires us to reach some conclusions. The most obvious one is that on the intellectual horizon of early Christianity images remained a problem, and that they continued to occupy the minds of Christian thinkers and teachers. From the apologists in the late second century to Eusebius in the early fourth, images were obviously felt as a challenge, both in social and ritual reality and in theological thought. Neither the furious attacks on idols, such as those by the apologists and Tertullian, nor the profound change that replaced pagan idols by Christian icons solved the problem of the image. Even belief in the invisibility of God, and therefore the utter impossibility of portraying God, did not do away with the constant feeling of danger that resided in the icon. The image of the God, of the "false" or of the "true" one, continued to exert a dangerous fascination on people's minds.

One wonders what made the image strong enough to survive in such an unsympathetic intellectual atmosphere. Did it draw its life force from the powerful iconic traditions of Hellenistic culture? Or was it the powerful human need for a visible approach to the hidden God that gave the image such strength? Perhaps no simple answer can be given, and it is not our task to speculate about the true yet hidden reasons for the image's survival. Be that as it may, in reading the Christian literature from Athenagoras to Eusebius one cannot question that the image was felt as a permanent challenge.

When considered in the historical context of the early fourth century, the distinction between two classes of pictures, the *symbola* and the *characteres,* in a sense reflects the two great cultural traditions and religious attitudes that met and fused in Christianity. In new, transformed versions we perhaps see here, on the one hand, the Hellenistic attitude to the ritual image, and, on the other, the theology of an invisible God, a theology that has its roots in biblical concepts. Was the

division of the two classes of images an attempt to find a compromise between an anti-iconic religion and the habit of adoring images? Or did history rather force into the open the conflict between the contrasting tendencies within Christianity? An examination of the theory presuming two types of sacred images for what it may disclose about social and doctrinal developments still remains to be made.

For the subject of the present study, the theory of the sacred image, Eusebius's most important contribution is the very distinction between two categories of holy pictures—symbolic images and iconic images. It would not be easy to draw a clear dividing line between the two types of icons, as Eusebius understood them, even if the texts he left us had been more detailed and specific than in fact they are. In practice, setting off *symbola* from *characteres* is difficult and confusing, particularly since the figures represented in them are often the same. It is the same Christ who appears in the monument commemorating the miraculous healing of the woman with the hemorrhage, and in the icon that Constantia wished to have. And yet, as we have seen, Eusebius reports on the one with appreciation, and totally rejects the other. The distinction between the two types of religious image, then, rests on other foundations than the personage represented. The splitting of the holy icon had an important afterlife, both in the Church and in views on art.

NOTES

1. The scholarly literature, needless to say, is of somewhat fearsome dimensions. For our purpose, see E. Boularand, *L'hérésie d'Arius et la "Foi" de Nicée*, I (Paris, 1972). See also the article by Harry A. Wolfson, "Philosophical Implications of Arianism and Apollinarianism" (describing Arianism as a "leftist heresy") in his *Religious Philosophy: A Group of Essays* (Cambridge, Mass., 1961), pp. 126–57. I am not aware, however, of any detailed study of the Arianic Dispute with particular reference to the painted icon.
2. It was Jean Boivin de Villeneuve who printed them in his edition of of Nicephoros's *Byzantina historia* (Paris, 1702). And see George Florovskii, *Christianity and Culture*, I (Belmont, Mass., 1974), pp. 107, 237 ff.
3. See the literature mentioned above, chapter 2, from which I should like to repeat only S. R. F. Price, *Rituals and Power: The Roman Imperial Cult in Asia Minor* (Cambridge, 1984), pp. 170 ff. For the icon in the life of an individual, see also Peter Brown (written with Sabine MacCormack), "Artifices of Eternity," *New York Review of Books*, XXII (1975), pp. 19 ff., and

reprinted in Peter Brown, *Society and the Holy in Late Antiquity* (London, 1982), pp. 207 ff. See also T. D. Barnes, *Constantine and Eusebius* (Oxford, 1981).

4. I use the translation by Cyril Mango. See *The Art of the Byzantine Empire, 312–1453 (Sources and Documents)* (Englewood Cliffs, N. J., 1972), pp. 16–17. The original text, with a Latin translation, is best available in J. P. Migne, *Patrologiae cursus completus, Series graeca*, XX (Paris, 1856), cols. 1545 ff.

5. The major formulations, as one knows, are Exodus 20:3–5 ("Thou shalt not have other gods before me. Thou shalt not make unto thee any graven image or any likeness of any thing that is in heaven above, or is in the earth beneath, or that is in the water under the earth. Thou shalt not bow down thyself to them, nor serve them.") and Deuteronomy 5:7–8, with almost precisely the same wording. And see above, chapter 1.

6. The Vulgate, the traditional Latin translation of the Bible, uses the verb *absorbeo*. In the Latin translation the sentence from 2 Corinthians 5:4 reads, "Nam et qui sumus in hoc tabernaculo ingemiscimus gravati, eo quod nolumus exspoliari, sed supervestiri, ut absorbeatur quod mortale est a vita."

7. The concrete formulations of this problem have been discussed in the literature on the ancient *epiphaneia*. See the entry "Epiphanie" by F. Pfister in Pauly-Wissowa, *Realencyclopädie der classischen Altertumswissenschaft*, Supplement 4 (1924), cols. 277–323; the entry "Epiphanie" by E. Pax in *Reallexikon für Antike und Christentum*, V (1962), cols. 832–909; and the interesting article by H. S. Versnel, "What Did Ancient Man See When He Saw God? Some Reflections on Greco-Roman Epiphany," in Dirk van der Plas, ed., *Effigies Dei: Essays on the History of Religions* (Leiden, 1987), pp. 42–55.

8. Eusebius, *The History of the Church from Christ to Constantine* VII, 18. I use the English translation by G. A. Williamson (Penguin Books, 1986), pp. 301 ff.

9. The motif of this group is well known from Roman supplication coins, perhaps most common at the time of Hadrian. See, e.g., Richard Brilliant, *Gesture and Rank in Roman Art* (New Haven, Conn., 1963), p. 135, ills. 3.78, 3.79. But it was also known in Eusebius's own time; it appears on a medallion representing Constantine I. See Brilliant, p. 190, ill. 4.72.

10. Hugo Koch, *Die altchristliche Bilderfrage nach den literarischen Quellen* (Göttingen, 1917), p. 41, who defines Eusebius as an "outspoken enemy of images" in the Constantinian period, thinks that Eusebius's description of this monument stresses its pagan connotations. In the description Eusebius does indeed say that it is the gentiles who thus expressed their gratitude to the Savior. A similar interpretation of Eusebius's description is also indicated by Jaroslav Pelikan, *The Spirit of Eastern Christendom, 600–1700 (The Christian Tradition*, II) (Chicago, 1974), p. 101.

11. *Vita Constantini* III, chapter 49.
12. *Vita Constantini* III, chapters 3 and 49.
13. Ch. S. Peirce, *Collected Papers,* mainly II (Cambridge, Mass., 1935), pp. 227 ff. For some of the complexities of the concept, without reference to art however, see Umberto Eco, *A Theory of Semiotics* (Bloomington, Ind., 1979), pp. 190 ff.
14. Johannes Kollwitz, "Zur Frühgeschichte der Bilderverehrung," in W. Schöne, J. Kollwitz, H. Campenhausen, eds., *Das Gottesbild im Abendlande* (Witten and Berlin, 1959), pp. 57–75. The article originally appeared in *Römische Quartalschrift,* XLVIII (1953), pp. 1 ff.
15. The article, dealing with icons in Sinai, appeared in Russian in *Visantiiskii Vremenik,* IX (1902), pp. 343–77. Important in our context are especially pp. 349 ff., 354.
16. The scholarly literature on classical *historiae* is large and complex. Important for their discussions of the theoretical dimensions involved are Carl Robert, *Bild und Lied* (Berlin, 1881); idem, *Archäologische Hermeneutik* (Berlin, 1919); Kurt Weitzmann, *Illustrations in Roll and Codex* (Princeton, 1970 [originally 1947]); and recently Richard Brilliant, *Visual Narratives: Storytelling in Etruscan and Roman Art* (Ithaca and London, 1984).
17. One quotation will illustrate this well-known approach. In *Contra Celsum* (II, 69) Origen proclaims, "The truth of the events recorded to have happened to Jesus cannot be fully seen in the mere text and historical narrative; for each event to those who read the Bible more intelligently is clearly a symbol as well" (p. 118 of the English translation).
18. See the text quoted above (for details see note 4) and the observations after this quotation.
19. The Gospel according to St. John 10:7–18; and Daniel 6:16–24.
20. Origen, *In Joann,* 13, 60. See Migne, *Patrologia Graeca* XIV, col. 521. And cf. Gerhart Ladner, "Medieval and Modern Understanding of Symbolism: A Comparison," *Speculum,* LIV (1979), pp. 223–56, reprinted in Gerhart B. Ladner, *Images and Ideas in the Middle Ages: Selected Studies in History and Art,* I (Rome, 1983), pp. 239–82.
21. *Demonstratio Evangelica* I, 10, 39. In the English translation by W. J. Ferrar, *The Proof of the Gospel: Being the Demonstratio Evangelica of Eusebius of Cesarea,* I (New York, 1920), p. 60.
22. *Demonstratio Evangelica* I, 10, 37. English translation, p. 58.
23. See Migne, *Patrologia Graeca* XX, col. 1545.
24. J. Kollwitz, "Zur Frühgeschichte der Bilderverehrung," p. 60.

Dionysius Areopagita: "Poetic" Theology

1. Some Characteristics of His Thought

In the preceding sections we have tried to follow the path, and mark the main stages, of articulations of views concerning the visible images of the invisible god. We have witnessed the unfolding of a paradoxical problem, and have watched the contradictions implied in the very nature of this problem becoming explicit and manifest. The dialectics of this problem come to a climax and are fully revealed, so it seems, in the writings of an author as mysterious as he was influential, Dionysius Areopagita.

Whenever the question of the validity and "truth" of the holy icon came up in the Middle Ages or in the Renaissance, probably no name appears as frequently as that of Dionysius Areopagita. The influence of his theories, in fact, by far exceeded the mentions of his name.[1] Dionysius was considered an authority second only to the Bible, and the ever-

recurring references, open or implicit, to what was believed to be his doctrine are a weighty factor in the reflection on sacred images. Strange as it may seem, both parties in the debate about icons, the movement condemning sacred images as idols and demanding their destruction, as well as the movement defending them and preaching their veneration, drew on Dionysius Areopagita, and both claimed him as their authority.

This unusual ambiguity holds true even for modern students and interpreters. Thus John Meyendorff, a historian of Eastern orthodox thought, believes that it was Dionysius Areopagita who shaped the iconclasts' attitude to symbol and icon.[2] In a review of studies on iconoclastic thought, undertaken as recently as 1980, this assessment of Dionysius's influence is even described as "obvious."[3] But another contemporary scholar, the Russian historian and student of ancient aesthetics, V. V. Byckov, sympathetically and convincingly describes how the "orthodox" party in the eighth-century iconoclastic dispute (that is, the party that defended the images) drew its basic arguments in favor of the holy icons from the same writings of Dionysius Areopagita.[4]

The critical student cannot help being dismayed. How can one account for such a flat contradiction in the reading of a well-known and well-established text? The conflicting interpretations offered throughout the ages, we are compelled to assume, mirror an intrinsic conflict in Dionysius Areopagita's thought itself—which may even reflect some immanent difficulty of the problems our author was dealing with.

In studying Dionysius Areopagita one gets used to paradoxes. Throughout many periods his writings exercised a profound influence on attitudes to works of art, and on aesthetic reflection in general. It was particularly the attitude to the visual arts, especially painting, that was determined by Dionysian thought. This is all the more remarkable since Dionysius Areopagita himself did not pay any attention to painting. Modern studies have not sufficiently stressed that in the whole body of writings attributed to our author, in the so-called Corpus Areopagiticum, we find not a single treatise that deals with art, not a single chapter devoted to painting or to a picture (or, for that matter, to a piece of sculpture), and there is not a single extensive statement that can be related specifically to an artistic activity or product. Were we to judge only by what is explicitly said in Dionysian writings, we would have to conclude that our author did not have any use for art. How then, one wonders, are we to explain his profound and far-reaching impact on the

ways art was regarded and interpreted in many ages? It is obviously not in details, in specific areas of reflection that we can look for an answer to these questions. We must consider the general orientation of his thought.

The pivotal theme of Dionysian theology, the problem around which the whole of his thought is built, is not new; but in the formulation he gave it, it seems to have been destined to form the basis of a philosophy of sacred art. The theme, briefly described, is that of theophany in our world, of the revelation of God to mortals. How can God appear to humanity, and how can God, who is beyond matter, be revealed in a world of material things? How can God, who is invisible by nature, be experienced in a world in which everything is perceived by means of the senses? This is the old question that, with new impetus and in new formulations, lurks in the background of Dionysian thought, and gives his theology its direction.

Dionysius Areopagita's guise, or rather disguise, is quite appropriate to the central subject matter of his thought. We know next to nothing about the person who composed the writings that form the Corpus Areopagiticum. There are good reasons to believe that he lived in the early sixth century, possibly in Syria. Students of Byzantine culture have tried to identify him with different historical figures,[5] but, so far as I can see, no conclusion has been reached. Certain it is that the name used by the unknown author was known from, and hallowed by, the New Testament text. In the Acts of the Apostles (17:22–34) we read of St. Paul's sermon preached at Athens. It was a sermon preached near an altar inscribed "To the Unknown God" (17:23).[6] At the end of the sermon "certain men clave unto him, and believed: among the which was Dionysius the Areopagite" (17:34). It was this piece of pseudo-epigraphy that contributed to giving the writings of "Dionysius Areopagita" an almost canonical status; but the story in *Acts* also somehow announces one of our author's central themes, the unknown god.

2. Conflicting Themes

The comprehensive spiritual vision of Dionysius the Areopagite, his theology and his view of how God and humanity relate to each other, are marked by an intrinsic tension resulting from conflicting tendencies existing next to each other, and even interacting in various ways. Any

attempt to analyze the central problems in the Dionysian text will have to deal with this tension, and so will attempts to understand what it was that made him so significant in the theory of images. I shall start with a brief and schematic survey of the two tendencies, and shall then ask what they may have meant for thought on visual symbols in general and holy icons in particular.

(i) *Transcendence* Belief in the absolute transcendence of the divine is the first feature in Dionysian theology. Our unknown author's point of departure is a profound awareness of the abyss separating the two worlds, the celestial and the terrestrial, or the divine and the human. The notion of the two worlds, it need hardly be said, is age-old, and it is well known that it loomed large on the spiritual horizon of the early Christian centuries. Dionysius Areopagita, however, endowed this traditional notion with an intellectual and emotional urgency that was rarely matched.

The divine being, Dionysius teaches, cannot be properly experienced or grasped, and therefore it also cannot be expressed. In putting forward these views, he sometimes touches upon problems that belong to the very foundations of visual experience and of the visual arts.

Just as the senses can neither grasp nor perceive the things of the mind, just as representation and shape cannot take in the simple and the shapeless, just as corporeal form cannot lay hold of the intangible and incorporeal, by the same standard of truth beings are surpassed by the infinity beyond being, intelligences by that oneness which is beyond intelligence.[7]

In view of that total ineffability, Dionysius naturally asks, "How then can we speak of the divine names? How can we do this if the Transcendent surpasses all discourse and all knowledge. . . ? How can we enter upon this undertaking if the Godhead is superior to being and is unspeakable and unnameable?"[8]

It is statements like these that make Dionysius Areopagita a major figure in what is known as "negative theology." Affirmative *(katophatic)* theology, we have learned, states perfections as the characteristics of God; negative *(apophatic)* theology denies that these perfections are characteristics of God. Any perfections we know, and can attribute to God, are those found in the created world; projecting them onto the divine being is necessarily a "clouding" of the divine purity. God, therefore, can be known only "through unknowing."[9] The idea occurs in the

whole body of writing that goes under Dionysius's name, but it becomes particularly obvious in the *Mystical Theology,* a short treatise (only a few pages long) that had a profound influence on European thought. Here Dionysius offers a hymnic praise of apophatic theology. Of what is called the Supreme Cause he says,

There is no speaking of it, nor name nor knowledge of it. Darkness and light, error and truth—it is none of these. It is beyond assertion and denial. We make assertions and denials of what is next to it, but never of it, for it is beyond every assertion, being the perfect and unique cause of all things, and, by virtue of its preeminently simple and absolute nature, free of every limitation, beyond every limitation; it is also beyond every denial.[10]

Everybody who studies, however briefly, negative theology in the context of our present subject—that is, what it may mean for the understanding of the images of God—will have to consider an aspect we have not mentioned so far, the psychological aspect. Even our brief and sketchy comments will show, I hope, how crucial this particular aspect is for the doctrine of icons.

In mainstream theology the claim to objective knowledge prevails. The great teachers of theology referred to the sources of authority (Scripture, the Fathers, or the decrees of councils), and they expounded the doctrines according to the accepted rules of rational discourse.[11] Yet even objective theology, however systematic and fully articulate, left room for the mystery and the ineffable. "Every word of God written for men according to the present age is a forerunner of the more perfect word to be revealed by him in an unwritten way in the Spirit," said Maximus Confessor, the dominant theologian of early Byzantine thought.[12]

Against this dialectic background of an objective theology that is aware of its limitations, another theology emerged. It was a theology of subjective knowledge and religious experience. In the fifth and sixth centuries a.d. the theology of an intuitive knowledge of God reached a climax in the Christian East. As is well known, this was a period of high religious tension, and trends of personal devotion, sometimes fervent, developed here. The movement of the Eastern monks was probably the best known. It was these trends, particularly monasticism, that emphasized the psychological aspects of religious life.[13] The concern with psychological problems, with the urgency of religious experience, existed not only alongside systematic theology; it even penetrated into the body of systematic doctrine.

(ii) *Hierarchy* The other motif that forms a focus in Dionysian thought is perhaps somewhat less traditional than the concept of God's absolute transcendence, though it seems to be deeply rooted in human attempts to understand how God relates to the world. It is the idea of hierarchy. The theme of hierarchy to a large extent dominates the reflections and deliberations that make up the Dionysian corpus. Differing from the concept of God's total transcendence, Dionysius's fascination with hierarchy is openly displayed. One of the most extensive treatises in the corpus deals with, and bears the title, *The Celestial Hierarchy*.[14] Another treatise, even slightly longer, is devoted to *The Ecclesiastical Hierarchy*.[15] It is therefore no exaggeration to claim that hierarchy is the pivotal point of Dionysius's whole system.[16] As we shall shortly see in some detail, he also played an important part in developing and articulating the implications of hierarchy for religious and cosmological thought. An important modern philosopher and historian of thought could claim that it was Dionysius Areopagita who presented the problem of hierarchy in all its acuteness.[17]

Dionysius's consistent and lasting concern with hierarchy is of particular significance when we compare it with the other leading motif in his thought, God's otherness and complete transcendence. The concept of hierarchy is apt to emphasize gradual transition, the graded passing from one condition to another. These connotations sharply conflict with the concept of divine transcendence, a notion suggesting a sharp, irreparable break between the worlds. It is this collision that makes it necessary to look briefly into the history of hierarchy concepts before the sixth century a.d.

The notion of hierarchy, it is well known, has been employed in a bewildering variety of contexts, from the choirs of angels to the ranks of the military. This variety of applications, however, has not obscured the basic characteristics of the notion. In all variations, it seems, two features can always be found; they constitute the nature of the concept, and without them we cannot speak of hierarchy. One of the features is that any hierarchy must be considered as a whole. It is the same substance, as it were, that prevails throughout the whole system, the same authority that dominates all its parts. A hierarchy can exist only as a whole. The individual level detached from the whole structure does not form part of a hierarchy, as an individual rung, isolated from the whole, does not form part of a ladder. In antique sources, it is worth recalling, hierarchy

was often compared to the human body; the individual limb, these sources say, cannot exist for itself; it is only within the whole organic body that it has any distinct being.[18]

Without going into any further analysis of this characteristic we can say that it is precisely because of this unity, of the interdependence of the specific rungs, that hierarchy can serve as a mediator linking the top of the scale to its bottom.

The other characteristic feature of hierarchy is more conspicuous. It is the gradation of the scale. While the unity of the hierarchic scale is implicit, the gradation is openly displayed; it is the external hallmark of hierarchy. Wherever a hierarchy is perceived, there we find a scaling, every rung is related to any other in a quantitative way, so that it can be expressed in terms of "more" or "less." Often this quantitative relationship is cast in spatial terms: we speak of up and down; a given rung in the ladder, we say, is "high" or "low."

The idea of hierarchy was not alien to early religions. The most famous example is, of course, Jacob's ladder (Genesis 28:12). Homer's golden chain, suspended from heaven, is another, though more problematic, illustration.[19] In the philosophical and scientific thought of Antiquity one also finds some, rather rudimentary, reflections suggesting a "scale of being," particularly a scale of nature.[20] Suggestions of hierarchy can be found in Plato, particularly in the *Timaeus* that was so influential throughout the Middle Ages. It is in this work that he describes the return journey from the higher region of the "absolute being" to the lower world. Among the philosophers of nature it was Aristotle who seems to have perceived a detailed scale of perfection. Thus among living creatures he conceived of a scale of eleven grades, beginning with zoophytes at the bottom and ending with humanity at the top.[21] Yet though the idea of hierarchy was "in the air," as it were, in classical Antiquity it did not crystallize in a theory.

It was only in the last stages of the ancient world that a hierarchic image of the world was approached. Neoplatonism, in its particular orientation and interests, showed a tendency to see a coherent general scheme of things in a descending series of levels.[22] Plotinus's concept of emanation, based on the principle of the expansiveness and self-transcendence of "the Good," which became the essential conception of Neoplatonic cosmology, had an inherent affinity to the idea of hierarchy. Plotinus himself, however, did not insist on the hardened, stable forms

and structure of each particular level in the descending row, each "hypostasis," as he said, to the extent of impressing upon his readers the image and doctrine of a firmly graded scale. In his mind, it seems, emanation was primarily a dynamic, ever-changing process of overflowing, not a definitively structured scale.

In the century that saw, at its close, the work of Dionysius Areopagita, the notion of hierarchy was a little more closely intimated. Macrobius, in the early fifth century, provided Western Europe with a Latin abridgment of Plotinus's cosmology; he also summarized the conception of—somewhat obscured—cosmic hierarchy, as it results from the Plotinian doctrine of emanation. It was this summary that was a major source for the Latin Middle Age's acquaintance with the Neoplatonic picture of the world.[23]

In the intellectual world of early Christianity, as in contemporary pagan culture, the idea of a scale or a ladder was not altogether alien, although it did not crystallize into an articulate doctrine of hierarchy. Clement of Alexandria, for example, is aware of a hierarchy as a "political" fact within the ecclesiastical structure—the hierarchy of bishops.[24] Clement finds authority for ecclesiastical hierarchy in the choirs of angels, which he perceives as cast in hierarchic order. The hierarchy of bishops is a reflection of the hierarchy of the angels. Leo the Great, the dominant figure of late fifth-century theology, seems to have been aware of both the necessity and the dangers of hierarchy. All the apostles were chosen, but even they, Leo the Great says, received grace to different degrees, and hence they received distinction and authority to different degrees; some apostles were superior to others. It is this canonical model that lends legitimacy to the different ranks of the bishops.[25]

3. The Doctrine of Symbols

The themes I have outlined as the background and framework of Dionysius Areopagita's speculative thought are, of course, well known. He himself was fully aware of their traditional character, and approached them as time-hallowed topoi. But does he really only repeat what his predecessors have already said? As happens so often, in taking over and further developing traditional concepts and themes, Dionysius, in fact, gave them a new turn, and emphasized aspects that in earlier stages had received less attention. We can therefore ask, what is Dionysius's new

and original contribution to those traditional problems? I should like to concentrate on two subjects only: one is what he has to say about the nature of the symbol in general, and, if possible, the image in particular; the other is what effect he thought the symbol, or image, has on people.

Before we turn to his doctrine of symbols, we must mention another of the paradoxes to which the student of Dionysius Areopagita becomes accustomed. Both the central significance of the symbol in Dionysius as well as the influence this theory exerted on medieval and Renaissance thought are well known.[26] It is therefore particularly remarkable that in the Corpus Areopagiticum, as we now have it, no detailed and systematic presentation of Dionysius's views on the symbol can be found. In several of his writings he refers to a treatise he composed under the title "Symbolic Theology," yet this treatise is lost. It is strange, modern scholars have noticed,[27] that of an author whose whole work is permeated by reflections on symbolism it was precisely this treatise that has disappeared. Was it never actually written? One cannot help wondering. Dionysius ends his work *The Divine Names* by saying, "So here I finish my treatise on the conceptual names of God, and, with God's guidance, I will move on to *The Symbolic Theology*."[28] But in one of the letters attributed to him he writes that he is actually sending "the full text of my *Symbolic Theology*."[29] And at the beginning of the *Mystical Theology*, some scholars believe, we probably have a full table of contents of this work.[30] Whether Dionysius's *Symbolic Theology* was lost or was never written, the Dionysian writings, as we now have them, contain no systematic presentation of his thoughts on symbolism, a subject of crucial significance in his intellectual world. One has to reconstruct his doctrine from the many observations scattered in all his extant writings.

Dionysius Areopagita's references to his systematic treatise on symbolic theology suggest two conclusions. The first and obvious one is that he considered the subject of symbolic theology a topical theme, of pressing importance to his time. A second conclusion, less obvious yet still likely, is that in the literary tradition with which he was familiar (both that of the Church Fathers and of the "pagan" authors) he had not found a text that he could accept as the theory of symbolic theology he was looking for.

Now, how did Dionysius Areopagita understand the symbol, and how does his doctrine of symbolism pertain to the painted icon?

Dionysius's use of the term *symbolon* calls for some explanation.

René Roques stressed that the Dionysian *symbolon* is not fully translated by the French (or English) "symbol."[31] The Greek term, as used by Dionysius, differs both in range of meaning and in emotional connotation from its meaning in modern languages. It would be foolhardy to attempt a discussion of present-day usages of the concept of "symbol"; the literature pertaining to this subject has reached unmanageable proportions. Nevertheless, one cannot help feeling that when we nowadays speak of "symbol" we tend to emphasize the gap between the object (or form) that serves as symbol and the idea (or other content) that is to be symbolized. In Dionysian thought, the *symbolon*, while never negating the difference between symbol and symbolized, represents mainly what they have in common. *Symbolon*, in his view, is not only a sign, but is actually the thing itself.

In the context of Dionysian theology the function of the symbol is to overcome the contrast between God's transcendence and the hierarchy that links God to the material world. This end is achieved, or at least approached, in a two-way movement: one is a descent, motivated by grace, of God to humanity; the other is an ascension of humanity to God. The two processes, of God's revelation, theophany, and of humanity's elevation to the divine, *anagoge,* merge to overcome the contrast.

I shall now try to outline the two processes, but I shall do so with a specific question in mind. This is, what are the aspects of the Dionysian theory of symbols that are of particular pertinence for a theory of artistic images? To be sure, these aspects are not clearly spelled out by Dionysius himself. But if we approach his writings with this question in mind, we can grasp the outlines of an answer. In trying to present Dionysius's theory of symbols with this question in mind, one must present a picture that will differ, if only slightly, from what the historian of theology will see in this doctrine.

The idea of the two complementary, if opposed, processes is not new. In Neoplatonic thought the double process—the emergence of the many natural beings and appearances from the supernatural One, and their ultimate return to their source—was a familiar image. It was also considered a matter of course that the two processes complement each other. Dionysius Areopagita follows this model, and, partly by bracketing pagan themes with supporting biblical quotations, transforms them into Christian doctrines. A good example is the opening paragraph of *The Celestial Hierarchy*:

"Every good endowment and every perfect gift is from above, coming down from the Father of Lights" [James 1:17]. But there is something more. Inspired by the Father, each procession of the Light spreads itself generously towards us, and, in its power to unify, it stirs us by lifting us up. It returns us back to the oneness and deifying simplicity of the Father who gathers us in. For, as the sacred word says, "from him and to him are all things [Rom. 11:36].[32]

Let us now consider each of the processes separately, and begin with the idea of God's revelation, of theophany.

4. God's Descent

God's descent to man, his revelation, is the most essential process in the world, and it is thus superior to man's attempts to rise to the full understanding of the divine. Even when people believe that they are ascending to the divine by their own forces, they are, in a sense, the victim of an illusion; in fact, it is God who is descending to them. Dionysius (though in a different context) illustrates this belief in a lively image:

Or picture ourselves aboard a boat. There are hawsers joining it to some rock. We take hold of them and pull on them, and it is as if we were dragging the rock to us when in fact we are hauling ourselves and our boat toward that rock.[33]

Perhaps no other theologian has seen the dialectical nature of revelation so sharply as did Dionysius Areopagita. The revelation of the divine is not alien to God, nor is it something that happens to God; rather, it follows from God's own nature. But even when revealing itself, the god cannot annul the difference between the divine and the terrestrial. To explain how a revelation of God is possible, Dionysius uses a concept from aesthetic thought; it is the concept of resemblance. As we have seen,[34] in late Antiquity the concept of resemblance played an important part in reflection on art. Planting the aesthetic concept in metaphysical and theological contexts, Dionysius endows it with a new meaning.

For anything to reveal God, to be the body of revelation, as it were, it has in some way to resemble the divine; but God, we also know, is altogether different from everything we can see and experience. Dionysius's way out of this dilemma is his doctrine of dissimilar similarity.

Scripture itself asserts that God is dissimilar and that he is not to be compared with anything, that he is different from everything and, stranger yet, that there is

none at all like him. Nevertheless words of this sort do not contradict the similarity of things to him, for the very same things are both similar and dissimilar to God.[35]

The concept of dissimilar similarity is one of Dionysius Areopagita's most interesting contributions to the theory of the icon, and to aesthetic thought in general. This concept epitomizes his tendency to perceive contrasts in, and as, the very structure of reality. Dissimilar similarity, though the formulation strikes us as paradoxical, is not a play on words; it is crucial for the understanding of his thought in general, and for grasping his theory of symbols in particular.

Similarity, as a concept and as a term, was not devoid of what one might call "cultural connotations." In late Antiquity, the idea of similarity was firmly linked with painted or carved images, though it was also used, of course, in much wider contexts. By Dionysius's time the term, particularly when used in the context of images (however broad the meaning of the latter may have been), must have evoked the general notion of what would today be called aesthetics. But what Dionysius wished to express by this term was not a matter of art theory, but one of theology. The crucial statement about how God relates to the world is cast in the terminology of aesthetics.

Dionysius's idea of God, and of the urges and drives within the divine nature, would make a fascinating subject for analysis, but it is not one we can take up here. For the present purpose it will be sufficient to state —not without hesitation—that he discerns two opposing urges rooted in the god's nature: the desire to reveal itself to humanity, and the wish to retreat into itself and to cut off any links with what is outside of itself. The principles of hierarchy and transcendence are transferred into the god's own nature, and are made impulses of its being.

Revelation, it goes without saying, is a kind of divine communication to the world. Ancient thought made popular the image of the god communicating itself to the world. In religious language this communication was termed "revelation." Implied is the powerful, if tacit, assumption that God's revelation, the theophany, is not detached from the god itself. The god reveals itself by embodying itself in the appearances it makes people see. It is this assumption that grants the concept of similarity a significance that goes beyond mere sense perception.

Now, what I want to suggest is that Dionysius Areopagita's use of the term "similarity" in his analysis of theophany implies a position con-

cerning the nature of what we perceive. What God's revelations make appear before our eyes is not a mere optical illusion, a delusion of our senses. What we perceive as a revelation of God does have some real affinity to the divine. Similarity, in Dionysius's usage, denotes something objective, a property of what actually exists, not merely a spectator's impression. A thing is similar to something else because it takes part in the nature of that other being. Therefore, the more one thing partakes in another, the more similar it will be to that thing.

While theophany, God's revelation, offers us as it were a real glance at God, it can never be complete. Were it complete, nothing of God's transcendence would be left. The god who reveals itself appears, or is embodied, in terrestrial things and sensual appearances, that is, in objects and phenomena that, in themselves, remain alien to the divine, and can never show it fully. However genuine the similarity of the revealed god to its essence may be, an unsurmountable element of otherness remains. Similarity to the divine, it follows, is always limited and relative; it is doomed to remain fragmentary, and to contain its opposite. This is the origin of "dissimilar similarity."

The shapes, things, and appearances that are characterized by dissimilar similarity are what Dionysius calls "symbols."

It may be useful to compare Dionysius's views with those held by the greatest thinker of Christian Antiquity, Augustine. Augustine precedes Dionysius by two or three generations, and in many respects they are worlds apart; Dionysius is rooted in Greek, Eastern traditions, Augustine in Latin, western culture. Yet the problems they faced were close enough to allow a brief comparison of their views on our subject.

The problem of sign and symbolism played a significant role in Augustine's thought. Already in his early treatise *On Dialectics*, written in 387, when he was thirty-three years old, he discussed the subject. Almost thirty years later, in 415, in *On the Trinity*, he stated the problem as he saw it in old age. But the most specific presentation of his theory of symbolism is found in *On Christian Doctrine*, written in 397, about halfway between the two other works.[36]

What Augustine says about the symbol marks an important stage in the development of semiotics.[37] It differs in character from Dionysius's statements; and we shall look in vain in the writings of Dionysius Areopagita for the analytical distinctions characteristic of Augustine. If different types and categories of symbols are at all to be found in

Dionysius's thought, they are veiled and hidden; the student has to bring them to light.

Not less important for our purpose is the emotional attitude to the symbol. For Augustine, symbols are instruments that trigger mental processes; in themselves, apart from what they do or perform, they are devoid of value. Essentially he conceives of them as signals.

That symbols are essentially signals we can learn from the fact that they remain unintelligible if we don't know their code. Knowledge of the code, however, does not come by nature; it has to be acquired. This is obvious when we think of words, but it also holds true for visual experience. Pantomime might appear, at least at a first glance, to be a domain of natural expression, intuitively grasped by the spectator. Yet even pantomime requires a convention, which the spectator has to learn. In one of Augustine's most probing discussions of the symbol he says,

If those signs which the actors make in their dances had a natural meaning and not a meaning dependent on the institution and consent of men, the public crier in early times would not have had to explain to the Carthaginian populace what the dancer wished to convey during the pantomime. Many old men still remember the custom, as we have heard them say. And they are to be believed, for even now if anyone unacquainted with such trifles go to the theater and no one else explains to him what these motions signify, he watches the performance in vain.[38]

That the code always has to be learned only shows that, in Augustine's thought, the symbol, or sign, is not understood as arising primarily from the nature of what is symbolized. To be sure, Augustine does not explicitly say so, but from the trend of his thought it follows that the sign, in itself, is devoid of inherent meaning or sanctity.

Dionysius Areopagita's thought on the symbol differs from that of Augustine. It is not difficult to recognize how readily Dionysius sees a community between the nature of the symbolized and the symbol. His teachings on the sacraments epitomize this attitude. The sacrament actually partakes in Christ's nature. "It is while there are placed on the divine altar the reverend symbols by which Christ is signaled and partaken that one immediately reads out the names of the saints."[39] Signaling and partaking are closely related to each other.

Another example is the rite of burial. The "blessed ordinances grant divine communion" to both the soul and the body. For the soul they do so by way of mere contemplation. "And they do so for the body,"

Dionysius goes on to explain, "by way of the imagery of the most divine ointment and through the most sacred symbol of the divine communion."[40] Once again we see that the symbol of Christ is not a signal; it takes part in Christ's nature and therefore communicates sanctity.

What all this amounts to is an emphatic feeling of certainty that, in some inexplicable way, God is actually present in the symbol. By way of hierarchy, then, God, or something of God, does actually come down to the level of human experience. Dionysius Areopagita epitomized this feeling, which, in perhaps less fervent form, was common to some mystical trends in his time.

5. Ascent of the Mind

So far we have been dealing with what we have described as God's descent to the sensually perceptible symbol, God's theophany. But God's descent to humanity, as we have said, is only one of two complementary processes linking the divine with the human. We now turn to the other process, to humanity's ascent to God, the *anagoge*. In his reflections on humanity's ascent, Dionysius touches on the problem of how we perceive divine symbols, and perhaps what, in a more general way, visual appearances can do to us. Underlying these questions is a concept, even if only a vague and hazy one, of what we would now call the subject or, in our context, the spectator. It would be both anachronistic and exaggerated were we to say that Dionysius explicitly considers what we now call the spectator. But it is true that he devotes attention to the human side of the hierarchic ladder, to how symbols are perceived. Without in any way ascribing a psychology to him, we have to say that he here ponders an aspect of the symbol that, as a rule, was rather disregarded. In these observations one finds, I believe, an original contribution.

A first indication of the reality of the spectator in Dionysius Areopagita's thought is the idea that the divine manifestation, whatever its specific form, is not perceived with the same distinction and clarity by everybody; different people will perceive and understand the same symbol in different degrees. Now, this may be an obvious idea, self-evident on the basis of everyday experience, and so, one feels certain, it must have been to people in late Antiquity. Yet in the large body of theories dealing with the symbol that Greek thought bequeathed to us, the differences in perception between different individuals were simply not con-

sidered. That Dionysius Areopagita does precisely this indicates that the subject, what we in our context often call the spectator, has become an important matter to him.

In several of his writings, Dionysius emphasizes that the ability to receive revelation may differ from person to person. To make this point he uses various similes and metaphors. His use of the traditional topos of the seal impression is a good illustration. Over many generations, we remember, the impression of the seal on the wax continued to be quoted.[41] As a rule, it served to show the more or less complete identity of the original and the copy. Though the impressions are many, thinkers using this simile stressed, the form is one and the same, and it originates in the seal itself. In roughly the same, though not quite identical, sense we also find the topos in Dionysius's writings. "There are numerous impressions of the seal and these all have a share in the original prototype; it is the same whole seal in each of the impressions and none participates in only a part."[42] And yet it remains true that there are differences from one impression to the other: "Maybe someone will say that the seal is not totally identical in all the impressions of it." This is an acknowledgment of the endless variety of degrees in which God's revelation is perceived and understood. To explain the differences in what is perceived, in the seal impressions, Dionysius continues, "My answer is that this is not because of the seal itself, which gives itself completely and identically to each. The substances which receive a share of the seal are different. Hence the impressions of the one entire identical archetype are different."[43] These differences are a universal human condition. "For the truth is that everything divine and even everything revealed to us is known only by whatever share of them is granted."[44]

My aim in quoting these references to the individual's abilities and limitations in perceiving divine revelation was not to deal with Dionysius's view of the individual; I rather wished to show that, in his thought, the person who perceives the revelation, who contemplates the symbol, is not merely a postulate of abstract thought, a logical requirement, as it were; that person is a real person with individual limitations. The spectator is given substance and reality. We now turn to the spectator.

The real human being is not able to perceive the divine without the help of protective layers, and these mediate between the original and the copy. A good illustration is provided by another time-honored topos, which Dionysius took over from Neoplatonic literature, the topos of

light and light rays. It is not possible for us to perceive the divine light directly. The divine ray "can enlighten us only by being upliftingly concealed in a variety of sacred veils which the Providence of the Father adapts to our nature as human beings."[45] Time and again he comes back to the assertion that the veils that cover God's pure appearance make it possible for us to perceive the divine revelation.

This, as is well known, was a common topos in the theological thought of Antiquity and the Middle Ages, familiar also to wide audiences, and used in the literature dealing with different subjects. The preceding chapters of the present book have also shown that this was one of the most commonly used themes. That the topos figures so prominently in Dionysius Areopagita's writings would, therefore, not be remarkable in itself. But in using this theme our author stressed two features that were rather neglected in the thought and writings of other authors who had similar views and employed the same similes. And it is these traits, or aspects, that were most important to the further reflection on images.

The first feature to be noted—and Dionysius Areopagita formulated it several times—is that the veils concealing the full, ineffable essence of God are themselves a gift of God. It is God who, in his "love of man" *(philanthropia)*, hides behind the symbols. The veiling of God is "a concession to the nature of our own mind." To a modern reader it may seem self-evident that the veils concealing an omnipotent god are also God's work. But earlier thinkers who dealt with the idea of veils concealing God stressed the gap between the god itself and the symbols representing God; they did not emphasize in any way that the symbols are God-willed. Dionysius does precisely this. Moreover, not only does he present the veils as following from God's own intention, but he also sees them as an expression of God's goodness and love for humanity.

For ecclesiastical doctrines of icons this attitude holds, even if only implicitly, far-reaching consequences. If the painted image is taken as a "veil," as was the case in later generations, Dionysius could be considered as providing a justification for its use. Moreover, he himself seems to sanction such interpretation. In a highly ambiguous passage in *The Celestial Hierarchy* Dionysius, on the one hand, rejects images of specific appearances ("We must not have pictures of flaming wheels whirling in the sky"), but, on the other, defends poetic images in a

wording that is worth careful reading: "The Word of God makes use of poetic imagery when discussing these formless intelligences but, as I have said, it does so not for the sake of art, but as a concession to the nature of our own mind."[46] The image, then, is not justified "for the sake of art," but it is defended as the embodiment of God's "concession to the nature of our own mind."

There is still another characteristic that Dionysius Areopagita discovered in the topos of the veils concealing the divine. These veils, he taught, not only attenuate the light radiating from the divine source, thus making it perceptible to human eyes; he also ascribed to them an active role. The symbols, or veils, incite people to go beyond mere external perception. Here Dionysius sings a palinode to the paradox, especially when perceived in visual form. It is the strikingly incongruent, the obviously inappropriate and unsuitable symbols, that stir our thought, that provoke wonder, and thus make us at least attempt to lift the veil.

It is from this point of view—the ability of the symbol to stir us to move on—that Dionysius distinguishes between two types of symbols. Sacred revelation, we learn from our author, works in two ways: "It does so, firstly, by proceeding naturally through sacred images in which like represents like, while also using formations which are dissimilar and even entirely inadequate and ridiculous."[47]

The first type of symbols, those in which similarity is more dominant, contains the great danger that people will take the symbols for the meanings, or ideas, or supernatural beings, that they signify. Thus we may take literally the anthropomorphic metaphors, as they occur in Scripture. Here lurks the great danger of idolatry. As modern readers we should add that a purely aesthetic approach to visible symbols also has something in common with this danger. An aesthetic approach will not distinguish between what we see and its meaning; it will not spur us to go beyond what we perceive. Because of this danger Dionysius prefers the second type of symbols. Let us listen to Dionysius himself. The passage is so significant that it warrants extensive quotation.

Since [in the theology of "Names"] the way of negation seems to be more suitable to the realm of the divine and since positive affirmations are always unfitting to the hiddenness of the inexpressible, a manifestation [in the reality perceptible by the senses] through dissimilar shapes is more correctly to be applied to the invisible. So it is that scriptural writings, far from demeaning the

ranks of heaven, actually pay them honor by describing them with dissimilar shapes so completely at variance with what they really are that we come to discover how these ranks, so far removed from us, transcend all materiality. Furthermore, I doubt that anyone would refuse to acknowledge that incongruities are more suitable for lifting our minds up into the domain of the spiritual than similarities are. High-flown shapes could well mislead someone into thinking that the heavenly beings are golden or gleaming men, glamorous, wearing lustrous clothing, giving off flames which cause no harm, or that they have other similar beauties with which the Word of God has fashioned the heavenly minds. It was to avoid this kind of misunderstanding among those incapable of rising above visible beauty that the pious theologians so wisely and upliftingly stooped to incongruous dissimilarities. . . . At the same time they enabled that part of the soul which longs for the things above actually to rise up. Indeed the sheer crassness of the signs is a goad so that even the materially inclined cannot accept that it could be permitted or true that the celestial or divine sights could be conveyed by such shameful things.[48]

The great value of the dissimilar symbol, then, is that it spurs the spectator, that it goads and incites him. But what is it that the dissimilar symbol encourages? To answer this question, Dionysius's language abounds in metaphors and images, all remarkably close to each other. It is the soul's ascent to God, what he calls *anagoge*.

With many variations Dionysius speaks of humanity's ascent, of God raising humanity upwards, of people's "climbing" upwards, of their being "uplifted" to the divine, of being led upwards, and so on. One would like to know what in fact *is* this process, for which so many descriptive turns are used. A comprehensive discussion of this image, as used by Dionysius Areopagita, would by far transcend the limits of the present study; therefore I shall only make a few comments concerning those aspects that have a direct relation to the problem of images.

Nowhere did Dionysius define the process of rising or being uplifted, or describe in some detail what actually happens when we are raised or uplifted. One of the few things we know is that the process has a direction. Both the term *anagoge* and all the images employed to suggest it show that the process is conceived in spatial terms. Time and again the movement upwards is stressed; the "higher" layers are those to which we are brought, or where we desire to arrive. Whatever he may have thought happens during this ascent, it is obvious that the background and source of his images is the myth of the soul's journey to the heavens or God. The mythology of the *Himmelsreise* was widespread in

the centuries of late Antiquity, and exerted a formative influence on the fantasy and thought of the period.[49]

Like the stories about the soul's ascent to heaven in late antique pagan religions, Dionysius Areopagita's idea of ascent not only has a spatial orientation; it also has a direction of character and quality. The mind uplifted is not only transplanted from one spot in space to another; it is also moved from one mode of being to another.

What the world to which the uplifted soul or mind are transferred looks like, what the soul sees in its flight, as it were—all this remains ineffable. Dionysius Areopagita employs an abundance of metaphors to adumbrate what cannot be properly articulated. He thereby richly illustrates the power of the paradox. When the mind is lifted up to the level of divine mysteries, it leaves behind all its prior notions of the divine. Thus, when the uplifted Moses sees the many lights, he "plunges into the truly mysterious darkness of unknowing."[50] Being uplifted, we become speechless.[51] At the end of his *Mystical Theology*, perhaps the most decisive of his writings,[52] Dionysius Areopagita gives a concise summary of apaphatic (negative) theology in the shape of a compressed description of what happens when we are being uplifted:

Again, as we climb higher we say this. It is not soul or mind, nor does it possess imagination, conviction, speech, or understanding. . . . It is not number or order, greatness or smallness, equality or inequality, similarity or dissimilarity. . . . Darkness and light, error and truth—it is none of these. It is beyond assertion and denial. We make assertions and denials of what is next to it, but never of it, for it is both beyond every assertion, being the perfect and unique cause of all things, and, by virtue of its preeminently simple and perfect nature, free of every limitation, beyond every limitation; it is also beyond every denial.[53]

It is tempting to speculate what Dionysius could have had in mind when he tried to imagine, however vaguely, what the ascending soul might meet on its way upwards. This is not the place to indulge in such speculation. But what the student of images must note, however, is one essential qualification: whatever the specific metaphors Dionysius employs when speaking of that upper world, they all have in common a negation of form, a canceling of distinctions and articulations to be perceived by the eye. "If only we lacked sight," Dionysius exclaims.[54]

The result of *anagoge,* of ascending and being uplifted, then, is the negation of visible form, along with the negation of all other positive

distinctions. The term Dionysius uses is *aphairesis*, literally translated as "taking away." It is a term that was common mainly in the Aristotelian tradition,[55] but was also used by Plotinus and in the Neoplatonic school.[56] To explain what he means by *aphairesis*, Dionysius employs a simile taken from the artist's workshop. Could we reach the stage of unknowing, "we would be like sculptors who set out to carve a statue. They remove every obstacle to the pure view of the hidden image, and simply by this act of clearing aside *(aphairesis)* they show up the beauty which is hidden."[57] Note that, in Dionysius's usage, the sculptor's work does not lead to the emergence of a figure, but rather to the unveiling of a "beauty" that does not consist of distinct shapes.

There is still another indication that the world into which *anagoge* leads us is devoid of form. Dionysius Areopagita stresses the "simple" nature of the Transcendent. Whatever its symbols, in itself the Transcendent is "an imageless and supranatural simplicity."[58] Somewhere else he says that "the beauty of God—so simple, so good, so much the source of perfection—is completely uncontaminated by dissimilarity."[59] Now absolute simplicity, it should be kept in mind, excludes form. Any form is a relationship between parts, and it is precisely this that Dionysius wants to exclude from the divine.

Yet although the mind's ascent eventually brings it to the domain in which there is no form, the process begins with a shaped object or appearance. It is, as we know, the image and the vision that goad the mind to its flight. "There is nothing absurd," Dionysius says, "in rising up, as we do, from obscure images to the single cause of everything."[60] God in his grace made it that "we might be uplifted from these most venerable images."[61] For us, he says later, it is "by way of the perceptible images that we are uplifted as far as we can be to the contemplation of what is divine."[62] Of the leaders of the ecclesiastical hierarchy he says that in "using images derived from the senses they spoke of the transcendent." They do so because "in a divine fashion it needs perceptible things to lift us up into the domain of conceptions."[63]

Dionysius Areopagita goes even further; he explicitly attributes to the sort of images we would now classify as works of art the ability to lift us up. The Bible ("The Word of God," as he says) "attributes to the heavenly beings the form of bronze, of electrum, of multicolored stones." Pondering these descriptions, he looks for symbolic meanings hidden in

them, and concludes, "Indeed you will find that each form carries an uplifting explanation of the representational images."[64]
The image, then, is the starting point of the flight to heaven.

NOTES

1. Scholarly literature dealing with the various aspects of Dionysius's legacy is large and complex. A good, and richly documented, survey of his influence on medieval and modern thought, though not dealing with the problem of images, is found in the entries by André Rayez and by David Gutiérrez in *Dictionnaire de spiritualité*, ed. C. Baumgartner, III, cols. 287–429.

2. See John Meyendorff, *Christ in Eastern Christian Thought* (n. p., 1975), pp. 183 ff. The book is translated from the French (*Le Christ dans la theologie byzantine* [Paris, 1969]).

3. See Hans Georg Thummel, "Der byzantinische Bilderstreit: Stand und Perspektiven der Forschung," in Johannes Irmscher, ed., *Der byzantinische Bilderstreit: Sozialökonomische Voraussetzungen—ideologische Grundlagen—geschichtliche Wirkungen* (Leipzig, 1980), pp. 9–40, esp. p. 28.

4. See V. V. Byckov, "Die philosophisch-aesthetischen Aspekte des byzantinischen Bilderstreits," in Irmscher, ed., *Der byzantinische Bilderstreit*, pp. 58–82, esp. pp. 63 ff.

5. The main attempts at identification are summarized by Jaroslav Pelikan in his introduction (titled "The Odyssey of Dionysian Spirituality") to *Pseudo-Dionysius: The Complete Works*, translated by Colm Luibheid (London, 1987), pp. 11 ff.

6. I should like to refer here to the important work by Eduard Norden, *Agnostos Theos: Untersuchungen zur Formengeschichte religiöser Rede* (Leipzig and Berlin, 1923), of which St. Paul's sermon is the central underlying theme.

7. *On Divine Names* 1, 1; col. 588B; p. 49 of the English translation. The English version of the quotations in the present chapter are taken from *Pseudo-Dionysius: The Complete Works*. In quoting I shall give first the title and chapter of the specific Dionysian work referred to, then, after a semicolon, the column in J. P. Migne, *Patrologia cursus completus, Series Graeca*, IC (Paris, 1856); the second number, after a comma, refers to the section of the text; and finally, after another semicolon, the page number of the English translation.

8. *On Divine Names* 1, 5; col. 593A f.; p. 53.

9. *On Divine Names* 7, 3; col. 872A f.; p. 109.

10. *On Mystical Theology* 5; col. 1048A ff.; p. 141.

11. For the following section, see the exposition in Jaroslav Pelikan, *The Chris-*

tian Tradition, II, *The Spirit of Eastern Christendom* (600–1700) (Chicago, 1977), pp. 30 ff.

12. Maximus Confessor, Book of Ambiguities, in P. Migne, *Patrologia Graeca* XCI, col. 1252. I quote Pelikan's translation, *Pseudo-Dionysius*, p. 31.

13. See Karl Holl, "Uber das griechische Monchtum," in the author's *Gesammelte Aufsätze zur Kirchengeschichte*, II, *Der Osten* (Tubingen, 1928), pp. 270–82, esp. pp. 278 ff. See also Arthur Vööbius, *History of Asceticism in the Syrian Orient*, II (Louvain, 1960), pp. 305 ff.

14. The original text in Migne, *Patrologia Graeca*, IC, cols. 120A–340B; the English translation in *Pseudo-Dionysius*, pp. 145–91. See René Roques, *L'Univers Dionysien: Structure hiérarchique du monde selon le Pseudo-Denys* (Paris, 1983), especially pp. 145 ff.

15. Original text in Migne, cols. 371B-569A; the English translation in *Pseudo-Dionysius*, pp. 195–259. And see Roques, *L'Univers Dionysien*, pp. 171 ff.

16. See Otto Willmann, *Geschichte des Idealismus*, II (Aalen, 1975), p. 153. The original edition of this work appeared in 1896.

17. See Ernst Cassirer, *The Individual and the Cosmos in Renaissance Philosophy* (New York and Evanston, 1963), p. 9. The original German edition of this work (*Das Individuum und der Kosmos in der Philosophie der Renaissance*) appeared as volume X of *Studien der Bibliothek Warburg* (Leipzig and Berlin, 1927).

18. The best-known text is probably *Plato's Republic*, 435 ff. See Willmann, *Geschichte des Idealismus* II, p. 95.

19. *Iliad*, 8, 19. On the interpretations, especially in late Antiquity, of this Homeric metaphor, see Ludwig Edelstein, "The Golden Chain of Homer," in *Studies in Intellectual History* (Baltimore, 1953; reprint New York, 1968), pp. 48–66. See also Robert Lamberton, *Homer the Theologian: Neoplatonist Allegorical Reading and the Growth of the Epic Tradition* (Berkeley, Los Angeles, London, 1989), pp. 270 ff.

20. See Arthur Lovejoy, *The Great Chain of Being* (Cambridge, Mass., 1936; reprint New York, 1960), especially chapter 2.

21. See *De generatione animalium*, 732A-733B. Cf. Lovejoy, pp. 58 ff.

22. Many references could be quoted, but see, e.g., *Enneads* IV, 8, 6, and V, 2, 1–2.

23. Macrobius's summary is found in his commentary to Cicero's *Somnium Scipionis* I, 14, 15. See *Ambrosii Theodosii Macrobii . . . Comentariorum in Somnium Scipionis*, ed. Franciscus Eysenhardt (Leipzig, 1893). An English translation of the crucial passage is found in Lovejoy's *The Great Chain of Being*, p. 63.

24. See *Stromateis* VI, 13, 107. And cf. Willmann, *Idealismus* II, p. 47.

25. See Leo's eleventh letter. The English translation of a selection of Leo's letters (*St. Leo the Great: Letters* [Washington, D.C., 1957]) unfortunately omits this letter. And cf. Willmann, *Idealismus* II, p. 42.

26. See, e.g., Heinrich Weisweiler S.J., "Sakrament als Symbol und Teilhabe:

Der Einfluss des Ps.-Dionysius auf die allgemeine Sakramentenlehre Hugos von St. Viktor," *Scholastik*, XXVII (1952), pp. 321–43.

27. Otto Semmelroth S.J., "Die *theologia symbolike* des Ps.-Dionysius Areopagita," *Scholastik*, XXVII (1952), pp. 1–11.
28. See *Divine Names* 13, 4; col. 298A; p. 131 of the English translation.
29. See Dionysius's ninth letter, 6; col. 1113B; p. 288
30. This is the opinion of some modern students. See, for instance, Semmelroth, p. 1.
31. René Roques, *L'Univers Dionysien*, p. 10, note 10.
32. *The Celestial Hierarchy* 1, 1; cols. 120B f.; p. 145 of the English translation.
33. *The Divine Names* 3, 1; col. 680C; p. 68 of the English translation.
34. See the last section of chapter 1 of the present book.
35. *The Divine Names* 9, 7; col. 916A; p. 118 of the English translation.
36. A detailed study of the subject is found in the article by B. D. Jackson, "The Theory of Signs in Saint Augustine's *De Doctrine Christiana*," *Revue des Etudes Augustiniennes*, XV (1969), pp. 9–49; reprinted in R. A. Markus, ed., *Augustine* (Garden City, New York, 1972), pp. 92–147.
37. See Tzvetan Todorov, *Theories of the Symbol* (Ithaca, N.Y., 1983), pp. 36–56. For the *Doctrina Christiana* in the context of Augustine's intellectual development, see Peter Brown, *Augustine of Hippo* (Berkeley and Los Angeles, 1967), pp. 259–69.
38. *On Christian Doctrine* II, xxv, 38. I use the English translation by D. W. Robertson, Jr. (Saint Augustine, *On Christian Doctrine* [Indianapolis and New York, 1959]); for the passage quoted, see p. 68.
39. *The Ecclesiastical Hierarchy* 3, 3, 9; col. 437C; p. 219.
40. *The Ecclesiastical Hierarchy* 7, 3, 9; col. 565B; p. 257.
41. See chapters 1 and 9.
42. *The Divine Names* 2, 5; col. 644A; p. 62.
43. *The Divine Names* 2, 6; col. 644B; p. 63.
44. *The Divine Names* 2, 7; col. 645A; p. 63.
45. *The Celestial Hierarchy* 1, 2; col. 121B, C; p. 146.
46. *The Celestial Hierarchy* 2, 1; col. 137A, B; p. 148.
47. *The Celestial Hierarchy* 2, 3; col. 140B, C; p. 149. The translator of the English translation here used, Colm Luibheid, stresses (p. 149, note 20) that Dionysius does not claim that the two types of images are mutually exclusive. On the contrary, Dionysius suggests that "the very same things are both similar and dissimilar to God." See *Divine Names* 9, 7; col. 916A; p. 118.
48. *The Celestial Hierarchy* 2, 3; col. 141A-C; p. 150.
49. The subject has been discussed in many studies. See now Ioan Petru Culianu, *Psychanodia I: A Survey of the Evidence concerning the Ascension of the Soul and Its Relevance* (Leiden, 1983), with a useful bibliography. See also the old study by W. Bousset, *Die Himmelsreise der Seele* (reprint Farmstadt, 1971; originally in *Archiv fur Religionswissenschaft*, IV [1901]).

50. *On Mystical Theology* 1, 3; col. 1001A; p. 137.
51. Ibid. 3; col. 1033B, C; p. 139.
52. For the significance of *The Mystical Theology* both in the intellectual development of Dionysius and in the system of his theology, see Walther Volker, *Kontemplation und Ekstase by Pseudo-Dionysius Areopagita* (Wiesbaden, 1956), pp. 218–63; and Jan Vanneste, *Le Mystère de Dieu: Essai sur la structure rationelle de la doctrine mystique du Pseudo-Denys l'Aréopagite* (Brussels, 1959), pp. 30 ff.
53. *The Mystical Theology* 5; col. 1048A, B; p. 141.
54. Ibid. 2; col. 1025; p. 138.
55. See, for instance, Aristotle, *Metaphysics* X, 3 (1061A, B), and *On the Soul* III, 7 (in Migne, 431B) where the process of "taking away" in thinking is described.
56. See, e.g., Plotinus, *The Enneads* II, 4, 4. To bring a late example, close to Dionysius's time, I shall mention Proclus's *The Elements of Theology*, translated by E. R. Dodds (Oxford, 1963), propositions 208, 209; pp. 182 ff. For Proclus, see above, chapter 4.
57. *The Mystical Theology* 2; col. 1025A, B; p. 138.
58. *The Divine Names* 1, 4; col. 592B; p. 52.
59. *The Celestial Hierarchy* 3, 1; col. 164D; pp. 153 f.
60. *The Divine Names* 5, 7; col. 821B; p. 100.
61. *The Celestial Hierarchy* 1, 3; col. 121C; p. 146.
62. *The Ecclesiastical Hierarchy* 1, 2; col. 373; p. 197.
63. *The Eccelsiastical Hierarchy* 1, 5; cols. 376D-377A; p. 199.
64. *The Celestial Hierarchy* 15, 7; 336B, C; p. 188. Dionysius has in mind mainly Ezra 1:4, 1:7, 1:27, 8:2, 40:3; Daniel 10:6; Revelations 4:3, 21:19–21.

The Doctrine of the Icon

In Defense of Images:
John of Damascus

1. The New Stage

We have now reached the concluding stage of the story this book has undertaken to tell. The debate over the image of God and the representation of the invisible, it goes without saying, continued to be waged. The headings changed, but the passion, sometimes even the violence, of the debate remained. In the present study, however, we have tried to examine its development only up to the stage when, in the Byzantine world, the question was pronounced resolved. So far we have been watching the unfolding of the different aspects of the argument over the question of whether there can, or cannot, be a "true image" of God. History, like a good schoolmaster, has transformed every new situation, every new social and political development, into a new question, and to every question it has produced an answer that has further impelled the intellectual movement.

A student who reenacts in his mind the development of Christian thought on images from the sixth to the eighth century—say, from Dionysius Areopagita to John of Damascus—cannot fail to notice a distinct change of intellectual atmosphere. On the face of it the change would not seem to go very deep. The themes discussed are largely traditional, there is little difference in terminology, and even the internal conflicts and paradoxes are known from earlier periods. And yet, the attentive reader cannot doubt that the discussion has entered a new stage.

The changes are most easily grasped when we look at the historical circumstances that formed the direct, immediate background of the theories of icons to be discussed here. Foremost among these conditions is what might be called the "politicization" of the icon, making it the centerpiece of violent political debate. To be sure, the discussions of images that occupied the Christian world in earlier centuries never completely suppressed the political connotations. This is true even if the earlier debates were carried on in what seem to be purely theological terms. This, as is well known, changed drastically in the eighth century. The Iconoclastic Debate, the major event or process in Eastern Christianity of the eighth and ninth centuries, made the icon explicitly and directly an object of political struggle, a central political symbol.

It is not for us here to describe the history of the iconoclastic movement, or even to trace the theoretical and ideological debates that accompanied, and reflected the different stages of, this movement. All this has been done more than once, and we do not need to repeat what is already well known. The one thing I should like to remark here is that when the image became a central political issue, the theoretical questions raised from time to time in the course of the preceding centuries were endowed with a new urgency. Many ideas and attitudes that for centuries were only half articulate had to be fully crystallized; arguments that for many generations had remained up to a point either loose reflections or literary metaphors now had to be given a clear solution. It was these historical conditions that gave the theories of images a new character.

The so-called Iconoclastic Dispute was brought to an end, at least in the Byzantine world, by a political decision. After many centuries of glimmering conflict, and after more than a century of open and violent struggle, the dispute over the status of the image was concluded, and, as the now conventional phrase has it, "orthodoxy was restored." This

end, it hardly needs stressing, did not come because the inner logic of the intellectual conflict had ineluctably led to a solution. As far as the theoretical argument is concerned, the "solution" was one imposed from the outside, and it was no solution at all. It was because of the outcome of a power struggle that the "restoration of orthodoxy" became the official and accepted doctrine.

But once again we must say that, regardless of what were the historical causes of, and the social forces that brought about, the veneration of images and their worshipping, the victorious ideology in fact proposed a doctrine of images, a theory concerning the portrayal of the invisible. In the course of the debate, the "orthodox" ideology made the distinct claim that, in a certain sense, the divine image is true or valid. Moreover, it quoted and analyzed the reasons that, so it was believed, support this claim. What were those reasons? And what do they mean when you take them out from their traditional context and terminology and transplant them into modern concepts and language? These are the questions we shall ask in the rest of this book.

The theoretical defense of images, a great intellectual process that eventually triumphed in the century-old battle and shaped the spiritual world of Eastern Christianity, was not the work of a single author. Many groups, even generations, of scholars, commentators, and preachers contributed to articulating, and firmly establishing, the victorious ideology that eventually led to the famous veneration of icons in Byzantium. There is, however, one figure in that intellectual process that stands out with rare distinction, and this is John of Damascus. No other author had such an impact on the theoretical foundation of the belief in holy images as had John of Damascus. It will be best, therefore, to study the arguments in defense of sacred images by concentrating on his writings. By so doing, I believe, we shall be able to learn more about the thought of the defenders of images than by surveying the writings of many other authors.

One comment, I think, should be made in advance. Some students have tended to treat John's doctrine of icons as if it were a well-rounded, consistent system of thought. Such an assumption, I believe, is not warranted by what we actually read in the Orations. A careful reading of what he says in defense of icons shows different, perhaps even conflicting, trends of thought. To be sure, John's practical aim is always the same: he wants to defend sacred icons, to justify their use and the

worship offered to them. The reasons he evoked in support of this position, however, are not uniform. In the following discussion I shall not try to harmonize the different strands in John's thought. The differences, and even conflicts, in theoretical argumentation are not less significant than the practical aim that informs them.

2. John of Damascus: The Man and the Author

The *Three Apologies against Those Who Attack the Divine Images,*[1] the three orations in defense of the veneration of icons that John of Damascus composed in the early eighth century, it has been maintained, are the first attempt made by a Christian theologian to formulate a coherent theory of images. John may well be the first thinker in the Christian tradition to explicitly ask simple, naive questions, such as what is a picture, and are there different types of images and what are they?[2] This is a striking claim. As we have seen, reflections on images, on their power and on the dangers inherent in them, have a venerable history, reaching back to late Antiquity.[3] To this we should add that John of Damascus did not set out to be "original"; he did not wish to go beyond accepted doctrine. He saw himself neither as an inventor nor as a reformer; on the contrary, he wished to be "orthodox," that is, to be completely within the mainstream of ecclesiastical teaching. "I shall say nothing of my own," he promises at the very beginning of his major work of systematic theology, *The Fount of Knowledge,* "but I shall set down things that have been said in various places by wise and godly men."[4] This is also his attitude in dealing with images. In the *Apologies* he quotes biblical and patristic sources, as was the custom of his time, and he even quotes *in extenso* lengthy passages by different religious authorities to support his views, a less conventional form. In spite of all this it remains true that John's Orations form the first Christian treatise devoted explicitly and exclusively to sacred images. The observations on images by the Christian Fathers were always made in discussing some other subject. Icons were mentioned, sometimes even briefly discussed, in order to clarify some other argument or point. None of these earlier remarks was made only for the sake of elucidating what an image is, or what its limits are. In this respect John of Damascus did set himself apart from the tradition into which he proposed to merge.

To inquire into John's motivation in writing the Orations would seem

to ask for the obvious. The three orations were composed, as every beginner knows, as a statement in defense of icons in the raging Iconoclastic Debate. John himself clearly formulates the political origin of his pronouncements: "I see the Church which God founded on the apostles and prophets, her cornerstone being Christ His Son, tossed on an angry sea, beaten by rushing waves, shaken and troubled by the assaults of evil spirits. Impious men seek to rend asunder the seamless robe of Christ and to cut his body in pieces."[5] The modern student cannot help noting that some features in John's character and personality may have made him particularly attuned to taking up the task offered him by the political struggle of his time: the defense of icons—of objects, that is, that can also be considered as works of art.

The general outline of John's life—based on a Greek *vita* of the eleventh century, to which some newly discovered sources can now be added[6]—is well known. He was born around a.d. 675 in Damascus (the precise dates of both his birth and his death remain obscure), that is, at a time when that city had already become the seat of a khalif. As the son of a wealthy and socially highly respectable Christian family (whether or not of Greek descent is a matter of dispute), John, and his adoptive brother Cosmas, enjoyed an excellent education, largely thanks to Cosmas of Calabria, a Christian scholar and philosopher whom John's father ransomed from Muslim captivity. Some modern students have pointed out John's familiarity with classical Greek literature; others have wanted us not to exaggerate that acquaintance: quotation from, and references to, Greek literature, do not necessarily mean that he actually knew the full texts from which the quotations were taken. The so-called *florilegia,* that is, selections from classical texts, were in general use, and they may well account for much of John's seeming familiarity with the masterpieces of classical literature.[7] Around a.d. 730 (possibly somewhat earlier) John left Damascus, abandoning whatever functions and social positions he may have held there, and joined the monastery of Mar Saba near Jerusalem (a territory then also under Muslim rule). He was not appointed to any high rank in the ecclesiastical hierarchy, and scholars are now agreed that this was so because he did not want to occupy any important post. It was mainly here that he developed an extensive literary activity, including his participation in the Iconoclastic Controversy. He died probably in the year 749, in Mar Saba.

The intellectual personality of John of Damascus emerges clearly from his large and versatile literary work. It is not my task to present this work in its entirety; I shall rather emphasize, by way of introduction, certain aspects other than those usually stressed. John of Damascus is best known for his systematic theology, mainly the *Fount of Knowledge,* a treatise described by modern scholarship as the first synthesis of Greek philosophy and Christian dogmatics.[8] The *Fount of Knowledge* exerted a major influence on systematic theology in the West. Peter Lombard, a thinker who played a crucial role in establishing western Scholasticism, accepted and imitated John's method of collecting texts and presenting them in systematic patterns, and none other than Thomas Aquinas revered John and followed his model in the structure of the *Summa theologica.*[9] Some other systematic works by John of Damascus, such as the *Sacra Parallela,* a collection of more than three hundred quotations from the Bible and patristic writings arranged alphabetically (though that arrangement may have originated at a later period), combined ethical teachings and dogmatic theology. The great diffusion of this work is suggested by the fact that several versions of it have come down to us.[10]

Though systematic theology was probably John of Damascus's main concern, and the major reason for his lasting influence, I should here like to emphasize his nontheoretical works. In hymnology, the central form of ecclesiastical poetry, John, and his adoptive brother, Cosmas, are regarded as the main representatives of what is called the "third period" of Byzantine church poetry. From the *Suidas,* a Byzantine encyclopedia composed in the tenth century, we learn that "the poetic *canones* of John and Cosmas are lofty beyond comparison, and will remain so to the end of all days,"[11] a vivid testimony to the high regard in which they were held. John and his brother brought the canon, a delicate but highly intricate and artificial form of poetry, to perfection.[12] In modern critical literature it has been said that the canon is devoid of emotional inspiration. It is not for me to question this opinion of expert scholars. As historians, however, we should keep in mind that at the time it was the accepted form of poetry among the educated public. Whatever the canon may lack, to bring it to a complete development surely betrays great sensitivity to matters of style.

Tradition has also credited John of Damascus with the invention of the *Oktoekhos* (the book of eight tones), containing the liturgical cycle

of eight weeks repeated between the second Sunday after Pentecost and the following Lent. Whether he was indeed the inventor of this liturgical cycle (probably also containing some elements of music), as some scholars believe, or whether he only radically reformed an existing model, as other scholars assume,[13] can again see his interest and creative activity in established formal patterns, his concern with style.

The drama, as we know, was a rather undeveloped art form in Christian culture of the early period. Some hesitant attempts made at reviving this artistic genre remained isolated and without significant influence. In the eighth century, it seems, the iconoclasts may have favored some plays. In all these respects it is remarkable that John of Damascus should have composed a theater play, called *Susana*. The text itself has not survived, but we have an interesting testimony to it: in the twelfth century, that is, more than four centuries after John's death, Eustatios, deacon of a church in Constantinople and teacher of rhetorics, still knew the play and described it as "Euripidic."[14]

Even a casual glance at the literary activities of John of Damascus catches still another feature. For many centuries it was believed that he was the author of the Barlaam and Joasaph story, the most famous and possibly the artistically most accomplished spiritual novel of the Middle Ages, a story told and written all over the world, from the Far East to North Africa and everywhere in Europe. It is a story presenting its religious message through lively narrative and convincing characterization of the figures.[15] Recent research has questioned the authorship of John of Damascus, although even today the attribution still has many adherents.[16] But all scholars agree that John of Damascus was deeply concerned with the Barlaam and Joasaph story; if he did not compose, he certainly thoroughly revised it. For the purpose of the present study the difference is not crucial. Again, what is important for us is John's profound concern with the arts.

John's concern with the arts, one cannot help feeling, made him particularly suited to undertake the defense of images. Though he is pleading from a theological point of view, his artistic sensitivity, and his understanding of art as such, play an important, though hidden, role in his thought.

3. Definition of the Image

John's discussion of holy icons, as I have already said, was the first attempt by a Christian theologian to deal extensively and systematically with the subject of images. As we have seen in the chapters of this book, references to images are not rare in the theological literature, in the exegeses and sermons of the preceding centuries. But the Church Fathers did not deal with the icon as a subject in its own right. This may be the reason that a certain conceptual equivocation prevailed in their treatment of the subject. Under the heading of "image," patristic literature refers to many themes and concepts, often without distinguishing between them. John of Damascus, it goes without saying, grew out of the patristic tradition and was familiar with large parts of its literature. But in the revered writings of the Fathers he could not have found the general structure of a discussion of images, the questions to be asked and the themes to be discussed, and the sequence in which they should be treated. Ancient ("pagan") philosophy also did not provide a model that might have been followed when defending the holy icon. All this he had to establish for himself.

John of Damascus, we should never forget, approached images as an urgent political issue, not merely as a theoretical subject to be examined with a certain detachment. It was the political pressures that determined what precisely required clarification. The concrete question that stirred people's minds and emotions was, as one knows, the worshipping of images. John's doctrine, therefore, focuses on two themes—the images themselves, and the worship offered to them. His systematic mind leads him to make a clear distinction between the two themes, and to divide the discussion into two separate parts, a discussion of images and a discussion of worship.[17] For our purpose the subject of worship is marginal, and we shall disregard it; we shall concentrate on what John says about images themselves.

John's doctrine of images consists of the discussion of four major topics.[18] In taking up each of these he approaches the general subject—the holy icon—with a different question in mind, focusing, as it were, on a different aspect of the problem. The first subject is an attempt to define the image, to explain what precisely he means by this term. The purpose of the holy image, the reasons for producing icons, make up the second theme. What kinds of images are there?—this question forms the

third subject. Here John tries to distinguish between the different types of images and to arrange them in an appropriate order. The fourth theme is the visibility of spiritual beings. A fifth topic—who first made images?—does not contribute much to the doctrine of images, and I shall therefore not discuss it here.

Modern critics might claim that the sequence of these topics, as John presents it, is not compelling; systematic thought might demand a different order.[19] Yet if the sequence is somewhat haphazard, this order of discussion is in itself an interesting historical testimony: it shows that in the eighth century a comprehensive and systematic treatment of the holy image was a new and unusual undertaking. For our study it will be best to follow the order of discussion John himself suggested.

Following John of Damascus we, then, begin with the definition of the image. It is the urge of the systematic thinker that compels him to first define his subject. "Since we are speaking of images and worship," he says in the first Apology, "let us analyze the exact meaning of each." As I have said, we shall disregard the discussion of worship, and concentrate on the definition of the image. His definition is remarkable both as an important step in the historical development of thought, and for what it actually says; we should therefore look at it in some detail. In our context it is important to remember that, in defining the "image," John has primarily the actual icon in mind. In the course of his discussion the meaning of the term broadens (so as to include the mental image as well as other connotations), but where he defines the term, he clearly means the painted icon.

An image, so reads his first definition, "is of like character with its prototype, but with a certain difference. It is not like the archetype in every way."[20] It may be surprising that John begins his definition of the image by relating it to the prototype, but this is how he proceeds in all his discussions of the subject: he does not begin by defining the image in itself, but by defining its relation with the archetype. In his great work of systematic theology, *The Orthodox Faith*, he devotes a short chapter to the adoration of images, and here he repeats the essential idea of his definition of an image given in the first Oration. "The original," he says in the comprehensive theological treatise, "is the thing imaged from which the copy is made."[21] He repeats the same formulation in the second and third Apologies.[22]

Let us return to the first sentence in the definition of the image. "An

image," John here says, "is a likeness, or a model, or a figure of something, showing in itself what it depicts."[23] Short and seemingly simple as the sentence is, it announces two claims: first, that the image is a "likeness"; second, that it "shows in itself" what it depicts. To some extent, these claims seem to point in different directions. They call for a brief analysis of what they may imply.

The first assumption John makes in his definition is that the image is a "likeness" of something. That something, whatever its precise nature, exists outside the image, and independently of it. The image, on the other hand, is not independent of what it portrays. What an image is, he obviously believes, can be grasped only when it is seen in relation to the prototype. Does this imply that the very being, the existence and reality of the image are also derivative, and in a sense inferior to those of the prototype? John does not explicitly deal with the question of how real, or imagined, an image is. Yet one cannot escape the feeling that the reality he attributes to the image is less authentic than that of the prototype.

Great ancient traditions of thought and belief may have supported John in his belief that the image does not have the full reality that the model has. In the Platonic tradition, a continuous influence on the culture of the early medieval centuries, "image" is often a synonym for an appearance lacking full substance and reality. "By images [*eikonas*]," said Plato himself, "I mean, first, shadows, and then reflections in water and on surfaces of dense, smooth and bright texture, and everything of that kind, if you apprehend."[24] A passage from another of Plato's dialogues sheds further light: "Obviously we . . . mean the images [*eidola*] in water and in mirrors, and those in painting, too, and sculptures, and all the other things of the same sort."[25]

Whatever the connotations later acquired by the concept of image, its original meaning of a lack of full reality adhered to it. Plotinus, who more than any other philosopher perceived of a gradation in the fullness of reality, taught that the Intellectual Principle imparts "to Soul nearly the authentic reality, while what Body receives is but image and imitation."[26] And Proclus, the last great representative of the Platonic trend in Antiquity, claimed that the Soul possesses by derivation the irradiations of "intellectual forms," a condition he understands as possessing images.[27]

In denying full reality to the image, John may also have been the heir

of Greek reflection on mimesis in art. In that tradition, which was never far from authentic Platonic thought, the image produced by the artist was considered as an "illusion," that is, the appearance of an object or a figure, articulate in form and convincing the beholder, yet devoid of the full physical reality of the prototype. Ever since Plato we know of the "weakness of the human mind on which the art of painting in light and shadow, the art of conjuring, and many other ingenious devices impose."[28] Painting aims at producing "constant delusions." Looking at a picture is like dreaming. "Is not the dreamer, sleeping or waking, one who likens dissimilar things, who puts the copy in place of the real object?" Plato rhetorically asks.[29] The tradition of ancient art criticism, less given to abstract speculation than that of philosophy, strongly supported and popularized the view that the picture is a piece of illusion. To produce a successful illusion, one that will mislead spectators, even beasts and birds, to take the image for reality—this became a standard formula for praising the artist's work. But this view, it goes without saying, implies that the picture lacks the full reality of the object it depicts. The artist's achievement consists precisely in covering up this deficiency in reality. John of Damascus, familiar with ancient culture, may well have been influenced by the heritage of ancient art criticism, and may have transformed concepts from the critical literature into theological notions.

Whatever his sources, by describing the image as a "likeness," that is, by seeing it as a "copy" and comparing it with the original, John suggests that the image possesses less reality than that which it portrays.

So far we have commented on one of the claims John makes in his definition of the image. But in this definition, as I have said, he makes still another claim: an image, he says, is a likeness "showing *in itself* what it depicts."[30] This claim is more original than the first one: it is not derived from traditional teachings; I am not aware of any earlier formulation that can be seen as foreshadowing it. What John here says—that the image "shows in itself what it depicts"—is therefore more difficult to interpret. In attempting to understand it, we have to rely on the text alone. We shall not be able to ask what the notion may have meant in his time and culture.

That an icon "shows" what it depicts seems, at a first glance, to state the obvious. What is a picture of something, one cannot help wondering, if it does not show what it depicts? In stating the obvious, however, John

is in fact adumbrating an intellectual position that was not altogether trite. The Platonic approach, as we have seen, was primarily concerned with the being of the image; philosophers belonging to the Platonic school focused on the existential relation between the icon and the prototype: the picture *is* the image of something. In John's second claim, the focus of interest has shifted: here he does not ask what a picture is, but rather what it does. By stressing that the image shows what it depicts, he indicates that it is the icon's function, the "showing," that he considers as the true subject of definition.

Even more important is *how* the image shows what it portrays. The image, John of Damascus says, shows "in itself" what it depicts. The attention of the historian is instantly awakened. The claim that an icon should show what it portrays may be considered as self-evident. But emphasizing that the showing should be done by the image "in itself" is, in fact, highly unusual. Though the showing in itself, one could argue, is implicit in the very idea of the icon, I am not aware of any earlier statement expressing the same demand, or declaring that the picture does the showing "in itself." For all his professed intention to stick to tradition, John of Damascus here reveals his original mind. Even his followers, though influenced by his doctrine, did not readily take up this particular idea.

What actually did John of Damascus mean when he included this qualification—that the picture shows "in itself" what it portrays—in his definition of the image? The formulation, as it stands, has a surprising, perhaps a deceivingly modern, ring. One hesitates, of course, to make John an honorary citizen of the modern world, or to describe him as a forerunner of the autonomy of the aesthetic object. On the other hand, the qualification is so important that it requires careful attention.

Two trains of thought suggest themselves as possibly explaining his intention. One points in the direction of the picture as an autonomous object. To be sure, in its emergence and very "existence" the picture is not autonomous. Time and again John stresses, or takes it for granted, that the image reflects a model,[31] and that the model that the picture depicts precedes the image. But in the process of our grasping what is represented in the image, the picture comes to enjoy an autonomy of sorts. To understand what it shows the spectator does not have to rely on something else; the picture shows that "in itself." If such an interpre-

tation is permissible, it would mean that John of Damascus focuses on what we might nowadays call the spectator's aesthetic experience.

Another trend of thought may make us shift from the spectator's experience to the nature of the image itself. We can read John's definition of the image as referring to what is now described as an "iconic sign."[32] Such a sign, one knows, has itself the properties of what it designates. If there is an inherent affinity, an identity of sorts, between the representation and what it represents, the image itself is then a presence of what is reflected in it. In this sense, the picture may be said to "show in itself" what it refers to.

A theologian will, of course, shrink from admitting that the icon is in some sense identical with the divinity it represents. John of Damascus, we shall later see,[33] is aware of the danger inherent in the perception, however vague, that the icon is similar, or in some respects even identical, to what it represents. Blurring the distinctions between icon and prototype is bound to lead to idolatry. It is this awareness, one assumes, that makes him insist on the difference between icon and prototype. Whenever he has to say what an image is, he emphasizes that it "is not like its archetype in every way."[34] "For the image," we read in another passage, "is one thing and the thing depicted is another; one can always notice differences between them, since one is not the other, and vice versa."[35] Once again we encounter the question that the student of religious images is so familiar with: How can the picture both "show in itself" what it portrays, and yet be so completely different from its prototype?

Put in an oversimplified, perhaps crude, form, we could say that John perceives the difference between prototype and image not so much in their form as in their (material) substance. True, he never says as much directly, in explicit words, but the examples he uses to illustrate his arguments suggest such a reading. One quotation will be sufficient to show this. "An image of a man," he says in his third Oration, "even if it is a likeness of his bodily form, cannot contain his mental powers. It has no life; it cannot think, or speak, or move."[36] Though this is not said of a man-made image, the work of an artist, it allows us to draw a conclusion concerning the painted icon. The artist's product can, in principle, be identical with the appearance of the living person whom it portrays. They differ not in shape, but in their substance.

That the icon and its prototype may be close to one another, so close as to be identical in form while being totally different in substance—this is a view that was held in Antiquity, and was taken over by the Greek Church Fathers. John knew (in fact, he quoted) what St. Athanasius said in his *Book against the Arians,* and it may be worthwhile to recall this well-known statement:

If we use the example of the emperor's image we will find this [the divinity of the Son who resembles the Father] easier to understand. This image bears his form and appearance. Whatever the emperor looks like, that is how his image appears. The likeness of the emperor on the image is precisely similar to the emperor's own appearance, so that anyone who looks at the image recognizes that it is the emperor's image; also anyone who sees the emperor first and the image later, realizes at once whose image it is.[37]

Athanasius's formulation—and we know that it could be multiplied by quotations from other authors—is of consequence to the student of aesthetics because it implies that form can be detached from the matter into which it is cast or imprinted. It can be experienced in itself, isolated from other, more substantial, components of a figure. It is such form detached from substance, I venture to claim, that the image can "show in itself."

In summarizing John of Damascus's definition of the image there are, I believe, four points that should be made. First, John sees the image as necessarily related to a prototype. Its very essence is that it portrays something outside of itself, the prototype. The image is "mimetic"; it is only in relation to the prototype that the icon is an "image." Hence there can be no image that does not represent something. Secondly, the specific relationship prevailing between the image and its prototype is best described as similarity: the icon resembles the model it portrays. John never says what precisely similarity is, but much of his reflection would suggest that similarity is a kind of partial identity (though he refrains from explicitly drawing that conclusion). Thirdly, the similarity —whatever its precise definition—is located in the form of both icon and prototype; the icon resembles the prototype in form, in visible shapes only. Similarity never extends to their substance. From here we reach the fourth point, implied rather than explicitly stated, namely, that —at least in our reflection—the form shown in the image can be detached from the substance into which it is impressed. To speak once again in modern terms: form can be considered for itself.

4. "Why Are Images Made?"

(i) *The Questions* John opens the presentation of his doctrine of images with a definition of the icon. It is the systematic nature of his thought that makes him first outline, as clearly as he can, the object of his discussion, that is, to begin with a definition. But his mind, as we know, was not oriented towards mere definition. All his writings, even the most theoretical and speculative, aim at the impact of ideas, at the effects they attain in the reality of human life. It is not mere knowledge that he strives for and that motivates him, but the urge to shape his world. This also holds true for his discussion of images. With John's third question —why are images made, and what are icons good for?—we therefore come to the issue that actually concerned him, the significance of the icon in our world. The Apologies, after all, were not composed as an academic exercise, nor were they so widely received for doctrinal reasons only. Moreover, the formulation lacks the detachment one would expect in a purely scholarly text; on the contrary, John here explicitly presents a partisan view, passionately defending the position of one political group in the debate. The merely theoretical question of what an icon is, it should be kept in mind, received attention primarily as a consequence of another question, namely, what role it should play. The definition as such seemed more marginal, whereas the purpose and use of icons looms large in the discussion, and is obviously seen as a central issue. These are also the proportions in which the different aspects of the icon are treated by John of Damascus. Only two brief paragraphs are devoted to the definition of images, while the treatment of the purpose and function of icons forms a large part of the text.[38]

Before we turn to John's views of the purpose of icons, however, we should pause for a moment and consider what "purpose" in general may mean in this context. Showing what is the purpose of images becomes a justification of producing them. "Why are images made?"—this is what John asks when he speaks of the "purpose" of images. In the third Apology he puts the question explicitly, whereas in the first it is more implicit, but it always forms the background of his discussion. In fact, a large part of what he says about icons can be read as an answer to this particular question.

John's definition of the image and his statement concerning its purpose are quite close to each other. What distinguishes them is only a

shift in perspective. In the definition, as we remember, he states what the image is meant to show, namely, the invisible; in the discussion of the image's purpose he considers whether and how this goal is actually attained. In fact, definition and purpose hang together. The definition is cast in terms of a task to be fulfilled: it is the task of the image to show the invisible. The purpose is to attain this goal. What is different, I shall claim, is primarily the perspective he has in mind. The definition focuses on the image itself, and disregards what lies outside it. In discussing the icon's purpose, the focus is on the spectator. In the definition he does not ask whether, or not, we can indeed perceive what the image is supposed to show (that is, something of the invisible); in the discussion of the image's purpose, he mainly asks whether and how the icon reaches the spectator, and what actual impact it has on him or her. Using modern terminology—which was, of course, far removed from John's mind and time—we could say that what he says about the image's purpose deals with the audience. Let us now turn to John's views.

(ii) *Schemes for Vindicating Images* It was not eighth-century icono-clasm, of course, that invented the question, what is an image good for? Since the beginnings of the Christian world the purpose of art in general, and of the visual arts in particular, had not been considered self-evident; the picture and the statue had to be "justified"; it had to be explained why they should be made, or accepted. For centuries the task remained important; a large part of medieval literature dealing with the visual arts is devoted to vindicating a painting or a piece of sculpture.

The major method employed in medieval thought to vindicate the picture is to invoke its purpose. It is not difficult to see why this should have been so. Medieval culture in all its variations accepted the truth— not articulate, yet pervasive, and underlying any thought touching on matters of aesthetics—that any kind of art object, including the picture, does not have an autonomous value, that it is not valuable in itself. It may be tolerated, it can even be desirable, because of its effects. Medi-eval philosophical views, and value judgments, of works of art are based on the assumption that the image has some effects on us. The effects are considered important, and it is they that are the reason for the vindica-tion of the painting that brings them about. In other words, the icon, or any other product of artistic skill or talent, is not vindicated because it

embodies a value in itself; it is justified because it leads to effects that are valuable.

The need to justify the image and explain what it is good for, it should be said in parentheses, does not mean that medieval audiences did not know what aesthetic experience was, or that spectators in the Middle Ages did not enjoy the sensual beauty of the forms and materials they could see in paintings and other art objects. Contrary to what some romantic scholars would like us to believe, medieval literature, both secular and religious, yields many expressions of sheer aesthetic delight and undisguised pleasure at the brilliance of materials and the quality of workmanship.[39] The vindication of images, needless to say, does not take place on the level of direct aesthetic experience; it is a philosophical reflection upon that experience, and it is, of course, tinged by the scale of values underlying a great deal of medieval culture. That art was thought to be in need of vindication shows only that in the *theoretical* doctrines prevailing in the Christian Middle Ages, art was normally understood as lacking in autonomous value.

Most of the medieval vindications of images and objects, or decorations, produced by artists fall into two groups. One type sees artistic decoration as a result of the desire to pay homage to the sacred object or building, or to attract attention to what was deemed important in the church building, the liturgical implement, or the sacred book, by richly decorating the respective area. This attitude is best articulated in medieval workshop treatises. *The Various Arts* by Theophilus, a well-known twelfth-century text, is a good example. Decorating the house of God, the artisan-author says, is the artist's major task. This can be done by depicting images, such as paradisiac scenes "glowing with varied flowers, verdant with herbs and foliage, and cherishing with crowns of varying merit the souls of the saints."[40] But the decoration need not be limited to figural images or to the representation of any identifiable scene or object. What is represented, if anything at all, is in fact rather irrelevant as far as the decorative effect is concerned. Theophilus himself bears witness to nonfigurative ornament, or the sheer beauty of material in church decoration. He admiringly tells of works in "gold and silver, bronze, gems, wood, and other materials." The spectator, he suggests, is overwhelmed by what he or she sees in the church, but not a single figure is mentioned: "For the human eye [of the spectator] is not able to consider, on what first to fix its gaze; if it beholds the ceilings, they glow

like brocades; if it considers the walls, they are a kind of paradise; if it regards the profusion of light from the windows, it marvels at the inestimable beauty of the glass and the infintely rich and varied works-manship."

Theories belonging to this type do not bring up the problems of figural imagery, let alone the specific questions of the icon. They are concerned with embellishment.

Another approach to vindicating images actually equates the picture with figurative representation. It is the well-known theory that considers images as didactic implements. The most famous formulation of this approach is the classic statement by Gregory the Great. This sixth-century pope was in fact taking part in an iconoclastic debate of sorts (long before the movement so called emerged into the open) when he said that "it is one thing to venerate a picture, and another to learn the story it depicts." The image helps the illiterate to learn the story. In his words, "the picture is for simple men what writing is for those who can read, because those who cannot read see and learn from the picture the model which they should follow. Thus pictures are above all for the instruction of the people."[41] And "the picture is exhibited in the church, so that those who cannot read may, by looking at the walls, at least read there what they may be unable to read in books."[42] This doctrine was officially adopted by the church. "Illiterate men can contemplate in the lines of a picture," the Synod of Arras decided in 1025, "what they cannot learn by means of the written word."[43]

Vindicating the images because they convey the story—this doctrine is of course limited to spectators who cannot read. For people who can read, the picture is altogether useless, and for them it cannot be justified. In the so-called *Libri Carolini*[44] this is clearly put: "Painters," we there read, "should keep alive the memory of historical events, but what can be both looked at and described in words should not be depicted and presented to the public by painters, but by writers."

It is not altogether clear what precisely "learning" means here: Is it the acquiring of new information, or is it rather a kind of indoctrination? In spite of this obscurity, the main thought of this kind of justification of the artwork is obvious. The image is vindicated because of its social or educational function, and this function is restricted to the illiterate. If the spectator is able to read, the image—including, one assumes, the

sacred icon—becomes superfluous. It is only logical that in this case it should be altogether abandoned.

Having briefly outlined the frame of reference of John's thought in the history of ideas, we now return to his body of teaching. The student here encounters two questions that, though they hang together, should be treated separately; one is of a more historical, the other of a more theoretical character. The first one is, how does John of Damascus's defense of images fit into the traditional scheme here indicated? The other is, what does John consider as the purpose of the icon? What is his own vindication of images? I shall begin with the first question, and shall compare his attitudes to those prevailing in the thought of his time.

John of Damascus shares with his contemporaries, and his medieval followers throughout the centuries, the essential point of departure, that is, the belief that the value of the picture does not lie in itself, but in what it effects in the beholder. In this respect John is very articulate and clear. Continuing what he has said in his definition of the image, namely, that "all images reveal and make perceptible those things which are hidden," he naturally evokes his anthropology. Since "man does not have immediate knowledge of invisible things," he says, "the image was devised that he might advance in knowledge."[45] In other words, the purpose of the image is to bring about something in the spectator's mind or soul, and this is the purpose of the icon.

We shall shortly come back to this general attitude, and to possible problems that may arise from it for John's doctrine. Here we limit ourselves to asking, how does he stand in relation to the specific argumentations we have just indicated? The first type of vindication—that is, using images as embellishment of sacred objects—is altogether absent from John of Damascus's intellectual horizon. It may seem paradoxical but it is true that, although he was one of the most influential defenders of painted images, John does not seem to have known how a picture is made, and he apparently had no appreciation for artistic imagination and workmanship. Although he sings an ecstatic hymn to the icon,[46] the reader notes that John never mentions a specific feature or aspect of the icon, and he never observes the workmanship. It obviously did not occur to him that the icon could be seen primarily as an embellishment.

With the second type of justifying images—that is, employing them as didactic devices—he was definitely familiar. In the orations in defense

of images he refers several times to Gregory the Great.[47] Though he never quotes the pope's famous dictum that we have just mentioned, there is little doubt that he was familiar with it and accepted the idea it expressed. Moreover, he shows a significant affinity with the authors who considered the picture as a means to affect people. Like most thinkers of that age who claimed that the picture is primarily a didactic instrument, John of Damascus was aware of the icon's impact on ritual, and, in a more general way, on what we now call "the spectator." We shall shortly come back to this aspect of the icon's purpose and function, that is, the "spectator." In the present stage of our study, however, we are concerned neither with the intellectual sources of John of Damascus nor the traditions familiar to him. Instead we shall concentrate on his doctrine itself, and particularly on what singles it out in the context of medieval reflections on art. And I should say right at the beginning: John of Damascus does indeed display a great deal of original thinking on our subject, and thereby he considerably diverges from views held throughout the Middle Ages.

Most Christian thinkers of his world kept the effect of the image in mind when they approached the definition of the icon. The best-known instance is, of course, Pope Gregory's famous comparison, repeated countless times, of images and script: the image is for the illiterate what the text is for those able to read. John, too, is profoundly aware of the icon's effect, of what it does to people (hence the sigificance of what, using a modern term, we have called "the spectator"). But when he comes to define what specifically the icon does to the person looking at it, he deviates from opinions and beliefs that were common in his time. And as we shall see, it is because of its specific effect that the icon is conceived in terms not only of what it *does*, but also of what it *is*, of its nature, as it were. To be sure, a certain ambiguity and incongruence remain, but the main trend of his thought is clear.

(iii) *John's View of the Image's Purpose* So much for the attempt to place John in the context of medieval conceptual approaches to the defense of the image. We are now leaving historical questions, and turning to John's own doctrine. How does he himself vindicate the image? What is the argument that leads him to the belief that he can "save" the image?

Before attempting to discuss John's thoughts on the purpose of the

image I should say that, in spite of his scholastic leanings, he does not present his views on the subject in any systematic manner. He often drops the treatment of a problem without bringing it to a conclusion. Followings his thought, as it develops in the *Apologies,* brings home that he is walking a tortuous road. Nevertheless, in the following pages I shall not attempt to make it appear simpler and more consistent than it is. The very twists of John's thought, I believe, not only tell us something about his thinking (and that of his time); they also reveal some of the conceptual difficulties inherent in his enterprise, and of the problem he is treating.

In the vindication of images John's position is more precarious than that of his medieval followers. The reason for this problematic position is that his concept of the image is more complex and makes more far-reaching claims than theirs. Medieval defenders of icons, regardless to which of the two types they belonged, actually said precious little about what the image is. Without defining the image as such, they seem to have had actual, material images in mind, and they probably took it for granted that everybody understood what they were talking about. That their thought remained close to the real object, an actual picture, one even sees from their formulations. Theophilus speaks of the decoration of the church building; Gregory the Great, and his many medieval followers, say that the "images on the wall" are the script of the illiterate. None of these formulations indicates an abstract concept of the image.

John stands out from this tradition: he defines the image as such, altogether detached from any connection to the material condition or the character of the icon as an object. Moreover, as we have seen, he assigns to the image the great metaphysical task of making a bridge between the worlds. The image, he taught, reveals to us what lies beyond the limits of our sensual perception. He expresses the central idea of his defense of sacred images as well as of his theory of art when he says that "all images reveal and make perceptual those things which are hidden."[48] The redeeming power of the icons derives from the fact that "they make things so obviously manifest, enabling us to perceive hidden things."[49] Though he mainly stresses the human need for images, he also suggests that they do have a supernatural power and are indeed able to fulfil the task of revelation: "Anyone would say that our inability immediately to direct our thought to contemplation of higher things makes it

necessary that familiar everyday media be utilized to give suitable form to what is formless, and make visible what cannot be depicted."[50]

In sum, then, John believes that revealing the invisible is the purpose of the holy image, and therefore it is the reason for the vindication of the material, visible icon. Were it not for the revelation of the invisible, one cannot help concluding, there would be no need for the icon, or cause to vindicate it. Now, to show to the eyes what is invisible by nature, to manifest the hidden—this is evidently a paradox. But precisely because it is evident at a first glance that this is a contradiction, one has to show that it is possible, that the paradoxical task of the image can be performed. The whole defense of images, as John understands them, depends on whether one can show that the divine, although invisible in itself, can be seen, or had been seen. No wonder that a considerable part of John's reflections revolves around this point.

Theological speculation. To grasp the full significance of the contradiction that is the very essence of the image, one should see why, in his view, God cannot be seen, and hence cannot be depicted. That the invisible, by the very fact of being beyond the reach of our vision, cannot be represented in a picture that appeals to the eyes is, of course, a simple truism. Yet John is more specific—though in his texts much remains implicit—in his explanation of why God is beyond the reach of portrayal. The divine is beyond portrayal not only because it is removed from the reach of our sense experience, too far for us to see, as it were. Were we able to expand our perceptual faculties (their nature remaining as it is), even into the infinite, we would still not find it possible to portray the divine. It is not only beyond our vision; its nature lacks the very elements that would make it an object of vision, and thus portrayable: "It is impossible to portray one who is without body: invisible, uncircumscribed, and without form."[51]

It is worth our while to have a brief look at the terms John here employs. In part they are general indeed. In the language prevailing in the theological literature of the early Middle Ages, terms such as "bodiless" and "invisible" were used so frequently that they sometimes lost precise meaning. But in addition to such general terms, John also used others that are more specific and precise, particularly in the text of a Church Father. God, he says, is "uncircumscribed" and lacks "form."

This is an exact statement, particularly in the thesaurus of an eighth-century theologian.

"Outline" and "form" are terms that denote the essential features of the painted image. John of Damascus's statement that God is "uncircumscribed" *(aperigraptos)*[52] would, in a strictly literal translation, mean that God is not "marked round, fenced in, enclosed." The Greek verb here translated by "circumscribe" was rendered in Latin by *delineare*. In a precise sense of the word, John of Damascus says that God is not outlined, that is, has no contour.

The other term, *schema,* translated by "form," had a rather wide range of connotations. Essentially, however, it meant "form" or "shape" in a distinct, concrete sense. In the artistic workshops of Antiquity, *schema* was used as a technical term, though it is not possible to offer definite proof for this usage. Since the first century A.D., one modern interpretation claims, the term *schema* referred mainly to a figure at rest (a *Standmotiv,* in German professional language), while the closely related term *rhythmos* was used primarily to designate figures considered in motion.[53] But there are also reasons for doubting this hypothesis.[54] If it were correct, however, it would fit in well with John of Damascus's use of the term *schema*. God, he believes, is at rest, not subject to any kind of motion.[55]

Now, whatever the specific connotations of the terms, what they mean in John's use is that the divine cannot be represented, not only because it is hidden or obscured, but because, in a profound and precise sense, it lacks the very element of form, it cannot be "fenced in" within an outline.

All this, the reader cannot help noting, does not contribute to a defense of images. John was obviously aware of the difficulties just indicated, and it was this awareness that prompted him to reformulate the problem. His rhetoric conveys a sense of urgency. "How can the invisible be depicted?" he demands. "How does one picture the inconceivable? How can one draw what is limitless, immeasurable, infinite? How can a form be given to the formless? How does one paint the bodiless? How can you describe what is a mystery?"[56] In short, it is the very embodiment of a paradox.

In a simple and direct sense, John does not solve the problem. In spite of his rhetoric in asking the questions, he does not answer them, and does not show, on the level of philosophical reflection, how the invisible

can be represented—in other words, how the problem of the icon can be solved. What he does instead is, first of all, to claim that in reality the problem was indeed solved, that is, that in history God, or angels, did appear in visible form and were seen by people. He then also refers to the most famous appearance and treats it as a theological problem. We shall follow these lines of thought separately.

On the first point he invokes the authority of Scripture, the most obvious procedure in his time. The Old Testament abounds in stories about men who saw God in more or less bodily forms, and John of Damascus mentions some of them. Thus Adam saw God and heard the sound of God's feet as God walked in Paradise (Genesis 3:8); Jacob struggled with God, who evidently appeared to him as a man (Genesis 32:24 ff.); Moses saw, as it were, the back of a man (Exodus 33:24 ff.); and Isaiah saw God as a man sitting upon a throne (Isaiah 6:1).[57] All these stories show that God appeared in visible form.

In using the biblical text John takes a further step. God, he tells his readers, "wills that we should not be totally ignorant of bodiless creatures."[58] Therefore God has permitted, as we learn from the Bible, the making and displaying of some images in the temple, as the carved figures of the cherubim testify.[59] The cherubim, and angels in general, play a versatile role in John's thought; to a metaphysical aspect of the angels' appearance we shall return at the end of this chapter.[60] Here I shall only mention what John says about the carved figures of cherubim in the Solomonic Temple. God allowed the cherubim, he says, "to be made and shown as prostrate in adoration before the divine throne."[61] John remembers what the ancient skeptics said against the adoration of images, arguments probably taken over from some of the Church Fathers. Some doubting minds of Antiquity as well as the Hebrew prophets, as we remember, sought to belittle the value of images by stressing that they are man-made objects consisting of ordinary, often base, materials.[62] In the *Apologies* these arguments are very much alive, and John tries to repudiate them by again reminding us of the cherubim figures on Solomon's throne: "Are they [the figures of the cherubim] not the handiwork of man? Do they not owe their existence to what you call contemptible matter?" And he continues, "What is the meeting tent itself if not an image?"[63] The carved figures of the cherubim in the Solomonic Temple show that images, though originating in the manual work of humble craftspeople, and carved in ordinary materials, can carry out the

basic function of the image—they show us what would otherwise remain invisible. John's exegesis, tinged by the urgent political issues of his own day, refutes the skeptics' arguments against images.

Frequent as John's references to biblical testimonies are, the main reason for his belief that images of the divine are indeed feasible is not one of the events related in Scripture; it is an argument of theoretical theology, the central mystery of Christian religion. The Incarnation itself, the fact that Christ has become man, and thus has placed himself within the reach of human experience, that he could be seen and hence also depicted—is this not a sanction of images, an indication that the depiction of the divine is possible? "I boldly draw an image of the invisible God," we read early in the first Apology, "not as invisible, but as having become visible for our sakes by partaking of flesh and blood." John of Damascus knows how complex the theological problem is, and he therefore qualifies his statement. "I do not draw an image of the immortal Godhead," he continues, "but I paint the Son of God who became visible in the flesh, for if it is impossible to make a representation of a spirit, how much more impossible is it to depict God who gives life to this spirit?"[64]

An attentive reader, keeping in mind that the question is whether an image of the invisible God is at all possible, does not really know what to make of this passage. What John here says is ambiguous. Christ Incarnate—that is, Christ as man, as every other man—has of course "circumscription" and "form," and is thus susceptible to depiction, just as every person, every natural creature and material object would be. But is such a portrayal of Christ as man only a manifestation of the invisible?[65] John must have been aware of these questions. In the passage from which we have just quoted, he goes on to say, "The flesh assumed by Him is made divine and endures after its assumption. Fleshly nature was not lost when it became part of the Godhead, but just as the Word made flesh remained the Word, so also flesh became the Word, yet remained flesh, being united to the person of the Word."[66] It is "therefore," that is, because the Word has become flesh, John of Damascus says, that he boldly draws an image of the invisible God.

In the second Apology he comes back to the same argument. It would be "sinful" were we to attempt to make an image of the invisible God.[67] "But we are not mistaken," he continues, "if we make the image of the God incarnate, who was seen on earth in the flesh, associated with men,

and in His unspeakable goodness assumed the nature, feeling, form, and color of our flesh." And a little later he says, "Since divine nature has assumed our [human] nature, we have been given a life-bearing and saving remedy, which has glorified our nature and led it to incorruption."[68]

In John's time it was not new or unusual to invoke the Christological argument in defense of icons. The topic was publicly discussed in the synods that make up the official Iconoclastic Debate. Iconoclastic theologians concentrated their attention on this argument, and they articulated the conceptual difficulties inherent in it. A single document, perhaps composed in the year of John's death, will show what the problem was, but also how clearly iconoclastic theologians perceived the difficulties of the argument. In the *Horos* (definition) adopted by the Council of 754, we read,

After examining these matters with much care and deliberation . . . we have found that the illicit craft of the painter was injurious to the crucial doctrine of our salvation, i.e., the incarnation of Christ. . . .

This man makes an image and calls it Christ; now the name "Christ" means both God and man. Hence he has either included according to his vain fancy the uncircumscribable Godhead in the circumscription of created flesh, or he has confused that unconfusable union . . . and in so doing has applied two blasphemies to the Godhead, namely through the circumscription and the confusion. So also he who reveres [images] is guilty of the same confusion.[69]

This decision was adopted in the year of John's death, but the ideas that shaped it were, of course, current in the preceding decades.[70]

The theological discussion itself, beyond its application to the image, is not our concern. Once again, however, the theological controversy implies, or even articulates, attitudes that have a direct bearing on the question of the icon's truth and validity. The decision here quoted sets forth in a distinct way the iconoclastic criticism of the Christological argument as used in the defense of sacred images. What the criticism says, to put it in simple words, is that the icon portrays only one part of Christ's nature, his body; the divinity of Christ remains unportrayable, and the Incarnation does not change this state of affairs.

This also holds true for John of Damascus. Stripping his attitude in the debate, particularly his use of the "Christological argument," of the theological terminology, it becomes obvious that he raises the question

of whether and how a visible form is at all able to portray a nonmaterial meaning that in itself is not directly present in what we see.

The modern student of images may be permitted here to outline, in a few words, John's theoretical position. He did not want to adopt—and, given the limitations of his time and spiritual world, he could not adopt —the view that the icon is a mere "sign" of God, and that it is understood as such because a common convention makes this possible. He also could not accept a psychological explanation of the link between the visible icon and the invisible being it purports to represent. It was not the spectator's experience that was his concern. John faced the problem of whether a material image can actually portray an idea or a spiritual being, in its purest form, without the aid of "conventional" concepts or psychological explanations.

On this level John does not give a clear answer; the mystery of how an image carries an intimation of the invisible remains in full force.

The icon in popular beliefs. So far we have looked at John's views concerning the purpose of the image as they appear on the level of abstract theological speculation. But, as I have said earlier in this section, abstract argument, conducted on the intellectual level of theological speculation, was only one part of what he had to say on the subject. In addition, John also puts forth his views on the purpose of the image on a different level, the one we have termed "popular beliefs." It goes without saying that our author nowhere distinguishes between a "theoretical" and a "popular" discussion. It is the task of the modern student to extract the different approaches from the same text. But though the elements were not neatly separated from each other in John's mind, in his text it is possible to distinguish between the different layers of thought.

It is not for me here to attempt a characterization of abstract versus popular thought; all I shall do is to suggest some tentative observation of different approaches to our specific subject, namely, the purpose of the image in the reality of human life. Not surprisingly, the core of the subject was, once again, what is the relationship between the visible icon and its invisible prototype?

Philosophically minded theologians understood this relationship as a spiritual affinity or parallelism, a connection that cannot be perceived in our reality. This attitude tended to deprive the image of any link with

the painted icon. In popular beliefs the elusive connection between the prototype and the copy tends to become a physical unity of sorts. Underlying popular beliefs is the tacit assumption that there is some direct link, as it were, between the icon and its archetype. To be sure, the link is only partial, since the icon does not become an embodiment of the invisible, but nevertheless the link remains one of substance. The picture, in a sense, becomes an extension of the being or figure portrayed, a projection of the saint depicted, perhaps even of the divine. No wonder, then, that the god or the saint portrayed can use the picture as a means of intervening in the affairs and fate of people.

An extension of this kind well known to us from everyday experience is the shadow one casts. In John's doctrine of images the cast shadow does indeed play a significant role. The New Testament itself seemed to support the idea that a saint's shadow is an extension of the saint's body, and, like other extensions, carries a special power. The apostles performed miracles with extensions of their bodies. "Peter's shadow, or handkerchiefs and aprons carried from Paul's body, healed the sick and put demons to flight."[71] Concentrating on the shadow, John speaks of the marvelous ability of the apostle's shadow to expel demons. Christ's servants and friends "have received the power over all demons and diseases," and they have the power to drive away evil spirits. They exert this supernatural power through their shadows. "Their shadow alone expels demons and diseases."

John follows his Christian sources; the story of the apostle's healing and miracle-working shadow is of course taken directly from the New Testament (Acts 5:15). Yet he transforms the story in a significant way. The specific conclusion that John draws from the story—namely, that there is a link between the shadow and the icon, that the shadow is a model of what the icon is—is not suggested by the New Testament text. Though he does not put it as a definition, it is obvious that he makes the shadow cast by a figure, especially a holy one, a legitimation of the painted icon. The internal connection between shadow and icon goes so far that he even doubts which is closer to the original model, the icon or the shadow: "Would not a shadow be reckoned weaker and less honorable than an icon? An icon is a more distinct portrayal of the prototype."[72] And therefore, "Pagans make images of demons which they address as gods, but we make images of God incarnate, and of his servants and friends, and with them we drive away the demonic hosts."[73]

While Scripture does not suggest this link between the shadow cast by a figure and the painted icon, John may have inherited the idea from ancient, "pagan" culture. In Greek thought and literature an intimate connection between the two was often assumed. Plato used the words for "shadow" and "icon," *skia* and *eikon*, as synonyms.[74] Moreover, ancient lore considered the shadow we cast as the very origin of painting and sculpture. This belief was epitomized in the famous story of the girl who, wishing to hold her departing lover, outlined the shadow he cast on the wall, and filled the surface between the lines with paint. The image that remained behind even after the lover was gone is thus directly derived from his shadow, and in an implicit sense it is considered as replacing the living figure. Our best witness to this myth in Greco-Roman culture is Pliny,[75] who uses this story to explain the emergence of the visual arts. In slightly different versions the belief was common in the regional subcultures of classical Antiquity, and it has been shown that it can be found in primitive cultures in different parts of the world.[76] The story of the maiden outlining the shadow of her departing lover was well known to early Christians. In the second century A.D., Athenagoras, who was less hostile to pagan images than other Christian apologists, explains how "tracing out shadows" led to painting and relief modeling, which then were followed by sculpture and molding.[77]

For Christian authors of the second century, however, the two stories about the shadow—Peter's shadow working miracles, and the lover's shadow being outlined and thus serving as the origin of painting and sculpture—remained altogether separated. This seems to have changed in later centuries. In the minds of well-educated Byzantine theologians in the eighth and ninth centuries the link between the shadow and the painted icon appears to have been firmly established. Not only John of Damascus combines the two stories; so also, shortly after him, does Theodore of Studion in his *Refutations of the Iconoclasts*. Theodore retains a certain traditional ambivalence in the interpretation of the shadow. On the one hand, the shadow is considered the counterpart of truth and of full reality. "For the shadow and the truth are not the same thing," he makes the heretic say.[78] But, on the other, the apostle's shadow carries the apostle's power and conveys to everybody on whom it is cast something of his sanctity. The Cross "has such power," the defender of icons writes, "that by its mere shadow it burns up the demons and drives them far away from those who bear its seal."[79]

John's intention in linking the icon with the apostle's shadow, though never explicitly stated, is clear: the image is considered as issuing from the prototype himself, even if not directly. There is a semicorporeal continuity leading in an unbroken flow from the god itself to its painted icon. Such a continuity, if it can in any way be accepted, is of course the highest legitimation of the icon. The painted image attests to a quasimaterial presence of the god; it is a kind of relic.[80]

On this level of rather crude materialization, the purpose of the icon differs from what it had been on the level of abstract theological speculation. Now the image serves more practical purposes. "Images are a source of profit, help, and salvation for all," says John of Damascus in the section in which he explains why images are made.[81] Our author seems to have had in mind mainly the warding off of evil spirits. Towards the end of the third Apology John says once more that the saints' "shadow alone expels demons and diseases. Would not a shadow be reckoned weaker and less honorable than an icon?"[82] In the commentaries to the quotations from venerated texts that he appended to the *Apologies*, the *florilegia*, he is sometimes even more explicit. In commenting on an early Christian text, John explicitly says, "Devils are in fear of saints, and flee from their shadow. A shadow is an image; therefore I make images to terrify the demons."[83] Here John's intellectual conscience seems to have awakened. He continues, as if speaking to himself, "If you say that only intellectual worship is worthy of God, then take away all corporeal things: lights, the fragrance of incense, prayer made with the voice." Adding an example, he comes back to the the image, and quite specifically to the relationship between archetype and copy in the image of the divine: "Purple cloth by itself is a simple thing, and so is silk, and a cloak is woven from both. But if the king should put it on, the cloak receives honor from the honor given to him who wears it." Note that the cloak receives honor not because it means the king, or reminds us of the king, but rather because the king has worn it, because there was some kind of bodily meeting and thus a flow of subtle matter, as it were, from the king himself into the cloak.

The constant interaction between conceptual reflection of a highly intellectual character and the almost tangible reification of bodiless, spiritual beings is typical of John's complex personality. A modern student may find it difficult to reconcile the sophisticated distinctions made in John's theological views of the image with the crude beliefs in

its miracle-working power. How can a thinker, one cannot help asking, who so subtly unveiled the complex dialectical nature of the image as a spiritual revelation of the invisible also believe that the painted icon drives off almost tangible demons? This incongruence, as I have said, is a pervasive characteristic of John's thought, and perhaps also of Byzantine culture as a whole. It is found in the reflection on many themes. An analysis of this characteristic would go far beyond the scope of the present study, and here I shall only say that it impresses itself on John's doctrines of why images are made.

The divine image and human nature. So far we have seen that John considered the purpose of the image in two different ways. First he tried to show, in defense of the painted icon, that an image of the divine is possible in principle, and to do this he ultimately based his argument on the incarnation of Christ. Secondly, he treated the image as a reified piece of sanctity, as understood by simple folk—something that emerges more or less directly from the holy figure, and is endowed with the ability to ward off evil spirits and disease.

The student of John's thought concerning the purpose and functions of the sacred image has to direct attention to still another aspect. Our author did not coin a special term for this aspect, as he did not for the others, and no traditional label easily comes to mind; it may therefore be best to describe it in modern terms: it is an approach to the image in terms of the human condition. Here John's reflection revolves around the question of why we need the icon, and how we perceive it. In the center now stands humanity, its abilities (and their limitations) as well as its needs. In the metaphysical, or theological, discussion, John naturally does not ask how the image is perceived. It is the cosmological chain, to which we shall turn in the next section, that ensures the validity of the icon and defines its purpose as a step in the hierarchy of being; here the human experience is not of crucial significance. In the beliefs we have called "popular," humanity and its nature also do not figure as a problem. The expelling of demons is a tangible, material expression of what is imagined as a cosmic contest, as it were; it does not take into account what the image as such means to people. But John does touch on the problem of what the image means to people, and this is an aspect we must consider, elusive as his observations may be.

One should of course be careful not to project modern concepts onto

the thought of an early medieval mind. In defending icons, John of Damascus was not concerned with psychology, neither in the ancient nor in the modern sense of that term. He was also not concerned with "hermeneutics"; apparently the idea of establishing rules for a correct "reading" of the icon did not even cross his mind. Nevertheless he takes into account in this context some basic problems of human existence in the world, and thus adds a significant dimension to what he has to say on the purpose of images.

In touching on the human condition, John offers, even if only as an implicit sketch, the outlines of a philosophical anthropology, at least as far as it relates to the purpose and function of the image. Our saint's anthropology has two traditional and well-known assumptions that have been repeated countless times. One assumption says that we, mortal human beings, are not able to endure the unmitigated revelation of the divine, and are not capable of thinking without material residues. This follows from the basic fact that humanity, being composed of body and soul, has a dual nature. It is our physical, material nature that prevents us from perceiving directly the nonmaterial, spiritual glory of the divine. "Since we are fashioned of both soul and body," our saint says, "and our souls are not naked spirits, but covered, as it were, with a fleshly veil, it is impossible for us to think without using physical images."[84]

The other assumption is perhaps a little less trivial; though not explicitly discussed in early Christian culture, it was perhaps more doubted. It says that matter surrounding humanity and imposing crucial limits on its nature is not altogether opaque; it does not place us behind an impenetrable wall casting complete darkness. The bodily elements can be made diaphanous, at least to a certain extent. "By using bodily sight," John says, "we reach spiritual contemplation."[85] Moreover, inborn in us is a longing for the sight of God. Commenting on a text by St. Basil, John writes, "Since I am human and clothed with a body, I desire to see and be present with the saints physically. . . . God accepts my longing for Him and for His saints."[86]

The two assumptions of John's anthropology call for a mediator, as it were. It is here that, in his view, the image comes in. The sacred icon mitigates the full force of the divine, a force we would not be able to endure. But at the icon of God we *can* look. On the other hand, the bodily forms shown in the icon are transparent towards the holy; they

enable us to get a glimpse of the sacred or divine. The icon suggests the divine without fully unveiling it.

It is interesting to compare John's definition of the divine as proposed in the context of the hierarchy of being, without regard to the human experience, and the description of the image made in the context of his anthropology. Where he considers the holy image with a view to the human condition, he stresses characteristics other than those he emphasized when he was considering it as a revelation of the divine. As seen by people, the most prominent characteristic of the icon is that it is a mediated revelation—it suggests the divine without fully portraying it. "Visible things," we read in the first Apology, "are corporeal models which provide a vague understanding of intelligible things."[87] The contrast with the definition of the image as such is striking: where John speaks of the image as such, without looking for what it means in human experience, the icon is taken to be "a likeness, or a model, or a figure of something, showing in itself what it depicts";[88] yet when he considers the icon in the human context, all the holy image can do is to give us "a vague understanding" of what it represents. Moreover, in defining the image as such John stresses how close the likeness is to the prototype. An image of a person, so one feels after carefully reading John's text, is an almost identical "likeness of his [the prototype's] bodily form," differing from the prototype only in that the likeness does not contain the "mental power" of the prototype who is portrayed.[89] Yet when John discusses the image of God in the human mind, as that image is perceived by our human eyes, the proclamation of near identity is seriously qualified and toned down. Not only is there a difference in substance, as it were, between prototype and image; there is even a difference in form. Speaking of the icon in the context of human perception, John stresses the distance between the prototype and the copy.

That John turns to Scripture for quotations that would serve as legitimation of his views is, of course, typical of his age and culture. But the specific quotation from Scripture he adduces to that end is not usual. It not only legitimizes John's views; it explains a crucial aspect of his doctrine of images. It becomes part of his doctrine of images, as well as being a commentary to a fundamental question in that doctrine. He quotes Paul's famous statement, "For now we see through a glass, darkly, but then face to face" (I Corinthians 13:12). Generations of

readers and commentators have understood this sentence as a statement on the human condition in the two stages of cosmic history. In the present state, that is, before full redemption, we are not capable of looking face to face at the full glory of God; in a future state, after full redemption will have freed us from the bonds of the flesh, we shall be in a condition to perceive that glory, and to see God face to face.[90]

The reason for using the dark glass is not spelled out in Paul's text, and most of the commentators did not ask this question; they focused on other aspects of the famous statement. Intuitively, however, Paul's intention is obvious. From everyday experience we know that we look at the sun through a dark glass because looking at the sun without some kind of shield would hurt our eyes. In other words, the "dark glass" is a mediator between the overwhelming power of the light and the frailty of our eyesight; it is a protection of our eyes. This, as both everyday experience and the literary context of the sentence in Paul's letter suggest, is also how the apostle himself meant it.

That John should have employed this sentence in his discourse is not surprising. But his specific interpretation of Paul's metaphor is not traditional at all, and deserves careful reading. The "dark glass" is the prototype of the icon: "Now the icon is also a dark glass, fashioned according to the limitations of our physical nature."[91] He comes back to the same idea, and though he does not explicitly quote Paul, John's wording reminds one of the apostle's imagery. Speaking of icons of Christ he says, "Reverently we honor His bodily form, and by contemplating His bodily form, we form a notion, as far as is possible for us, of the glory of His divinity."[92] So far as I am aware, John of Damascus is the first theologian to formulate this idea, and in this particular respect he also remained without much following.

Seeing the image as a "dark glass" or as an "aenigmatic mirror" implies an important conclusion for the icon. Thus conceived, the icon provides for a mediated vision, for an indirect cognition of God. What we could not endure in direct experience is made possible by the mediation of the image. The icon makes us experience the divine (as far as this is possible), and, at the same time, protects us from the unspeakable results of such an encounter. In different versions John comes back to the same theme. "Therefore," that is, in view of humanity's limitations, "the image was devised that he might advance in knowledge, and that secret things might be revealed and made perceptible."[93]

(iv) *Some Implications for Art* At the conclusion of these considerations, some brief comments by a modern reader may be in order. First, a note on the historical context. John of Damascus, as we know, grew out of the Platonic trend in antique speculation. But with his argument concerning the power of the image the Platonic tradition has, at least in this one respect, come full circle. Plato and many of his followers believed, as we know, that the painted image can portray only what is anyhow available to the senses. Moreover, being a "shadow" of the reality represented, the painted image shows less, and does so less correctly, than what we can observe in the prototype, the natural object itself.[94] Now, John of Damascus claims exactly the opposite. The image, at least the holy icon, reaches farther than the perception of the human eye in natural experience; it shows what lies beyond the realm of visual experience. All of John's efforts to sustain the validity of the sacred icon aim precisely at showing that the icon reveals more than can be seen in nature.

John of Damascus, then, believes that the central function of the icon is to make us see something of the invisible, to overcome our limitations. This view necessarily affects what we think of the scope of painting. By making the visible manifestation—one could even say revelation—of the invisible the main end and purpose of the image (and vindicating the material, painted icon on this ground), John both expands and reduces the scope of the representative arts. The expansion is clear. For centuries it had been taken for granted (mainly in the culture of Antiquity) that the aim of painting is the representation of what can be visually perceived in the world around us. In defining painting as the rendering of perceived nature, one also set the limits of the art. It is only what we actually see that can become the subject matter of painting. But if you believe that the icon shows what otherwise *cannot* be seen, you enlarge the scope of painting as compared to the views held earlier. A new dimension is now incorporated, as it were, into the domain of the image.

The reduction of the scope of painting that John's definition of the icon involves is less obvious; he does not state it expressly, yet it follows, I believe, from what he sees as the aim of the icon and from the reasoning by which he vindicates the image. If the icon's main value, actually the only one he explicitly mentions in the *Apologies*, is that it reveals to our eyes what otherwise cannot be seen, it follows that the depiction of the real world—that is, the world and objects we can and

do experience directly with our senses, without the aid of the picture—has no inherent value, and therefore cannot be justified. What sense would it make to portray objects that we can easily look at in nature? This kind of reasoning is adumbrated in some of Plato's well-known reflections on painting. If Plato believed that illusionistic painting is, at most, nothing but an attempt to produce a doublet of the real object,[95] and hence altogether superfluous, John of Damascus follows this line of thought, and takes it one further step. He does not even intimate mimesis as such, the artistic portrayal of the visible world—which in classical Greek thought was so commonly considered a central value of the work of art—as a value of the image, or a possible reason for producing it.

5. Types of Images

Among John of Damascus's most original contributions to a doctrine of icons, as he saw it—and to an aesthetics of the visual arts, as we now understand it—was his classification of the types of images. He himself seems to have considered this classification an important part of his doctrine; he stated it twice in relative detail, and he assigned to it a significant part in his view of how the world is structured. Studying his classification we learn what he considered to be the main types of images, and what he perceived as the characteristic features of each type. The sequence of the individual classes indicates how, in John's mind, the image works in the cosmic order of things. In the present section I shall first follow the exposition given in the third Apology.[96] Later I shall ask what some of John's views may mean to us today.

John's classification of images is not based primarily on actual observations or immediate experiences; his approach, needless to say, was not empirical. What determines his classification is, rather, theological speculation. More specifically, it is the theologian's awareness of the abyss between the celestial and the terrestrial worlds, and the intense desire to bridge it, and to show its continuous unity, that formed the background and point of departure of John's classification. In late Antiquity the speculative imagination of philosophers and religious visionaries conjured up several models of bridging that gap. The most famous single example is probably Emanation, the overflowing of light from its celestial source and eventually reaching the darkest corners of the earth. The idea of hierarchy, as we have seen in a former chapter, is another

model.[97] Hierarchy itself was imagined in various similes. Among these there was also the notion of a series of likenesses, reflections or mirror images, leading from heaven to earth.

As one knows, the image of the chain or the ladder leading from heaven to earth was not limited to Christian thought only; it was a common motif in various doctrines in late Antiquity. Let us listen to a classic formulation by Macrobius:

> Since from the Supreme God Mind arises, and from Mind, Soul, and since this in turn creates all subsequent things and fills them all with life, and since this single radiance illumines all and is reflected in each, as a single face might be reflected in many mirrors placed in a series . . . And this is Homer's golden chain, which God, he says, bade hang down from heaven to earth.[98]

A row of mirror reflections, a descending series of images in general, is, however, a frequent notion in Christian formulations. We are best acquainted with it from Dionysius Areopagita's influential doctrine of the hierarchy of images.[99] John of Damascus, a self-confessed disciple of Dionysius Areopagita,[100] was of course familiar with the simile of a chain of images, and treats it almost as a matter of course.

Between the time of Dionysius Areopagita and John of Damascus the image of the hierarchic ladder attained its most famous formulation. At the turn of the sixth and seventh centuries another monk of the same region, John Climacus, composed a treatise that was to become a popular book. John Climacus was elected abbot of the central monastery of the Sinai Peninsula, allegedly built on the spot where Moses ascended to heaven. John was asked by the abbot of a nearby monastery "what like Moses of old you have seen in divine vision upon the mountain." *The Ladder of Divine Ascent* was written in answer to this request. Though the audience addressed by John Climacus was thus monastic, the influence of the book was soon felt in Byzantine culture as a whole. It has been maintained that, with the exception of the Bible and liturgical books, no work in Eastern Christendom has been studied, copied, translated, and read aloud more often than *The Ladder of Divine Ascent*.[101]

No wonder, then, that John of Damascus was so familiar with the metaphor of the ladder, and used it when he wished to present a picture of his system of images. We should note, however, that, while the culture of his time was familiar with the idea of the hierarchic ladder in general, even with a series of images, no prior attempts seem to have been made to make the motif concrete and specific. The individual types of images

constituting the chain had not been described before. So far as I am aware, we know of no earlier endeavor to establish how many types of images there are. John of Damascus, we can safely say, converted a well-known, but general, metaphor into a specific doctrine.

John builds his hierarchic system of images by doing three things. First, he establishes the number of image types. There are only six basic classes of images, and they make up the whole chain. Secondly, he describes the specific nature of each class. This is actually the core of his doctrine. What he says about the six types forms the central part of his contribution, and this is also where he departs from inherited models of thought. Finally, he gives this complex of six image classes a definite direction—from God the Father to the painted icon—thus transforming it into a well-ordered, hierarchic system. By giving the individual classes ordinal numbers, he defines the specific place of each type within the whole system. I shall first survey the individual classes, and then turn to some aspects of the system as a whole.

The first class of images, John of Damascus tells his readers, is "the natural image."[102] Now, this term, "natural image," may be misleading, particularly to a modern reader who takes for granted the connotations certain terms have acquired in our time. The term John uses—"natural image"—may ultimately well be sought in the vocabulary of ancient aesthetics or art criticism. In classical discussions of art, as one knows, the combination of naturalness and image was common; it had an articulate meaning, and a very broad appeal. To a Christian theologian, however, the words had another meaning, one far removed from that prevalent in the language of art criticism. When John speaks of a "natural image," what he has in mind is not a convincing depiction of an object in nature. To him, the term rather denotes a primordial relationship, not produced by an artist's skill, but found as given, as a primary, irreducible component of an ultimate reality. The son is the image of the father—this is the first type of image, the one he calls "natural." By the time of John of Damascus the statement that the son is the image of the father was already a time-honored dogma of Christian thought, possessing a centuries-long history.[103] The dogma in itself need not detain us; we shall look at it only for what it may tell us of how John understands the painted icon.

John's very definition of the image, as we have seen,[104] says that any *eikon* has both a certain identity with, as well as a certain difference

from, its prototype. This general definition is particularly valid for the first Image. In speaking of the Son as an image of the Father, John stresses the identity between them. Though he, of course, also mentions the difference between the two, the reader is left with the impression that it is the identity that is more significant: "The Son is the natural image of the Father, precisely similar to the Father in every way, except that He is begotten by the Father, who is not begotten." [105] Now, what else can "precisely similar" mean but identity? This seems particularly so since the Father has no visible shape, and the only difference our author mentions is a difference in position, as it were: the one is the Begetter; the other is the Begotten. Sometimes John seems even more emphatic in emphasizing the identity between Father and Son: "The Son is the living, essential, and precisely similar Image of the invisible God, bearing the entire Father within Himself, equal to Him in all things, except that He is begotten by Him, the Begetter." [106]

One is, of course, aware that John here reiterates a central theological statement (Christ as an image of the Father), and is therefore not free to make any qualification. The theological idea of identity in difference between the Father and the Son, it is well known, was articulated without any thought on matters of aesthetics. But when this theological statement is repeated in the context of a discussion of icons, it necessarily endows the notion of "image" with a far-reaching identity with the prototype. To say it once more: except for their respective status within the mutual relationship (the one Begetter, the other Begotten), Father and Son, or prototype and image, are fully identical.

We descend one rung in the ladder. The second type of *eikon* comes close to what, in the language of psychologists, is sometimes called the "mental image." But John does not intend to outline any rudiment of a psychology of humanity; the image he is speaking about does not dwell in a human mind, but appears in the mind of God. The concept of this kind of image explains how God created the world; by implication it may also serve as a model of how any "making" or "producing" (not to say "creating") takes place.

"The second kind of image," says John of Damascus, "is God's foreknowledge of things which have yet to happen." [107] The section devoted to this type of image is short, the formulation very concise, almost fragmentary; nevertheless, it suggests several interesting conclusions. Underlying John's observation on this type of image is the ques-

tion of how the world (or any reality) that has not yet been created exists. His answer is, things preexist their actual creation by God in the form of images dwelling in the divine mind. The problem itself was not new.[108] The answer frequently given was that the as yet uncreated world preexists in God's mind as a notion, an *idea,* or a design. Now, John replaces the more abstract concepts by the more concrete "image" *(eikon).* Replacing one term by another, "idea" by "icon," is not merely a matter of terminology; it indicates an important shift in emphasis. What is suggested by this shift in terminology is that the divine knows the things to be created in the future by looking at their images that dwell in its mind. Looking—that is, the visual experience taking place within God's mind—is a primary form of knowledge.

These images in God's mind suggest that the bridging of the chasm between God's uncreated nature and the nature of the created world takes place within the divine itself. What John suggests, without explicitly saying so, is that when the world is created, "at the time which has been predetermined by Him," it is not the divine itself who is being materialized, but the images dwelling in the divine mind. This also helps to explain the complex problem of the transition from the eternal to the temporary. "The divine nature is immutable," says John in the same short paragraph; "his purpose is without beginning," is "changeless." On the other hand, however, we know that the divine plan comes to pass at a certain time; while God's purpose is beyond time, the realization of this purpose in material reality, what is known as the creation of the world, takes place in time.

A third point, vaguely adumbrated but deserving of attention, is what John's brief paragraph may imply for the understanding of the process of artistic production. John does not speak of God as an artist, but this was a well-known simile.[109] The process of creating the world, or of making a predetermined event happen, is conceived as a projection of what already exists, albeit in the form of an image, in God's mind: "In God's providence, these things predetermined by Him were characterized, depicted, and unalterably fixed before they even come to pass." The process of creation, or of materialization, cannot add to or change even the slightest detail; it is nothing but projecting onto the outside that which existed inside the divine mind.

The first two types of image are situated within the divine; they are to be found inside God. For John of Damascus, as for other early Christian

theologians, these were specific categories of the divine, though both the resemblance of the Son to the Father and the foreknowledge of things to come are applicable to a variety of observations in ordinary experience. With the third type of image we leave the sphere of the divine, and enter the terrestrial world.

Humanity as an image of God is the third type of *eikon*. Here the transition from the divine to the terrestrial is carried out. The concrete contents is a highly traditional topos, the biblical version of the theme. Christian audiences, one assumes, were familiar with the biblical saying, "And God said: let us make man in our image and after our likeness" (Genesis 1:26). John obviously refers to this biblical statement as an ultimate authority sanctioning the material image of the divine. What interests him in this hallowed topos is the basic question of the doctrine of icons: "How can what is created share the nature of Him who is uncreated?" It is the philosophical question of how the visible can resemble the invisible that haunted reflection on icons for many centuries.

The way John puts the question may sound merely rhetorical, but in fact he here attempts an answer. It is imitation, he claims, that makes possible this community of nature that we find so difficult to grasp: "How can what is created share the nature of Him who is uncreated, except by imitation?"[110] One could, of course, ask, how can we imitate something that is totally different from ourselves? But it is difficult to know what precisely John meant here by "imitation." He may well have borrowed the term from the vocabulary of antique aesthetics with which he was familiar. Yet in Greek aesthetics and criticism, "imitation" could mean different things. So far as we can see, in John's short passage "imitation" does not refer to something we do, which would have been the primary meaning of the term in the language of ancient art criticism. In speaking of "imitation" he here rather has in mind a certain analogy of position in the order of the world and in relation to other creatures and objects.

The fourth type of image is the most complex of all the types; it is also the most equivocal and obscure. In the third type, with the shaping of humanity as an image of God, the step was taken from the divine sphere to the terrestrial. But it was only a matter of principle; it remained abstract. Since John was here following the biblical text closely, he avoided dealing with the specific problems that arise with this crucial

transition from one world to the other. Now, in turning to the fourth type of image, he faces all these difficulties without being able to rely on biblical authority.

John must have felt that the fourth type presents more difficulties than all the others. The section dealing with this type is the longest of all, and it is the most involved and intricate in formulation; moreover, at first glance at least, it is not immediately obvious what precisely is the subject matter of this "type." In the presentation, even of complex theological thought, John of Damascus is usually clear; what he says is easily grasped. That this clarity is lacking in his presentation of the fourth type of image may have something to do with the very wide range of subject matter evoked. In fact, what we have here is a sketch of the overall doctrine of the icon of the invisible.

The fourth kind of image, so begins the section in the third Apology, "consists of the shadows and forms and types of invisible and bodiless things which are described in Scripture in physical terms." [111] We do not have to discuss in detail John's semantics (e.g., what precisely terms such as "shadows and forms and types" mean). [112] Here we are concerned with the principle that material objects have a meaning, and should be "read." In the first Apology John refers to the same problem by saying, "Visible things are corporeal models which provide a vague understanding of intangible things." [113] The formulation here is even more sweeping than that in the third Apology: the whole world of material bodies becomes a collection of models of the invisible and intangible.

Here John of Damascus draws from a great cultural tradition (perhaps one could call it "emblematic") that was a significant factor in shaping the intellectual life and imagination of Europe. The core of this tradition is the belief that all things in this world, events as well as creatures or objects, refer to a hidden reality that, in itself, remains ineffable—that all things in this world "mean" something. It was particularly in late Antiquity—a period to which John was closely related—that this approach to the world acquired central significance. [114] Already Philo, in the first century A.D., suggests that the events related in the Bible embody a multiple truth, at once literal and figurative. [115] In late Antiquity such double reading of stories and objects was common both among pagan authors, mainly Neoplatonists, and Christian writers, including some of the central Fathers of the Church. Suffice it to mention St. Basil (extensively quoted by John of Damascus in his *Apologies*) [116]

who in one of his major works, the homilies interpreting the creation (the so-called *Hexamaeron*),[117] reveals the meaning of everyday objects.

None of the former authors, however, whether pagan or Christian, ever described natural objects as a form of image. By conceiving of the multiplicity of meanings carried by the objects we encounter in regular experience as a model for the relationship between prototype and icon, John departed from tradition. The modern student, carefully reading the concise, and not always clear, passage on the fourth type, cannot help asking, why did John of Damascus describe these meaning-carrying objects as "images"?

In presenting this view, that natural objects carrying meaning are images, John's tone is polemical. Both in the first and in the third Apology he emphasizes how dangerous it would be were we to reject all images. Invoking the authority of Gregory the Great he claims that "the mind which is determined to ignore corporeal things will find itself weakened and frustrated."[118] People, it turns out, need images; using images is our way to come to terms with the invisible.

It is worth noting that only in the discussion of the fourth type of image does John speak of, and devote much attention to, how we perceive what can, and what cannot, be seen—in other words, that he here devotes thought and reflection to what we nowadays are used to calling "the spectator." John stresses human limitations: "It is impossible for us to think immaterial things unless we can envision analogous shapes."[119] In other words, it is we, mortal human beings, who need images; could we directly experience the invisible, one cannot help concluding, there would be no need for images. Now, we are unable to perceive the invisible itself, but the "image" goes as far in intimating the invisible as we are able to perceive.

The other question that immediately imposes itself upon us is, why are these intimations considered as images? In the regular, simple sense of the term, the natural creatures and objects grouped together in this fourth class are not icons at all. In what sense, then, does John conceive of them as images? His answer is—because they suggest by analogy. Paraphrasing a passage from the opening chapter of Dionysius Areopagita's classic *On the Ecclesiastical Hierarchies*, John of Damascus says that if "the Word of God, in providing for our every need, always presents to us what is intangible by clothing it with form, does it not accomplish this by making an image using what is common to nature

and so bringing within our reach that for which we long but are unable to see."[120] And to make what he means even clearer, John brings examples: "For instance, when we speak of the holy and eternal Trinity, we use the images of the sun, light, and burning rays; or a running fountain; or an overflowing river; or the mind, speech, and spirit within us; or a rose, a flower, and a sweet fragrance."[121]

In sum, then, the natural objects classified as the fourth type of image do not represent the invisible directly, in a way that might be called "physiognomic imitation." But they do refer to the invisible, and represent it by analogy. These, it turns out, are the features characteristic of the image.

The fifth type of image extends the idea of analogy, but transplants it, as it were, into a different dimension of being. While the fourth class of image, the "shadows and forms and types of the invisible" is valid for all the material objects that fill our world, and is found wherever the human condition prevails, that is, wherever the bodiless cannot be seen directly, the fifth type is limited to a specific domain, to history, as Christian theology understood it; it is concerned with what we are used to calling "prefiguration."

Prefiguration, as is well known, dominated Christian concepts of history, and particularly the reading of Scriptures, both of the Old and New Testament.[122] The events that were to happen in the New Testament (as well as the events announced in the Gospels for future times) are anticipated and announced, though in veiled form, in the Old Testament; the New Testament reveals what was present, though obscured, in the Old Testament. To John of Damascus, typology is a matter of course, a truth he does not question: "The fifth kind of image is said to prefigure what is yet to happen, such as the burning bush or the fleece wet with dew, which are foreshadowing the Virgin Theotokos." He is of course familiar with the typological symbols known in his time: "The brazen serpent typifies the Cross and him who healed the evil bite of the serpent by hanging on it. Baptismal grace is signified by the cloud and the waters of the sea."[123]

All this was, of course, a matter of common knowledge, and no student will be surprised that John of Damascus was intimately familiar both with the principle of Christian typology and with the main specific themes that emerged in this exegetical tradition. What is unusual, however, and particularly remarkable in our context, is that he conceives of

the typological foreshadowing as a kind of image. So far as I am aware, biblical typology, though recounted many times, had not been described as an image, and has never been subsumed under the philosophical category of the icon.

It is not for us to attempt here an analysis of the precise connotations carried by the exegetical terms John uses. Sometimes they are ambiguous, as experts have noted.[124] I should only stress that in carefully considering the terms, especially those employed in explaining how typology belongs to the doctrine of images, one cannot help noting their pronounced visual nature: "The law and its ordinances were a shadow [*skiagraphia*] of the image that was to come, that is, our true worship, which itself is the image of the good things yet to happen. These good things are the heavenly Jerusalem not fashioned with hands."[125] Using this term John says that the Old Testament is a "shadow" of the New.[126] *Skiagraphia*, here translated by "shadow," was a widely used term, continuously employed from Plato to Athenagoras, the Christian apologist.[127] But we should keep in mind that it was also a technical term in both the workshops and the critical vocabulary of Antiquity. Whether or not John wished to do so, by using this term he shows that his doctrine of typology is linked with the painter's craft.

The suggestive power of individual terms, however, cannot replace an explanation. Once again one asks the crucial question, what precisely does it mean that the *typos* is an image? John's language is vague. Worship, he says, "is given to those images which were seen by the prophets (for they saw God in the images of their visions). These images were of future things, such as Aaron's rod, which prefigured the mystery of the Virgin, or the jar of manna, or the altar. . . . Joseph was a figure of the Savior. . . . The tabernacle was an image common to all the world."[128] Or, "an image foreshadows something that is yet to happen, something hidden in riddles and shadows. For instance, the ark of the covenant is an image of the Holy Virgin and Theotokos, as are the rod of Aaron and the jar of manna."[129]

Although John does not explicitly say why he considers the *typos* an image, the direction of his thought is obvious. Both the "type" and the image combine a fully visible, directly graspable, articulate shape, or object, with a meaning or idea that is invisible, and cannot be directly experienced. The image and the "type" indirectly reveal the meaning; they place us in the field of tension between what is materially present

and what can only be understood or divined. When we take away the theological formulation, this turns out to be a surprisingly modern vision of the image.

It is only in the sixth, and last, class that we come to the proper subject that was at the center of the great historical debate, and in the defense of which the Apologies were written, the painted icon. Even here the actual picture, painted on a piece of board, is mentioned only in passing at the end of the section. In the sixth class John includes both texts and material objects. The images of the sixth class "are of two kinds: either they are words written in books, in which case the written word is the image, as when God had the law engraved on tablets and desired the lives and deeds of holy men to be recorded, or else they are material images."[130] Even the material objects, then, are not mainly paintings; most of them are sacred objects that do not depict anything. John mentions the jar of manna, Aaron's staff, and the onyx stones engraved with the names of the tribes, but there are, of course, other, humbler objects. The painted icon forms part of the class of material objects. Although it has a venerable ancestry, as it were, the proper place of the painted icon is close to, or at the very bottom of, the ladder.

John also tells his readers why these material objects are set up. He conceives of them as of monuments in the classic sense of the term; they are meant to remind the audience of heroes or deeds. In explaining the reasons for erecting these monuments, John shows how close he still is to ancient hero worship, though he may have had in mind martyrs instead of heroes. These material "objects" are set up "for the remembrance of past events, such as miracles and good deeds, in order that glory, honor and eternal memory may be given to those who have struggled valiantly." John concludes this section, and the discussion of image types in general, with an explicit reference to the artistic monument: "Therefore we now set up images in remembrance of valiant men, that we may zealously desire to follow their example." But these images also "assist the increase of virtue, that evil men might be put to shame and overthrown, and they benefit generations to come, that by gazing upon such images we may be encouraged to flee evil and desire good."[131]

Having reviewed John of Damascus's classification of the different kinds of images, we shall look at this list as a whole, and briefly consider the principles underlying it. In doing so, however, I do not follow John, but

try to look at the classification from the point of view of a modern student of the arts. Obviously the explicit theological implications will concern us less than the implied ideas and themes that particularly appeal to the present-day student.

In setting up the list of image types, John's aim, as we have already said, was not merely to analyze the nature and characteristics of each individual class. He was not a modern philosopher, and he did not consider knowledge as such, knowledge that does not lead to some results, as an end in itself. His establishing the list of image types was motivated by his desire "to save" the icon. By placing the man-made icon in a cosmic chain, a chain leading from Christ as an image of God the Father to the humble portrait of Christ painted by an artist, John attempts to provide an ultimate legitimation to the embattled icon. We now ask: How did he proceed to achieve this end? Whatever modern students of arts and images may think about John's attempt, they cannot help admiring the boldness of thought involved in trying to bestow upon the icon such ultimate legitimation. Rarely do we now encounter such an explicitly metaphysical foundation of art.

To derive the painted icon from the whole cosmic chain, it is essential to show that the links have an affinity to each other, that an underlying unity prevails in all of them; one could also say, it has to be shown that they are indeed "images." John did not explicitly formulate this requirement, nor can one be sure that modern criticism could accept his exposition as "proof" of such underlying unity. But reading his texts in the conceptual language of his own world, one sees that, in fact, he consistently tries to discover some common structure in all the types that make up his scale. Analyzing this structure, one also learns more about what is John's true concept of the image. Keeping the actual quest for a common structure in mind, I shall now try to look briefly at how John describes the individual types of images.

One can speak of images—this is what follows from John's presentation of his scale—when there is an articulate relationship between two poles, the one preceding the other, the one being a model, the other a copy. It may be worth our while to have a brief look at the individual image types from this particular point of view.

In the first type, the "natural image," the Father precedes the Son, and is his model. Considering the theological constraints, it might have been difficult to say that the Father precedes the Son in time.[132] But John

clearly sees the one as the model (or "begetter"), the other as the something reminding one of a result (the "begotten").

In the second type of image, "God's foreknowledge of things which have yet to happen," the time sequence is explicit: the image dwelling in God's mind clearly precedes its materialization in the terrestrial world. John here makes it a special point to stress the image's precedence in time: "The divine nature is immutable, and His [God's] purpose is without beginning. His plans are made before all ages, and they come to pass at a the time which has been predetermined for them."[133] But while it is plain that the image precedes the creation in time, John says little about the role the image plays in the process of creating. Did the divine look at the image in its mind when creating heaven and earth? In other words, did the image in God's mind serve as a model, or was it rather a mere "foreknowledge," which did not play any part in the making of the world?

The third type of image, the divine creating humanity in its own likeness, presents a very clear case, at least in formulation. God the Maker not only precedes the figure shaped in God's own likeness; God's self-image is obviously also the model God is following in shaping Adam. The passage raises other, well-known problems (does God look like Adam, whom God shapes "in His likeness"?), but it very clearly shows what John considers the structure of the image relationship.

As we have already seen earlier, the fourth type of image is the most complex and obscure of all;[134] this is also true with regard to its internal structure. What John here stresses is the two-dimensionality of material objects: on the one hand they are tangible and visible; on the other hand, they carry meanings that, in themselves, are intangible and invisible. In the fourth type of image we have, then, a tension between two poles. But in this tension there is no earlier or later, no time sequence. The visible objects "remind us," John here says, of the invisible meanings. This may be taken to suggest that in our own experience we first encounter the object and later are reminded of the meaning. But even if such a reading were correct (given the conciseness of John's formulation, we cannot be certain of this), nothing would follow as to the time sequence of object and meaning themselves.

In John's discussion of the fourth type of image there is also no intimation of the functions of model and copy, of one in some way following the other. It is interesting that here (and only here) John speaks

of "analogy," a term he usually avoids. Referring to Dionysius Areopagita John says that "it is impossible for us to think immaterial things unless we can envision analogous shapes."[135] The notion of analogy, we should keep in mind, does not indicate a time sequence, of earlier and later; it also does not evoke, however slightly, the concepts of model and copy. On the contrary, it would seem that "analogy" suggests independent, perhaps even unrelated, beings or shapes that are analogous.

It is finally worth noting that only here, in the section devoted to the fourth type of image, does John speak of human limitations, of the spectator's inability to see and experience the purely spiritual. Thus, we can get only a "faint apprehension of God," "it is impossible for us to think immaterial things," and we are unable "immediately to direct our thoughts to contemplation of higher things."[136] This shows again that the fourth type of image is a particular class.

Coming to the fifth type, we find again the time sequence, the pattern of earlier and later, as an essential element of structure. That the prefiguration precedes the full figure in time—that, for instance, the brazen serpent comes before the cross—is expressed in the very term "prefiguration." But does the prefiguration also serve as a model for the full and final figure? Here John's text is ambiguous. A modern student of the arts could understand a process in which the first formulation is only a vague beginning, and fully develops in the course of time. But in other types, John sees the model as fully articulate, and the realization only as a faithful copy.

The sixth type consists of heterogenous elements, words, material objects, and paintings. In all of them, however, the time sequence is clear. The very concept of the image as a "memorial" indicates the awareness of past events and their commemoration in the present. But it is not clear whether the past here serves as a model. In the sixth type the very concept of image is blurred, possibly because of the variety of objects included, and hence the underlying structure is also obscured.

In sum, in most types of images, though not in all, we do find the time sequence of an earlier and a later feature. In some types, the earlier appearance is clearly the model copied in the later. John nowhere speaks about the process of creating an image, but following his classification one cannot help feeling that this process seems to him the very field in which images most fully exist. It is only in this process that "earlier" and "later," "model" and "copy" achieve their full reality.

Prefiguration, as we have seen, is also close to some kind of mental imagery, though it may lack the vague psychological connotations carried by the image in God's mind. When we say that Christ is present as an image in the brazen serpent, we somehow have in mind a dematerialized form. The shape of the Cross, detached both from the material foundation carrying it and from the subject (divine or human) who experiences it, is granted a certain existence. It is this "pure form," to use a modern term, that John of Damascus also classifies under the heading of "image."

It is from this point that we reach the images "made for the remembrance of past events." It is remarkable, however, that, when speaking of the material images made by people, John emphasizes human needs and conditions rather than the metaphysical chain of beings. He certainly sees the man made icon as ultimately derived from the cosmic ladder of images, but what he believes to be most characteristic of it is its effect upon the spectator, evoking the "zealous desire" to follow the admired examples. This effect of the man-made image on the human audience, it should be noted, does not follow from the icon's metaphysical origin. In the end, the icon turns out to be a specifically human object.

There is another point that the modern student reviewing John of Damascus's doctrine of images is bound to notice: the question of how far the different classes of images are visible, and what role visibility plays, or does not play, in his classification of icons. We have just seen that in the analysis of the individual classes he nearly always refers, in one way or another, to the relationship between what comes earlier and what later, between model and copy. Seen against this recurrent motif, it is striking how little attention he devotes to the question of whether, or not, the image can be perceived in visual experience. In none of the classes does he explicitly mention visibility. Occasionally he does speak about "similarity," but here, too, it is not clear just how concretely he understands this term.

Now, does John not speak of visibility because he takes it for granted that visibility is a constitutive element of any image, and therefore does not have to be spelled out separately, or does he not devote sufficient attention to it because it is not important enough to be mentioned? I do not intend here to take up again the central question of how the invisible can be manifested to the eye, a problem that has concerned us in the

previous chapters of this essay. All I should like to do is to find out whether visibility is a factor in determining the classification, that is, whether one type of image is more visible than another. When we look again at what he says about the six types of images, it seems that our visual experience plays no important role in his classification.

It is mainly in the section devoted to the first type of image, the one called "the natural image," that John takes up the problem of visibility. We should not expect a clear-cut solution; John does not "solve" the problem. This section, however, shows that he was aware of the problem posed by the paradox mentioned. His text may also be taken as an intimation, however vague, that he conceived of seeing as a kind of mystical experience.

The Son, he says at the beginning of this section, "is the first natural and precisely similar image of the invisible God."[137] John must have felt the difficulty of making a visible image "precisely similar" to the invisible model. This may be the reason for his calling on the authority of Scripture. He quotes the Gospel of John: "No man hath seen God at any time" (1:18) and, "Not that any man hath seen the Father" (6:46). But several times in that short section John stresses that the Son, who is the "natural image," is "precisely similar" to the Father, "except that He is begotten by the Father." He does not mention that the Son differs from the Father in visibility. Does this imply that seeing itself is a supernatural, a kind of mystical experience? However that may be, John here does approach the problem of visibility.

In the following sections he occasionally touches on visibility, but the problem never becomes a central issue, and it never serves as a criterion of classification. In some cases he seems to have in mind what we call a "mental image." Without trying to enter the debate among psychologists concerning the nature, and even the very existence, of the mental image, we can say that John of Damascus considered the mental image as something real, something that can actually be looked at. God experiences his "foreknowledge of the things which have yet to happen"—this is what seems to be suggested in his text—by a kind of introspection: the divine knows what is to happen by looking at the images dwelling in its mind. All this, however, he never formulates explicitly; though it is convincingly sugested, it remains an intimation.

In the fourth kind of image, the material things of the world of our experience, the visibility is of course not doubted. However, what we

here see is merely the material object. These visible things are "only dim lights," and the meanings to which they refer remain unseen; the objects perceived only "remind us of God." The same vagueness obtains in the fifth type of image. Prefiguration, the fifth type, is described in terms of images, but again one wonders whether the link between past and future is visible.

How, then, does the modern student summarize John's scale of images? Three points, it seems, need to be stressed. First, John's major attempt to defend the icon was by showing that it is part of a cosmic chain of images. It was this argument that must have had a powerful appeal to his audiences, and his time in general. Secondly, the central feature of the image is the bipolarity of model and copy. It is this bipolarity that forms the basic structure of the image, actually recurring in all the types. Finally, visibility, in a simple, everyday sense, plays a minor, subordinated part in the characterization of the image. As a result one may say that, while the hierarchic scale may have had a powerful appeal to the imagination of his time, the modern student will express some doubt as to whether John of Damascus did indeed finally "save" the image. His classification of images, and the linking of meanings, mental images, and actual, painted icons will remain an interesting attempt to find a philosophical justification of the picture.

6. The Visibility of Bodiless Beings

After outlining in detail the internal hierarchic structure of all being as a series of reflections, one expects that John will have finally put to rest all doubt concerning the validity of the sacred image, and particularly concerning whether the invisible can be portrayed. In the sketch of the types of images as a cosmic continuity leading from God the Son to the painted icon, the reader could follow, step by step, the path by which the image reaches down from the heights of the divine glory to the humble painter of the icon. But John's mind does not seem to have achieved tranquility. Having discussed at some length the individual character and unique place of each particular class of images, he now once more comes back, in a short section, to the essential question that has lurked behind every section of the *Apologies*. This section[138] concludes John's discussion of images, their nature, function, and power; after this section the third Apology goes on to deal with the worshipping

of icons, and in these later sections the emphasis is naturally laid on the worship of icons rather than on the icon itself. The few comments of which the epilogue consists are thus, as it were, John's last word on the subject. It deserves our careful attention.

Concise as the epilogue is, it evokes many ideas and themes, some of which are far more significant in John's spiritual world than one could guess from the few sentences he here devotes to them. Though he has treated several of these themes elsewhere, they appear here in a new context, and sometimes also in a more explicit articulation. I should like to discuss two of the themes as they are here mentioned. One is the old subject of what the image may, or may not, represent; the other, barely indicated, is rather new: it is the question of the proper audience, or, as we may say, who sees what.

"What may be depicted by an image, and what may not, and how images are to be made?"—so runs the title of the epilogue, and the title does indeed suggest the central topic of the section. His aim in the epilogue is to show, perhaps in a way slightly different from what he has done so far, that the transcendent world can indeed be portrayed, and that this possibility of depicting the Beyond is founded in the *Weltbild* of the Bible itself.

John opens the brief text by stating that "physical things which have shape, bodies which are circumscribed, and have color, are suitable subjects for image making."[139] This is, of course, an old and well-known idea, here put in an elementary form. As one knows, it was a cornerstone of the ancient theory of mimesis, and became almost an article of faith in the interpretations of classical aesthetics. Put in its crudest form, it would mean that only what is visible in nature can be rendered in a work of the visual arts, the implicit assumption being that the pictorial representation is based on an intimate affinity, perhaps even an identity, of the shapes and colors observed in the outside world and the shapes and colors applied in the painting that represents a piece of this world. John of Damascus, it is to be assumed, was familiar with the fact that this opinion formed part of classical culture, and he was probably aware of the theoretical consequence it entails. It is worth noting that, in fact, John gives the classical doctrine of mimesis a certain interpretation by stressing one aspect (which was not prominent in the ancient theory itself). From his concise presentation it follows that in the ancient doctrine the visible was inseparably linked to the material and tangible.

Visible is only what has a body, and consists of matter. The title given to the epilogue makes this abundantly clear. Yet painting as the representation of what is visible in everyday reality was not a subject that occupied John's mind. In his former discussion of images, the ancient theory of mimesis, as he understood it, is not even mentioned as such. As we know, he was not content to stay within the domain of the material objects that are available to everyday sight. What he is concerned with is, in a sense, the very opposite; he wants to go beyond the visibility of tangible bodies and material objects, and he asks, how can we attain the vision of the invisible—how can we experience visually, and represent, figures or beings that have no body, no material nature, and that therefore lack shape and color? Our desire to visually perceive what is beyond the realm of "physical objects," as we have seen above,[140] results from our very nature; it belongs to the basic human condition. Moreover, John believes that this desire can, at least to some extent, be fulfilled. The divine plan of creation assures us of this. "God [himself]," he says, "wills that we should not be totally ignorant of bodiless creatures."[141]

What all this amounts to is that now, after presenting the chain of images as a cosmic structure, John broaches anew the old problem of justifying the image, and asks once more how it can manifest the invisible to the human eye. After the presentation of the chain of images, we are, then, back to the central problem of justifying the image. The epilogue, however, is not simply a repetition of what had been said in the former sections of the *Apologies*. John now approaches his task from a different angle. Concentrating on a single point, he wishes to show that the bodily and the visible are not inseparably linked to each other; they can, and should, be separated. In fact, in the domain of the transcendent there are beings that are altogether immaterial and yet visible. These bodiless beings *can* be visually experienced, without our having to ascribe to them a material nature. If they can be seen, it follows, they can also be represented in a painted image.

In John's thought, it should be kept in mind, the transcendent world, the domain of the bodiless and the invisible, is neither vague nor ill defined; it has not the general psychological quality of blurred outlines that, since Romanticism, this notion so frequently carries. On the contrary, the transcendent world is characterized by a clearly outlined order

that we can retrace. Speaking in human terms we could say that the nature of the transcendent world is, in a sense, "objective."

Surveying, as it were, the realm of the transcendent and invisible, John divides it into two parts that differ from each other with regard to their ability to be made visible. One part is the divine itself, the divine in its true nature: "The divine nature alone can never be circumscribed and is always without form, without shape, and can never be understood."[142] A true picture of God, that is, a picture portraying the "divine nature" itself, is thus unattainable. God's true nature, then, is forever removed from human cognition and appearance. God can be seen, or otherwise experienced, only in a nonproper way, as we shall shortly see.

In the transcendent, invisible world there is still another component, consisting of what John calls "intellectual beings." They are "an angel, or a soul, or a demon."

Let us read in full what John says here; the passage not only shows the direction of his thought; it also manifests the difficulties he encounters. After having said that visible shapes belong to material bodies, as quoted above, he continues:

Nevertheless, even if nothing physical or fleshly may be attributed to an angel, or a soul, or a demon, it is still possible to depict and circumscribe them according to their nature. For they are intellectual beings, and are believed to be invisibly present and to operate spiritually. It is possible to make bodily representations of them just as Moses depicted the cherubim. Those who were worthy saw these images, and beheld a bodiless and intellectual sight made manifest through physical means.[143]

The nature of the angels, and, perhaps to a lesser degree, that of the demons and of the human soul, is a subject that fascinated medieval thought. Do angels have a body, however subtle and "thin," or are they altogether bodiless? Can they be properly seen and experienced? These questions were often asked. The answers given, it goes without saying, often had important implications for the understanding and evaluation of the painted image.

In John of Damascus's time, the exploration of the angels' nature had not yet reached that climax that so forcefully impressed itself on the thought and imagination of later stages. But even if we confine ourselves to the comparatively early periods of Christian thought that preceded John's time, we still find ample testimony for the concern with this

question. Some of the Fathers seem to have believed that the angels have some kind of body. Justin, Clement of Alexandria, Origen, and even Augustine held this view, though they insisted on the subtle nature of this body. Other early Christian thinkers, such as Gregorius of Nyssa, Eusebius, and John Chrysostomus, denied to the angels any kind of body.[144] They all seem to have agreed, however, that angels, whether or not they have a body, are visible, at least under certain conditions.

It was mainly Dionysius Areopagita, the great theoretician of angelic hierarchies,[145] who profoundly impressed upon the Christian world the concept of the bodiless yet visible angel. Dionysius Areopagita, as we have already noted,[146] had a formative influence on John of Damascus, who frequently quoted "the bishop of Athens."[147] It was in following Dionysius that John articulated his idea of the nonmaterial but visible angel.

With regard to the angels' bodies John does not seem to be of one mind; some of his statements would appear to contradict other earlier statements. What looks like his indecision may well reflect the opinions of different schools. The angels, he says, God has "clothed . . . with forms and shapes, and used images comprehensible to our nature." Only the god is by its very nature totally without body, "but an angel, or a soul, or a demon, when compared to God (who alone cannot be compared to anything) does have a body, but when these are compared to material bodies, they are bodiless."[148]

What John here says deviates, in several respects, from some of the statements he made earlier. When he outlined his comprehensive system consisting of six classes of images, he suggested to the reader that there is an unbroken continuity leading from the sublime god to the simplest of icons. Imaging, the relationship between model and copy, is found within God himself; the Son is an image of the Father,[149] and he is the anchor of the whole chain of images that dominates the world. In the epilogue, however, we are told that God is "utterly without form," and is thus altogether separated from all images.

This is not the place to analyze in detail John's views of how God relates to the world. Here we are concerned only with the angels. And though we are left guessing what John's thought on the specific nature of the angels' bodies was, one conclusion clearly emerges, namely, that angels are "spiritual" beings and yet visible. The link between tangible

physical nature and visibility is broken. A being may be bodiless and yet manifest itself to our eyes.

The belief in appearances that are devoid of material substance is not limited to the angels in Christian thought. The soul, also mentioned by John, is another example of bodiless appearance. The image of the clearly outlined, yet nonmaterial soul, was not primarily biblical; it developed mainly in the Greek world. Suffice it to remember the Homeric belief in the nature of the souls of the dead, often called *eidola*. To give but one example: the *psyche* of Patroclus visits Achilles in a dream. When Patroclus departs, Achilles tries to embrace him, but Patroclus's *psyche* evades him and vanishes. He then realizes that it was a "*psyche* and *eidolon*," although it was "wondrous like him."[150] The concept of the visible, yet immaterial image, the *eidolon*, had a long and persistent life.

The specific nature of the soul, its being devoid of material existence yet capable of being seen, has attracted the attention of classical scholars, especially of students of Greek religion. They have asked whether this double characteristic is typical of the soul only, or whether it shares it with other beings, such as the dream figure.[151] This question is not for us to decide. What is here important is that an educated Christian theologian in the early eighth century, to whom the classical tradition was still alive, could in the "wisdom of the [pagan] ancients" as well find some support for his belief in the existence of bodiless yet visible spiritual beings.

After this short glance at John's sources, let us come back to the principal subject. Why, one cannot help asking, is John of Damascus so interested in angels or in souls? He is here trying once again to justify the icon. What is the significance of these spiritual beings in his doctrine of sacred images? It is not difficult to find the answer. The "spiritual creature"—whether angel, demon, or soul—offers "empirical" proof, as it were, that the image can reach further than the tangible, material reality. In the very existence of the "spiritual being" the apparently absolute connection between the tangible and the visible, the heavily material and the visually perceptible, is denied; the human eye can perceive what dwells beyond the limits of matter. The very existence of the angel, the demon, and the soul constitutes a sanction of the spiritual image.

But is the seeing of a "spiritual being" the same experience as the

visual perception of any regular object? Do we see an angel as we see a table or a pot? In other, and more theoretical, words, is the visual perception of the supernatural being the same kind of experience as seeing in our regular world? John did not formulate these questions explicitly, but they cannot have been far removed from his mind. This may be the reason why he asked, who is the person who perceives the supernatural being? Not everybody can see spiritual beings, it turns out; such perception is not part of a common human faculty. The ability to visually experience supernatural beings is granted only to a selected few —to people, that is, who in their nature differ from the regular person: "Those who were worthy saw these images, and beheld a bodiless and intellectual sight made manifest through physical means."[152] As if this were not clear enough John stresses that the spiritual images, as suggested in the Bible, "were not seen by everyone, nor could they be perceived with the unaided bodily eye, but were seen through the spiritual sight of prophets or others to whom they were revealed."[153] God, who "wills that we should not be totally ignorant of bodiless creatures, . . . clothed them with forms and shapes, . . . which could be seen by the spiritual vision of the mind."[154] These spiritual visions, it becomes clear from the context, are also understood as the grace granted only to a few.

John so emphatically stressed the fact that the prophets saw "spiritual beings" in order to lend further, and authoritative, support to the painted icon. But here critical readers, in John's time as well as today, cannot prevent themselves from asking, does the fact that some select prophets perceived in their visions the shape of supernatural beings have the same significance for the status of painted images that a regular perception, granted to every human being, would have had? Limiting the perception of bodiless creatures to only a few prophets and saints shows how difficult and problematic it is to ascribe visibility to supernatural beings. Yet despite the vague and metaphorical formulation, John's reference to the prophets' vision should not be regarded as a slip of the pen; it must be taken as a statement indicating an important theme in his thought. Two issues should be mentioned. The fact that some prophets and saints, however few they may have been, perceived the vision of bodiless beings shows, as it were, that these beings do indeed have the ability of being visible, or becoming so in certain conditions. Since these beings, mani-

fested in the prophets' vision, can, in principle, be visible, one can also consider them as an ultimate sanction of the icon, an embodiment of the domain of visibility. What can be seen, in however exceptional conditions—this is what is implied in John's argument—should also be portrayable. The prophet's vision, then, provides an ultimate basis for the icon.

But even if the prophet's vision is considered as "seeing," this raises the other issue, one that, for the vindication of sacred images, is even more crucial: How does the "image" come from the prophet's or saint's mental eye to the eye, the hand, and the workshop of the artist who actually paints the icon? It is the old question, which so persistently kept reemerging, of how to bridge the gap between the worlds. What prophets perceive in their visions, we remember, is not given to everybody; on the contrary, it is precisely that prophets and saints perceive spiritual beings in their visions that shows they are set apart from the rest of humanity. Seeing the otherwise invisible manifests their exceptional status. Had John suggested that the painter also perceives a vision of spiritual beings, he would have solved the problem. But the painter would then be the equal of the prophet and saint. It is enough to even hint at such a reading to see immediately how utterly impossible it is. In the whole text of the *Apologies,* John does not even once refer to the artist who produces the icon, and he does not say a single word about the process by which an icon is produced. In his time and intellectual world it was altogether unthinkable to bring the artist into any concrete relation with the prophet or saint, or to link in any way the toil of "making" an icon with the vision God granted, as a special grace, to the few holy figures whom God selected in the course of the ages. One cannot help concluding, therefore, that John of Damascus does not in fact explain how the image, distinctly visible in the prophet's vision, can reaches the picture we see in the church or even in the home.

He cannot tell how the "pure" forms of the spiritual beings can reach the painter's board. The continuous chain leading from the pure shapes perceived by the prophet to the actual, material icon remains obscure. With all the great suggestiveness and rhetorical power of John's formulations, the critical reader cannot help feeling that the old problem that haunted the thought of centuries, the overcoming of the chasm between the worlds, asserts itself again in the *Apologies of the Divine Images.*

NOTES

1. See John of Damascus, *On the Divine Images: Three Apologies against Those Who Attack the Divine Images*, translated by David Anderson (Crestwood, N.Y., 1980), the translation I shall use. It will be quoted as *Apologies* with the number of the Oration in Roman, the number of the chapter in Arabic numerals, and the page number in the English translation after a semicolon. An earlier translation by Mary H. Allies (London, 1898) seems to have appeared in a limited edition, and was not available to me while writing this chapter. The original text of John's Orations is best available in J. P. Migne, *Patrologia cursus completus, Series Graeca*, XCIV (Paris, 1856), cols. 1231–420.

2. The most detailed analysis of John's doctrine of images is found in a dissertation by Hieronymus Menges, *Die Bilderlehre des Johannes von Damaskus* (Wurzburg, 1937). See also Edwym Bevan, *Holy Images* (London, 1940), pp. 128–44. For the concept of image in earlier Christian thought, see Gerhart Ladner, "The Concept of the Image in the Greek Fathers and the Byzantine Iconoclastic Controversy," *Dumbarton Oaks Papers*, VII (1953), pp. 1–34. This important study is reprinted in Ladner's *Images and Ideas in the Middle Ages: Selected Studies in History and Art*, I (Rome, 1983) pp. 73–111.

3. See above, chapters 2 and 3.

4. There is an English translation by Frederic H. Chase, Jr.: *Saint John of Damascus: Writings* (Washington, D.C., 1958). For the sentence quoted, see p. 10.

5. *Apologies* I, 1; p. 13.

6. For the literature on John's life, see mainly Joseph Nasrallah, *Saint Jean de Damas: Son époque, sa vie, son oeuvre* (Paris, 1950). Dionys Stiferhofer's introduction to his German translation of John's *De fide orthodoxa* (*Des Heiligen Johannes von Damaskus genaue Darlegung des orthodoxen Glaubens* [Munich, 1923]) is also useful for the saint's biography.

7. See especially Basilius Studer, *Die theologische Arbeitsweise des Johannes von Damaskus* (Ettal, 1956), passim, esp. pp. 91 ff. For *florilegia* in Byzantine literature, see Karl Krummbacher, *Die Geschichte der byzantinischen Literatur von Justinian bis zum Ende des oströmischen Reiches* (Handbuch der Altertumswissenschaft IX, 1; Munich, 1891), pp. 289 ff.

8. For an English translation, see above, note 5.

9. For John's influence on Peter Lombard, see E. Buytaert, "St. John Damascene, Peter Lombard, and Gerloh von Reichersberg," *Franciscan Studies* X (1950), pp. 323–43. For John as a model for western Scholasticism in general, see Adolf von Harnack, *Lehrbuch der Dogmengeschichte*, II, *Die Entwicklung des kirchlichen Dogmas* (5th ed., Tubingen, 1961), pp. 509 ff.

For John's influence on Thomas Aquinas, see Krummbacher, *Geschichte der byzantinischen Literatur*, pp. 174, 206.

10. The most detailed and thorough study of the *Sacra Parallela* seems still to be Karl Holl, *Die Sacra Parallela des Johannes Damascenus* (Texte und Untersuchungen, 1; Leipzig, 1897), dealing with authorship and textual problems. For the illuminated manuscripts of this work, see now Kurt Weitzmann, *The Miniatures of the Sacra Parallela, Parisinus Graecus 923* (Princeton, 1979).

11. Quoted after Krummbacher, *Geschichte der byzantinischen Literatur*, p. 321. The hymns traditionally assumed to be composed by John of Damascus are published in Migne, *Patrologia Graeca* XCVI, cols. 818–56.

12. See Krummbacher, *Geschichte der byzantinischen Literatur*, p. 320. For a brief survey of Byzantine hymnology, see John Meyendorff, *Byzantine Theology* (London and Oxford, 1974), pp. 122–24.

13. Krummbacher surveys the different opinions expressed in earlier traditions in his discussion of John's position in Byzantine literature.

14. Quoted after Krummbacher, *Geschichte der byzantinischen Literatur*, p. 297. For Eustathios, in addition to Krummbacher, pp. 242 ff., see A. A. Vasilev, *History of the Byzantine Empire, 324–1453* (Madison, Wis., 1976), pp. 495–96.

15. For the Barlaam legend, its sources and distribution, see Hiram Peri (Pflaum), *Der Religionsdisput der Barlaam-Legende, ein Motiv abendländischer Dichtung* (*Acta Salmaticensis*, Filosofias y Letras XIV, 3; Salamanca, 1959). See also B. Studer, *Die theologische Arbeitsweise des Johannes von Damaskus*, pp. 27 ff.

16. The John of Mar Saba mentioned in some early manuscripts of the novel, some scholars maintain, was a monk of the same name and place, but of a generation later than our Church Father. For a survey of the different opinions, see Peri (Pflaum), pp. 11–31.

17. In the third Apology, the most elaborate and systematic of the three, the division is clearest: sections 16–26 deal with images, sections 27–41 with worship. I am not aware of any earlier treatment of the subject that would clearly make this distinction, though the problem was of course always present.

18. He himself explains his procedure. True to his systematic mind, he lists the themes; see *Apologies* III, 14; p. 73. Though he takes up the themes in all three *Apologies*, it is only in the third that he names them, and treats them in the order he announces.

19. One could argue that in a strictly systematic presentation the question "what can and what cannot be represented?" (John's fourth theme) should be considered before we devote our attention to the different types of images (John's third subject).

20. *Apologies* I, 9; p. 19 of the English translation.

21. *On the Orthodox Faith,* Book Four, chapter 16 (English translation, pp. 370 ff.).

22. *Apologies* III, 16; pp. 73 f.
23. *Apologies* III, 16; p. 73.
24. *Republic* 510A. It is, of course, beyond the scope of the present study to go into Plato's concept of the image. Useful for our purpose is the discussion in Goran Sörbom, *Mimesis and Art: Studies in the Origin and Early Development of an Aesthetic Vocabulary* (Uppsala, 1966), pp. 152 ff.
25. *Theaetetus* 239D.
26. Plotinus, *Enneads* V, 9 , 3.
27. See Proclus, *The Elements of Theology,* edited and translated by E. R. Dodds (Oxford, 1963), pp. 169 ff. (propositions 194–95).
28. *Republic* 602D.
29. *Republic* 476C. And cf. Sörbom, *Mimesis and Art,* pp. 141 ff.
30. See *Apologies* III, 16; p. 73 of the English translation, where the definition is best formulated. The italics are mine. In another definition of the picture (*Apologies* I, 9; p. 19), the clause "in itself" is missing, but shortly thereafter is perhaps adumbrated, even if only in a general sense.
31. This of course is true also where John stresses that the picture reflects the model only in an imperfect and limited way.
32. Without going into the large literature of semiotics, I shall refer here only to Umberto Eco, *A Theory of Semiotics* (Bloomington, Ind., 1979), pp. 191 ff. Interesting for our purpose is also the brief discussion in Charles Morris, *Signs, Language, and Behavior* (New York, 1946), pp. 190 ff.
33. See above, the section discussing John's views on "Why Are Images Made."
34. *Apologies* I, 9; p. 19 of the English translation.
35. *Apologies* III, 16; pp. 73 ff.
36. *Apologies* III, 16; p. 74. Interestingly enough, the idea of the animated statue, a subject John of Damascus must have been familiar with from his acquaintance with classical literature, is altogether excluded in his doctrine.
37. Athanasius's *Sermo di sacris imaginibus* is reprinted (and best available) in Migne, *Patrologia Graeca,* XXVIII, col. 709. For a brief discussion, see Kenneth M. Setton, *Christian Attitudes towards the Emperor in the Fourth Century* (New York, 1941), pp. 198 ff. John quotes the passage in his *florilegium* to the Third Oration; pp. 100 ff. of the English translation.
38. The best formulation of the importance and function of images is found in the third Apology, chapter 17; p. 74 of the English translation.
39. See the classic study by Meyer Schapiro, "On the Aesthetic Attitude in Romanesque Art," now easily available in the author's *Selected Studies,* I, *Romanesque Art* (New York, 1977), pp. 1–27. See also the interesting discussion (though not directly dealing with our present subject) by Robert Jauss in his paper on "Die klassische und die christliche Rechtfertigung des Hässlichen in mittelalterlicher Literatur," reprinted in the author's *Alterität und Modernität der mittelalterlichen Literatur* (Munich, 1977), pp. 385–410.
40. See Theophilus, *The Various Arts,* translated by C. R. Dodwell (London,

1961), p. 63. See also my *Theories of Art, I, From Plato to Winckelmann* (New York, 1985), pp. 74–80.

41. *Epistula ad Serenum (Monumenta Germaniae Historia), Epistulae* II, pp. 270–71. I use the English translation in Wladislaw Tatarkiewicz, *History of Aesthetics,* II, *Medieval Aesthetics* (The Hague, Warsaw, 1970), pp. 104 f.

42. *Epsitula ad Serenum* (ibid. II, p. 195). See Tatarkiewicz, pp. 104 f.

43. See G. D. Mansi, ed., *Sacrorum Conciliorum nova et amplissima collectio,* XIX (Florence, Venice, 1759–1798), p. 454. And see Tatarkiewicz, p. 105.

44. The *Libri Carolini* are reprinted in Migne, *Patrologia Latina* XCVIII; the passage quoted on col. 1147. For the significance of this work as a source in the study of art, see J. von Schlosser, *Schriftquellen zur Kunstgeschichte der Karolingischen Kunst (Quellenschriften für Kunstgeschichte,* New Series, IV; Vienna, 1892). For the significance of the *Libri Carolini* in the history and theology of the Iconoclastic Debate, see Gert Haendler, *Epochen Karolingischer Theologie: Eine Untersuchung über die karolingischen Gutachten zum byzantinischen Bilderstreit* (Berlin, 1958).

45. See *Apologies* III, 17, p. 74. The fragmentary quotations in this paragraph derive from the short chapter of the third Apology.

46. *Apologies* II, 12; p. 59: "The icon is a hymn of triumph, a manifestation, a memorial inscribed for those who have fought and conquered, humbling the demons and putting them to flight."

47. See *Apologies* I, 11 (p. 20); I, 19 (p. 27); I, 25 (p. 32); III, 21 (p. 77).

48. See *Apologies* III, 17; p. 74.

49. *Apologies* III, 17; p. 74 of the English translation.

50. *Apologies* I, 11; p. 20.

51. *Apologies* I, 7; p. 17: "You see that He forbids the making of images because of idolatry, and that it is impossible to make an image of the immeasurable, uncircumscribed, invisible God." And see also *Apologies* I, 15; p. 22:"Is it not obvious that since it is impossible to make an image of God, who is uncircumscribed and unable to be represented."

52. In addition to the passages quoted in the preceding note, see *Apologies* III, 24; p. 78: "The divine nature alone can never be circumscribed and is always without form, without shape, and can never be understood."

53. F. W. Schlikker, *Hellenistische Vorstellungen von der Schönheit des Bauwerks nach Vitruv* (Berlin, 1940), p. 82, drawing a distinction between "rhythmos" and "schema."

54. See J. J. Pollitt, *The Ancient View of Greek Art: Criticism, History, and Mythology* (New Haven, 1974), pp. 261 ff.

55. John of Damascus stresses the unchanging, motionless nature of the divine. See, for example, *Apologies* III, 19: "The divine nature is immutable," and *Apologies* I, 21: Christ is "the living image of the invisible God, and His unchanging likeness."

56. *Apologies* I, 8; p. 18. The formulation shows, it is worth remembering, that our author had actual pictures in mind, and does not use the terms only

metaphorically. The uses of the words "draw" and "paint" are obviously meant in a precise, concrete sense.

57. *Apologies* III, 26; pp. 80 f., where these and additional examples are mentioned. See also *Apologies* I, 5; pp. 16 ff., where John shows that the prohibition of images is qualified by the Bible itself.

58. *Apologies* III, 25; p. 79.

59. See *Apologies* I, 15 (p. 22); I, 20 (p. 27); II, 9 (pp. 56 ff.); II, 14 (p. 61); II, 22 (pp. 66 ff.); III, 25 (p. 79). For the images of the cherubim in the Bible, see above, chapter 1.

60. See the sixth section of the present chapter.

61. *Apologies* I, 15; p. 22.

62. See above, chapters 1 and 3.

63. Ibid. And see also *Apologies* II, 14; p. 14, where the image of the tent is linked with the "handiwork" of man: "Behold the handiwork of men becoming the likeness of the cherubim! Was not the meeting-tent an image in every way?" For the symbolism of the tent, see the still important work by Robert Eisler, *Weltenmantel und Himmelszelt: Religionsgeschichtliche Untersuchungen zur Urgeschichte des antiken Weltbildes* (Munich, 1910). That the biblical tent is a central archetype for the church building is too well known to require documentation.

64. *Apologies* I, 4; p. 16.

65. Following other theologians, one cannot help asking whether this depiction is a *complete*—and thus also a *true*—image of Christ. Does an icon representing Christ as man depict the Savior's *whole* nature, or is it the image of one aspect only?

66. *Apologies* I, 4; p. 16.

67. *Apologies* II, 5; pp. 52 ff. On this subject, see J. Meyendorff, *Christ in Eastern Christian Thought* (Crestwood, N.Y., 1975), pp. 115, 124.

68. *Apologies* II, 11; pp. 58 ff.

69. The text of the *Horos* is reprinted in Mansi, *Sacrorum conciliorum nova et amplissima collectio* XIII, pp. 240 ff. I use the English translation by Cyril Mango, *The Art of the Byzantine Empire, 312–1453* (Toronto, 1986), pp. 165 ff.

70. In addition to the literature listed above, see Ernst Kitzinger, "The Cult of Images in the Period before Iconoclasm," *Dumbarton Oaks Papers*, VIII (1954), pp. 85–150.

71. *Apologies* I, 22; p. 31. John here refers to what is told in *Acts* 5:15.

72. *Apologies* II, 41; p. 89.

73. *Apologies* I, 24; p. 32.

74. For Plato's use, see, e.g., *Republic* VI, 510E; and VII, 517D. For the use of skia in Philo and especially in the New Testament, see G. Friedrich, ed., *Theological Dictionary of the New Testament*, VII (Grand Rapids, Mich., 1971), pp. 394–98.

75. "All, however, agree that painting began with the outlining of a man's

shadow." See Pliny's *Historia naturalis* XXXV, 15. For an English version, see *The Elder Pliny's Chapters on the History of Art,* translated by Jex-Blake (Chicago, 1968).

76. See E. Kris and O. Kurz, *Legend, Myth, and Magic in the Image of the Artist: An Historical Experiment* (New Haven, Conn., 1970). The original edition, *Die Legende vom Künstler,* appeared in Vienna, 1934.

77. See Athenagoras's *Apology* 17.3–4. And see Robert M. Grant, *Greek Apologists of the Second Century* (Philadelphia, 1988), pp. 104 ff.

78. First Refutation, 11. I quote from St. Theodore the Studite, *On the Holy Icons,* translated by Catharina P. Roth (Crestwood, N.Y., 1981); the sentence quoted may be found on p. 31.

79. First Refutation, 15; English translation, p. 35. For Theodore of Studion, see below, chapter 11.

80. For the subject of relics, and the intellectual and emotional sources of its emergence and power, see Peter Brown, *The Cult of the Saints: Its Rise and Function in Latin Christianity* (Chicago, 1981).

81. *Apologies* III, 17; p. 74.

82. *Apologies* III, 41; p. 89.

83. In the *florilegium* to the first Apology; p. 36 of the English translation.

84. *Apologies* III, 12; p. 72.

85. Ibid.

86. In the *florilegium* to the first Apology. See *Apologies,* p. 37.

87. *Apologies* I, 16; p. 20.

88. See above, the discussion of John's definition of the image.

89. See *Apologies* III, 18; pp. 73 ff.

90. This sentence has, of course, given rise to a huge amount of exegesis. It is not for me, and not in my competence, to take up the commentaries. Let me only mention Norbert Hugede, *La metaphore du mirroir dans les épitres de Saint Paul aux Corinthiens* (Neuchatel, 1957), esp. pp. 151 ff.

91. *Apologies* II, 5; p. 53.

92. *Apologies* III, 12; p. 72.

93. *Apologies* III, 17; p. 74

94. We cannot go here into the problem, discussed by historians of aesthetics, of whether this attitude is characteristic of Plato's views on art in general, or is perhaps limited to the earlier stages of his thought. For the internal development of Plato's theory of art, see Goran Sörbom, *Mimesis and Art: Studies in the Origin and Early Development of an Aesthetic Vocabulary* (Bonniers, Sweden, 1966), pp. 99–175. Art theories, throughout their long history, accepted this view as "the" Platonic concept of the image.

95. See mainly *Republic* 598D, 602D. Only a god could could make a doublet of a living being; see *Cratylus* 432B, C. And see W. J. Verdenius, *Mimesis: Plato's Doctrine of Artistic Imitation and Its Meaning for Us* (Leiden, 1949), esp. chapter 1.

96. An abbreviated formulation of the classification is given in the first Apology,

sections 10–13 (pp. 21–23 of the English translation). A more detailed
and systematic formulation is found in the third Apology, sections 18–23
(pp. 74–78). I shall follow mainly the exposition in the third Apology.

97. See above, chapter 9, especially Dionysius Areopagita's views on hier-
archy.

98. *Ambrosii Theodosii Macrobii Commentariorum in Somnium Scipionis* I,
14, 15. I quote the English translation given by Arthur Lovejoy in his *The
Great Chain of Being: A Study in the History of an Idea* (New York,
1960), p. 63.

99. See above, chapter 9, section 2.

100. In the *Apologies* he naturally adopts the ideas of Dionysius Areopagita. In
the *florilegia* he explicitly refers to Dionysius's texts. See, for instance, the
florilegium to the first Apology, pp. 34 ff. (references to Dionysius's *Let-
ters, Divine Names,* and *Ecclesiastical Hierarchy*); and the *florilegium* to
the third Apology, p. 91 of the English translation.

101. The documents relating to the writing of *The Ladder* are collected and
translated into English in John Climacus, *The Ladder of Divine Ascent,*
translated by Archimandrite Lazarus (Moore), (Boston, 1978), pp. 41–44.
As is well known, John of Climacus's work had profound influence on the
western Middle Ages. To give but one example: Bernard of Clairvaux took
The Ladder as a model for his influential *Steps of Humility*. See Bernard of
Clairvaux, *The Steps of Humility,* translated by G. B. Burch (Cambridge,
Mass., 1940). For other examples, see M. Bloomfield, *The Seven Deadly
Sins* (East Lansing, Mich., 1952), pp. 359 ff.

102. *Apologies* III, 18; pp. 74 f. And see also I, 9; p. 19.

103. See above, chapters 5–8.

104. See above, chapter 10, section 3.

105. *Apologies* III, 15; p. 75.

106. *Apologies* I, 9; p. 19. John here alludes to Colossians 1:14–15, which
reads, "In whom we have redemption through his blood, even the forgive-
ness of sins; who is the image of the invisible God, the firstborn of every
creature."

107. *Apologies* III, 19; pp. 75 f.

108. It seems to have been Philo who, combining biblical traditions and Greek
philosophical speculation, set the direction of western speculation on this
problem. See Harry A. Wolfson, *Philo: Foundations of Religious Philoso-
phy,* I (Cambridge, Mass., 1947), pp. 295–324.

109. Modern investigations of this comparison usually concentrate on later
versions. See, e.g., Milton C. Nahm, *Genius and Creativity* (Baltimore,
1956). In Antiquity, however, the comparison was an accepted topos.
Plato's theory of the "demiurge" in the *Timaeus* is the classical formulation
in Greek Antiquity. See the brief, but interesting, excursus "God as Maker"
in Ernst R. Curtius, *European Literature and the Latin Middle Ages* (New
York, 1953), pp. 544–46.

110. *Apologies* III, 20; p. 76.
111. *Apologies* III, 20; p. 76.
112. See above, chapter 10, section 5.
113. *Apologies* I, 11; p. 20.
114. The literature on this subject is vast and not easily surveyed. For a brief and lucid introduction, see George Boas's introduction to his translation of *The Hieroglyphics of Horapollo* (New York, 1950). In greater detail the subject has been investigated by Hans Blumenberg, *Die Lesbarkeit der Welt* (Frankfurt, 1981). The first five chapters deal mainly with the periods of importance for the study of John of Damascus. See also the concise presentation by Ernst R. Curtius, *European Literature and the Latin Middle Ages*, pp. 319–26 ("The Book of Nature").
115. See mainly his *Legum allegoria*.
116. John quotes St. Basil mainly in the *florilegia* he adds to each of the Apologies. See, for instance, the extensive quotations from different works of St. Basil in John's *florilegium* to the first Apology, pp. 35 ff. of the English translation. And see also the *florilegium* to the third Apology, pp. 91 ff.
117. St. Basil's work, *Homilia in Hexaemeron*, is best available in Migne, *Patrologia Graeca* XXIX. For the survival of Greek thought, especially aesthetics, in this work, see Y. Courtonne, *St. Basile et l'Hellénisme* (Paris, 1934).
118. *Apologies* I, 11 (p. 20); III, 21 (p. 77).
119. *Apologies* III, 21; p. 76.
120. *Apologies* III, 21; pp. 76 f. And cf. Dionysius Areopagita's *On the Ecclesiastical Hierarchies* I, 2; p. 197 of the English translation, *Pseudo-Dionysius: The Complete Works*, translated by Colm Luibheld (London, 1987). See also Dionysius's *On the Celestial Hierarchy* I, 3; p. 146.
121. *Apologies* III, 21; p. 77. In his *On the Celestial Hierarchy* (I, 3; p. 146), Dionysius also mentions a combination of lights and odors.
122. Every theological reference work has, of course, informative entries for typology. Particularly useful is Leonhard Goppelt, *Typos: Die typologische Deutung des Alten Testaments im Neuen* (Darmstadt, 1966 [original edition Gütersloh, 1939]). Erich Auerbach's famous essay "*Figura*," dealing with the term and the concept of "typology" in medieval literature and art, is available, in an English translation, in the author's *Scenes from the Drama of European Literature* (Manchester, 1959).
123. *Apologies* III, 22; p. 77.
124. Basilius Studer, *Die theologische Arbeitsweise des Johannes von Damaskus* (Ettal, 1956), pp. 85 ff.
125. *Apologies* II, 23; p. 67.
126. "But the law was not an image, but the shadow of an image" (*Apologies* I, 15; p. 23).
127. The material has been collected by J. J. Pollitt, *The Ancient View of Greek*

Art: Criticism, History, and Terminology (New Haven and London, 1974), pp. 247–54.

128. *Apologies* III, 36; p. 87.
129. *Apologies* I, 12; pp. 20 f.
130. *Apologies* III, 23; pp. 77 f.
131. All these quotations are from *Apologies* III, 23; pp. 77 ff. They are not quoted in the order in which they appear in John's text. See also *Apologies* I, 13; p. 21.
132. It is, of course, well known that early Christian theologians believed that Christ was eternally the Father's Son. Sonship is not a matter of time, but of position, as it were.
133. *Apologies* III, 19; pp. 75 f.
134. See above, chapter 9, especially the discussion of Dionysius Areopagita's opinions on transcendence.
135. *Apologies* III, 21; p. 76.
136. Ibid.
137. *Apologies* III, 18; pp. 74 f.
138. *Apologies* III, 24–25; pp. 78–79.
139. *Apologies* III, 24; p. 78.
140. See above, especially section 4 of the present chapter.
141. *Apologies* III, 25; p. 79.
142. *Apologies* III, 24; p. 78.
143. *Apologies* III, 24; p. 78.
144. The literature on angels is, of course, very large, but students do not focus on the question that concerns us here, the visibility of the bodiless angels. But see Jean Danielou, *Les Anges et leurs mission d'apres les Pères de l'Eglise* (Chevetogne, 1951). A great deal of pertinent material has been collected by Denis Petau, *De angelis*, easily found in Migne's *Patrologia Graeca* VII.
145. I should like to refer once again to René Roques, *L'Univers Dionysien: Structure hiérarchique du monde selon le Pseudo-Denys* (Paris, 1983), esp. pp. 154 ff.
146. See above, section 2 of the present chapter.
147. See particularly the beginning of the *florilegium* to the first Apology, p. 34 of the English translation; third Apology, 21, pp. 76 ff., on the related subject of shadows and "bodiless things"; and at the beginning of the *florilegium* to the third Apology, p. 91.
148. *Apologies* III, 25; p. 79.
149. See above, section 4 of the present chapter.
150. Homer, *The Iliad* xxiii, 104–7. From the large literature dealing with this subject I should like to mention only Jan Bremmer, *The Early Greek Concept of the Soul* (Princeton, 1987), pp. 78 ff.
151. The scholarly literature is now very large, and I shall mention only some examples. See, for instance, Joachim Hundt, *Der Traumglaube bei Homer*

(Greifswald, 1935); and the interesting discussion in E. R. Dodds, *The Greeks and the Irrational* (Berkeley, Los Angeles, London, 1971), chapter 4.

152. *Apologies* III, 24; pp. 78.
153. *Apologies* III, 24; p. 79.
154. *Apologies* III, 25; p. 79.

The Icon and the Doctrine
of Art: Theodore of Studion

1. The Second Cycle of the Iconoclastic Debate

Around the turn of the eighth and ninth centuries what is called the Iconoclastic Debate burst forth again. Whatever the changes that had occurred in ecclesistical policy and in the attitudes of the rulers in preceding decades, whatever the final "truth" proclaimed by one party or the other, the icon did not cease to be a problem. The victory of the orthodox party may have suppressed for a while explicit expressions of iconoclasm, but, at least in intellectual respects, questions concerning the icon's validity and truth remained alive, and continued to agitate people's minds. Shortly after the death of John of Damascus a new series of upheavals set in, and what is known as the second period of the Iconoclastic Debate began, causing a great deal of violence both against works of art and against their defenders. In now turning to this late stage we shall, once again, not concern ourselves with the social forces

or with the political struggles; as before, we shall limit our attention to the philosophical problems posed by the icons of God. Even in this limited domain, the second period of the great debate produced important statements that are worthy of the student's attention.

John of Damascus's contribution to solving the problem posed by the image of the divine, significant as it was, remained in a sense inconclusive. No intellectual solution, however consistent, and convincing, could have had a conclusive effect on a great historical movement that drew its force from many and various sources, most of them not intellectual in nature. But as we have just seen, even in the domain of mere intellectual reflection John's doctrine did not solve the problems he confronted.[1] What he said about icons called for continuation and completion. When the debate flared up again,[2] the new phase of political and social upheaval necessarily also brought into new focus the theoretical issues of the movement, and the ideological attitudes of the different parties involved. It goes without saying that the essential theme of the Iconoclastic Debate did not change, but the second cycle, which took place mainly in the early decades of the ninth century, had its own emphases and versions of the general theme.[3]

Students of the Byzantine world have often stressed the ominous conditions that formed the background of the second phase of the Iconoclastic Debate. By the latter part of the eighth century Islam was solidly entrenched in countries and regions that were once essential parts of the Christian domain, and the growing power of Islam was casting dark shadows on what remained of the Christian world of the East. The three apostolic patriarchates—Jerusalem, Alexandria, and Antioch— were now in the hands of the "infidels." To the north of the Byzantine empire, the Bulgarians, their ruling class still firmly clinging to pagan beliefs, were perceived as an aggressive, violent power, a threat looming on the horizon. In the west it was the rising Carolingian power that, in political as well as in cultural respects, was to overshadow the world of Eastern Christianity, and to shape the history of Europe for many generations to come. The shadows covering the Byzantine world were reflected, so historians believe, in the internal strifes and conflicts that shook the Eastern Empire in the late eighth century and during large stretches of the ninth century. The iconoclastic theme was the central ideological issue around which most of the internal struggles crystallized.

The central theme of the Iconoclastic Debate, the core of what we

have called "ideological issues," did not, then, change radically in the course of the last phase, but the theologians had to adjust to shifting political and ideological conditions. The attitude prevailing in Byzantine culture was conservative, and people were always appealing to the authority of tradition. Almost any Byzantine author would have agreed with Theodore of Studion, the subject of the present chapter in our study, that "to confirm what has been said we would do best to support the statement with patristic testimony."[4] But as happens in every culture that intends to stick to tradition, it is, knowingly or not, periodically forced to define anew the problems and to justify again the seemingly traditional attitudes. In the debate about icons, the most important conceptual developments characteristic of the late eighth and early ninth centuries converged around two themes. One of them is best described by the question of what precisely the worship of icons is. Analyses of ritual and liturgy were formulated, subtler than those offered in earlier stages of the debate. Questions such as, what precisely is worship, and how can it be distinguished from other forms of adoration and veneration? were passionately discussed. The literature that emerged from these debates is a lasting contribution to ecclesiastical thought. The other theme is that of the icon itself, on which we shall concentrate. What, then, were the specific questions concerning the icon, the particular variations of the theme, raised in the second phase of the debate, and what were the answers given, particularly by the defenders of icons?

In the second cycle of the Iconoclastic Debate Theodore of Studion was the principal spokesman of the defenders of images. His personality, as it comes down to us through the ages, was probably not as multifaceted or fascinating as that of his great predecessor, John of Damascus, though they do resemble each other in some respects. Like John, Theodore was also deeply involved in the struggles of his time. However, he did not live in a distant country ruled by Islam. Caught up in the fierce struggle between ecclesiastical claims and royal rule, he and his disciples had to endure several periods of persecution and exile. He spent most of his life in monasteries, partly as abbot, first in the monastery of Saccadion (Bithynia) and later in the monastery of Studios, in Constantinople. Modern students see Theodore's main merit in his having been one of the major reformers of the monastic movement in Eastern Christianity.[5] The "Studite Rule" is probably the work of his disciples, but the principles they reflect are those that Theodore introduced and supported.

Theodore himself composed the instructions to monks that are now assembled in two collections, the "small" and the "large" *Cathecheses*. Among the principles upon which he built his concept of monasticism, liturgy played an important part. We should recall that in cultures such as the Byzantine, ritual in general, and perhaps liturgy in particular, were the area in which most artistic activities, the drives and desires to create a rich, formal expression for a variety of ideas and emotions, found their place.[6] Theodore's connections with the arts and his impact on activities in which the aesthetic dimension is predominant were diversified and had a wide range. He and his disciples are credited with introducing the minuscule hand, the script that for centuries was generally used in copying Greek texts. A central contribution to the artistic sphere in his culture, especially in liturgy, was his work in hymnography. The hymns he wrote for the Lent season made a particularly deep impression.[7]

Theodore's major contribution to theology, the defense of holy images, is also linked with this profound, if only implicit, concern with the arts. It goes without saying that he did not approach icons from we might now call an "aesthetic" point of view; his explicit subject remains theology. Yet behind his theological treatment of images one senses, I believe, how perceptive he was to aesthetic values. Theodore's doctrinal defense of holy images is found in the three Refutations of the iconoclasts, the so-called *Antirrhetici*.[8]

2. *Theodore's Concepts and Terms*

The manner in which Theodore of Studion presents his thought on images indicates something of the problems he faced, and of the intellectual situation that was his starting point. It also reflects, I believe, something of the dilemma inbuilt in our problem, at least as it was seen in the early ninth century. The Refutations, especially the second and third, are composed in a form that recalls scholastic discourse; it is the form of a well-ordered, formalized argument in which the positions taken by the sides are fully presented. Theodore juxtaposes question and answer, contention and criticism, the iconoclast's—or, as he puts it, the heretic's—statement and the orthodox reply or counterstatement. This manner of presentation does indeed anticipate the type of discourse best known from western Scholasticism.

Theodore of Studion's scholastic presentation indicates an overall tendency of Byzantine thought that was increasing in strength. As we have noted above, John of Damascus already shows a leaning towards systematic ordering and formulation that made him one of St. Thomas's models.[9] Theodore's thought does not have the range characteristic of John of Damascus, and he also does not have the same intention to build a comprehensive system. But a modern student who compares the writings on images by these two authors cannot help noting that the formalizing tendency had increased in the texts of the later writer. In Theodore's Refutations one senses something of a legal way of thinking and arguing. Whatever the reason for this development, in Theodore of Studion, probably more than in John of Damascus, the scholastic presentation is not only a matter of literary form; it is a mode of thought.

The scholastic form of presentation may have had a subtle, yet significant, impact on the ideas presented, and on what was emphasized. The desire for clarity and consistency may have deflected attention from nuances and transitions in the positions adopted by the different parties, and, instead, helped to cast the views discussed, especially those of the opponents, into hardened molds. Such sharply articulated, immovable types may make the opponents, particularly the iconoclasts (whom Theodore always calls "heretics"), appear more consistent than they were in reality.

The desire to make the opinions appear clear and consistent in themselves, does not seem, however, to have obscured from Theodore's mind the fact that the holy image itself is, in fact, a complex and multifaceted object. This one learns from his attempts to refine the categories for discussing the nature of the image. It is particularly the terminology he uses that bears important testimony to this awareness.

The range of Theodore's terminology, which is wider than that used by previous generations, indicates that he did distinguish shades or facets in the concept of the image. His vocabulary contains more than one generic term that does not, however, call to mind any particular aspect or quality of the icon. The term he most commonly used to designate the holy image is, of course "icon" *(eikon)*. Another term, best translated by "likeness" *(homoioma)*, almost equally broad in meaning, is almost as frequent. These two terms are generic, and their validity is wide. In addition, however, Theodore also uses some other terms that in the great debate were less common as designations of the holy image. Was their

meaning more limited? Were they intended to evoke particular aspects of the image? The answer is not easily given. The modern translator treats them as "a series of approximate synonyms."[10] Some of these terms are borrowed from the vocabulary of ancient Greek philosophy; others have perhaps a less elevated origin. I shall briefly review our author's major terms.

Sometimes Theodore uses the term *eidos* to designate the holy image. No other term has as venerable a history as *eidos;* it was time honored even before it was canonized by Plato. Theodore uses it in the sense of visible "appearance," and since the term is derived from the root "see," he is faithful to its original meaning. It kept this meaning, which it already had in Homer, in the literary tradition.[11] The modern student should remember that in Theodore's usage, nothing of a subjective nature is intended. *Eidos* is not an "idea" in the artist's imagination, a stage in the evolving icon, something initial and unfinished, as it were. On the contrary, with this term, as with the others, he describes the completed image, visible in all its parts, though it may be the image residing in our mind.

Another traditional term our author uses to describe the image is *typos.* Now, usually translated as "a blow" or "the mark of a blow," the term has given rise to an interesting and illuminating discussion among modern scholars.[12] As we have seen in the former chapter, *typos* was already employed by John of Damascus to describe a class of images.[13] But the meaning attached to the term is altogether different in the texts by John and by Theodore. To John of Damascus this word has the sense of a general Christian symbolism. In his usage, "type" is the technical term that designates the hidden relationship between the Old and the New Testament. Theodore's usage is altogether different; he does not even suggest this particular aspect that John had in mind. He employs the term to describe the image as such, be it a material image, an icon painted on a piece of board, or an image dwelling in the mind, but one that we see clearly. What he may have been emphasizing by using this particular term is the close dependence of the image—painted or imagined—on the metaphysical original, the close affinity of image to prototype, like the impression of a seal to the seal itself.

Still another term that Theodore employed to indicate the holy image is *morphe,* and he did so perhaps more frequently than other authors of his time. *Morphe* is now commonly translated by "form," but "form,"

as has correctly been pointed out,[14] is an ambiguous concept. The Latin *forma* replaced two Greek terms, *eidos* and *morphe*. *Eidos* perhaps emphasized the aspect of ordering the parts of a structure, that is, of proportion and symmetry, and therefore could also more easily be used in an abstract sense (although the root of the word, as I have just said, is "see"). Scholars are not altogether agreed as to what is stressed by the term *morphe* in classical Greek. Some believe that it is "applied primarily to visible forms,"[15] while others think that it carried, even if only vaguely, the connotation of comprehensiveness, of "comprehensive form" or the "form of the whole."[16] It is not for me to decide which of the readings is the more accurate one. For our purpose it is sufficient to say that, in either case, the term *morphe* evoked the sense of a visually perceptible presence.

We are not surprised to come across the term *schema* in Theodore's discussion of images. As we have seen in the previous chapter, John of Damascus, on whom Theodore so heavily relied, also used this term to designate an image.[17] In briefly commenting on John's use of the term, I have already said that *schema* probably originated in a domain different from the lofty regions of philosophical speculation; in the early stages of its history it may have had some perceptible links with workshop vocabulary, and at least to some people's minds it may have suggested a compositional device or pattern.

Finally, Theodore refers to the image by the word *character*. This term, perhaps even more than *schema*, at least in its initial stages, definitely had a material connotation. As one knows, *character* originally meant a "seal," or rather the "imprint of a seal." What it immediately called to mind was therefore the seal itself or its impression—both material, tangible objects—and perhaps also the process of imprinting the seal on the wax. In the context of the Iconoclastic Debate the seal and its impression acquired a clear metaphorical meaning, intelligible to every reader or listener. What it indicated was that the impression reproduces exactly the configuration of the seal itself. In other words, the use of this term in our context showed the belief that the icon is (or at least, can be) a faithful rendering of the prototype. Theodore of Studion himself makes this clear. "Is not every image a kind of seal and impression bearing in itself the proper appearance of that after which it is named?" he rhetorically asks.[18] We shall come back to this statement in a different context. Here it should only be considered as a confirma-

tion of the meaning the term *character* bore; it is the meaning of the image as a true and faithful depiction of the prototype.

Without trying to investigate Theodore of Studion's vocabulary (a task that would go beyond my competence), one can understand the problem that this rich vocabulary poses. The different terms used to describe the same object, even if not used consistently, point to different aspects of the image; they attest, as I have already said, to our author's sense of the icon's complexity.

There is a tension between the attempt to grasp everything in clear and consistent categories, on the one hand, and the sense of the object's complexity, on the other. This tension marks Theodore's intellectual position in general, and what he, and other defenders of images, said about the holy icon.

3. Trends and Themes in the Second Cycle

Having briefly indicated some features of Theodore's personality, I should also mention some of the intellectual conditions in which our author had to make his contribution to justification and defense of the holy icons.

The second phase of the Iconoclastic Debate, one may say, has a character of its own. To be sure, conflicting tendencies and a somewhat fluid, frequently changing terminology may account for a certain conceptual haze that makes it difficult for the modern student to see clearly what it was that characterized the late phase of that great historical altercation, the Iconoclastic Debate. Moreover, in the second stage of the debate neither the essential theological problem nor the basic attitudes adopted by the parties differ radically from those we encountered in the earlier stages. There is indeed a significant continuity, both in the core problem and in the principal attitudes, throughout the history of iconoclasm and the struggles against it. Historians have noted, however, certain differences between the earlier and the later stages of the debate. The differences noted are both of tone—a more restrained style of disputation in the later stage—and of emphasis—stressing certain themes in the traditional subject matter that in the earlier phases remained more in the background.[19] Some problems even seem to be new. Once again I shall disregard the many issues, events, and opinions that are important for political and other reasons; I shall concentrate only on the subjects

that may shed some light on such views on holy images as are of interest to the present investigation.

The difference in tone, to begin with this point, is best seen in the fact that in the second stage of the debate the iconoclasts did not accuse the defenders of icons of engaging in simple idolatry. "We refrain from speaking of images as idols," the Council of 815 decreed, "because there are degrees of evil."[20] It was probably only in the lower strata of society, in popular propaganda, that the worshippers of icons were accused of crude idolatry. The literary arguments, those that have come down to us, were carried on by more educated people, some of a highly elitist culture. As a rule, the written arguments were more sophisticated and intellectual than those of the earlier stages. The greater refinement and sophistication had an obvious impact on the specific contents of the debate, on what precisely was discussed. It is not surprising that problems and aspects of the traditional subject matter that remained less articulated in the earlier stages of the debate now became manifest.

The subjects that during the second period of the Iconoclastic Debate dominated the controversies over the status of icons were mainly that cluster of opinions and beliefs that go under the label of the "Christological argument." Concentration on this argument had many results; one of them was a transformation of the very concept of the holy image.

In the late eighth and early ninth centuries the Christological theme, and particularly its implications for the visual rendering of the sacred, stand out with clarity and distinction. The argument itself, of course, is not new. Throughout the ages the image of Christ was discussed as a problem of dogmatic theology. Since the beginning of the Iconoclastic Debate, this particular "argument" agitated the minds of believers, but it was mainly in the later stages of the movement that it became a matter of passionate dispute. Although the theme is old, when we look at the conclusions arrived at in the second stage of the great controversy we find new and significant developments that are of interest even for the modern student of art.

During the first period of the great debate, the full weight of the Christological argument was felt only at the end, when it was considered a final justification of images.[21] In the second phase of the controversy the Christological argument was brought up right from the beginning, and it soon became the central theme of all theoretical deliberations. Put in its crudest form, the argument is simple enough: since Christ became

a man, he can be portrayed as any other man. It was with a discussion of this argument that the second stage of the controversy began. To outline the well-known history, we must go back to the year of John of Damascus's death. In 754 the emperor Constantine V, Copronymus, convened a church council with the aim of confirming a new iconoclastic policy. The emperor himself addressed the council.[22] In the domain of theory, or theology, one of his aims was to show that the Christological argument cannot serve as a justification of holy images. On the contrary, a proper understanding of Christology shows that a true portrait of Christ is altogether impossible, and that all icons are therefore deceptive.

The modern student of the arts, always concerned with the question of whether the invisible can be represented in painting, will find the conclusions accepted by the council, as well as the fragments of the emperor's address, interesting. "Satan seduced the people to worship creatures [man-made idols] instead of the Creator," so begins the Council's "definition" *(horos)*.[23] After condemning "the unlawful craft of painters," which "by the deceitful operation of color draws away the human mind from the service which is sublime and befits the Divinity, to the base and material service of creatures," the members of the council turned to what was for them the central question, namely, what does a proper understanding of Christ's nature really imply for assessing the icon's truth? They were agreed that all the Fathers believed and the ecumenical councils confirmed was that, in the well-known formulation of Chalcedon (451), Christ was "in two natures without confusion, without change, without division, without separation."[24] Students of ecclesiastical history have shown that, particularly in the course of the earlier centuries, the Chalcedon formula was understood in different ways, and thus gave rise to various "heretic" readings.[25] No wonder, then, that the iconoclastic Council of 754 proceeded to give what its members thought was the correct interpretation of that famous formulation.

It is worth our while to carefully read at least parts of the decision adopted. After reiterating the basic assumption that the two natures of Christ must not be confused, the decision reads,

What, then, is the senseless conceit of the painter of foolishness who, out of wanton greediness, for profit practices what should not be practiced, namely the depicting, with profane hands, of those things which are believed with the heart and confessed with the mouth? Such a person made an image and called it

"Christ." The name of Christ means God and Man. Hence, it is a picture of God and Man, and consequently in rendering the created flesh he foolishly also depicted the Godhead that cannot be represented, and he therefore confused what should not be confused. He thus committed a double blasphemy: once because he wished to represent the divine, and secondly because he confused the divine with the human.[26]

The purely theological problems do not concern us here. I should only like to say that, following this controversy with the mind of a modern student who wishes to understand the riddle and limitations of mimetic art, one clearly senses that what were being debated in the council, and decreed in the *horos,* were not only issues of dogmatic theology. If we disregard the theological vocabulary, and extract the question discussed from the doctrinal framework within which it was treated, it is not difficult to see that, whatever else may have been involved in the dispute, implicitly it dealt with the subject of the power of images and its limits, and with the question of what an icon's "truth" actually means. Leaving aside for a moment the historical framework of our discussion, I should like to say that we may perhaps believe that we understand how the human figure, that is, a material and circumscribed body, can be rendered in a picture, but the iconoclasts, as stated in the *horos* here under discussion, asked, how can the *divine* nature, that is, a nature that is neither material nor circumscribed, be represented? To a certain extent, this question applies to a wide domain of the mimetic arts. Almost every true work of art attempts, in one way or another, to represent both bodily, material and intangible, spiritual nature (and a modern student can see "divine" nature as belonging to the intangible and spiritual). The council itself was not concerned with problems of aesthetics, but behind its arguments there is more than just the question of the power and limits of the icon. Students of art here discover a cardinal question from their own province.

The *horos* of the Council of 754 may perhaps not be considered a document of Theodore's immediate environment. Simple chronological reasons would seem to speak against it: he was born five years after the emperor Constantine V convened the council. Nevertheless, I believe, it is appropriate to see the iconoclastic decision of Hierera as an important —perhaps even a central—document of the overall intellectual conditions Theodore encountered. The long reign of Constantine V lasted till 775. The emperor's "radical theology"[27] was a legacy that was not

easily overcome in the last part of the eighth century. The questions that prevailed in the theoretical reflections of several decades were those inspired by Constantine V.

The iconoclastic legacy, as formulated by the Council of 754 and supported by many later statements, consisted not only of explicit statements, but also of half-articulate suggestions. To one of those vaguely hinted themes of reflection we must here direct our attention. We must remember that the iconoclastic attitude towards art was not altogether negative. The ecclesiastic and political leadership did not reject art as such; it was the validity of only one specific branch of art that was questioned, or outright denied: the divine image. While the iconoclasts rejected the images of Christ, the Virgin, and the saints, and thought that pictorial depictions of events narrated in the Gospels should be excluded, they readily admitted, defended, and even actively advanced the decoration of church and palace (and perhaps also private houses) with pictorial renderings of secular themes. Many writings, collected and studied by modern scholars,[28] attest to the fact that the iconoclasts favored secular decoration, often (if we are to believe the texts) even replacing holy icons and sacred scenes by such worldly depictions. After the Council of 754, says a text written in 806, "wherever there were venerable images of Christ or the Mother of God or the saints, these were consigned to the flames or were gouged out or smeared over. If, on the other hand, there were pictures of trees and birds and senseless beasts and, in particular, satanic horse-races, hunts, theatrical and hippodrome scenes, these were preserved with honor and given greater lustre."[29] The same text says later that Constantine V "converted the church into a storehouse of fruit and an aviary: for he covered it with mosaics [representing] trees and all kinds of birds and beasts, and certain swirls of ivy-leaves, [enclosing] cranes, crows and peacocks."[30] A later text, written in the tenth century at the behest of Constantine VII, relates that during iconoclastic rule "holy pictures were taken down in all churches, while in their stead beasts and birds were set up and depicted, thus evidencing his [the iconoclast's] beastly and servile mentality."[31]

These texts do not explicitly refer to "religious art" or "secular art." These terms were not employed, either by iconoclasts or by iconophiles. In the theological, theoretical dispute between the two parties, however, this conceptual distinction was clearly foreshadowed.[32] In earlier periods we often find the encounter between the representation of pagan and

Christian themes. In Byzantium of the sixth and seventh centuries we have many legends telling of the images of mythological figures being replaced by the images of Christian saints.[33] But these legends refer to the art of two religions; eighth-century Byzantines could perceive of the image of Aphrodite as pagan and demonic, but they did not perceive it as "secular." It was the second phase of the Iconoclastic Debate that introduced the concept, though not the term, of a secular art, that is, of an art that is not religious at all, that (if I may use the term) is religiously neutral. The distinction between religious and secular art was one that no later discussion of icons could ignore. It is still very much with us.

4. Theodore's Reply to Iconoclastic Arguments

These, then, were the problems that Theodore of Studion had to face. How did he answer the questions raised, and how did he deal with the arguments presented?

Before we embark on an analysis of Theodore's views, we should outline the precise theme of his thought. As he never referred to a distinction between religious and secular art, his only theme is the images of Christ and, to a much lesser degree, of the Virgin and the saints. The same attitude we have already found in John of Damascus,[34] but in Theodore's writings it is more clearly visible. Like John of Damascus, Theodore of Studion deals with questions that no student of art would even think of, such as, what is the proper definition of worship, what do the different categories of veneration, adoration, and worship mean, and for whom, for which saints, is each category appropriate?[35] Where he treats the holy image as such, the Christological argument forms the center of his reflections. To show that the pictorial rendering of Christ is in principle impossible, and that therefore the icon is misleading and sinful, the iconoclasts, as we remember, presented the defenders of icons with the well-known theological dilemma: Christ, according to the accepted doctrine, has two separate natures, a divine and a human. Both natures are essential to Christ the incarnate god, but they must not be confounded, so that they become one single nature; they ought to remain distinct from each other. Applied to the question of painted icons this means that one of Christ's natures, the bodily one, can be portrayed, while the other, the divine, is altogether beyond the reach of portrayal.

Now, if you assume that in Christ the divine nature was completely melted with the human, bodily nature, so that the portrayal of Christ's bodily shape also fully reflects his divine essence, you might conclude that a proper portrayal of the redeemer is indeed feasible. Such an assumption, however, would involve a grave heresy, known as the heresy of Monophysitism. Should you, on the other hand, assume that the icon portrays only Christ's human nature, you would not only invalidate the icon as a full and appropriate portrayal of Christ, but would, moreover, be committing another heresy, that of separating the Savior's two natures, a heresy known as Nestorianism. In either case, the iconoclastic party concludes, a pictorial rendering of Christ is unacceptable for theological reasons.

Theodore of Studion did not explicitly quote this dilemma,[36] but from his argumentation it follows that to the dilemma presented by the iconoclasts he replied with a dilemma of his own. If we claim that Christ cannot be portrayed because he is not like every other human being, that is, he lacks a full-fledged human nature, we are guilty of another heresy that played a significant part in early Christian thought, the heresy of Docetism.[37] Docetism, to put it briefly, held that Christ never ceased being God; he assumed human shape only in appearance (his suffering therefore being illusionary). Should we, on the other hand, assume that Christ cannot be depicted because in his person the two natures fully merged, so that actually only one nature obtained, we would be back at the heresy of monophysitism. The claim that Christ cannot be portrayed, it turns out, is not less heretical than the claim to the contrary, namely, that a portrayal of him is totally beyond our powers.

His confronting the theological dilemma of the opponent party with a counterdilemma of his own might create the mistaken impression that Theodore of Studion was a thinker who replaced fundamental problems of religious reality with technical distinctions or contradictions. This is not so. He saw the contradictions in religious reality itself, and, in fact, he was aware, as were few theologians of his time, of the fragility and precarious state of our beliefs, and of the dialectical, paradoxical nature of central dogmas, including the belief that Christ can be portrayed. Describing how "because of His [God's] great Goodness one of the Trinity has entered human nature and become like us," he says of the Incarnate Christ,

There is a mixture of the immiscible, a compound of the uncombinable; that is, of the uncircumscribable with the circumscribed, of the boundless with the bounded, of the limitless with the limited, of the formless with the well-formed.[38]

And he concludes this sentence with the statement, "which is indeed paradoxical."[39]

It is precisely the paradoxical nature of the Incarnation that Theodore of Studion makes into the very foundation of the holy image. Continuing the sentence just quoted, he says,

For this reason [that is, because of the paradoxical mixture of the immiscible] Christ is depicted in images, and the invisible is seen. He who in His own divinity is incircumscribable accepts the circumscription natural to His body. Both natures are revealed by the facts for what they are: otherwise one or the other nature would falsify what it is.

5. Different Concepts of the Image

So far I have tried to indicate the theological basis of Theodore's doctrine of the icon; we now turn to what he says of the holy icon itself. Theodore's theory of the image, as we have noted several times, is altogether embedded within the mold of traditional reflections on the subject. I shall attempt to show that, in fact, new ideas are found in his text, and that, at least in some of his conclusions, he made manifest what had been hidden or dormant in the traditional reflections on the subject. Two of the themes that he, like so many other theologians, intensively discussed, are of special significance for our study. One of these concerns the relationship between the image and its prototype; the other is the final definition of the image. I shall briefly analyze each of these separately.

Theodore of Studion, it has been said,[40] perhaps more than any other theologian of his time, wholeheartedly accepted the views concerning the relationship between prototype and image that were common during late Antiquity and the early Middle Ages in the Greek East. These beliefs and concepts he applied to Christian theological thought. To properly understand the significance of what Theodore here did, we should keep in mind in what specific sense these concepts were applied. In the Greek schools of the Eastern provinces, long after they had become Christian, it was common to speak about the "original" and the "copy." These notions belong to the core of the Platonic heritage that exerted such a

powerful and formative influence on the intellectual life of many centuries. The connotations these terms carried there differed, however, from those they may have nowadays. In modern thinking about original and copy it is taken for granted that they relate to each other in a rather loose way. There is no necessity for the copy to follow from the original. This was not so in the theological thought of the period we here have in mind. Between original and copy, it was generally accepted, a *necessary* relationship prevails. This belief had a particular bearing on the problem of the icon. It was perhaps not a matter of chance that this problem became so prominent and manifest in the course of the Iconoclastic Debate, and that the defenders of icons particularly had recourse to it. There is an interesting development in the views on this particular question that pertains to our subject. While the general theme of original and copy is by far too large for us to review, we may make some observations on one specific aspect of it.

John of Damascus believed, of course, that there is an intimate connection between the original and the copy, between the prototype and the copy. Reading his texts, however, one cannot help feeling how he hesitates to state plainly that the copy is necessary for the prototype, or, in other words, that without having a copy, or rather producing one, the prototype cannot be what it is. What he does is to emphasize that prototype and image are linked in a dialectical manner: they are, at the same time, both identical with, and different from, each other.[41]

In the particular subject of the relationship between original and copy, Theodore of Studion takes an additional step; it is one that proved to be of great consequence for the reflection on images. He explicitly states that the image necessarily follows from the prototype. He comes back to this subject several times, especially in the third Refutation, the most systematic of the three. "The prototype and the image belong to the category of related things," we here read.[42] Lest his statement not be fully understood, he emphasizes that "the prototype and the image have their being, as it were, in each other."[43] So basic is this interdependence that the one exists *for* the other: "For the archetype the image and the image for the archetype exists, appears, and is venerated."[44] Moreover, it is even essential for the image, that is, for the copy, to be a material object. To an iconoclast's objection Theodore makes the orthodox answer: "However, it is not admissible to call something a prototype if it does not have its image transferred into some material."[45]

Theodore's view that the image *follows* from the prototype is clearly seen in the example he brings to explain the process: it is the body casting a shadow. In metaphors the shadow can have the connotation of lacking in full reality. So, for instance, he protests that "the shadow and the truth are not the same thing."[46] Usually, however, the "shadow" evokes the close connection, the inseparable link, with the body casting it. "If the shadow cannot be separated from the body, but always subsists along with it, even if it does not appear, in the same way Christ's own image cannot be separated from Him," he says at the very end of his Refutations.[47] What he goes on saying clearly suggests his belief that the shadow somehow dwells in the body, and it is the body that, under certain conditions, casts it upon the outside world. It is precisely because the shadow follows from the holy body that it can work miracles. Therefore Theodore credits the shadow of the cross with the ability "to burn up demons."[48]

To understand how the general principle of a necessary relationship between the original and the copy applies to our subject, the holy icon, we now have to turn to the other theme of special significance, namely, to the question of what precisely Theodore understood by "image." Here, I believe, an original contribution to aesthetic thought may be found. Modern historical research has treated the views on what an icon is that prevailed in the centuries of the Iconoclastic Debate as if they were altogether independent of the different camps and the different stages of the debate. Twentieth-century students who investigated the early Christian and Byzantine approaches to our subject, the image, were, of course, aware of the differences in attitude; they examined rejection and acceptance of icons in great, and often illuminating, detail. At the same time, however, they treated the very definition of the image as if it did not change according to the parties in the dispute, and the stage of the debate. But was this really the case? Did, in fact, all camps, the iconoclasts as well as the defenders of images, have exactly the same concept of what the image is?[49] To be sure, in its essential features the concept of the image was indeed remarkably stable and unified. Nevertheless, the historian can note, I think, that the opposing camps differed from each other not only in how they appreciated the image, but also in what they emphasized in the underlying common definition, a definition they inherited from ancient philosophy. As a result of such varying emphases, certain diverging shades of meaning appeared in the common

concept. Moreover, as time passed and the debate unfolded, some internal development became manifest in the concept of the image itself. This specific subject, of shifts and changes in the concept of the image, is worth careful examination. I do not intend to present such an examination here; that would require a study of its own. Since I am not aware of any other preliminary studies, I can only offer some impressions. I shall indicate, in bare outline, what seem to me the characteristic trends in the concept of the image of both the iconoclasts and the defenders of images. It goes without saying that such a coarse map disregards the finer shades, and projects contrasts that are sharper and more distinctly outlined than a complex reality would warrant.

The iconoclasts never seem to have described in detail what they understood by "image." To be sure, their texts were destroyed, or otherwise perished, and what we know of their thought we derive mainly from the writings of their opponents. Yet in spite of the distortions that are a necessary result of such a state of affairs, we are fairly well informed about the main lines of their thought with regard to this specific subject. They tended to understand the image, the representation or portrayal of a prototype, as some kind of replica of the original. This is perhaps best seen by analyzing their views of what a "true" image is. The criterion for the "truth" of an image is total correspondence: the true image corresponds to its prototype in as many aspects as possible, ideally, in all aspects. The very fact that the icon is a material object seemed to them to detract sufficiently from the image's truth to cancel its validity. "It is a degradation," Theodore makes the heretic (i.e., the iconoclast) say, "and a humiliation, to depict Christ in material representation."[50] Materiality itself is an obstacle to truthfulness. Towards the end of the third Refutation our author provides a kind of summary of the iconoclasts' argument: "If every thing which is made in the likeness of something else inevitably falls short of equality with its prototype, then obviously Christ is not the same as His portrait."[51] So far as we can see, *full* correspondence between image and prototype is the only criterion that validates an image as "true." Since such a full correspondence can never be achieved, a really true image is altogether impossible. The very foundation of the iconoclastic attitude is the view of the image as a total and precise representation of the original.

One effect of this attitude is actually to deny in principle the very existence of the image. If you make complete, total correspondence with

the prototype the only criterion for truth, the concept of "image" that will obtain will of necessity be abstract, lacking any character of its own, any specific structure that will set it apart from what it portrays. Trying to reconstruct what the iconoclasts pictured in their minds when they spoke about images, this is indeed the impression one receives. For the image as such there was in fact little room in their system of thought.

Turning to the defenders of icons we find a much richer and more dynamic concept of the image. I should repeat that here we have what the defenders of images themselves wrote, while with regard to the iconoclasts we have to judge on the basis of what their opponents tell us. In spite of this circumstance, we can be certain that even in the eighth and ninth centuries the iconodules' concept of the image was more complex than that of the iconoclasts. Problems for which the iconoclasts had no room and no use are amply developed in the doctrines of the iconodules, and attract their main attention. Two of these problems— interrelated, but not identical—are of particular significance for a theory of the artistic image, and I shall briefly outline what they say.

A central problem faced by the defenders of icons was how to explain that an image is both identical (at least, in some respects) with the prototype it portrays, and at the same time altogether different from it. In other words, they had to explain how the image captures the essence of what it depicts, and yet has a character of its own. This problem did of course not exist for the iconoclasts; to admit the essential difference between prototype and image to them meant to reject the validity of the latter altogether. By insisting that the image has to *fully* correspond to what it represents, they did not leave room for the image's ambivalence. To the defenders of icons it became a major task to show how the image can be both truthful to, and yet different from, the original. None of them believed, it goes without saying, that the icon they were worshipping was indeed, in a simple sense, identical with Christ. On the other hand, they could not accept (to use modern terms) that the icon was nothing but a mere arbitrary sign, a sign that could easily be replaced by a different one. The task they set themselves was to show that, notwithstanding the essential difference between icon and prototype, the two have some real elements in common.

Reading the principal systematic defenses of images in the Eastern church, one is struck by how much attention was devoted to this particular aspect. Time and again the major systematic theologians come back

to this theme. A few quotations will illustrate this trend. "An image is of like character with its prototype, but with a certain difference. It is not like its archetype in every way," said John of Damascus.[52] Theodore of Studion, concluding the Byzantine cycle of the Iconoclastic Debate, is even more concerned with the dialectical tension that is so crucial in defining the image. Defending his views against iconoclast attack he says that "Christ is one thing and his image is another thing by nature, although they have an identity."[53] And a little later, trying to understand more precisely what it means to say that the icon is holy, he says, "Thus if one says that divinity is in the icon, he would not be wrong . . . divinity is not present in them by a union of natures, for they are not deified flesh, but by a relative participation."[54]

The image, then, by its very nature is a dialectical object. Exploring that nature forced the defenders of icons to make distinctions, or to articulate objective differences. First, they had to distinguish between different types of images, and then, even more important, between different components of the image as such. Unlike the iconoclasts, they did not see the "image" as one uniform whole, lacking in internal structure and separations. They were also aware that in the minds of readers and listeners the notion of "image" carried different connotations. Thus one has to keep apart the image as a metaphor (such as humanity as the image of God) from the concrete mental images and material objects we describe by this term. Even within the limited domain of concrete, objective images they made distinctions that are a significant contribution to the understanding of art, and anticipate modern ideas. I shall briefly discuss two of the ideas thus suggested.

The first distinction is that between what we would now call "mental image," what we see, or believe we see, in introspection, and the material icon, that is, the picture painted with colors on board. The mental image, as we here intend it, is not an abstract figure of speech; it is a concrete appearance that has traceable shapes and specific colors, and is sensually perceived. The only difference between the mental image and the material icon is that the former exists only in our mind, while the latter has an "independent" existence in the outside world.[55]

The concern with the mental image is a characteristic feature of the intellectual world in which the Iconoclastic Debate took place; it is particularly prominent in the thought of the defenders of icons. Both John of Damascus and Theodore of Studion deal with it. John of Damas-

cus places mental images in the divinity itself. In God, he says, there are "images and models of His acts yet to come." In making these acts happen in the actual world—this is what follows from what he says—God is looking at the image in his mind, "just as a man who wishes to build a house would first write out a plan and work according to its prescriptions."[56] Theodore of Studion links the mental image with the painted icon; it is the model we follow in making an actual picture. "We are taught to draw," he says, "not only from what comes into our perception by touch and sight, but also whatever is comprehended in thought by mental contemplation."[57] And in the very last sentence of his Refutations he speaks of depicting Christ who "is seen mentally while [physically] absent." Would we not do this, "even the mental vision would be lost."[58]

Two points should here be stressed: first, the material nature of the painted icon is acknowledged as a pertinent dimension, as a realization that remains within the scope of the image, and is not a degradation; secondly, by making the transition from the mental image to the material icon appear smooth and without difficulties, the iconodule theologians strongly suggest that the real "medium" of the image (to use a modern term once again), its distinguishing mark, is the traceable shape and discernable color. In other words, it is form as such that constitutes the *eikon*, and that form is present both in the mental image and in the painted icon.

The other distinction made by the theologians who defended the icons, and particularly by Theodore of Studion, is even more significant for the study of art. It is less clearly formulated than the former distinction, that between the mental image and the painted icon, and to show it as clearly as possible I shall put it briefly in present-day words. It is the separation of "pure form" from any individual realization in a concrete work or vision. To see this idea clearly we must go back for a moment.

It was in the course of the Iconoclastic Debate, as I have already said,[59] that the simple question of what an image is was explicitly asked. John of Damascus was the first to put the matter in this straightforward way. A generation or two later, Theodore of Studion went one step further and raised the question of which components of the image, whether seen with the mind's eye or painted with materials, are those that perform the central function of imaging.

A modern reader cannot help being surprised to learn that orthodox

theologians around A.D. 800, defending the status of holy images, that is, pictures executed in visible shapes and tangible materials, came close to distinguishing between the work of art as a material object and the form that is cast into it. Their arguments and reflections reached a stage that made it feasible for them to see, at least in principle, that in a painted icon or in a vision seen with the mind's eye there is, in addition to the specific lines and colors perceived, a shape that, in itself, has an "ideal" existence only. That shape, or pure form, can be materialized in different painted or carved icons, or in various mental images; it has the innate ability to appear distinctly in all these realizations. Theodore of Studion did not set forth these ideas explicitly, and, it goes without saying, he did not draw from them the conclusions a modern student of aesthetics would draw. To understand his thought we shall have to look carefully at what the examples he uses may tell us.

The theoretical defenders of icons, and quite particularly Theodore, were fascinated with the process of impressing a seal on wax. Qua material objects, in their physical substance, the two objects, the seal and the wax, are obviously different from each other. And yet the image is transferred with great precision from one object to the other. What Theodore primarily learned from this example is that two objects may be altogether different in their substance, and still have some kind of identity. Now, what is it that is transferred from the seal to the wax, from one object to the other? Obviously it is nothing material. What is transferred is nothing but form, the configuration in the image. The example hints that form as such, or whatever else we shall name it, is isolated, is considered in itself. "Is not every image a kind of seal and impression bearing in itself the proper appearance of that which is named?" he rhetorically asks.[60] Even when Theodore applies the example of the seal impression to the specific subject of the veneration of icons, the idea of the pure form is preserved. Towards the end of the third Refutation we read, "It is not the essence [*ousia*] of the image which we venerate, but the form [*character*] of the prototype which is stamped upon it. . . . Neither is it the material which is venerated. . . . But if the image is venerated, it has one veneration with the prototype, just as they have the same likeness."[61] What here emerges may be somewhat hazy in formulation, but the idea is clear: form, the bearer of the likeness, is ideally detached from the individual appearances, and is considered as something in itself.

The existence of pure form, detached from any specific matter and therefore transferable to different materials was suggested in a widespread topos, common both in Antiquity and in early Byzantine theoretical literature, the emperor's image. As we know, the fact that the emperor's image, cast in different materials, still retains an identity with the one living emperor, fascinated both pagan philosophers and Christian theologians.[62] The defenders of icons quoted, time and again, St. Basil's statement to the effect that the statue of the emperor, called "the emperor," preserves an identity of sorts in its various casts.[63] It is this identity that is called "the emperor," and that identity is one and the same form. The topos of the emperor's image is, of course, applied to Christ and the icons representing him. There are many representations of Christ, Theodore of Studion says, but "there is only one Christ." And he concludes, "The use of an identical name brings together the many representations into one *form [character]*."[64]

Most surprising is Theodore's explicit statement that even when the various individual appearances of a form are not identical in detail, the pure form continues to exist as such and is recognizable in its identity. This we learn from what he says about the cross, a theme discussed several times in his Refutations. The recognizable identity of the cross does not depend on the many material objects that depict it (one could add, nor does it depend on the many crosses imagined). The formal and material details can vary, and yet the basic form remains. It is worth our while to read attentively one passage stating this idea. Speaking of the relation of crosses to the "life-giving," original cross, Theodore says,

In this case also the depiction does not have exactly the same form as the archetype, in length or width or any other relationship, because it is represented differently. Crosses can be seen small and large, wider and narrower, with blunt or sharp ends, with or without inscription. . . . Nevertheless, in spite of such great differences, there is one veneration of the symbol and the prototype; so evidently the same likeness is recognized in both.[65]

One cannot help concluding that the general shape of the cross exists as a pure form, detached from all specific crosses in hard materials or in the mind, and it is this ideal cross that lends identity to the individual objects and images.

6. The Icon and the Theory of Art

Not many words need be wasted to prove that Theodore of Studion did not consider the picture, or the work of art in general, as an end in itself. He did not even see hymns as justified in themselves by some intrinsic, autonomous value. Nor did he intend to compose a philosophical doctrine of the image as such, detached from its uses in the service of the church, that is, an aesthetics of the visual arts. This does not mean, however, that his mind was not concerned with certain problems relating to a theory of art. Careful reading of his Refutations does indeed reveal the vague outlines of a doctrine of art, or at least some components of such a doctrine. These individual components were not new in his time, but the fact that he related them to each other is a remarkable phenomenon of the history of ideas in the early ninth century. It demonstrates that the argument in defense of images, regardless of the specific motivation of those who undertook the defense, led them to at least adumbrate some outlines of a philosophy of art. For the student of aesthetic reflection it might be interesting to throw some light on these hidden outlines. That one cannot expect anything resembling a full system is of course obvious to every reader of Theodore's texts.

(i) *The Sense of Sight* Were we to attempt a reconstruction of Theodore's aesthetics of the image (if I am permitted to use such a pretentious term) we should begin with a statement that, in the historical context in which it was made, may be unexpected: he emphasizes the intrinsic value and significance of the sense of sight, and ranks it above all other senses. In words that remind us of Leonardo's famous eulogy of the eye, Theodore claims that the sense of sight precedes all the other senses. Like Leonardo he compares sight with hearing. "Sight precedes hearing," he asserts.[66] What does such a precedence mean? Among the senses sight not only has precedence in importance and value; it precedes the others also in time. We see first and only after that do we hear; moreover, in some way that remains mysterious, sight is the origin of the other sense perceptions, especially of hearing. The passage, the first sentence of which I have just quoted, reads, "Sight precedes hearing both in the location of its organs and in the perception by the senses. For one first sees something and then transmits the sight to the sense of hearing."

The belief in the superior value of sight, it should be noted, is of course a traditional theme. It goes back to the famous opening paragraph of Aristotle's *Metaphysics*. The senses, we there learn, "are loved for themselves; and above all others the sense of sight. . . . The reason is that this, most of all the senses, makes us know and brings many differences between things."[67] In Byzantine thought of the time the superiority of sight over all other senses seems to have been accepted in perhaps a small, but highly educated, circle. John of Damascus already declared seeing to be the first of the senses.[68] In the second phase of the Iconoclastic Debate the assumption that sight is superior to the other senses continued to be held, and seems to have been accepted by the leading thinkers of the defenders of icons. We have the important testimony of Theodore's contemporary, Nicephorus, the patriarch of Constantinople, who was one of the theoretical defenders of images in his time. In his Refutations of the iconoclasts he also elevates sight above all other senses. At the beginning of his third Refutation he praises sight for leading us directly to what we experience. Sight is therefore more effective than hearing. Being able today to see the life-giving tree of the cross makes up for the fateful "seeing" of the tree of the knowledge of good and evil in Paradise.[69] It was, however, Theodore of Studion who made the priority of sight a matter of theological doctrine.

Theodore was not a Leonardo; to prove the superiority of sight over the other senses, he does not look at nature but invokes the authority of the Bible. Isaiah first saw the Lord sitting on the throne of glory, and only then did he hear the six-winged seraphim praising him (Isaiah 6:1). Ezekiel (1:10) also begins by recording a visual experience: he sees the chariot of God. The New Testament, too, testifies to the precedence of sight: the disciples first saw the Lord, and only later did they write out the message.[70] (Incidentally, it is worth noting that without hesitation Theodore derives the written word from the spoken one, and thus relates it to the sense of hearing.) However far you go back in history, you will always find that the sense of sight is superior to all the others. The sense of sight, Theodore concludes (perhaps not altogether consistently), will also last longer than that of hearing: "It is undoubtedly necessary that if the sight of Christ is removed, the written word about him must be removed first."[71] The student of medieval theology, aware of the dignity and symbolic connotations carried by key concepts, and even terms, knows how far-reaching Theodore's formulation is. It implies the supe-

riority of vision over the word. The central significance of "Word" *(logos)* in Christian thought need hardly be stressed. To claim that the sense of sight will prevail after the word has disappeared is therefore a matter of great consequence. Theodore of Studion must have considered the priority of sight a matter of crucial significance to make those statements. Sight is so crucial to his mind because, as we shall immediately see, it is the basis of his defense of the position of the icon.

The concern with sight naturally leads to the question of the object of sight, to what can, or cannot, be seen. It is a question Theodore could not avoid, a topos that iconoclastic literature did not cease to discuss. Theodore treats it by connecting it with the great philosophical altercation of the universal and the individual. The general philosophical problem of the universal and the individual, so crucial in medieval thought, is not our concern here. We are interested only in what the evoking of it in our debate may indicate about the concept of the image.

The universal and the individual are grasped in different ways: "Generalities are seen with the mind and thought; particular individuals are seen with the eyes, which look at perceptible things."[72] Now, in "seeing with the mind and thought," the verb "seeing" is employed metaphorically; in "seeing with the eyes," it is meant literally. The object of regular sight is the individual object or body. Imaging, it follows from Theodore's distinction, is inseparably linked with the individual body. It is the individual trait, the feature that sets one apart from the general and universal, that make it possible for us to depict somebody. Christ, Theodore says, is no exception in this respect: "It is not because he is man simply (along with being God) that He is able to be portrayed; but because He is differentiated from all others of the same species."[73]

Another component of an art theory is the articulation of some of the formal elements we employ when shaping a work of art. For Theodore this means, of course, the shaping of an icon. It is mainly two notions that are thus discussed, either openly or implicitly—circumscription *(perigraphe)* and "place" *(topos)*. Both, as we shall immediately see, are derived from the Aristotelian influence that was felt in the ninth century.

(ii) *Circumscription* Circumscription is central among what we here call "formal" elements, and it is also the concept most seriously questioned and analyzed in the second phase of the Iconoclastic Debate. In

his *Physics,* Aristotle speaks of "the boundary of the containing body at which it is in contact with the contained body."[74] Aristotle did not write on painting and thus we do not know what terms he would have employed for contour, the line that delimits a figure painted in a picture.[75] In the course of time, however, the term became synonymous with "outline," and thus also with "circumscription" in the more limited and technical meaning it had in the ninth century. To barely suggest the historical context we should also remember that in the eighth century an Aristotelian revival began in Byzantine thought and letters, and that it is none other than John of Damascus who is considered a leading figure in initiating that movement.[76]

It would be a fascinating task to trace the history of that concept of "boundary," "outline," and "circumscription" through the centuries between Aristotle and John of Damascus. This cannot be attempted here. All I would point out in the present context is that in the Byzantine literature dealing with the icon, both that composed by the iconoclasts and that composed by the iconodules, by the breakers of images and by their defenders, it was taken for granted that there is an identity (or at least a close affinity) between the "boundary" of the body in nature and the "outline" drawn by the painter on his panel. So far as I know, no Byzantine author explicitly dealt with this particular subject (and considering the Byzantine attitude to art, this seems perfectly natural). Moreover, no Byzantine scientist or theologian seems to have asked what precisely "boundary" means. It is, therefore, not surprising that a certain vagueness obtains in the definitions of the concepts. But it is no exaggeration to say that the notions of "boundary" and "outline" (as here described) were used interchangeably. It was taken for granted that what was called "circumscription" *(perigraphe)* is a property common to bodies in nature and figures painted in pictures. One cannot help inferring that circumscription thus became the very foundation of pictorial depiction.

That circumscription was considered the very basis and condition for pictorial representation is frequently stated in the documents of the great debate. Time and again it was stressed that only the circumscribed object or figure can be depicted. It is sufficient to recall that John of Damascus, to mention only one representative example, says that "physical things which have shape, bodies which are circumscribed [*perigraphen somatiken*], and have color, are suitable subjects for image-making."[77] The

divine itself, he says elsewhere, is "uncircumscribed [*aperigraptou*] and unable to be represented."[78] In the early ninth century, however, a serious attempt was made to distinguish between circumscription in nature and circumscription in art. So far as I know, this is the only attempt of its kind in Byzantine thought, and in western thought as well not many parallels can be listed.

Between 818 and 820, Nicephorus, the patriarch of Constantinople, completed his three Refutations of the iconoclasts (the beginning of these treatises goes back to disputes earlier in the century). In the Refutations he several times discussed the concept of "circumscription," and attempted to distinguish between circumscription in nature and in painting, keeping the two concepts apart. He also used different terms for them: circumscription in nature he called by the traditional term *perigraphe*, while for representation in painting he used the term *graphe* (which can also mean painting in general). This distinction, it seems to be agreed by scholars,[79] was Nicephorus's own contribution to the theory of images. Though it does not seem to have made an impact on further thought on the subject, it deserves the attention of the student of aesthetic thought.

The context of Nicephorus's discussion of circumscription is the iconoclasts' belief (probably with particular reference to the declaration by the emperor Constantine V, Copronymus) according to which an image, to be true, ought to have an identity with the prototype. That would necessarily lead to the conclusion that a painting, having the same circumscription as the real Christ, captures Christ himself, and in the end, at least to less refined minds, *is* he. To prevent this confusion Nicephorus analyzes "circumscription." Circumscription in nature *(perigraphe)* is produced by place, time, etc. A portrait painter, on the other hand, does not enclose the person portrayed; the person need not even be present. While circumscription encloses the person by space and time, pictorial representation is achieved by colors and pebbles (mosaic stones).[80] A painting, therefore, is *related* to its prototype, but it is not *identical* with it. In other words, the two domains, nature and art, are related to each other, but each of them has a structure of its own. Nicephorus approaches this state of affairs from the theologian's point of view, but he is quite explicit: "And to sum up," he says in the second Refutation, "neither does pictorial representation circumscribe the man even if he is capable of circumscription, nor does circumscription represent him pic-

torially even if he is capable of pictorial representation, for each one will have its own function [*logos*]."[81] At least implicitly Nicephorus acknowledges art as a domain of its own.

Theodore of Studion perceives the difference between circumscription and pictorial representation from nature, but he does not separate the one from the other. Circumscription in the reality around us and in the icon we are looking at is essentially the same. Carrying on the dispute against the iconoclastic heretics, he says, "If every image is an image of form, shape, or appearance and color, and if Christ has all these, . . . then He is portrayed in just such a circumscription in His likeness."[82] He is aware that "there are many kinds of circumscription—inclusion, quantity, quality, position, places, times, shapes, bodies—all of which are denied in the case of God, for divinity has none of these. But Christ incarnate is revealed within these limitations."[83] Again one concludes that most, though not all, of these "kinds of circumscription" are found both in nature and in art. Theodore is closer to John of Damascus in believing that the difference between prototype and icon consists mainly in their material nature; the form, or the "circumscription," is the same in both. The icon "is perhaps wood, or paint, or gold, or silver, or some of the various materials which are mentioned. But when one considers the likeness to the original by means of representation, it is both Christ and the image of Christ."[84]

(iii) *Place* The concept of "place" *(topos)* plays an interesting and ambiguous part in Theodore of Studion's submerged concept of the icon, and the art that produces icons. Topos is, of course, a notion well known in Greek philosophy and physical science, especially in the Aristotelian tradition.[85] Aristotle, modern students believe, constructs "place" by combining elements of geometry and matter.[86] Theodore's discussion of "place" is part of the Aristotelian heritage that is of importance in his thought and in that of his time. In what he says about "place" in the Refutations there is perhaps a departure from what the schools taught, and it may well be related to specific problems of painting.

In Theodore's Refutations the notion of "place" lacks the philosophical distinction and rigor it has in the philosopher's work, but it has a certain ambiguity that, in modern terms, may perhaps be called "creative." On the one hand, "place" has a scientific meaning: every person, object, or event exists, or takes place, in a certain place and time. When

you record precisely where and when the body exists, or the event takes place, you actually define their nature and reality. This is also true for the incarnate Christ. When we say that Christ was circumscribed by place, this means that he was in Nazareth or in Jerusalem.[87]

In Theodore's writings, however, "place" may also mean something different from the real, material surrounding, from the landscape or the urban environment. Place itself, devoid of what occupies it, has an existence; it is circumscribed as a "place": "Not only the body is circumscribed, but also the place which it contains. Only that which is without any location is uncircumscribable, as it is limitless."[88] In this sense, location has little to do with places in the real world, with Nazareth or Jerusalem; it is the structure of the spatial extension, and as such it has directions and characteristics. Aristotle, one should remember, here spoke of up and down as characteristics of "place." It is in this sense that Theodore believes the body is "bounded by a place."[89]

Now the question, interesting in the context of our present investigation, arises: Is such a "place" also the spot on the painting surface, on the two-dimensional, spatial extension of the picture? No positive answer can be given, for Theodore simply made no statement on such a topic. All we can do is to try to infer from the contexts of his few, scattered remarks. But one suspects that he would have accepted that the spots in the painting surface do have a character of their own. The "center" of a painting's surface might be such a place. Thus in the Refutations Theodore describes a picture in a church, or rather quotes the description by the seventh-century bishop and author Sophronius. There he saw "a great and marvelous icon, with the Lord Christ painted in color in the center; on the left Christ's mother . . . and on the right John the Baptizer."[90] These spatial relations cannot be understood as relations of tridimensional figures located in an empty space, extending into depth; they are rather relations between different spots, *topoi*, on a flat surface. The spot, or area, that Theodore mentions, the "center," itself has a distinct character, resulting from what is seen to its right and left. It is because of the character of the empty "place" itself that the *topos* can fulfil a function in painting. Though this reflection is admittedly hypothetical, it well agrees, I believe, with Theodore's mind and with his intellectual world.

The modern student, carefully reading the Refutations, cannot help being surprised to come across a definition that is a rudiment of Euclid-

ian geometry. In the midst of discussing the circumscribability of Christ, Theodore, the early ninth-century theologian defending the worship of icons, writes, "A line is a length with no width, bounded by two points, from which a drawing begins. A figure is that which consists of at least three lines. From it begins a body, which is formed from different figures and is bounded by a place."[91] The art historian remembers that in fifteenth-century Florence Leone Battista Alberti, the founder of the Renaissance theory of art, began his book *On Painting* with several definitions taken from Euclidian geometry. Alberti wished to make the art of painting a scientific enterprise, and therefore derived his concepts from the ultimate authority in rational science, Euclidian geometry. But what makes a Byzantine theologian refer to this source?

Theodore's short passage raises several questions, such as what was the nature of his sources, and whether or not there were earlier instances of employing Euclidian definitions in the treatment of theological topics. These questions need not detain us here. What we are concerned with in the present context is only what Theodore's Euclidian reference may indicate. Here, I think, two features should be mentioned. The first is rather obvious. The line, which our author describes by using the Euclidian definition, is obviously part of the pictorial representation of Christ. Since in the sentences before and after the short passage quoted Theodore speaks of the circumscription of the incarnate Christ, he here again shows that he perceives a continuous transition from the "boundary" in real nature to the "line" in the painted icon. The second point is perhaps less obvious, but more significant for our topic. The primary context of the line is the surface. The drawing begins from "lines" rather than from "boundaries." The three lines, whatever their precise meaning, do not represent three dimensions. Theodore is here thinking of a flat, two-dimensional surface, on which alone "lines" have a meaning and can appear to the eye. The flatness thus vaguely intimated further supports, I believe, the interpretation of "place" as a spot on a flat surface. Taken together all this suggests, if I am not mistaken, that in Theodore's mind the characteristics of actual icon painting are somehow present. We may therefore conclude that, however veiled, Theodore's theology of the icon does not remain altogether abstract; it somehow leads to the painted image itself.

NOTES

1. See above, the last section of chapter 10.
2. For the so-called second cycle of the Iconcoclastic Debate, see the concise survey in A. A. Vasiliev, *History of the Byzantine Empire: 324–1453*, I (Madison, Milwaukee, and London, 1952), pp. 283–90. For the survival of the iconoclastic attitude much can be learned from Georg Ostrogorsky, *Studien zur Geschichte des byzantinischen Bilderstreits* (Breslau, 1929; reprint Amsterdam, 1964), esp. pp. 46 ff. For another religious context, the so-called Paulicians, see L. W. Barnard, *The Graeco-Roman and the Oriental Background of the Iconoclastic Controversy* (Leiden, 1974), pp. 104 ff.
3. For concise surveys of the ideological issues characteristic of the second cycle of the Iconoclastic Debate, see Edward J. Martin, *A History of the Iconoclastic Controversy* (London, 1930), pp. 184–97 (Chapter 10: "The Theology of the Second Iconoclastic Period"); and Hans Georg Beck, *Kirche und Theologische Literatur im Byzantinischen Reich, Handbuch der Altertumswissenschaften*, 12. Abteilung 2. Teil, 1. Band (Munich, 1959), pp. 303–6.
4. Theodore the Studite, *On The Holy Images*, translated by Catharine P. Roth, II (Crestwood, N.Y., 1981), 18. For further bibliographical information, see below, note 8.
5. All histories of the Iconoclastic Debate discuss, to some extent, his works and activities, but I am not aware of any modern monograph on Theodore of Studion. See, however, Alice Gardner, *Theodore of Studium: His Life and Times* (London, 1905); and the concise presentation by John Meyendorff, *Byzantine Theology* (New York, 1983), pp. 46 ff. Ernst Benz, *The Eastern Orthodox Curch: Its Thought and Life* (Garden City, N.Y., 1963), p. 91, describes him as "a key figure in the history of Orthodox monasticism."
6. Theodore assumed four basic principles of monastic life: obedience to the abbot, constant work, personal poverty, and an intensive liturgical life.
7. In the early ninth century, the monastery of Studion was the very center of ecclesiastical poetry; these were the years in which Theodore was the abbot of the monastery. See Karl Krummbacher, *Die Geschichte der Byzantinischen Litteratur* (Munich, 1891), p. 322.
8. The Greek text of the Refutations is found in volume IC of J. P. Migne, *Patrologia cursus completus, Series Graeca* (Paris, 1856). Recently an English translation has appeared, which I am using in the present chapter. See St. Theodore the Studite, *On The Holy Icons*, translated by Catharine P. Roth (Crestwood, N.Y., 1981).
9. See above, chapter 10, sections 1, 2.
10. See Catharine Roth's introduction to her translation (see above, note 8), especially p. 15. Theodore's terminology for the ritual (or general religious)

response to icons, she thinks, is consistent, especially the distinction between *latreia* (worship) and *proskynesis* (veneration in general).

11. The literature on *eidos*, "idea," is immense, even only with regard to imagery, and there is no sense in trying to review it. For a concise review of the principal philosophical meanings, see F. E. Peters, *Greek Philosophical Terms: A Philosophical Lexicon* (New York, 1967), s.v. "eidos," with select references. Pertinent to what this concept meant to reflection on art, though only in a general way, is the classic study by Erwin Panofsky, *Idea: A Concept in Art Theory* (New York, 1968 [original German edition, Leipzig, 1924]).

12. A good survey of the dispute among modern scholars, mainly philologists and archeologists, concerning the meaning of *typos* in ancient Greek thought and language is given by J. J. Pollitt, *The Ancient View of Greek Art: Criticism, History, and Terminology* (New Haven and London, 1974), pp. 284–93. For the meaning of the term *typos* in Christian symbolism, see above, note 120.

13. See above, chapter 10, section 5.

14. See the entry by W. Tatarkiewicz, "Form in the History of Aesthetics," in Philip Wiener, ed., *Dictionary of the History of Ideas*, II (New York, 1973), pp. 216–25.

15. Ibid., p. 216.

16. See Plato's *Meno* 79D. I use the translation by W. K. C Guthrie (Harmondsworth, 1972).

17. See above, chapter 10, section 3.

18. *On the Holy Icons* I, 9; p. 29 of the English translation.

19. Rather than adducing many historians, I shall mention only Beck, *Kirche und theologische Literatur*, p. 303.

20. See Cyril Mango, *The Art of the Byzantine Empire, 312–1435* (Toronto, 1986), pp. 168 ff., for an English translation of the pertinent passages. See Martin, *A History of the Iconoclastic Controversy*, p. 184. See also the general treatment by P. J. Alexander, "The Iconoclastic Council of St. Sophia (815) and Its Definition," *Dumbarton Oaks Papers* VII (1953), pp. 37–66.

21. See chapter 10 passim, particularly sections 1, 3, and 6.

22. His address has been reconstructed in part, and thoroughly discussed, by Georg Ostrogorsky, *Studien zur Geschichte des byzantinischen Bilderstreits* (Breslau, 1929; reprint Amsterdam, 1964), pp. 7–45. Ostrogorsky reconstructed the address from quotations found in Nicephorus's Refutation. The latter has come down to us in its entirety.

23. A detailed summary of the decision may be found in C. J. von Hefele, *Conciliengeschichte*, III (Freiburg, 1877), pp. 410 ff. There is also an English translation of Hefele's work.

24. For some of the sources of this famous definition, see above, chapters 9 and 10.

25. For a reading that can be of interest also for the student of art, see Jaroslav Pelikan, *The Christian Doctrine*, II, *The Spirit of Eastern Christendom (600–1700)* (Chicago, 1977), p. 91.
26. The text of the *horos* is translated into English in Stephen Gero, *Byzantine Iconoclasm during the Reign of Constantine V* (Louvain, 1977), pp. 68–94, and discussed on pp. 95 ff. For a German translation of the passage here quoted, see Hefele, *Conciliengeschichte* III, p. 413.
27. This is how Stephen Gero called the emperor's spiritual legacy. See Gero's *Byzantine Iconoclasm*, pp. 143–51.
28. See especially Andre Grabar, *L'Iconoclasme Byzantin: Dossier archéologique* (Paris, 1957), pp. 143–45, for a list of pertaining documents.
29. *Vita S. Stephani iunioris*, col. 1113. I am using the English translation in Cyril Mango, *The Art of the Byzantine Empire: 312–1453* (Toronto, 1986), p. 152.
30. *Vita S. Stephani*, col. 1120; Mango, pp. 152–53.
31. *Theophanes Continuatus*, p. 100; Mango, p. 159.
32. This was briefly noted by Louis Brehier, *La Querelle des images (VIII-IXe Siècles)* (Paris, 1904; reprinted New York, 1969), pp. 45 ff.
33. See, for instance, the texts collected by Cyril Mango in his *The Art of the Byzantine Empire*, pp. 113 ff.
34. See above, chapter 10, sections 4 and 6.
35. See *On the Holy Icons*, I, 13–14 (pp. 33 ff.); 19 (pp. 38 ff.); II, 12–15 (49 ff.); 27–40 (pp. 59–69); III, 3 (pp. 102–8). These passages are devoted specifically to veneration; in other parts of the Refutations the question often comes up, without lengthy discussion being devoted to it.
36. But he clearly summarizes it at the beginning of the first Refutation (I, 3, 4). See *On the Holy Icons*, pp. 21 ff.
37. For the philosophical basis of early Christian heresies, see Harry A. Wolfson, *The Philosophy of the Church Fathers*, I, *Faith, Trinity, Incarnation* (Cambridge, Mass., 1956), pp. 575 ff.; for Docetism, see pp. 587 ff.
38. *On the Holy Icons*, p. 21.
39. In the original Theodore uses the term *paradoxon*. See Migne, *Patrologia Graeca* IC, col. 332 A.
40. Karl Schwarzlose, *Der Bilderstreit: Ein Kampf der griechischen Kirche um ihre Eigenart und Freiheit* (Gotha, 1890; reprint Amsterdam, 1970), pp. 180 ff.
41. See, for instance, what he says in the third Apology, chapter 16; *On the Divine Images*, pp. 73 ff.
42. *On the Holy Icons*, p. 110.
43. *On the Holy Icons*, p. 110
44. *On the Holy Icons*, p. 112.
45. *On the Holy Icons*, p. 112.
46. *On the Holy Icons*, p. 31.
47. *On the Holy Icons*, p. 113. And see also the discussion by Schwarzlose, p. 181.

48. *On the Holy Icons*, p. 35.
49. On this subject, see Georg Ladner's important study, "The Concept of the Image in the Greek Fathers and the Byzantine Iconoclastic Controversy," *Dumbarton Oaks Papers* VII (1953), pp. 1–34; reprinted in Georg Ladner, *Images and Ideas in the Middle Ages: Selected Studies in History and Art* (Rome, 1983), pp. 73–111. I shall refer to this study in the latter edition. Ladner, too, emphasizes the common elements in the different versions of defining the image rather than the diverging features.
50. *On the Holy Icons*, p. 26.
51. *On the Holy Icons*, p. 102.
52. *On the Divine Images* I, 9; p. 19 of the English translation.
53. *On the Holy Icons*, p. 31.
54. *On the Holy Icons*, p. 33.
55. So far as I know, we have no investigation of the psychological doctrine of the Church Fathers, especially in the Greek East, that would discuss this problem. In defining the mental image and in making some generalizations as to its emergence and meaning in the writings of the early Fathers of the Church, I have thus to rely on impressions, which certainly should be amplified, and are in need of verification.
56. *On the Divine Images* I, 19; pp. 19 ff. of the English translation. A similar passage occurs in John's Third Oration (III, 19; pp. 75 ff.).
57. *On the Holy Icons* I, 10; p. 31 of the English translation.
58. *On the Holy Icons* III, D, 13; p. 114 of the English translation.
59. See above, chapter 10, section 3.
60. *On the Holy Icons* I, 9; p. 28.
61. *On the Holy Icons* III, C 2; p. 103.
62. I should like to mention again the recent study by S. R. F. Price, *Rituals and Power: The Roman Imperial Cult in Asia Minor* (Cambridge, 1984), esp. pp. 170 ff. And see also the still interesting wotk by Kenneth M. Setton, *Christian Attitude towards the Emperor in the Fourth Century* (New York, 1941), esp. pp. 196 ff.
63. See John of Damascus, *On the Divine Images* I, 21; p. 29. And see Theodore of Studion, *On the Holy Images* I, 9 (p. 28); II, 11 (pp. 48 ff.).
64. *On the Holy Icons* I, 9; p. 29. The italics are mine.
65. *On the Holy Icons* III, C 5; p. 104.
66. *On the Holy Icons* III, A 2; p. 78.
67. Aristotle, *Metaphysics* I, 1; 980 a 24 ff. I use the translation by McKeon (New York, 1941).
68. In his *De fide orthodoxa*, 18 (Migne, *Patrologia Graeca* XCIV, col. 933d).
69. *Antirrheticus* III, 3, 3 and 3, 5. For the original text, see Migne, *Patrologia Graeca*, C, cols. 380, 384 (the sentences referred to). And see Pelikan, *The Spirit of Eastern Christendom*, pp. 121 ff. See also Anne J. Visser, *Nikephoros und der Bilderstreit* (The Hague, 1952), pp. 116 f.; and especially Paul

J. Alexander, *The Patriarch Nicephorus of Constantinople: Ecclesiastical Policy and Image Worship in the Byzantine Empire* (Oxford, 1958), passim.

70. Theodore does not give any specific reference, but he was obviously thinking of the story of the Transfiguration, as related in Matthew 17:1–8, Mark 9:2–8, and Luke 9:2–8. In all these texts it is clear that the disciples first saw the vision, and only after that heard the words spoken.

71. *On the Holy Icons* A 2; p. 78.

72. *On the Holy Icons* III A 16; p. 83.

73. *On the Holy Icons* III A 34; p. 91.

74. Aristotle, *Physics* IV, 4, 212 a 7. I use the translation by Richard McKeon (New York, 1941).

75. For an interesting parallel, see Aristotle's *Poetics* VI, 15, 1450 b.

76. For John of Damascus as a pioneer of the Aristotelian revival, see Krummbacher, *Geschichte der Byzantinischen Litteratur*, pp. 171 ff.

77. John of Damascus, *On the Divine Images* III A 24; p. 78.

78. John of Damascus, *On the Divine Images* I, 15; p. 22.

79. See Alexander, *The Patriarch Nicephorus of Constantinople*, p. 209; and G. Ostrogorsky, *Studien zur Geschichte des byzantinischen Bilderstreits*, pp. 40 ff.

80. I have followed the lucid exposition by Alexander, *The Patriarch Nicephorus*, pp. 204–9.

81. *Antirrheticus* II, 13 (Migne, *Patrologia Graeca*, C, cols. 357b–360a). I use the English translation of this passage in Alexander, *The Patriarch Nicephorus*, p. 208.

82. *On the Holy Icons* III, A 11; p. 81.

83. *On the Holy Icons* III, A 13; p. 82.

84. *On the Holy Icons* I, 11; p. 32.

85. See mainly the fourth book of Aristotle's *Metaphysics*, 208 a 27–217 b 28.

86. See, for instance, S. Sambursky, *Das physikalische Weltbild der Antike* (Zurich and Stuttgart, 1965), pp. 133 ff.

87. "He was circumscribed by a place, living in Nazareth," we read in the third Refutation. See *On the Holy Icons* III A 31; p. 89.

88. *On the Holy Icons* III A 25; p. 87. Theodore is quite close here to Aristotle's famous discussion of *topos* in his *Physics* IV, 4, 212 a 5 ff.

89. *On the Holy Icons* III A 30; p. 89. For the probable source, see Aristotle's *Physics* IV, 4.

90. *On the Holy Icons* II, 18; p. 54. After Sophronius, *Miracles of Saints Cyril and John*. The text is found in Migne, *Patrologia Graeca*, LXXXVII, cols. 3557 ff. For an English translation, see Cyril Mango, *The Art of the Byzantine Empire, 312–1453* (Toronto, 1986), pp. 135 ff. As Cyril Mango notes (ibid., p. 135, note 67), this passage was quoted by John of Damascus and in the *Acts* of the Seventh Ecumenical Council. The art historian will notice that right and left are here noted according to the spectator's position.

91. *On the Holy Icons* III, A 30; p. 89.

Name Index

Subject Index

Printed in the United States
25928LVS00001B/178